DISCARD

BEYOND PRICE

Much recent discussion surrounding valuation of the arts and culture, particularly in the policy arena, has been dominated by a concern to identify an economic and financial basis for valuation of artworks, arts activities, and more general ways in which we express our culture. Whereas a great deal can be gained from a fuller understanding of the economic value of art, there is a real danger that financial considerations will tend to crowd out all other aspects of value. This book moves beyond the limitations implicit in a narrow economic approach, bringing different disciplinary viewpoints together, opening up a dialogue between scholars about the processes of valuation that they use, and exploring differences and identifying common ground between the various viewpoints. The book's common theme – the tension between economic and cultural modes of evaluation – unites the chapters, making it a coherent and unified volume that provides a new and unique perspective on how we value art.

Michael Hutter is Professor of Economics at Witten/Herdecke University, Germany, and holds the Chair for Economic Theory at that university. He has an extensive list of publications in the areas of economic theory, philosophy, and the economics of art and culture. He is a coeditor of *Soziale Systeme: Zeitschrift für soziologische Theorie* and a member of the editorial boards of the *Journal of Cultural Economics* and the *European Journal of Law and Economics*. Professor Hutter is a past president of the Association for Cultural Economics International and has held visiting appointments at the New School for Social Research (New York), the European University (Florence), the University of Catania, the University of Innsbruck, and the University of California, Berkeley. In the falls of 2003 and 2007 he was a Visiting Scholar at the Getty Research Institute, Los Angeles.

David Throsby is Professor of Economics at Macquarie University in Sydney, Australia. He has published widely on the economics of the arts and culture and the relationship between cultural and economic policy. His research has focused on supply and demand in the performing arts, the role of artists as economic agents, cultural policy, culture in economic development, sustainability and cultural capital, theories of value in the arts and culture, and the economics of heritage conservation. He is a past president of the Association for Cultural Economics International and is a member of the editorial boards of the *Journal of Cultural Economics, Poetics,* and the *International Journal of Cultural Policy*. Professor Throsby's most recent book, *Economics and Culture*, was published by Cambridge University Press in 2001; it has also been published in Spanish, Italian, Chinese, Korean, and Japanese translations. He is also coeditor of the *Handbook of the Economics of Art and Culture* (2006). He is currently working on a book on the economics of cultural policy.

Murphy Institute Studies in Political Economy

General Editor: Richard F. Teichgraeber III

The books in the series are occasional volumes sponsored by the Murphy Institute of Political Economy at Tulane University and Cambridge University Press, comprising original essays by leading scholars in the United States and other countries. Each volume considers one of the intellectual or analytical preoccupations or analytical procedures currently associated with the term "political economy." The goal of the series is to aid scholars and teachers committed to moving beyond the traditional boundaries of their disciplines in a common search for new insights and new ways of studying the political and economic realities of our time. The series is published with the support of the Tulane-Murphy Foundation.

Also in the Series:
Gordon C. Winston and Richard F. Teichgraeber III, eds., *The Boundaries of Economics*
John Dunn, ed., *The Economic Limits to Modern Politics*
Thomas L. Haskell and Richard F. Teichgraeber III, eds., *The Culture of the Market: Historical Essays*
James L. Regens and Ronald Keith Gaddie, *The Economic Realities of Political Reform*
John Ferejohn, Jack N. Rakove, and Jonathan Riley, eds., *Constitutional Culture and Democratic Rule*

Beyond Price

Value in Culture, Economics, and the Arts

Edited by

MICHAEL HUTTER

Witten/Herdecke University, Germany

DAVID THROSBY

Macquarie University, Sydney

CAMBRIDGE
UNIVERSITY PRESS

CAMBRIDGE UNIVERSITY PRESS
Cambridge, New York, Melbourne, Madrid, Cape Town, Singapore, São Paulo, Delhi

Cambridge University Press
32 Avenue of the Americas, New York, NY 10013-2473, USA

www.cambridge.org
Information on this title: www.cambridge.org/9780521862233

First published 2008

Printed in the United States of America

A catalog record for this publication is available from the British Library.

Library of Congress Cataloging in Publication Data

Beyond price : value in culture, economics, and the arts / Michael Hutter,
David Throsby [editors].
p. cm. – (Murphy institute studies in political economy)
Includes bibliographical references and index.
ISBN 978-0-521-86223-3 (hardback)
1. Arts – Economic aspects. 2. Culture – Economic aspects. 3. Art appreciation.
4. Arts and society. 5. Cultural policy. I. Hutter, Michael. II. Throsby, C. D.
III. Title. IV. Series.
NX634.B49 2008
306.4'7–dc22 2007010052

ISBN 978-0-521-86223-3 hardback

Contents

Color plates follow page 30.

Contributors

Lourdes Arizpe is Professor of Anthropology at the National University of Mexico, Centro Regional de Investigaciones Multidisciplinarias. Her research has focused on rural-urban migration, women and development, culture, global change, and cultural diversity. She held the position of Assistant Director-General for Culture at UNESCO from 1994 to 1998 and was a member of the independent United Nations World Commission on Culture and Development. She was also Director of the Institute of Anthropological Research at the National Autonomous University of Mexico and received a John H. Guggenheim scholarship and a Fulbright-Hayes grant. At present she is President of the International Social Science Council based in Paris. She holds a Ph.D. from the London School of Economics and an M.A. from the National School of Anthropology and History of Mexico.

Marina Bianchi is Professor of Economics at the University of Cassino, Italy, where she teaches microeconomics and industrial organization. She has written on problems related to the theory of the firm and on consumer choice theory. Her particular focus has been problems of preference formation and the role of novelty in consumption. Her more recent publications on these topics include (with Andreas Chai) *Consumption Time and Skills: Costs or Pleasure?* (2005) and a contribution to the *Handbook on the Economics of Happiness* (2007). She has also published papers in *Advances in Austrian Economics*, the *Journal of Economic Psychology*, the *Journal of Economic Behavior and Organization*, the *Journal of Medieval and Early Modern Studies*, and the *Journal of Cultural Economics*.

Arthur C. Brooks is Professor of Public Administration and Director of the Nonprofit Studies Program at Syracuse University's Maxwell School of Citizenship and Public Affairs. He writes about philanthropy, nonprofit organizations, and the arts. His most recent book is *Who Cares: The Surprising*

Truth about Who Is Charitable, Who Isn't, and Why It Matters for America (2006). Preceding his work in academia, he spent 12 years as a classical musician, holding positions with the Barcelona Symphony Orchestra and other ensembles.

Neil De Marchi is Professor of Economics at Duke University, where he collaborates with the art historian Hans Van Miegroet on the way markets in art emerged and functioned in early modern Europe. He is also trying to understand the market in Australian Aboriginal paintings. He has been developing and coteaching with Marina Bianchi a course on the Economics of Creative Goods, which both hope to apply to the question of how investments in the arts and culture might (or might not) contribute to the renewal of "museum" cities. Recent writings include contributions to the *Handbook of the Economics of Art and Culture* (2006) and *The Cambridge Companion to Adam Smith* (2006). With Hans Van Miegroet he has edited *Mapping Markets for Paintings in Europe, 1450–1750* (2006).

Bruno S. Frey has been Professor of Economics at the University of Zurich since 1977. He was Professor of Economics at the University of Constance from 1970 to 1977. He has received honorary doctorates from the Universities of St. Gallen (Switzerland, 1998) and Goeteborg (Sweden, 1998). He is the author of numerous articles in professional journals and books, including *Not Just for the Money* (1997), *Economics as a Science of Human Behaviour* (1999), *Arts & Economics* (2000), *Inspiring Economics* (2001), *Successful Management by Motivation* (with Margit Osterloh, 2001), *Happiness and Economics* (with Alois Stutzer, 2002), and *Dealing with Terrorism – Stick or Carrot?* (2004).

Victor Ginsburgh is Honorary Professor of Economics at the University of Brussels. He has written and edited a dozen books and is the author of more than 140 papers in applied and theoretical economics, including industrial organization and general equilibrium analysis. His recent work includes the economics of the arts, wines, and languages. He has published more than 40 papers on these topics, some of which have appeared in *American Economic Review*, the *Journal of Political Economy, Games and Economic Behavior*, the *Journal of Economic Perspectives*, the *Journal of the European Economic Association*, and the *Journal of Cultural Economics*. He is coeditor (with David Throsby) of the *Handbook of the Economics of Art and Culture* (2006).

Kurt Heinzelman is Professor of English at the University of Texas at Austin and Resident Faculty in the James A. Michener Center for Writers. He has

written extensively on both British Romanticism and modern poetry as well as on cultural economics. He has been a Danforth Foundation Fellow, a Fulbright Fellow at Edinburgh University, and a Fellow of the Society for the Humanities at Cornell University. He has also taught at the Institut du Monde Anglophone, Sorbonne Nouvelle (Université de Paris – III). His published work in cultural criticism and literary history has won awards from *Choice* (Outstanding Academic Book of the Year) and from the Keats-Shelley Association of North America, and his published poetry has won Pushcart Press recognition and the Borestone Mountain Poetry Award. In 2005, he was elected to the Texas Institute of Letters.

Elizabeth Honig is Associate Professor of Art History at the University of California, Berkeley. Prior to moving to Berkeley she worked at Tufts University, and she has been a guest lecturer at the University of Leiden. She is the author of *Painting and the Market in Early Modern Antwerp* (1998) and numerous articles on Dutch, Flemish, and British art. She is currently working on a book about the painter Jan Brueghel.

Michael Hutter is Professor of Economics at Witten/Herdecke University, Germany, and holds the Chair for Economic Theory at that university. He has an extensive list of publications in the areas of economic theory, philosophy, and the economics of art and culture. He is a coeditor of *Soziale Systeme: Zeitschrift für soziologische Theorie*, and a member of the editorial boards of the *Journal of Cultural Economics* and the *European Journal of Law and Economics*. He is a past President of the Association for Cultural Economics International and has held visiting appointments at the New School for Social Research (New York), the European University (Florence), the University of Catania, the University of Innsbruck, and the University of California, Berkeley. In fall 2003 and 2007 he was a Visiting Scholar at the Getty Research Institute, Los Angeles.

Bill Ivey is the Director of the Curb Center for Art, Enterprise, and Public Policy at Vanderbilt University, a cultural policy research center with offices in Nashville, Tennessee, and Washington, DC. He is also a Trustee of the Center for American Progress, a Washington, DC, think tank, and is Senior Consultant to Leadership Music, a music industry professional development program in Nashville. From 1998 to 2001, he was Chairman of the National Endowment for the Arts. For the two decades prior to his government service, he was Director of the Country Music Hall of Fame in Nashville. He was twice National Chairman of the National Academy of Recording Arts &

Sciences (NARAS) and is a four-time Grammy Award nominee. His book on cultural rights was published in the fall of 2007.

Steven Knopoff is a Lecturer in Music at the University of Adelaide, Australia, where he teaches courses in the areas of ethnomusicology, music theory, and popular music and culture. He is an ethnomusicologist and composer with wide musical interests, including Australian Aboriginal music and dance, music analysis, cross-cultural music practices, and the influence of technology upon musical aesthetics and performance practices. The primary focus of his research and publication has been the ceremonial songs and performance of the Yolngu people residing in and around Yirrkala, Northern Territory. He is immediate past President of the Musicological Society of Australia.

Richard Shusterman is the Dorothy F. Schmidt Eminent Scholar Chair in the Humanities at Florida Atlantic University. From 1998 to 2004, he served as Chair of the Philosophy Department at Temple University, Philadelphia. Educated at Jerusalem and Oxford, he has been awarded senior National Endowment for the Humanities (NEH) and Fulbright Research Fellowships. His books include *The Object of Literary Criticism* (1984), *T. S. Eliot and the Philosophy of Criticism* (1988), *Pragmatist Aesthetics* (1992, now in its second edition, 2000, and translated into twelve languages), *Sous l'interprétation* (1994), *Practicing Philosophy: Pragmatism and the Philosophical Life* (1997), *Performing Live* (2000), *Surface and Depth* (2002), and *Body Consciousness: A Philosophy of Mindfulness and Somaesthetics* (2008). An expert in somatic philosophy, in which he has developed a field called somaesthetics, he also works professionally on body-mind reeducation as a certified Feldenkrais practitioner.

Terry Smith is Andrew W. Mellon Professor of Contemporary Art History and Theory in the Department of the History of Art and Architecture at the University of Pittsburgh. During 2001–2002 he was a Getty Scholar at the Getty Research Institute, Los Angeles. From 1994 to 2001 he was Power Professor of Contemporary Art and Director of the Power Institute, Foundation for Art and Visual Culture, University of Sydney. He was a member of the Art & Language group (New York) and a founder of Union Media Services (Sydney). He is the author of a number of books, including *Making the Modern: Industry, Art and Design in America* (University of Chicago Press, 1993), *Transformations in Australian Art*, 2 vols. (2002), and *The Architecture of Aftermath* (2006).

Richard F. Teichgraeber III is Professor of History and Director of the Murphy Institute at Tulane University in New Orleans. He is the author of *Sublime Thoughts/Penny Wisdom: Situating Emerson and Thoreau in the American Marketplace* (1995) and *"Free Trade" and Moral Philosophy: Rethinking the Sources of Adam Smith's "Wealth of Nations"* (1986) and coeditor (with Thomas L. Haskell) of *The Culture of Market: Historical Essays* (Cambridge University Press, 1993).

David Throsby is Professor of Economics at Macquarie University in Sydney. He has published widely in the economics of the arts and culture and the relationship between cultural and economic policy. His research has focused on demand and supply in the performing arts, the role of artists as economic agents, cultural policy, culture in economic development, sustainability and cultural capital, and the economics of heritage conservation. His most recent book, *Economics and Culture*, was published by Cambridge University Press in 2001; it has also been published in Spanish, Italian, Chinese, Korean, and Japanese translations. He is coeditor (with Victor Ginsburgh) of the *Handbook of the Economics of Art and Culture* (2006). He is currently working on a book on the economics of cultural policy.

Sheila Weyers has a degree in philosophy and is interested in aesthetics and its relations with art history. She has published on movies, including remakes; on the art historian de Piles; and is now working on canons. Her papers have appeared in *Artibus et Historiae*, the *Journal of Cultural Economics*, *Annales d'Histoire de l'Art et d'Archéologie*, *Poetics*, and *Empirical Studies in the Arts*.

Carolyn Wilde is a philosopher at the University of Bristol working primarily on the later Wittgenstein and in aesthetics. She has chapters related to the essay in this volume in Peter Lewis, ed., *Wittgenstein, Aesthetics and Philosophy* (2004) and in P. Goldie and E. Schellekens, eds., *Philosophy and Conceptual Art* (2007). Previously qualified in fine art, she also teaches art and art theory and is coeditor of Blackwell's *Companion to Art Theory* (2002). She is an executive member of the British Society of Aesthetics.

Preface

The aim of this volume is to extend understanding of how value is formed and how valuation processes operate in the arts and culture. It does so against a background of a world in which market forces have become more and more powerful as a driver of public and private decision making. In these circumstances, economic considerations are playing an ever stronger role in assigning value to the things people make, consume, enjoy, buy, and sell. Of course in the arts and culture financial assessments of value have always been important, but there is a sense in the contemporary world that an economic basis for determining the value of art is tending increasingly to overshadow alternative concepts.

An essential premise of our project has been the recognition that a continuing difficulty in existing studies of value in the arts and culture has been the rigid disciplinary confines within which scholars have worked. This is especially true of economists, who tend to regard economic science as being capable of explaining all human behavior, past, present, and future, but it is also true in other directions – many cultural specialists do not comprehend what is going on in neighboring disciplines and may have a particularly ill-informed view of what economics can contribute to the debate. Accordingly, the project was designed with the purpose of opening up possibilities for interdisciplinary communication and dialogue.

As a first step, the two editors convened a workshop, Practices in the Valuation of Art, in fall 2000 at Villa La Collina in Cadenabbia (Como), Italy, supported by the Fritz Thyssen Foundation. The event drew together economists; historians of art, literature, and music; artistic directors; and artists. The workshop did not aim for a written account of the valuation processes under discussion, but rather it was designed to test whether a fruitful discussion across the disciplinary boundaries could be conducted.

The success of this initial meeting motivated the organization of a second workshop that could produce some tangible results.

The present volume originated in that second workshop, which the editors convened in spring 2004. This workshop was held at the Rockefeller Foundation Study and Conference Center in Bellagio, Italy. We invited a group of scholars from a variety of disciplines that deal with the two valuation processes. The editors and all the other economists involved had a background in cultural economics; in very diverse ways, they all had encountered the strange cohesiveness of cultural custom, artistic appreciation, and aesthetic taste. The other scholars were art historians, musicologists, aesthetic philosophers, literary scholars, anthropologists, and policymakers – many of them in multiple roles. All participants were asked to contribute papers with selected cases from their own field of competence that could assist in exploring differences and identifying common ground among the various viewpoints. In fact, virtually all the papers discussed concrete historical or contemporary cases and controversies.

The lead-up to the actual workshop was fraught with apprehension. To put it in a nutshell, the economists suspected that their colleagues from the humanities would deal in ill-defined concepts with only anecdotal evidence; the humanists, in turn, suspected that the economists would be bent on stubbornly instrumental interpretations of any artistic and cultural activity, focusing on nothing much more than the commercial exploitation of art. It took some time in the workshop itself to dispel these fears, but they were gradually replaced with a sense of curiosity among the economists about the strange consistency in the arguments of art historians or anthropologists, and with a sense of recognition on the part of the humanists of the economists' genuine intellectual quest to come up with an extended model that takes into account the peculiar properties of artistic and cultural valuation.

Following the workshop all sixteen papers were completely revised, extended, and reworked to account for the comments and feedback arising from the meeting and beyond, and to emphasize the common themes that provided the intellectual spine of our discussion. Together with the introductory chapter, these papers are now collected in the present volume.

We wish to express our gratitude to a number of organizations and individuals. Most importantly we would like to thank the Rockefeller Foundation for its generous support of the Bellagio workshop. Joan Shigekawa, Associate Director, Creativity and Culture, at the Foundation, attended the workshop and was our primary point of contact with the funding agency.

Susan Garfield and Peter Helm in the New York office provided valuable assistance, while special appreciation is due to Gianna Celli and her staff at the Villa Serbelloni for their hospitality and friendship during our meeting. The project grant was administered through the Department of Economics at Macquarie University, and we are grateful to staff there for their help. In particular we record our thanks to Delia McCarthy, who dealt with the logistics of organizing the workshop, and Laura Billington, who oversaw the editorial processing of manuscripts and illustrations for this volume. Three anonymous reviewers of the proposal for the volume provided valuable feedback. Finally, we express our appreciation of the role played by Scott Parris, Senior Editor, Economics and Finance, at Cambridge University Press, New York, in bringing this volume to fruition.

Michael Hutter
David Throsby
June 2007

ONE

Value and Valuation in Art and Culture

Introduction and Overview

Michael Hutter and David Throsby

1.1 Background

The guiding hypothesis on which this volume is based is that a distinction can be made between economic and cultural value, and that it is the nature of these twin concepts of value, how they are formed and how they relate or do not relate to each other, that needs to be investigated. These two concepts run like a leitmotiv through the volume, linking the chapters across the disciplinary boundaries.

To place the volume in its proper context, it is helpful to begin by looking over the historical evolution of ideas in this field, identifying the starting points and counterpositions from which the various chapters' arguments are derived. In the brief historical survey of the field contained in Section 2 of this chapter, we adopt a broadly chronological approach.[1] Then in Section 3 we discuss the contemporary debate, dealing with literature mainly from the second half of the twentieth century to date. Finally in Section 4, we provide an overview of the volume and its contents.

1.2 Starting Points in the Literature

Debate about the relationship between cultural and economic value has been carried on in philosophy since Plato and Aristotle. Ancient thought claimed the attainability of a supreme value through the experience of bliss or divine pleasure; the experience of art played only a minor role in attaining that goal, and commercial action ranked even lower, being associated with the merely practical arts. But it was not until the seventeenth and eighteenth

[1] Some of the following discussion draws upon results of a separate research project on the history of notions of economic and aesthetic value that was one of the unintended outcomes of the workshop; see further in Hutter and Shusterman (2006).

centuries that a major strand of modern aesthetic and economic thought was established. It was due to a series of English authors that included prominently the Earl of Shaftesbury, Francis Hutcheson, David Hume, and Adam Smith. All of them saw a distinction between value arising from the disinterested experience of beauty and value from objects that serve the self-love of individuals. The former was seen as clearly superior since it related to a contemplation of the Divine. Economic value, its complement, related to the pleasure derived from personal gratification. While morally inferior, the attainment of the greatest amount of utility became a legitimate and relevant goal of private consumption and of public action.

By the middle of the nineteenth century, the disciplines of economics and of aesthetic philosophy were well separated. W. S. Jevons and other economists were able to argue convincingly that "utility," like physical sensation, followed a pattern of decreasing intensity at the margin. This seemed to provide a sufficient common denominator for the determination of market value: When the aggregate utility of consumers and the aggregate costs of production were joined through processes of market exchange, an equilibrium price resulted. That price was called exchange-value. Aristotle had interpreted exchange-value as the lower limit to the many natural values in use; the economic theory that emerged at the end of the nineteenth century was built on exchange-value as the equilibrium of a self-coordinating mechanism, relegating use-values to a fuzzy penumbra of subjective "preferences." At the same time as these developments were occurring, aesthetic theory began to separate itself from the nonartistic world. Starting with Hegel, aesthetic philosophers narrowed their focus to the fine arts and claimed that artworks play a privileged role in the promotion of spiritual, comprehensive truth.

The twentieth century saw a continuation of these separate tracks of development. In aesthetic theory, the attempts to characterize the uniqueness of aesthetic value continued: Adorno (1984) insisted on the autonomy of art; G. E. Moore (1959) argued the case on the grounds of moral goodness; Wittgenstein (1970) based his language games on "cultured taste"; Gadamer (1982) focused on the relation to truth; and Budd (1995) pleaded for the intrinsic value of the artistic experience. Meanwhile in economics, theory acquired axiomatic rigor. Price expressed in monetary terms was identified with the impartial result of all the subjective and objective variables that impinge on any transaction. A new hierarchy was established wherein price and value became synonymous; in this logical universe, cultural and artistic value were seen as a subjective category, beyond the scope of scientific

inquiry. In Debreu's (1959) canonical version, *value* is defined as "market price times commodity volume."

1.3 The Contemporary Debate

Despite these uninviting conditions in much of the mainstream literature in all of the disciplines touched on previously, recent decades have seen substantial discussions of the relationship between economic and cultural value, particularly in reconciling the subjective, spiritual, or ineffable qualities of art and culture with the realities of financial valuation of these phenomena in the marketplace. Contributions to these discussions can be identified in economics, literary and cultural theory, sociology, anthropology, and cultural policy studies. The following survey presents only some of the most influential works in these five areas.

1.3.1 Economics

Among economists, there was little interest in reopening the value issue until the 1970s, when Scitovsky (1976) exposed the psychological sources of utility and emphasized the relevance of consumption skills as being indispensable for the enjoyment of cultural goods. The reaction to his ideas, however, was weak, and it took the art market boom of the 1980s to trigger a renewed interest in value, now focused specifically on the reasons for the high prices of some art-objects. Baumol (1986) started the debate with the thesis that future artistic prices are random, which helps to account for the abnormally low returns to investment in art-objects.[2] The contributions by Frey and Pommerehne (1989) were driven by problems in public policy. They shared the assumption that artistic quality can be expressed in market terms, but they did observe that reputations of artists and valuations of artworks are remarkably stable. Grampp (1989) sharpened the argument by outlining the factors that make up aesthetic judgments. He saw aesthetic value as being just as expressible as economic value. However, he claimed that "the value which the market places on works of art is consistent with the judgment which is made of their aesthetic quality" (p. 37); prices, therefore, are reliable indicators of priceless values.

[2] A spate of studies on rates of monetary return for paintings has since shown that returns can be high for small groups of buyers and precisely defined submarkets; see Frey and Eichenberger (1995) for a comprehensive survey.

The contemporary discussion within the economics of art and culture sees the relationship between the two values as being more complex than a simple monotonic transformation. Different disciplinary perspectives on the issue were collected for the first time by Klamer (1996) in a book that drew together essays from economists, philosophers, historians, political scientists, and artists; Klamer included short interviews with each author in an effort to increase the dialogue. Throsby (2001) clarified the distinction between economic and cultural value, the former being measurable by methods of economic analysis and expressible in monetary terms, the latter being multidimensional, deriving from a broadly cultural discourse and having no standard unit of account. He proposed a deconstruction of cultural value into its elements, including aesthetic, symbolic, social, and other components. A trenchant analysis of value treatment in economics can be found in Mirowski (1990, 1999), who argued that value is a socially constructed phenomenon and that the determination of value cannot be divorced from the social context in which it occurs.

1.3.2 Literary and Cultural Theory

The discussion in the early 1980s was enriched by contributions from the literary field that exposed the complex interweaving of artistic and economic valuations in actual works of literary and visual art. Heinzelman (1980) extracted complex economic meanings from works by Blake, Wordsworth, W. C. Williams, and Shakespeare. Marc Shell in several of his writings (1978, 1982, 1995) analyzed the penetration of economic meaning in literary works from the Greek myth of Gyges to the books of John Ruskin. In other studies, he explored the common communicative structure of coins, paper money, and art. Shell's interpretation of Goethe's treatment of money in his two *Faust* dramas is particularly illuminating.

In the cultural disciplines, interest in the topic was modest until the 1980s. In the French literature, particularly in the works of Pierre Bourdieu, the economic "field" is interpreted as one of several social domains, each with a distinct mode of discourse and valuation. Bourdieu (1985) suggested a distinction between the economic field, where objects have instrumental value, and the cultural field, where objects have symbolic value. Depending on which valuation was first, he saw the emergence of markets for large-scale cultural production or markets for restricted production. Bourdieu's concept of "cultural capital," introduced to denote the specific relevance of symbolic knowledge to individuals, has found empirical application in many sociological studies. It drew its inspiration from reference to Marxist notions

of social class, in contrast to more recent interpretations of cultural capital in orthodox economic terms as a long-lasting cultural asset (Throsby 1999). The influence of Marxist thought is also present in works by Baudrillard (1983), with a renewed emphasis on use-value and a belief that art, the "pure signifier," is untainted by the spread of commodification to the cultural world.

A breakthrough in the more abstract discussion of value in disciplines ranging from philosophy to literary criticism was made in the late 1980s by Barbara Herrnstein Smith. Smith (1988) started from the everyday experience of valuation: "We are always, so to speak, calculating how things 'figure' for us – always pricing them, so to speak, in relation to the total economy of our personal universe" (p. 42). An "economy," to her, was any set of resources and constraints in which individuals made decisions contingent on the conditions of such a "continuously fluctuating or shifting system" (p. 30). The aesthetic discourse could then be explained as such an economy "that embraces not only the ever-shifting economy of the artist's own interests and resources . . . but also all the shifting economies of her assumed and imagined audiences" (p. 45). In consequence, we can observe two "discursive domains":

On the one hand there is the discourse of economic theory: money, commerce, technology, industry, production and consumption, workers and consumers; on the other hand, there is the discourse of aesthetic axiology: culture, art, genius, creation and appreciation, artists and connoisseurs. In the first discourse, events are explained in terms of calculation, preferences, costs, benefits, profits, prices, and utility. In the second, events are explained – or, rather . . . "justified" – in terms of inspiration, discrimination, taste . . . , the test of time, intrinsic value, and transcendent value. (p. 127)

Smith's "double discourse" paradigm was enormously fruitful for the discussion of economic and cultural values in the humanities and in sociology, even if many of the subsequent contributions were critical of her approach. Let us consider two such examples. First, because postmodernist thought in philosophy and cultural studies was leading to a reemphasis on absolute values and a rejection of using instrumental values as a benchmark for judging aesthetic and other transcendent qualities, Smith's attempt to find absolute reasons for contingent values was said to fall short. Instead, Connor (1992) suggested a "paradoxical structure" as a solution: "The question of value cannot be seized all at once or all together," and this is precisely because "absolute value and relative value are not the sundered halves of a totality" (p. 32). Rather, each follows from and is implied within the other.

The second example relates to the reproach that Smith reduces "aesthetic value" to economic "use-value" – a distortion unacceptable to philosophical and literary scholars who grew up with Marxist political economy. In a broad study on the formation of the literary canon, Guillory (1993) discussed the "double discourse" paradigm and concluded: "To collapse exchange value into use-value . . . is to forget political economy in the very gesture of reducing the aesthetic to an expression of the 'economic'" (p. 302). However, exchange could now be treated as a general notion of interaction "without uttering a proposition about the economic" – an approach that Guillory traced to Georg Simmel (p. 298). That interpretation is relevant for sociological and anthropological studies of valuation, which we discuss in the following paragraphs.

Before doing so, however, we must deal with a contribution that is difficult to assign to any single discipline. Michael Thompson's "Rubbish Theory" made allusions to Wittgensteinian philosophy, to sociology, to formal topology, to cultural and anthropological studies, and to "Art and Language," a then prominent strand of Conceptual Art. Thompson (1979) suggested that three categories of value are in operation: the lowest is rubbish, which is literally overlooked; the most common is transient value, which diminishes over the life span of an object; and the highest is durable value, which is reached only by few objects at any given time. It is tempting to assign durable value to the objects of the art discourse and transient value to the objects of the market discourse. But as Thompson showed, value by necessity moves from one category to the next. In both discourses, objects with transient value are produced, most of them move on to the status of rubbish, a few of them move on to the status of durable value and remain there as long as the social conditions remain intact (p. 45). Economic and aesthetic valuations are tightly intertwined in this process. Academic myopia, he suggested, is not helpful in understanding such processes: "The more we insist on seeing the aesthetic and economic systems as clearly separate, the more we are forced to focus upon the connection between them" (p. 127).

1.3.3 Sociology

In sociology, various fields of practice, discourse, and interaction have a long tradition. Talcott Parsons's theory (1968), based on four "Systems of Social Action," was an early and rigidly formalized variation of that approach. In the works of Niklas Luhmann, communication was substituted for action. Instead of a fixed number of action systems, society operates in a changing, potentially growing number of self-coordinating communication systems.

Such systems begin to apply internal methods of valuation once their events have been successfully separated from the rest of their social environment by means of a "leading distinction." In a market system, everything that can be sold for money is either scarce or superfluous; in a legal system, all court sentences are either just or unjust; in the world of aesthetic discourse, all works of art are either beautiful or ugly. Predicates applied to events of the "wrong" social system are not understood, or they are considered improper. Luhmann laid out the basics of his societal theory in 1984 (Luhmann 1995). Subsequently, he investigated the major modern value systems, among them religion, the economy, politics, law, science, art (Luhmann 2000), education, and mass media. In Luhmannian terms, economic and aesthetic valuations are "structurally coupled." They provide each other with changing conditions – the market conditions of art and the cultural conditions of markets. These conditions are then used in each system as resources for new values, and thus for sustained self-reproduction.

1.3.4 Anthropology

In anthropology, issues of value and of "value spheres" inevitably arise since many of the civilizations or "cultures" studied by anthropologists operate without monetary exchange.[3] Two anthologies that offered perspectives on these issues provided an overview and interpretation; both of these anthologies continue to play a central role in the anthropological debate.

The first was Arjun Appadurai's anthology *The Social Life of Things* (1986). It contained studies that observed separations of exchanges into hierarchically ordered value spheres, namely, a "prestige sphere" and a "subsistence sphere," using gifts in the higher sphere and reciprocal transfers as well as barter in the lower sphere. Kopytoff (1986), in particular, applied it to exchanges of artistic objects in contemporary prestige spheres. He compared the value sphere practices of the Tiv people in Nigeria with the valuation practices in complex modern societies, and he isolated "singularization" as a distinctly modern cultural property: "In a complex society, the absence of such visible confirmation of prestige, of what exactly is an 'upward conversion,' makes it necessary to attribute high but nonmonetary value to aesthetic, stylistic, ethnic, class, or genealogical esoterica" (p. 82).

The second and more recent anthology was edited by Fred Myers and published in 2001. It focused mainly on the difference between Australian

[3] For further discussion of the evolution of concepts of value in anthropology, see Lourdes Arizpe in Chapter 9.

Aboriginal and Western culture in an attempt to "re-evaluate the relationship between material culture and exchange theory" (p. 3). Myers acknowledged that the Appadurai volume "offered the beginnings of a dialogue on the tensions between productions of value based on differentiations of objects and the options of economic gain that threaten to destabilize those differences." His volume "looks to the existence of multiple, coexisting, and variously related 'regimes of value'... and even to the embedding of exchange in more encompassing systems of value production" (p. 6).

1.3.5 Cultural Policy Studies

Early contributions to the emerging field that can loosely be called "cultural policy studies" maintained a distinction between fundamental cultural values and the sorts of values provided by a culture operating under a free market. For example, Lewis (1990) argued the necessity of articulating a set of values that commercial market-driven culture was *not* providing, going on to identify the value of diversity, of innovation, of creativity, and so on, as cultural values of importance in their own right. However, a primary concern of this and later writings in critical cultural policy studies such as those collected in Lewis and Miller (2003) has been with the questions, whose values? value to whom? The cultural policy studies paradigm, if it can be called that, interprets the determination of cultural value as lying within a system developed and maintained by the dominant power structures in society; in particular, the arts or high culture are regarded as the province of a cultural elite whose fine aesthetic distinctions bear little or no relevance to the concerns of the population at large.

In reviewing the values underlying cultural policy, a different line is followed by Holden (2004), who has been concerned at the increasing intrusion of purely economic or instrumental notions of value into policy formulation relating to the arts and culture in the United Kingdom. He uses the term *cultural value* to encompass the full range of values (including economic values) yielded by cultural goods and services such as the arts and cultural heritage. In his model the instrumental value of, say, the arts is augmented by the arts' intrinsic and institutional values; these latter "noneconomic" values, he suggests, should be regarded as just as important for policymaking as the instrumental ones. These sentiments have been echoed in a report from the RAND Corporation (McCarthy et al. 2005), which refers to intrinsic values as "the missing link" in judging the full value of the arts in the United States.

1.4 The Present Volume

As the above review indicates, efforts have been made in a number of disciplines over the last few decades to grapple with continuing problems in understanding value in art and culture. A reading of these various literatures gives rise to two observations. First, in keeping with our guiding hypothesis, it is apparent that there are indeed two distinct kinds of valuation at work, each with its own logic of operation. Far from being isolated from each other, economic value shapes cultural valuation and cultural valuation influences price. Their mutual interdependence leads to tensions in social practice, and these tensions are documented in the history of ritual, of art, and of its markets. The second observation is that despite interdependencies and tensions, there has been little cross-disciplinary dialogue connecting those scholars working on the various aspects of cultural value, especially with those specializing in economics. Indeed in the latter respect it can be said that there is a degree of mutual incomprehension between cultural and economic discourses in this area that cries out to be addressed. The chapters in this volume try to fill parts of that void.

In putting together the volume, we had of necessity to organize the chapters along a linear thread, a particularly challenging task given their multidimensionality. Many of the chapters touch on themes that resonate with the treatment of the same themes in other contributions. There are chapters that treat aspects of valuation in the reception and appreciation of the arts and culture (Smith, Shusterman, Ginsburgh and Weyers, Bianchi, and Brooks). Others focus on aspects of artistic production (Hutter, Throsby, Heinzelman, and Teichgraeber). There are chapters that use biographical evidence (Throsby, Honig, Heinzelman, and Teichgraeber), others that rely on historical reports and comments (Smith, Hutter, De Marchi, Wilde, and Brooks), and again others that use firsthand experience or statistical data (Knopoff, Arizpe, Ginsburgh and Weyers, Bianchi, and Frey). Some chapters deal with the economic, social, and cultural circumstances within which art is produced and consumed, contrasting the values of players in the art world and in the wider community (Frey, Brooks, and Ivey).

We opted for a thread that offers a possible heuristic approach to the issues involved. Five parts give structure to the enterprise. In every part, economists as well as humanists present their approaches. The title of Part I, "Origins of Meaning," suggests a focus on the precarious conditions under which artistic and cultural values emerge. Part II, "The Creation of Value in Artistic Work," emphasizes individual as well as social aspects of authoring

and exchanging works of art. In Part III, "Continuity and Innovation," changes in cultural valuation in archaic, traditional, and modern civilizations are studied. "Appreciation and Ranking" (Part IV) assembles four chapters, which are united by the common assumption that there are scales of quality along which excellence in the arts can be measured, and that these assessments of cultural value relate in some way to the economic value of the goods or services being considered. Finally, the chapters on "Cultural Policies" (Part V) take a pragmatic look at how evaluation procedures can clarify the grounds on which policy choices must be made.

We now proceed to describe the intention behind each of the five parts, and the major themes of each chapter.

Cultural value can be thought of as reflecting the meaning embodied in or expressed by artworks, artifacts, texts, performances, rituals, and customs. Part I, under the heading "Origins of Meaning," presents three chapters that explore how meaning generates value in three different contexts – in the production and marketing of Australian Aboriginal art, in the consumption of something called "entertainment," and in the history of various art genres. In each case the author puts the interplay of economic and cultural value into relief, reflecting on the conditions that give rise to different aspects of value and that mediate the relationships among them.

The origins of meaning in Australian Aboriginal paintings lie in the sacred rituals and imagery of these ancient people. Terry Smith (Chapter 2) teases out how the figurations that have evolved in Aboriginal religious practice resonate with the contemporary art market. "Sacred" value has spawned the commercial value of the artifacts that are produced in ever increasing number. The ritual meaning of the patterns and representations has been protected by a deliberate strategy of intransparency through abstraction, which has increased the fascination of art collectors whose tastes have been formed according to the criteria of Abstract Expressionism. Thus we see coexisting valuations arising from different origins of meaning – the sacred in traditional culture and the economic in the contemporary art market.

In a different context, coexisting valuations are tackled by Richard Shusterman (Chapter 3) through an etymological and logical analysis of the notion of "entertainment value." He succeeds in demonstrating that entertainment value can be interpreted as "the sort of directly experienced enjoyment that is grasped as valuable for itself rather than simply being appreciated for its instrumental value in achieving other ends." Given the generally commercial basis on which entertainment is produced and distributed, its economic value is readily recognizable. Shusterman, however, concentrates our attention on the transient and contingent qualities of entertainment

value, identifying it as an aspect of cultural value that coexists on equal terms with the more permanent aspects of aesthetic value.

Finally in Part I, Michael Hutter (Chapter 4) looks at causal historical connections between market valuations and new artistic meanings. He presents a set of cases from the history of painting, of film, and of rock music. All three illustrate a "trigger relationship" between economic activity and artistic achievement. Sudden changes in prices for commodities employed as inputs in the artistic process trigger changes in artistic formats, styles, and genres. The shift in economic values leads to shifts in artistic values. The new prices do not "enter" artistic valuation, but they "irritate" the context of artistic judgment, thus leading to new work, which is judged to enrich the stock of available cultural wealth.

Origins of value are also implicated in Part II, which bears the title "The Creation of Value in Artistic Work." If at least some aspects of the value of an artwork can originate from the creative input of the artist, what sorts of factors come into play to determine how it is valued once the work is completed? The three chapters in this part consider three different influences on the way value is formed: the original intentions of the artist in creating the work; specific modes of exchange, which indicate appreciation for the artist and his or her work; and the archival potential of a work as a source of value. In each case the authors compare and contrast the economic and the cultural valuations of the work or works considered.

David Throsby (Chapter 5) focuses on the historical figure of Hector Berlioz. Throsby is well aware that statements by artists as to their intentions in creating their artifacts cannot be taken at face value. But he is able to show how Berlioz had a clear conception of the artistic accomplishment he was after, and how this demonstrably took precedence over pressing financial motives for writing his music. Throsby considers the fluctuating forces that have affected the valuation of Berlioz's *Symphonie Fantastique*, which, after an initially controversial reception, eventually vindicated Berlioz's risky intention of inventing a new mode of musical expression.

Elizabeth Honig (Chapter 6) deals with a broader set of forces over a longer period. Her story leads to a new way of interpreting the literature in art history and theory during the sixteenth and seventeenth centuries. During the sixteenth century, market valuation spread through European societies, particularly in the economically most developed regions. In the distribution of master paintings, another system was still operating, the "honor system." Under this system, paintings were presented as gifts, to be reciprocated by the recipient. The gifts constituted reifications of social relationships, because "worthiness" was bestowed upon all the participants

in the exchange. As the art writers of the age tried to shore up the new market mode of value assessment, they appropriated the notions of excellence that had been promulgated in the honor system. Thus, the writers were able to maintain the distinction between recognition of an artist's *artistic* talent and of his talent for making money.

In the third chapter of this trio, Kurt Heinzelman (Chapter 7) works with a surprising yet instructive kind of artifact, namely, the archive. The archive is inevitably perched on the borderline: Is it valuable or is it "rubbish"? It may be that material appearing to be rubbish releases, over the course of time, new insights and interpretive connections, thus generating value that is measurable in economic as well as in artistic terms. Heinzelman offers three cases. First, he shows that the transient visual work of Christo and Jeanne-Claude needs the maintenance of repositories to generate sustainable aesthetic as well as economic value. His second example draws from the literary work of Louis Zukofsky, who employs the archive as the very subject of his artistic project. Finally, Heinzelman considers the sale of the Watergate Archives, a phenomenon that indicates the appreciation of the cultural value of documentary material that is firmly linked to a major political crisis in U.S. history.

Part III, under the title "Continuity and Innovation," shifts the focus specifically to the way the passage of time affects cultural value, identifying circumstances that either promote stability or exert pressure for change in cultural environments. The three chapters in this section consider these questions in widely differing contexts: a primitive society where continuity in cultural practice reflects centuries-old aesthetic and social tradition, a developing country in which inherited ritual that expresses spiritual meaning for rural communities adapts to a changing world, and an advanced country evaluating and reevaluating the cultural significance of a major literary figure as interpretations of value change over the years.

The ceremonial songs and dances of Aboriginal tribes in Northern Australia embody most forms of knowledge, including cosmology, law, history, science, and kinship. As Steven Knopoff (Chapter 8) argues, cultural value in these circumstances reflects manifold and deep meanings, including sacred, spiritual, aesthetic, and societal components. The clan songs and dances of the Yolngu people, his chosen case study, provide a source of stability in a community dealing with modern problems of poor health, lack of education, alcoholism, and unemployment. The cultural value of the tribal rituals is resilient to change, but Knopoff suggests that they are likely to be more seriously threatened in the future.

Rituals of a different sort are discussed in the chapter by Lourdes Arizpe (Chapter 9). She considers the "Day of the Dead" ritual as practiced each

year in a small rural town in Mexico. Like the Aboriginal ceremonies, this tradition cannot be comprehended in terms simply of exchange or individual maximizing behavior. On the contrary, Arizpe argues that the essential cultural value embodied in the ritual is one that makes participants think of themselves collectively; the ritual expresses their reciprocal loyalty and commitment to others in the group. The ritual has adapted to change over time, introducing contemporary objects and symbols as they become part of everyday living. In 2003, the Day of the Dead was added to the list of "Masterpieces of Oral Tradition and Intangible Heritage" by United Nations Educational, Scientific, and Cultural Organization (UNESCO), drawing it to world attention and making it a potentially marketable commodity (for tourists), thus marking yet another stage in its continuing evolution.

Evolutionary changes in interpretation of cultural value are also the subject of Richard Teichgraeber's chapter (Chapter 10), which examines the construction of the cultural value reflected in the reputation of a major American literary figure, Ralph Waldo Emerson. This chapter addresses a complex and recurring problem in the interpretation of cultural value: What do we mean when we say that an artist's life and work have been of "value" to a nation, to a culture, or to civilization as a whole? The Emerson case is revealing because of the shifting interpretations of his significance over time. Teichgraeber concentrates on the late nineteenth and early twentieth centuries and on the portrayal of Emerson as artist, secular saint, and champion of democratic reform. He is particularly concerned to identify an underrecognized influence on the popular conception of Emerson's value, the emergence of a commercial mass print culture in the later years of the nineteenth century, which greatly widened public access to Emerson's work, especially in schools. In a broader context, Teichgraeber argues that the construction of the cultural value of Emerson's reputation helps us to understand how Americans have gone about the larger task of building a national culture.

It seems almost inevitable that at some point in any consideration of cultural value the question of measurement will arise, if not in strictly quantitative terms, at least in terms of some "feel" for relative orders of magnitude. It is in this area that the confrontation between economic and cultural value takes on its sharpest definition, because it is always possible, at least in principle, to express economic value precisely (in terms of money), whereas cultural value remains multidimensional, qualitative, shifting, and contested, without an agreed unit of account by which it can be measured. Part IV of the volume, entitled "Appreciation and Ranking," contains four chapters that consider these issues from differing methodological backgrounds, respectively, econometrics, economic history, aesthetic philosophy, and contemporary microeconomic theory.

Victor Ginsburgh and Sheila Weyers (Chapter 11) use methods that have been developed in econometrics to test issues of artistic valuation. Prizes for motion pictures are used as indicators to construct a quantifiable sample that allows them to test whether aesthetic appreciation shifts in a random pattern or converges toward a few works that become canonical. The authors contrast two means of assessing aesthetic quality: first, the compilation of a set of characteristics that reflect the different elements of beauty, and, second, assessments of experts and the accumulation of such judgments over time. The cultural value attributable to a particular work by these means has clear implications in turn for the work's market prospects and thus for its economic value.

The connection between cultural value measured in terms of artistic criteria and economic value measured as market prices is explored further by Neil De Marchi (Chapter 12). He looks at three cases where artistic criteria and economic valuation are joined in a way that reflects their "confluence." The first of the cases exposes the artistic criteria explicitly mentioned in fifteenth-century Italian contracts for determining the actual price of painting commissions. Next, he analyzes the strategy of the eighteenth-century art dealer Gersaint, who invited potential buyers to choose among paintings with comparable, though differently bundled, pleasure-yielding characteristics.[4] De Marchi's third case is the same rise of the market in Australian Aboriginal painting that is discussed by Smith in Chapter 2. De Marchi concentrates on the strategy of intransparency, which had the albeit unintentional effect of fueling non-Aboriginal collectors' interest; this in turn, strengthened Aboriginal cultural practice. In each of the cases, he shows how a more detailed examination of the economic consequences of fulfilling a given canon of aesthetic value sheds new light on the coexistence of economic and cultural valuations.

In her chapter "The Intrinsic Value of a Work of Art," Carolyn Wilde (Chapter 13) asks whether agreement about the *meaning* of a work of art is necessary for agreement about the work's aesthetic value. She starts with Wittgenstein's notion of "cultured taste" as a way of describing the capacity to articulate and to decipher cultural meaning. She compares the criteria used to judge a fresco painted by Masaccio in 1427 and those used to evaluate an assemblage of plastic puppets executed by Dinos Chapman and Jake Chapman around 2000. The same set of criteria – figured content, temporal acuity of subject matter, and expressive quality – can be applied successfully to both works because both, in essence, function as "sites of meaning" within

[4] Gersaint's shop is the subject of the Watteau painting illustrating the cover of this volume.

a world that is strongly determined by economic relations – the relations of the Florentine merchant world in the case of Masaccio and the relations of the globalized market world in the case of the Chapmans. Her study leads to a remarkable insight: The agreement on aesthetic meaning is a competitive process of conflicting opinions that always remains incomplete; this stands in contrast to the settled results that are the object of competitive processes in the art market.

Each of the foregoing chapters in this section has referred to the eventual testing of cultural valuations when artistic goods reach the marketplace. Markets, of course, have two sides, supply and demand. The final chapter in this section takes up the question of demand for cultural goods. Marina Bianchi (Chapter 14) argues that the incentive structure affecting consumers of such goods is more complex and open-ended than it is for other goods. She analyzes time constraints on cultural consumption, accumulated consumption skills, and psychological factors that stimulate demand for cultural goods. To illustrate her argument, Bianchi takes a historical case, the spread of "reading for pleasure" in the eighteenth century; this example demonstrates the effect of changes in the price and availability of books on aesthetic consumption skills, particularly of the female readership in Europe and North America.

One of the most important ultimate testing grounds for a successful integration of cultural and financial valuation is in the policy arena. What level of financial support should a government provide for artistic activity? How does one best restore an architectural monument, with layers from many centuries, on a fixed budget? What sort of art should be the focus of public policy? In all of these issues, some assessment of cultural value is likely to be required as a means of interpreting and mediating the financial consequences of the decision. Part V of the volume, "Cultural Policies," deals with controversies around such public issues. All three chapters in this section demonstrate, in one way or another, how cultural value is accounted for in political decision-making processes.

Bruno Frey (Chapter 15) points to a paradox: Art economists tend to focus on cultural value in assessing the value of the arts. They emphasize external, non-market-related benefits that the arts can generate. People from the arts world – arts administrators, entrepreneurs, and others – stress the direct "economic impact" of the arts as a way of talking up the arts' importance. Frey gives us an overview of impact studies and willingness-to-pay studies as means of providing information about the value of the arts for policy purposes. He demonstrates the inadequacies of such studies in detail and advocates a broader focus for cultural policy, including art vouchers for

consumers and public assistance to the arts favoring organizations activating support from volunteers and donors.

Willingness-to-pay studies are one vehicle for quantifying the nonmarket economic effects of the arts. But problems arise when communities are widely split in their estimation of the effects of an artwork or a performance. Such is the nature of the effects discussed by Arthur Brooks (Chapter 16) in his account of differing perceptions of the cultural value created by the *Sensation* exhibition at Brooklyn's Museum of Art in 1999. Some attributed high cultural value to the exhibition and called it an important event in contemporary art. Others judged the value to be negative and pointed to particular works to prove the transgression of conventional standards of decency. Brooks analyzes survey data to determine the characteristics of people that influence their judgments about cultural value and draws policy implications relevant to museum managers and arts educators. One consequence of the publicity surrounding the exhibition was to raise the estimated market value of the collections from which the works were drawn; thus the controversy over the valid estimation of cultural value, stimulated and (via the title) promulgated by the exhibition organizers, had a predictable effect on the economic valuation of artworks.

Brooks's chapter raises the issue of whose preferences are or should be decisive in cultural value formation at the policy level. Bill Ivey (Chapter 17) confronts this question directly in the context of the U.S. arts system. He draws a distinction between the unrestrained commodification of the arts that has occurred in the for-profit cultural industries (film, recording, broadcasting) and the "art-is-what-you-need-even-if-you-don't-want-it" view of a knowledgeable elite of arts connoisseurs in the not-for-profit sector. In tracing the history of the two developments from the beginning of the twentieth century, he takes a pessimistic view. Neither side provides an appropriate means for specifying cultural value for purposes of cultural policymaking: The dominance of economic motives driving the for-profit industries subjugates cultural expression to the imperative of creating shareholder value; at the same time, the participants of the nonprofit arts world remain captive to the values of what he describes as elite and minority taste, remote from the demands of the general public.

1.5 Conclusions

This volume set out to juxtapose different disciplinary perspectives on matters of value and valuation in the arts and culture, guided by an underlying

hypothesis that a dual system of value, broadly characterized as economic value and cultural value, can be recognized. What have we achieved? First, we can point to the fact that all the chapters in the volume in one way or another support and amplify the underlying hypothesis. The essays presented here show that the kind of value associated with cultural, aesthetic, and artistic experience is sufficiently similar in a variety of different circumstances to warrant synthesizing it under the heading "cultural value," distinct from the "economic value" associated with market transactions. Thus, they support the conviction that there is indeed value beyond price, and that exploration of the dimensions of that value is a key to progress in our understanding of value and valuation processes in the arts and culture.

At the same time, the volume articulates the multiplicity of dimensions displayed by the two varieties of value across a wide range of historical phenomena in many civilizations, and across a variety of cultural goods and services from traditional rituals to contemporary visual art. Yet despite this complexity, the volume's authors demonstrate clearly by their chosen examples how the two forms of value relate to one another and inform the evaluation process in particular circumstances. Indeed, the essays present strong arguments for abandoning the usual assumption that such dualities are either oppositional or incommensurate.

Finally, the book demonstrates that the nature of the relationship between cultural and economic value can be observed adequately only if perspectives from a range of vantage points in the social sciences and in the humanities are joined. The chapters in this volume approach their topics from a wide variety of disciplines, building on different stocks of knowledge and differing in their accentuations, but dealing with similar, in some cases even the same, processes. Taken as a group, the chapters open up possibilities for a new multidisciplinary approach to thinking about value and valuation processes in economics, culture, and the arts. Indeed, we express the hope that they may stimulate the development of new models in which multiple, dynamic, and simultaneous systems of value can be seen as being at play in relation not only to socially complex commodities such as artworks but also to a wider range of cultural phenomena in contemporary society.

References

Adorno, Theodor W. 1984. *Aesthetic Theory*. London: Routledge.
Appadurai, Arjun, ed. 1986. *The Social Life of Things: Commodities in Cultural Perspective*. Cambridge: Cambridge University Press.
Baudrillard, Jean. 1983. *Les stratégies fatales*. Paris: Grasset.

Baumol, William. 1986. Unnatural Value: Or Art Investment as Floating Crap Game. *American Economic Review* 76:10–14.

Bourdieu, Pierre. 1985. The Market of Symbolic Goods. *Poetics* 14:13–44.

Budd, Malcolm. 1995. *Values of Art: Pictures, Poetry, and Music.* London: Penguin Books.

Connor, Steven. 1992. *Theory and Cultural Value.* Oxford: Oxford University Press.

Debreu, Gerard. 1959. *Theory of Value: An Axiomatic Analysis of Economic Equilibrium.* New York: Wiley.

Frey, Bruno, and Reiner Eichenberger. 1995. On the Return of Art Investment Return Analyses. *Journal of Cultural Economics* 19:207–220.

Frey, Bruno, and Werner Pommerehne. 1989. *Muses and Markets: Explorations in the Economics of the Arts.* Oxford: Blackwell.

Gadamer, Hans-Georg. 1982. *Truth and Method.* New York: Crossroad.

Grampp, William. 1989. *Pricing the Priceless: Art, Artists and Economics.* New York: Basic Books.

Guillory, John. 1993. *Cultural Capital: The Problem of Literary Canon Formation.* Chicago: University of Chicago Press.

Heinzelman, Kurt. 1980. *The Economics of the Imagination.* Amherst: University of Massachusetts Press.

Holden, John. 2004. *Capturing Cultural Value: How Culture Has Become a Tool of Government Policy.* London: Demos.

Hutter, Michael, and Richard Shusterman. 2006. Value and the Valuation of Art in Economic and Aesthetic Theory. In V. Ginsburgh and D. Throsby, eds., *Handbook of the Economics of Art and Culture.* Amsterdam: Elsevier.

Klamer, Arjo, ed. 1996. *The Value of Culture: On the Relationship between Economics and the Arts.* Amsterdam: Amsterdam University Press.

Kopytoff, Igor. 1986. The Cultural Biography of Things: Commoditization as a Process. In A. Appadurai, ed., *The Social Life of Things: Commodities in Cultural Perspective.* Cambridge: Cambridge University Press.

Lewis, Justin. 1990. *Art, Culture and Enterprise: The Politics of Art and the Cultural Industries.* London: Routledge.

Lewis, Justin, and Toby Miller, eds. 2003. *Critical Cultural Policy Studies: A Reader.* Oxford: Blackwell.

Luhmann, Niklas. 1995. *Social Systems.* Stanford, CA: Stanford University Press.

Luhmann, Niklas. 2000. *Art as a Social System.* Stanford, CA: Stanford University Press.

McCarthy, Kevin F., Elizabeth H. Ondaatje, Laura Zakaras, and Arthur Brooks. 2004. *Gifts of the Muse: Reframing the Debate about the Benefits of the Arts.* Santa Monica, CA: RAND Corporation.

Mirowski, Philip. 1990. Learning the Meaning of a Dollar: Conservation Principles and the Social Theory of Value in Economic Theory. *Social Research* 57(3): 689–717.

Mirowski, Philip. 1999. Ratio ex Machina: Value in Economics. *Center: Architecture and Design in America* 11:17–32.

Moore, G. E. 1959. *Principia Ethica.* Cambridge: Cambridge University Press.

Myers, Fred R., ed. 2001. *The Empire of Things: Regimes of Value and Material Culture.* Santa Fe: School of American Research Press.

Parsons, Talcott. 1968. *The Structure of Social Action.* New York: Free Press.

Scitovsky, Tibor. 1976. *The Joyless Economy: An Inquiry into Human Satisfaction and Consumer Dissatisfaction.* New York: Oxford University Press.

Shell, Marc. 1978. *The Economy of Literature.* Baltimore: Johns Hopkins University Press.

Shell, Marc. 1982. *Money, Language, and Thought: Literary and Philosophical Economies from the Medieval to the Modern Era.* Berkeley: University of California Press.

Shell, Marc. 1995. *Art and Money.* Chicago: University of Chicago Press.

Smith, Barbara H. 1988. *Contingencies of Value: Alternative Perspectives for Critical Theory.* Cambridge, MA: Harvard University Press.

Thompson, Michael. 1979. *Rubbish Theory: The Creation and Destruction of Value.* Oxford: Oxford University Press.

Throsby, David. 1999. Cultural Capital. *Journal of Cultural Economics* 23:3–12.

Throsby, David. 2001. *Economics and Culture.* Cambridge: Cambridge University Press.

Wittgenstein, Ludwig. 1970. *Lectures and Conversations on Aesthetics, Psychology and Religious Belief,* ed. Cyril Barrett. Oxford: Blackwell.

PART ONE

ORIGINS OF MEANING

TWO

Creating Value between Cultures

Contemporary Australian Aboriginal Art

Terry Smith

2.1 Introduction

Like many cultural movements of consequence, what is now readily identified as contemporary Australian Aboriginal art was shaped from its beginnings – more than 30 years ago in the Central Desert of Australia – by unprecedented meetings of agents acting from quite distinct cultural assumptions, necessities, and expectations of the other. Like the continuing interest in traditional and contemporary art from Africa, it has proved exceptional in its intensity, spread, and longevity. Aboriginal art from the remote communities maintains a distinct otherness from the development of Western modernist art. As a cultural product it originates from situations – in material actuality and spiritual inspiration – as distant from the nodes of international contemporary art as can be imagined. Yet it is, at the same time, uncannily familiar to those versed in the protocols of abstract art. In the contemporary conditions of decolonization and globalization, it is an instance of hybridity of artistic exchange that is at once unique and typical of its time.

Value clashes and public controversy have marked every stage of its development as an art movement. Yet, despite the racism that laces Australian life like an insidious poison, there is a widespread acceptance of this art by the broader community as a proud and positive contribution to the national culture. Notwithstanding the regularly expressed doubts of white professionals, nothing seems to be able to halt its accelerating powers of aesthetic self-replenishment or the growth of a deep and diverse market for its products. What has this development to teach us about how value is formed in such circumstances, and about how valuations are made within them? Can we identify the practices of valuing specific to the phenomenon and relate them to larger structures of value-formation in the visual arts?

2.2 Beginnings

Nothing begins *ab initio*, including that which has to do with Aboriginal culture. A number of precedents to the contemporary Aboriginal art movement may be found all over the continent in the years since exploration (the seventeenth century) and settlement (the later eighteenth century). I will review one, as it has many of the elements of the contemporary situation already present within it.

Albert Namatjira was trained in the representational modes of his people, the West Aranda (also written Arunta, Arrente) and, as a mature man, made a few souvenirs for visitors to the Hermannsburg settlement in which he lived, mainly scenes sketched on boomerangs by hot wire, the mode favored at the mission. In the mid-1930s, over a two-week period, he learned European watercolor technique from some visiting landscape artists whom he accompanied on a painting trip as their camel boy. When his work was first presented to a white public astonished that an Aborigine was capable of mastering such a complex and subtle European artistic technique, the art writer Robert Croll (1944) urged on his readers a dispassionate, disinterested approach:

The fact that he is dark-skinned, the fact that he is a member of a native tribe and has never left his tribal country, the fact that he has had none of the advantages usually gained by academic training and observation of the productions of great masters – all this should be ignored and the work considered solely from the point of view of its quality. (p. xiii)

What might "solely from the point of view of its quality" mean? Croll is using the language of late nineteenth-century Aestheticism and evoking the ideal of a purely aesthetic response to a work of art, one to which, as Clive Bell's famous "Aesthetic Hypothesis" proposes, "we need bring with us nothing from life, no knowledge of its ideas and affairs, no familiarity with its emotions."[1] What Croll probably meant, in practice, was that Namatjira's watercolors should be appreciated by criteria drawn from the connoisseurship of the medium as it had evolved in European art, and as it was brilliantly practiced in Australia by specialists such as Jesse Jewhurst Hilder and by oil painters who were equally accomplished in the medium such as Hans Heysen. On these grounds, it is arguable that, in the 1940s, Namatjira achieved a level of competence and subtlety in his work that

[1] Clive Bell, "The Aesthetic Hypothesis," *Art* (1913), cited in Harrison and Wood (2003: 109).

compares favorably with that of these minor masters and that outstrips that of the white artists who taught him the technique.[2]

This assessment of Namatjira's work – one that is now a commonplace – has taken over 50 years to form. His paintings were so widely popular in the 1940s and 1950s that reproductions of his scenes of sites in the MacDonnell Ranges seemed to be in most Australian homes. By that time, however, and probably in reaction against their popularity, his work was regarded by most art professionals as imitative, crude, and amateur in character, so close to tourist kitsch as scarcely to be "art" at all. The extremes of derision were reached by the anthropologist Claude Lévi-Strauss, who ridiculed Aranda art in general as "the dull and studied watercolors one might expect of an old maid" (Lévi-Strauss 1966: 89). Namatjira's reputation evaporated in the expanding Australian art world of the 1960s, which was dominated by abstract painting in an international formalist style. The only Aborigine to be granted full citizenship before the referenda of 1967, he died in 1959, shortly after release from prison for supplying alcohol to members of his family.

In recent years it has become clear that Namatjira's choice of subjects, while partly determined by their popularity as tourist spots, easy recognition, and ready sales, also resonated deeply with sacred meaning to him and his people. Furthermore, his aesthetic, while it showed signs of the mildly modern approach of his teachers, is also informed with aspects of the formal language of Aranda body marking and ground painting. This becomes evident when paintings of similar subjects by Namatjira, *Ghost Gum at Palm Paddock*, 1942 (Figure 2.1), and his teacher, Rex Battarbee, *A Decorous Ghost Gum*, 1940 (Figure 2.2), are compared.

By the mid-1990s, Aboriginal art had become the strongest force in Australian art according to any measure: the quality and challenge of much of the work, as well as its sheer quantity and attractive variety. It had become a contemporary art in its own right, and it was actively setting the terms of its own reception. A cultural movement can, when it gains momentum, force a shift in perception of "quality," largely by its own force as an emerging paradigm. In these circumstances, even those closest to the events, those who it might be presumed have the greatest power to influence and even direct the movement, find themselves often scrambling to keep up with the changes happening around them. These changes do, however, have a discernable structure. Let us review the history of one major strand of the

[2] I make this comparison in my chapter "Albert Namatjira and Margaret Preston: Changing an Unequal Exchange," in Smith (2002).

contemporary Aboriginal art movement, desert dot painting, paying particular attention to the emergence of values and to practices of valuation within it. The other major strands (bark painting from Arnhem Land and elsewhere, Aboriginal crafts, and the work of Aboriginal artists based in the cities) have related, but distinct, systems of production and valuing. Each of them has negotiated quite specific structures of value with local and national art institutions and markets.

2.3 From the Desert: Emergence at Papunya

The "painting movement" emerged at Papunya, a remote settlement in the Central Australian Desert, 250 kilometers northwest of Alice Springs.[3] At every stage, new forms of aesthetic, social, and cultural value were created, accompanied each time by controversies that were different in kind and degree. I will chart this pivotal interaction in the notes that follow.

Papunya was established in 1959 by the Commonwealth and Northern Territory governments in order to serve as a center from which the national census could be completed by counting the nomadic peoples of the region, and to offer them welfare services. A number of Pintupi, Luritja, and Walbiri peoples were drawn together – for some, this was their first contact with whites, for many their first sustained contact with both whites and other Aboriginal people. However, by 1964 many elders, dissatisfied with the downsides of dependency, removed their families to "outstations" in more remote and traditional locations. Cultural contestation prevailed in the "community."

When the art teacher Geoffrey Bardon arrived at the Papunya School in 1971, he had with him dreams of making cartoonlike films involving Aboriginal people. But his training in the new formalist abstraction at the National Art School in Sydney attracted him to the simple abstract designs that the children habitually drew in the sand (Munn 1973). Perfect for foundational design instruction, he thought, and readily translatable into murals, the newly fashionable form of public art. He set the children these tasks and was puzzled when they declined or did them half-heartedly. Men who worked at the school as yardmen and janitors explained to him that the children were insufficiently initiated to do this; instead of seeking to prohibit the use of their sacred symbols, the men offered to paint a large mural on the wall facing the yard as a way of displaying traditional knowledge to the young

[3] Basic references are Bardon (1979, 1991). The best recent survey is the essays in Perkins and Fink (2000).

people. In the first and foundational act of cultural negotiation at Papunya, these elders outlined the key symbols of the Honey Ant Dreaming, the creation story most specific to the Papunya area. Cultural controversy was avoided and traditional imagery appeared in a new form. This breakthrough was, however, invisible or irrelevant to the educational authorities in the region: At the next renovation of the school these murals were painted over and the walls returned to institutional white.

Meanwhile the school yardmen, key elders in the various tribes gathered at Papunya, were keen to seize the opportunity to convey the power of their designs – usually painted on bodies or laid out on the desert floor in small, closely positioned piles of differently colored minerals, sands, and crushed vegetative matter – to anyone who was interested. With Bardon's encouragement, and using the school's art materials, they covered every available surface and all forms of support with their imagery. When Bardon was able to convince a shopowner and then an art gallery in Alice Springs to sell these boards to the tourists who flocked through that city – the gateway to the desert itself – the "painting movement" took off. Prices at this time averaged $25 to $30,[4] at the higher end of the range for Aboriginal souvenirs. The cultural adjustment being made here is that of tourists looking for something marginally different from the usual range of souvenir artifacts, yet still cheap, portable, and "from the place."

Back at Papunya, the success of the initial sales fueled enthusiasm. The first painters produced more and more, leading to disputes over the limits of subject matter that it was appropriate to paint. This was regularly settled by confining representation to the Dreaming that each person was entitled to paint and able to give permission to others to paint. Other members of the community expressed the wish to paint: This had to be negotiated according to their rights to story. Men who had painted before and in other communities went to Papunya to share in this opportunity. These included Michael Nelson Jagamara, a Walbiri man, and Clifford Possum Tjapaltjarri, an Anmatyerre man, both of whom became major artists of the movement. Bardon was early on placed in the position of mediator within the Papunya settlement, the one who decided on entry into the "painting shed." To his credit, he soon stepped back somewhat from this role, and a collective of the artists took authority. This was soon formalized into the Papunya Tula Artists Cooperative (November 1972), an organization whose board consisted entirely of the artists involved. After Bardon's departure it

[4] Dollar values throughout this chapter are quoted in Australian dollars ($A1 = $US0.75 approximately).

employed a number of white art advisers, attracted a series of government grants, and in the 1980s established its own gallery in Alice Springs. This pattern continues to this day and has been imitated in Aboriginal art centers all over Australia.

Before this expansion, however, there was a contraction that threatened to choke the movement at its source. When people from nearby communities, notably from Yuendumu, saw designs that they knew to be secret/sacred ones appearing outside ceremonial circumstances on boards and then canvases in the shops of Alice Springs where the uninitiated could see them, they objected strongly. As many had kinship ties to the artists at Papunya, these were trenchant strictures. The Papunya artists, recognizing the point of the criticism, adapted in a most remarkable way. Essentially they turned their formal conceptions inside out. In their enthusiasm to communicate important information, many of the early Papunya works had included specific and detailed depictions of Ancestor Figures, often fully dressed for ceremony, painted up and bearing sacred implements, set out on bare ground and arranged symmetrically for maximal legibility. Certain works from 1971 and 1972 by Kaapa Mbitjana Tjampitjinpa, Noosepeg Tjupurrula, and Clifford Possum Tjapaltjarri exemplify this tendency. In response to criticism, these and other Papunya artists decided to make three formal changes that have provided the basis for most subsequent desert painting: They ceased almost entirely the use of figurative shapes, especially those that could be read as an Originary Being or an Ancestor Figure; they removed the detail from their images of sacred designs, leaving only generalized outlines; and they moved forward to the surface of their works those elements of background, in-fill, and incident – such as signs for wildflowers, sandy regions, rocky areas, water, the changes of the seasons, and movement across the land. As the custodian of water in the region, Johnny Warangkula was ideally placed to lead this change. This can be readily seen by comparing the emblematic directness of Clifford Possum Tjapaltjarri's *Emu Corroboree Man* 1972 (Figure 2.3), to the shifting surfaces of Warangkula's *Water Dreaming at Kalipinyapa*, 1973 (Figure 2.4). As paintings, the outstanding Papunya works consistently secure their powerful effects on their viewers through this characteristic internal tension between a firm, almost rigid underlying schema and a wildly provisional, mobile, and ambiguous surface. This is value being created at the root level of artistic form, and in the oblique fashion that much of the best art employs.

A subsidiary strategy was to concentrate on canvas as a painting surface, and to confine colors mostly to black, white, and ocher – colors that consumers, accustomed to the limited palette of natural materials applied to

bark painting, tended to associate with Aboriginal art in general. A stereo-type reasserts itself. This was of course also a move back from too close an association with the synthetic color range of European abstract painting. It is another indication of the deep-seated conservatism of the entire enterprise. In Aboriginal art from remote communities, the values of inherited culture are paramount. Aesthetic inventiveness, like every other cultural value, is devoted above all to securing the survival of long-standing tradition, and doing so with the minimal necessary renovation.

2.4 Value Spreads and Splits

After the initial outburst between 1971 and 1973, it took nearly a decade of dedicated promotion and dissemination of Papunya painting before it formed the basis of a mini-marketing boom and its model spread to become a nationwide Aboriginal art movement. I will not detail this development, as others have traced it in detail.[5] Rather, I list the highlights as they relate to the question of value and valuation.

During the 1980s large-scale canvases relating to wide tracts of country, particularly that related to the Tingari Dreaming cycle, dominated Papunya output. Symbols for sections of country were rendered in eccentric, closely drawn lines of dots and arranged so close together that they formed latticelike patterns. This amounted to a further degree of compaction of the formal tendencies noted earlier and tended to generalize the level of meaning of this work.

The art center model spread to more and more remote communities until, by the end of the decade, there was a total of nearly 60 viable art centers. Each followed the same developmental steps as at Papunya, although of course more rapidly. In each, a small number of elders took on leadership roles and became the major artists. Relationships between the communities and both governmental grants and the commercial market were mediated by advisers who gradually moved from prioritizing the welfare benefits of this development to recognizing the importance of its aesthetic achievements. These factors led to emergence of a distinctive style in each community. Some were sophisticated enough to emphasize a distinct approach to the art-making process itself; for example, at the Yuendumu community during this period much effort was devoted to painting large collectively produced

[5] Notably Myers (2002), which is a study that pays close attention throughout to the matter of value-formation and clashes of values. Among the many introductory texts to the movement as a whole, see Edwards (1974 and 1979), Sutton (1988), Isaacs (1984, 1989), Smith (2001), Caruana (1993), and Morphy (1998).

canvases incorporating a number of important stories, and individual profiling of the artists was discouraged. By the year 2000 thousands of Aboriginal people all over Australia were regularly producing art: around 10,000 in an Aboriginal population of over 250,000. This proportion matched closely the estimated total number of non-Indigenous professional visual artists in the overall Australian population of 18 million.[6]

Competition between regions became a feature of the movement during this period. Complaints were made that Central Desert art received too much governmental and commercial support relative to the older traditions of the Top End. Younger Aboriginal artists living in the cities resented the classification of themselves as "urban" and those living in the desert and up north as "tribal." In communities that housed sought-after artists, local resident and visiting dealers ran opportunistic markets by offering ready cash to artists for just-completed canvases. This practice continues to this day and targets the most famous living artists as well as those who the buyer believes show promise.

In the visual art market worldwide at the present time a convergence is occurring between primary and secondary markets, between what used to be the province of the commercial gallery and that of the specialist dealer and the auction house. Nowhere is this more systematically so than in the case of contemporary Aboriginal art (cf. Figure 2.5). This is largely due to the simple fact that the artists read in the newspapers of the extraordinary prices that their early works are fetching at auction and refuse to understand why the latest of their paintings of the same story should be worth any less. The work of many has reached such a point of demand that they are able to hold it back until their agencies find buyers who will pay such prices. Or they will agree to have the works sent straight to auction. However, other artists are beyond manipulating the market. For example, the painting by Johnny Warangkula mentioned earlier was first sold in 1973 for $150. It reached $210,000 in Sotheby's June 1997 sale, and in 2000 it fetched $486,500. Johnny Warangkula died, in poverty, in February 2001. Another example is the fact that in July 2003, Sotheby's established a "significant new auction record" of $509,300 for Emily Kngwarreye's *Untitled (Spring Celebration)*, 90 × 230 cm acrylic on linen, painted 1991 (Reid 2003: 283) (cf. Figure 2.6). She died in 1996, at which time a painting such as this would have sold for around $20,000; this was a price closely comparable with that which major living white Australian artists would fetch, then as now, for works of this size and relative quality. Kngwarreye made perhaps 30 of this kind, as well as

[6] Figures extrapolated from Altman (1989) and Throsby and Thompson (1994).

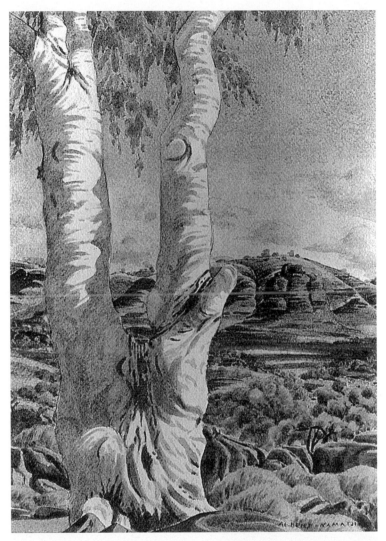

Figure 2.1. Albert Namatjira, *Ghost Gum at Palm Paddock*, 1942, watercolor. Reproduced from Charles Mountford, *The Art of Albert Namatjira*, Bread and Cheese Club, Melbourne, 1944.

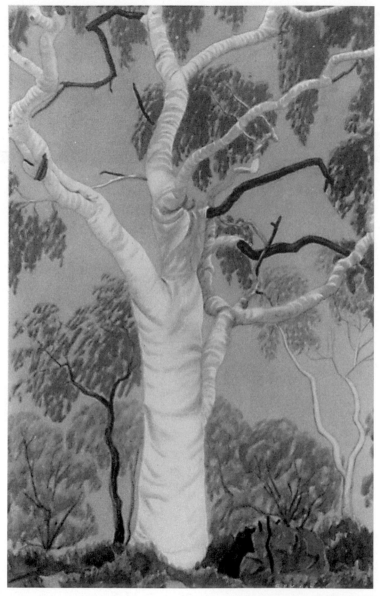

Figure 2.2. Rex Battarbee, *A Decorous Ghost Gum*, c. 1940, watercolor. Reproduced from T. G. H. Strehlow, *Rex Battarbee*, Legend Press, Sydney, 1956.

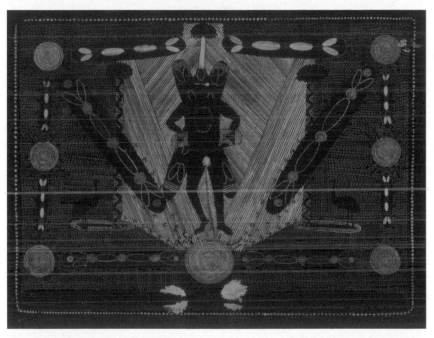

Figure 2.3. Clifford Possum Tjapaltjarri, *Emu Corroboree Man*, 1972, ochers on board. Courtesy Sotheby's Australia, © Clifford Possum Tjapaltjarri, licensed by VISCOPY, Australia, 2006.

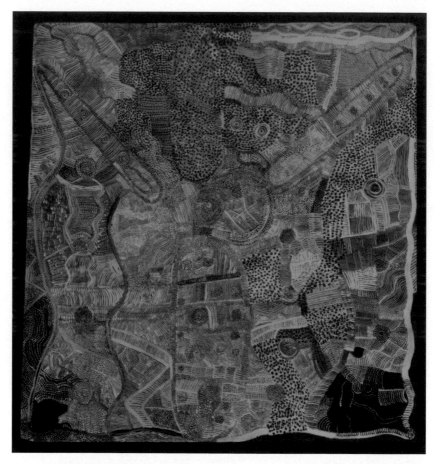

Figure 2.4. Johnny Warangkula, *Water Dreaming at Kalipinyapa*, 1973, ochers on board. Courtesy Sotheby's Australia, © Johnny Warangkula, licensed by VISCOPY, Australia, 2006.

Figure 2.5. Bidders with catalogs, Sotheby's Australia, Aboriginal art sale, Melbourne, June 2002. Photograph: Michael Clayton-Jones/Fairfaxphotos.com

Figure 2.6. Emily Kame Kngwarreye, *Untitled*, 1991, acrylic on linen, 230 × 131.5 cm. Courtesy Sotheby's Australia, © Emily Kame Kngwarreye. Licensed by VISCOPY, Australia, 2005. (Similar to Emily Kame Kngwarreye, *Untitled* [*Spring Celebration*], 1991, acrylic on linen, 90 × 230 cm).

Figure 4.1. Pierre-Auguste Renoir, *Les Parapluies*, 1883, oil on canvas, 100 × 115 cm. National Gallery, London.

Figure 4.2. Helen Frankenthaler, *The Bay*, 1963, acrylic on canvas, 210 × 240 cm. Founders Society Purchase with funds from Dr and Mrs Hilbert H. DeLawter. © Helen Frankenthaler 2006. Photograph © 1991 The Detroit Institute of Arts.

Figure 4.3. Bill Viola, *The Locked Garden*, 2000. Color video diptych on two freestanding hinged LCD flat panels. Photo: Kira Perov.

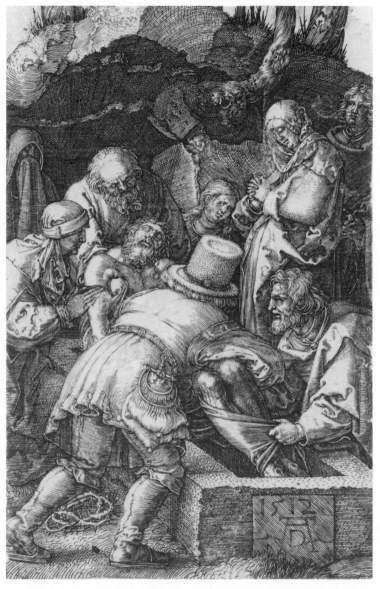

Figure 6.1. Albrecht Dürer, *The Entombment of Christ*, 1512. Engraving. Foto Marburg/Art Resource, NY.

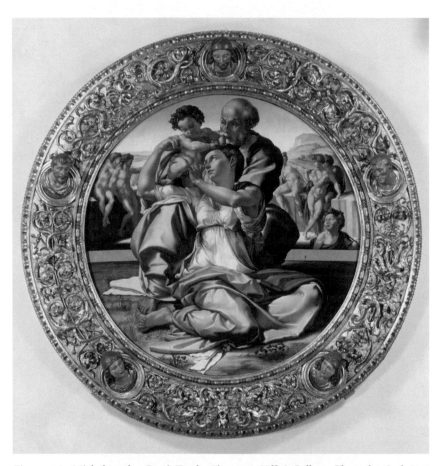

Figure 6.2. Michelangelo, *Doni Tondo*. Florence: Uffizi Gallery. Photo by Scala/Art Resource, NY.

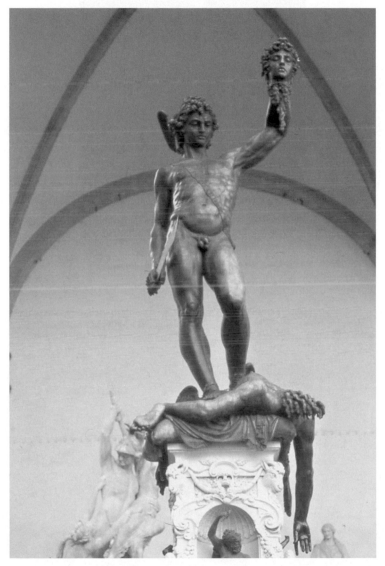

Figure 6.3. Benvenuto Cellini, *Perseus*. Florence. Photo by Mark Rosen.

Figure 6.4. Antonis Mor, *Cardinal Antoine Perrenot de Granvelle*. Vienna: Kunsthistorisches Museum. Photo by Erich Lessing/Art Resource, NY.

Figure 6.5. Pieter Bruegel (after), *The Massacre of the Innocents*. Upton House: Bearsted Collection. Photo by National Trust/Art Resource, NY.

Figure 7.1. Charles Pugsley Fincher, *Thadeus & Weez*.

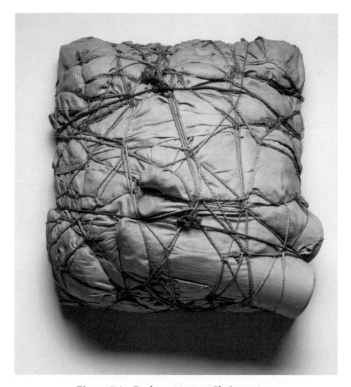

Figure 7.2. *Package* 1961 © Christo 1961.

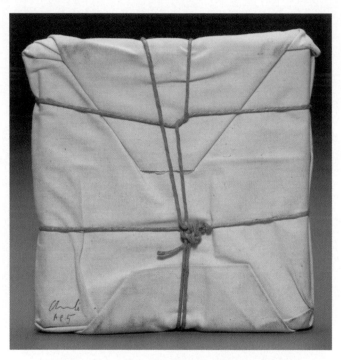

Figure 7.3. *Wrapped Book* 1973 © Christo 1973.

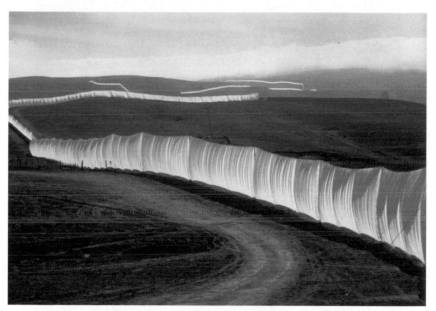

Figure 7.4. Detail from Christo and Jeanne-Claude, *Running Fence* © Christo 1976.

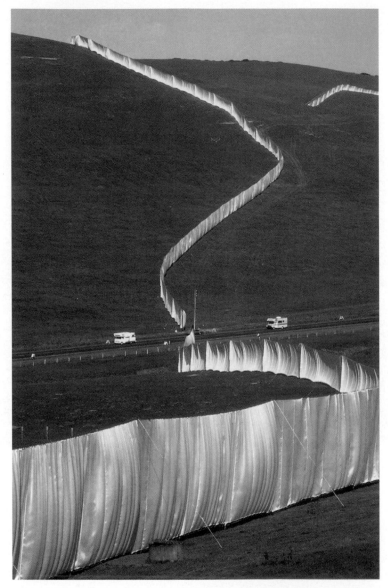

Figure 7.5. Detail showing gap in the Fence. From Christo and Jeanne-Claude, *Running Fence* © Christo 1976.

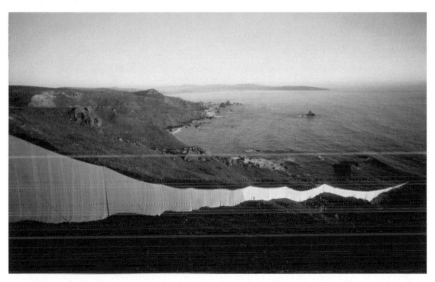

Figure 7.6. Detail showing Fence running into the sea. From Christo and Jeanne-Claude, *Running Fence* © Christo 1976.

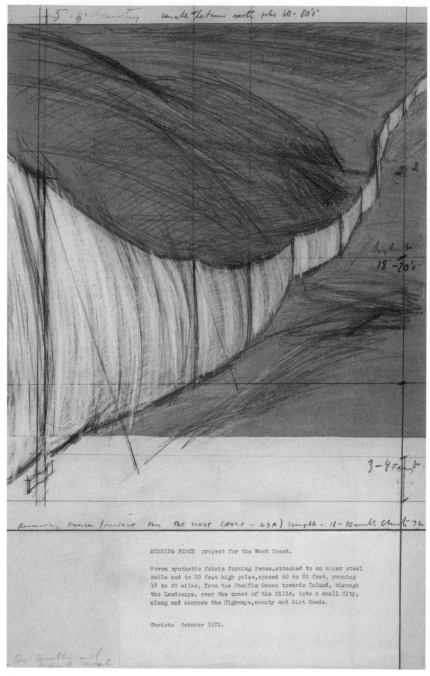

Figure 7.7. Engineering designs for Fence. Christo and Jeanne-Claude, *Running Fence* © Christo 1976.

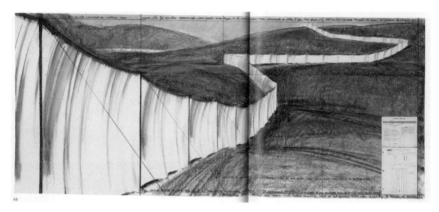

Figure 7.8. Engineering designs for Fence. Christo and Jeanne-Claude, *Running Fence* © Christo 1976.

Figure 7.9. Louis Zukofsky, notebook for *"A."* © Paul Zukofsky. All rights reserved.

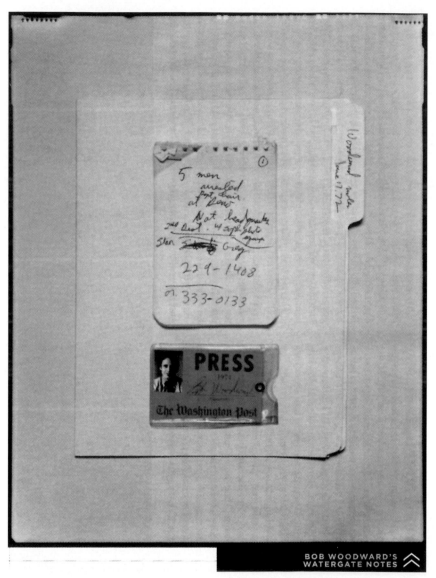

Figure 7.10. Woodward's note, 1972. Courtesy of the Harry Ransom Center.

Figure 8.2. Ceremonial dance at Yolngu funerals, Yirrkala, Northern Territory, 1990:
Male soloist dancing the Ghost associated with Morning Star. Photo by Steven Knopoff.

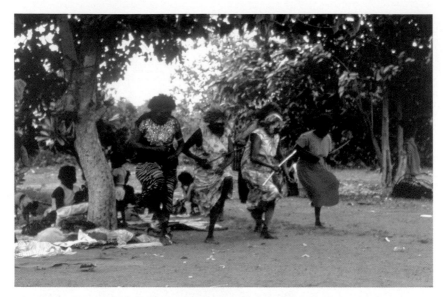

Figure 8.3. Ceremonial dance at Yolngu funerals, Yirrkala, Northern Territory, 1990: Women's ceremonial dancing and socializing. Photo by Steven Knopoff.

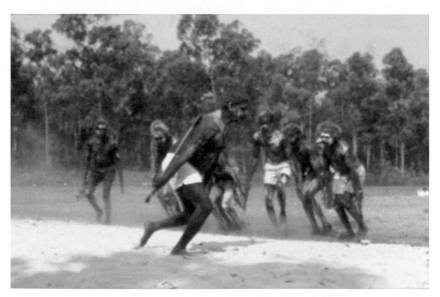

Figure 8.4. Ceremonial dance at Yolngu funerals, Yirrkala, Northern Territory, 1990: Male lead and group dancing Shark. Photo by Steven Knopoff.

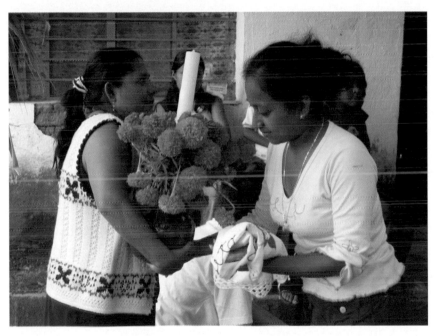

Figure 9.1. Day of the Dead ritual: arrival. Photo by Lourdes Arízpe.

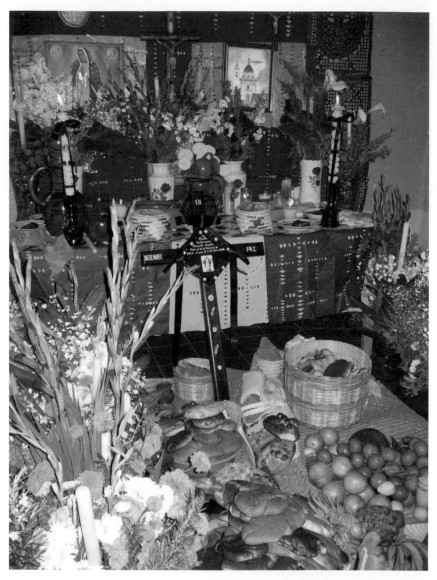

Figure 9.2. Day of the Dead ritual: altar. Photo by Lourdes Arizpe.

Figure 9.3. Day of the Dead ritual: in the cemetery. Photo by Carlos Ocampo.

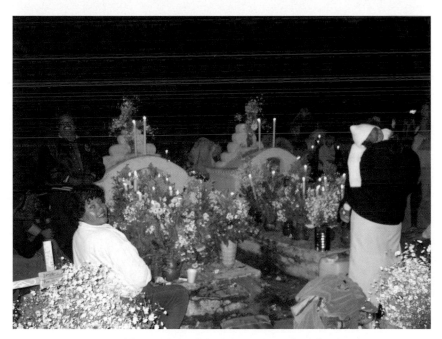

Figure 9.4. Day of the Dead ritual: in the cemetery. Photo by Lourdes Arizpe.

Figure 9.5. Day of the Dead ritual: in the cemetery. Photo by Lourdes Arizpe.

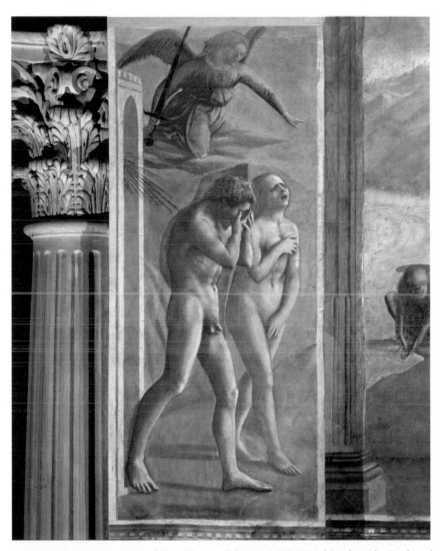

Figure 13.1. Masaccio (Maso di San Giovanni) (1401–1428). *Expulsion from the Garden of Eden*. Post-Restoration. Scala/Art Resource, NY. Brancacci Chapel, S. Maria del Carmine, Florence, Italy.

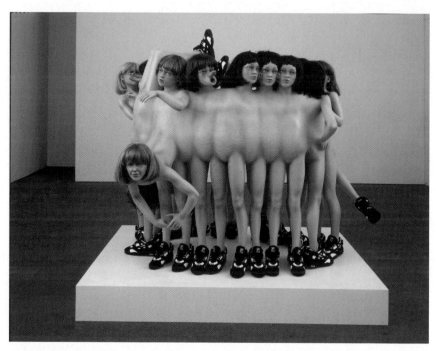

Figure 13.2. Jake and Dinos Chapman, *Zygotic acceleration, Biogenetic de-sublimated libidinal model (enlarged × 1000)*, 1995. Mixed media. 58 13/16 × 70 9/16 × 54 14/16 in. (150 × 180 × 140 cm) © the artist. Courtesy Jay Jopling/White Cube (London).

some larger and many fine smaller works. A major four-panel painting of 1996, *Earth's Creation*, sold for $1,056,000 at the Lawson-Menzies auction in Melbourne on May 23, 2007.

2.5 Value Internal and External

Precisely what kinds of value systems are at work here, at the point where the artwork is exchanged? Are they at the core of the entire system, or are they – as I prefer to argue – one of its vectors?

Fred R. Myers draws attention to significant shifts in the categories used by market analysts and funding agencies during their years of support of this movement. During the 1970s, the Aboriginal Arts and Crafts Agency noted four classes of objects: "traditional," "transitional," "adapted," and "market." As Myers (2002: 189) notes, this system was going in only one direction: Western. By 1981, however, analysts working for the agency had borrowed from the classifications devised by Nelson Graburn for relationships between "high" and "low" art around the world and developed a framework that recognized the crossover between objects valued in these two broad ways from both "Aboriginal cultural" and "Western aesthetic" points of view.[7] The greatest divergence was over the secret ritual objects valued highly by Aborigines but regarded by outsiders as "ethnographic," and between the Aboriginal low regard for abstract aesthetic ("decorative") qualities and the high value accorded them from Western perspectives. Both agreed, however, on the low value of "tourist" objects and the high value of those that were labeled "bicultural." These were precisely the new kinds of artwork being produced by certain Aboriginal communities; it is these that were funded, that expanded greatly in quantity and became most successful aesthetically, most marketable, and most effective as a form of cultural communication. Artistic, cultural, and economic value converged in this case.

This classification introduces a crude set of distinctions as to likely preferences of Aboriginal producers and non-Aboriginal consumers of cultural products in Australia. Its major conceptual limitation is that it assumes that Aborigines are motivated primarily by cultural concerns, whereas Westerners are driven by aesthetic desire. Surely, however, both sides are capable of both sets of impulses, and of course of many more. Let us ask a different question: What *processes* of value-creation do the Aboriginal producers pursue, and which *processes* of valuation do the non-Aboriginal

[7] See Graburn (1976) and Pascoe (1981: 20).

consumers of their work undertake? The interaction between these two sets of approaches is what generates the dense framework that is the object of inquiry.

The process of making works of art pursued by Aboriginal people from different regions – from the Central and Western Deserts, from the Kimberley, and from the regions of Arnhem Land – and using different materials – canvas, bark, board, or free-standing objects – permits the artist to fulfill a variety of cultural duties while enabling the work to convey both readily apparent and deeper meanings to others. This occurs on four different levels. Each of these has two aspects, and all operate simultaneously, reinforcing each other. The artworks are (i) depictions through inherited forms and techniques of stories, events, and figures of sacred significance, as both a broad narrative involving many related people and a specific moment or moral particular to the Ancestors of the artist; (ii) a cartography of a place owned by the dreamer-painter, including journeys across it, both by the Originary Beings, the Ancestors, and by the artist as a hunter or gatherer; (iii) a witness that the duty of representing or singing the Dreaming has been done, thus constituting a restatement of title or deed to the land indicated; and finally (iv) an individual interpretation of these duties and practices, varying according to personal preference and thus keeping alive the obligations and pleasures of painting. There is a hierarchy of value here, from (i) down to (iv).

How does this schema relate to the work of each individual artist? It relegates personal expression to the same minor, subsidiary space that "individual interpretation" inhabits in the community itself. Doing something "properly" – that is, according to traditional form – meant the same thing in the earlier years of the painting movement as doing it well. Doing something at all was in those days a matter of authority, of having the right to represent, to refer to a Dreaming at all. Thus the power of elders was reinforced; while the younger generation related to the colonizers more through print and official institutions, the elders related through visual imagery and art centers. In some places this has itself led to a generational division and considerable anxiety among the elders as to whether their grandchildren will continue their practices. Currently women artists in their middle years are carrying much of the work of innovation and diversification.

So, the first value in such settings is authority, and then the second is the importance of the story being painted qua story. A third criterion would be how much of the story, and which elements, are being shown (this can range from "the whole lot" through just the main *kuruwari* – Dreaming – lines to quite minor incidents or byways in the main narrative). Finally, there is

the manner of the painting: Is it the result of evident, careful, correct labor, or was it done quickly and carelessly (a "flash" painting)? Although a much greater number of men than women occupy the positions of elder and the patriarchal nature of traditional culture gives them greater general authority, these criteria apply to work by both men and women. As the movement has diversified into valuing craftwork, greater numbers of people, especially women, have become art producers. This in turn has led to a different kind of appreciation of individual differences, one based on the more widely shared skills of the crafts.[8]

It is clear that the major artists of the movement soon ceased to be adequately described as elders who either occasionally or regularly painted; rather, they became elders whose identity and community contribution revolved around their painting. They became in effect professional artists, and their persistent, growing, and improving art became increasingly well made and capable of carrying increasingly subtle meanings. Already by the year 2000, dozens of artists from more than 20 communities were acknowledged as major creative figures. They continue to be recognized with one-person exhibitions and retrospectives. While their work remains broadly the result of the four-level processes outlined previously, in each case it has taken on a distinctive force and developed a persuasive power of its own, setting its own terms. It has moved perhaps from being a deeply representative product of a hierarchical system to being a heterarchical contribution to its disturbance and thus to its renovation.

Looked at from the other side, distant from the point of production, the first concern of most consumers remains the question of authenticity. Is this a genuine work of art made by a real Aboriginal person? In the present context, this is ethnological fantasy. It is the desire to discover an artifact made for who knows what spiritual purpose by a person ignorant of the very idea of art, a person who nevertheless in all innocence has created what we can see to be an artwork of strange but compelling beauty. So powerful is this need of consumers that works by Aboriginal artists are still regularly sold with certificates of authenticity certified by the local art agency that include an account of the "story" of the painting, set out briefly in a quasi-anthropological kriol.

The second factor from an external viewpoint has been the aesthetic coincidence between the look of much desert painting and the concerns

[8] The four criteria just sketched are adequate as generalizations and apply best to the early stages of artwork produced in these communities. They do not fit readily to the different kinds of complexities facing Aboriginal artists who work in the cities, in the local art worlds, and in the international art circuit.

for surface, facture, inflexion, and color variation that typify international abstract art, especially high Modernism. Just at the moment when this style lost its force within the development of Western art history, an art that looked a lot as if it emerged from the center of the Australian desert. And it was being made by people who had no idea about Modernism at all – indeed, they were not so comfortable with modern society as such.

The third factor, the individualization of artistic creativity and the treasuring of the artwork as a trace of the artist's uniqueness, is so precious a value in the Western art system that it would be surprising if its influence were not felt in the making and marketing of Aboriginal art. Complex works by key artists – for example, Michael Nelson Jagamarra's *Five Dreamings* (1984) and Uta Uta Tjangala's *Yumari* (1981) – were treated as canonical, oft reproduced, and used as standards against which to measure similar work. They became, in a word, icons of the movement as a whole. Nowhere was this process of individualization taken to so great an extreme as in the case of Emily Kngwarreye, the major painter from Utopia mentioned earlier. Having become, in her mideighties, one of the most sought-after artists in the country, she spent much of her last two years coping with daily and sometimes hourly visits from a coterie of art dealers, each of whom was marketing her work as possessing a distinctive style. They had each latched onto one aspect of her style as the "essential Emily" and were insisting that she keep producing more works for them to sell in that manner (Smith 1998).

Yet it is no surprise that those who are selected out by the press of circumstances and who concentrate their energies on a task bring about advanced artistic development. It is evident in the fact that the artists mentioned so far have managed to create the richest and most diverse art being produced in Australia.

2.6 Processes of Valuing: A Proposal

In this section I take a step beyond this particular case study and ask whether the ensemble of individual and institutional relationships that it displays has a structure that might be read back through the history of the making and valuing of works of art in such a way as to permit some broader questions to be posed and answered. When it comes to the arts, is there any kind of generalizable shape to practices of valuing and the choices as to what counts as a value?

In the West at least (and in the thinking of certain Eastern theorists), aesthetic and cultural valuing in the *response* to art has tended toward two

types of approach: that which nominates one quality (feature) of art as the key to arriving at a judgment of the quality (value) of its instances, and that which lists a number of qualities (features, attributes, inputs, effects, outcomes) as in some combination essential to this assessment of quality (value). A closer examination of the first of these reveals that in all actual cases it is an instance of the latter, with one of the qualities that stands out from a number of others being taken as the essential outcome of the others – that is, one that encompasses, summarizes, or entails them. Further, when we look at the list of *internal* qualities of works of art that have been over the centuries advanced by commentators as definitive, it becomes obvious that they too tend toward one of two types of listing. The qualities may be understood as (i) multiple elements that simply occur together and that constitute varying aspects of a work or a process, or they may be seen as (ii) a steadily accumulative series of steps or stages that gather force as they ascend. In the first case value is the result of the presence of a sufficient number of elements, or the elements themselves may be assessed separately as to their degree of internal success and then added up in some sense – or not, at the inclination of the assessor. In the second case value rises as the process unfolds, as the steps are successively mounted. Often this is attributed to the artwork, as if it had a kind of agency itself. At other times it is understood as a function of a successful interpretation. In all cases, it seems, the qualities *of* works of art, and the quality of their demonstration or performance, are being taken as keys to the understanding of their quality *as* art.

There seem to be certain consistencies in the qualities that, in both the East and the West over the centuries, have been recognized and admired in works of art. My suggestion is that these point us to the inherent artistic values of these works. They tend to cluster into five types, each associated with the observable properties or the demonstrable effects of artworks. The types are existent value, representation value, formative (form, craft) value, insight (idea) value, and transformation value.[9] Their process-oriented character animates each of these, and the relations between them: Creativity *in* the making of artworks is a matter of activated process, often multiple processes; so too are engaged response and active interpretation *of* artworks.

[9] Art historians and others will recognize here and in the following paragraphs the resonance of the four levels of response deemed appropriate to figurative art in the Western tradition in Erwin Panofsky's famous essay of 1936, "Iconography and Iconology: An Introduction to the Study of Renaissance Art," reprinted in Panofsky (1955). I am treating the first level more phenomenologically, and as more important than did Panofsky, because I regard the involuntary level of response as a primary ground of valuing.

Let us consider each of the types of value in turn.

(i)*Existent value*. Let us assume that most people, animals, and things exist in order to appear to others: Art if it is nothing else is the intensification and concentration of this quality of being as appearance. In works of visual art, this occurs at the most primary level as a vis-à-vis physicality, body to body, as a visceral reciprocity between, say, skins, surfaces, touches, textures, colors, and so on. In cinema we have all this, unfolding in quasi-narrative forms. In music it is less a matter of face to face, more an exchange of inner body vibrations, rhythms, drifts, sharpness, shared between the piece of music and the listener. A performance heard is a mutuality of time-thoughts textured by sound. In reading literature it is a communing (a murmuring?) of interiorities. Within these aesthetic bodies and at the same time within our own bodies, we recognize the familiar; we replay it for comfort and confirmation. But we also know when something new and different is occurring and we know how to relate it back to what we know, or, sometimes, how to use it to recast our sense of what we know. This all occurs in a crucial sense *prior* to our acknowledging, categorizing, and distancing the object or event as a work of art. In the case of contemporary Aboriginal art, this quality is inflected by the works' being surrogates – much mediated, to be sure – for painting sacred animistic markings on the body of the ceremonial participant and on the surface of the earth, which is itself both the Ancestors' and the artists' body.

(ii)*Representation value*. The qualities and distinctiveness of the work of art as a representation bring into play an immediate set of qualities that make the work a secondary object or event (and it evokes immediately that which is representational in us). For example, standing before any work in the Western figurative art tradition, the viewer instantly acknowledges its degree and kind of naturalism – that it is an instance of a long practice of picturing (on a bounded two-dimensional surface), or a surrogacy (if a sculpture) of phenomena otherwise observable in the world, in religious texts, or in fables. Exceeding verisimilitude can attract value in its precision, its exactness, its concentrated, elaborated craft skills (always an excess). In other traditions such as European folk art or Eastern high amateur and professional art, other less pictorial kinds of display or exhibition value are employed. A more subtle kind of representational value is evident in the work's relationships to other art; in the repertoire of imagery that it evokes; in the confirmatory or innovatory impacts it has on that repertoire as an imagery or as a set of pictures; and in how technically it does this work of evocation and innovation. In Aboriginal art, as we have

seen, what is important at this level is the power of the sacred imagery given or alluded to in the work, which in turn evokes the larger cycle of ceremonial narrative in which it is embedded, as well as the sacred/natural settings of these narratives.

(iii)*Formative value.* I noted earlier that no artwork is merely a passive product of the interplay of external forces. Nor is it the simple outcome of whatever existent and representation values that happen to be at hand. Formative processes are essential to the art of art. Artists assay raw form as a kind of base grammar of creativity; its most fundamental materials – preliminary drawings in the visual arts, barely choate sounds seeking the musical "idea" – are the first discernable evidence of this already some- what advanced stage of making. Form marshals these representational possibilities, trying them out against the unconscious impulses, the social demands, and the dense cultural repertoire that converge on the creative process. Forming is the concentration of this play of valuing into a config- uration that will display their conjunction, or some significant aspect of it, to stunning effect. In this sense form in a work of art means much more than arriving at adequate compositional balance, pleasing harmony, the right sequence, or a resolved narrative. Form is the making of content. In much Aboriginal art this formative quality exists right through from the practice of marking the surface as if it were a body being readied for ceremony, through the authoritative choice of symbols, and leading to the reshaping of them in the conditions of communicating beyond the home community to imagined and mostly non-Aboriginal audiences.

(iv)*Insight, idea value.* This value refers to the content of a work of art, what it is about, the idea in it, the way it shows the world to us, the perceptiveness of it. This is in the territory of what Throsby (2001: 28–29) names social, historical, spiritual, and symbolic value. It is, however, not only a consumption value; it is only partly brought into being by the viewer or listener matching the completed work in some way with already existing social or historical values. It is at the same time a production value: Philosophical, social, and historical ideas emerge visually, performatively, and musically – that is, as specifically cultural ideas within the processes of making artworks, staging performances, writing, or composing. Artworks are part of the continuous widespread creation of live meaning. Certainly art is shaped by historical, social, and cultural forces of many kinds: Such forces will be a major factor in forcing the work into existence, and they will leave their traces on it irrespective of the author/artist's intentions. But artworks are also active in the formation of these forces. The idea value

of an artwork is to be found in its voice within the chorus of its culture of origination and in its distinctive addition to the plurality of voices that speak that culture into existence and take it through continuity and change. For Aboriginal artists this is at the core of their enterprise, from its inspiration in their deepest and most sacred knowledge to the evocation and translation of this knowledge into forms that will protect its secret particularity and at the same time reveal its potent generality.

(v) *Transformatory value, the deep differential.* This is the value that we find (in whole or in significant part) in the exceptional work of art, the one that redefines its type, redefines its practice, redefines art as such, and redefines culture. In such a work, everything adduced earlier is not just present in this work to a high degree, but also refigured irrecoverably into something more. We are talking here not just about originality (a nineteenth- and twentieth-century value) and not just about the utmost perfection of performance (a seventeenth- and eighteenth-century value). Exceptional works introduce a domain of differentiation where everything is possible, indeed where pure possibility is the terrain. Yet everything in this extreme terrain exists always as a contingency, is always tied to something known in however attenuated a fashion, because nothing utterly arbitrary really works in this kind of context. It is a kind of differencing that promotes transformation of the known, that brings into being forever a new state of play, a new set of conditions for what it is to create art, and to value it creatively. It is an impulse that risks the whole enterprise, that backs its best judgment, that courts failure by acting beyond criteria. It is an art that redefines what it is to value value. These are the works that occupy pride of place in the canon of great art in the Western tradition, that are recalled as models within Eastern artistic traditions, and that have come to stand out among the plethora of current art, including those works of contemporary Australian Aboriginal art singled out in this chapter. Membership of these sets will be forever contested. What is being proposed here is that it is the transformatory power of these works, not their capacity to be representative or to demonstrate high conformity, that entitles them to canonicity.[10]

2.7 Conclusion: Meaning and Value

The process identified in this chapter generates a multiplicity of values within each work of art, values of different kinds: existential, material, formative,

[10] See further in Smith (2007).

cultural, and, when the process is operating to its fullest, transformatory of the process itself including all the elements within it. At each stage these values are generated to different degrees and with distinguishable degrees of success. An artwork seen in this way may be more or less meaningful at any point in the multiplicity, but always in ways specific to that point. Individual works of art may be meaningful in ways specific to the practices, processes, conventions, and innovations of art as these have developed over the centuries. That is to say, they may confirm or interrogate already established meaning, yet each work of art also has the potential to concentrate its emergent capacities so as to generate new meanings at each of its levels, including those that will transform what it is for something to be meaningful in the culture at large and beyond its culture of origin. Of course, artworks may fail to achieve their potential – indeed in most cultures most of the time all but a few works remain at low or middling levels of competence and conventionality. And receivers of art, however much they pronounce as to the value of what they are looking at, often fail to grasp the meaningfulness of that which stands before them. Nevertheless in optimal conditions, when both artist and receiver are realizing their potential to the fullest as in the case of works by Aboriginal artists singled out in this chapter, maximal meaning is achieved, and the distinction between artistic and cultural value falls away. Art is one of the sets of ways in which meaning is made and remade within cultures. Meaning is value taking shape and taking effect. Meaning happens when values count.

References

Altman, Jon., ed. 1989. *The Aboriginal Arts and Crafts Industry, Report of the Review Committee*. Canberra: Australian Government Publishing Service.

Bardon, Geoffrey. 1979. *Aboriginal Art of the Western Desert*. Adelaide: Rigby.

Bardon, Geoffrey. 1991. *Papunya Tula: Art of the Western Desert*. Melbourne: McPhee Gribble.

Caruana, Wally. 1993. *Aboriginal Art*. London: Thames and Hudson.

Croll, Robert. 1944. Foreword. In Charles P. Mountford, *The Art of Albert Namatjira*. Melbourne: Bread and Cheese Club.

Edwards, Robert. 1974 and 1979. *Australian Aboriginal Art*. Canberra: Australian Institute of Aboriginal Studies.

Graburn, Nelson, ed. 1976. *Ethnic and Tourist Arts*. Berkeley: University of California Press.

Harrison, Charles, and Paul Wood. 2003. *Art in Theory, 1900–2000*. Oxford: Blackwell.

Isaacs, Jennifer. 1984. *Arts of the Dreaming: Australia's Living Heritage*. Sydney: Lansdowne.

Isaacs, Jennifer. 1989. *Australian Aboriginal Painting*. Sydney: Craftsman House.

Lévi-Strauss, Claude. 1966. *The Savage Mind*. Chicago: University of Chicago Press.

Morphy, Howard. 1998. *Aboriginal Art*. London: Phaidon.

Munn, Nancy. 1973. *Walbiri Iconography*. Ithaca, NY: Cornell University Press.

Myers, Fred R. 2002. *Painting Culture: The Making of Aboriginal Art*. Durham, NC: Duke University Press.

Panofsky, Erwin. 1955. *Meaning and the Visual Arts*. Garden City, NY: Doubleday.

Pascoe, Timothy. 1981. Improving Focus and Efficiency in the Marketing of Aboriginal Artefacts: Report to the Australia Council and Aboriginal Arts and Crafts Pty. Ltd. Sydney: Arts Research, Training and Support, June.

Perkins, Hetti, and Hannah Fink, eds. 2000. *Papunya Tula: Genesis and Genius*. Sydney: Art Gallery of New South Wales.

Reid, Michael. 2003. Aboriginal Art at Auction: A Record Sale at Sotheby's. *Art and Australia* 41(2): 283–285.

Smith, Terry. 1998. Kngwarreye Woman Abstract Painter. In Jennifer Isaacs, ed., *Emily Kngwarreye Paintings*, 24–42. Sydney: Craftsman House.

Smith, Terry. 2001. From the Desert. In Bernard Smith with Terry Smith and Christopher Heathcote, *Australian Painting 1788–2000*, Melbourne: Oxford University Press.

Smith, Terry. 2002. *Transformations in Australian Art*. Vol. 2: *The Twentieth Century – Modernism and Aboriginality*. Sydney: Craftsman House.

Smith, Terry. 2007. Canons and Contemporaneity. In Anna Brzyski ed., *Partisan Canons*. Durham, NC: Duke University Press.

Sutton, Peter, ed. 1988. *Dreamings: The Art of Aboriginal Australia*. New York: Viking.

Throsby, David. 2001. *Economics and Culture*. Cambridge: Cambridge University Press.

Throsby, David, and Beverley Thompson. 1994. *But What Do You Do for a Living? A New Economic Study of Australian Artists*. Sydney: Australia Council.

THREE

Entertainment Value

Intrinsic, Instrumental, and Transactional

Richard Shusterman

3.1 Introduction

We often speak of the entertainment value of novels, plays, music, and other works of art. But cultural critics just as often contrast art to entertainment, viewing the former as culturally far superior in value. Is entertainment value an important part of art's value or merely a subordinate, inessential means to conveying that value? Is it perhaps even an unwanted distraction from true artistic value? This chapter takes some preliminary steps toward clarifying the notion of entertainment value by investigating the very concept of entertainment and considering its complex and often problematic relationship to art and to art's most cherished sense of value, which in the philosophical tradition of modernity is generally characterized as aesthetic value.

Although the precise nature of aesthetic value is unclear and hotly contested,[1] it is generally conceived as an intrinsic rather than an instrumental value. Entertainment, however, seems to imply instrumentality – a means of distracting, amusing, or refreshing oneself, or a way of enjoyably passing one's time. So besides examining the concept of entertainment, I will also analyze the crucial but problematic notion of intrinsic value. This analysis will enable me to argue that intrinsic value can be reasonably construed in a way that allows a contextual contrast with instrumental value without presuming a radical dichotomy between them that would deny intrinsic value to things that clearly have instrumental value. Being instrumentally effective would not then automatically preclude entertainment value from being also an intrinsic value of art and aesthetic experience and would allow it to be considered a possible constituent of aesthetic value.

[1] One controversial issue is whether aesthetic value can be reduced to purely formal values, and one reason for the appeal of the formalist view of aesthetic value (despite its obvious limitations) is that it supports the idea that aesthetic value is intrinsic.

One prominent aspect of aesthetic value is its experiential quality. Such value does not lend itself to quantitative calculation or discursive proof but is realized or made evident in direct experience. It is in the experience of an appreciating subject that this value comes to life and is demonstrated; that is why aesthetic value is often described as being subjective in some sense, even when it is argued that such judgments also exhibit some objectivity of consensus and criteria of evaluation.[2] In this sense of experiential value, it does not really make sense to speak of appreciating the aesthetic value of an artwork by merely having read or heard about it but without ever having experienced it, either in its original form or in an adequate reproduction. In the same way, entertainment value needs to be appreciated in direct and personal experience of the artwork enjoyed.

There are also other values that play an important role in evaluation of art, especially whenever we go beyond the specific aesthetic domain to consider the wider field of culture. We sometimes praise (or condemn) an artwork in terms of its social value – its effects in promoting social harmony or social progress. We also speak of the political value of art in similar terms. In the debates over the value of popular art, for example, there are arguments affirming its social and political value in terms of democratic expression, just as there are vehement allegations of its noxious social and political effects in terms of lowering of cultural standards and promotion of an unthinkingly conformist, mass mentality (Shusterman 1992, Ch. 7). Moreover, there are economic valuations of art that relate to sales and profit figures, and those that relate to issues of symbolic capital and status that are more difficult to quantify. To understand or appreciate such values it does not seem necessary to base one's evaluation on vivid, direct experience of the artwork itself; one can instead concentrate on the work's effects and relationships in the social, political, or economic fields in which it is situated.

These dimensions of valuing art most aestheticians regard as clearly extrinsic to genuine aesthetic value. But there are two other ways of valuing art that seem closer to the core notion of intrinsic aesthetic value but can still be distinguished from it: art-historical value and artistic value. The first relates to the contribution an artwork or genre has made to art history and cultural history. An artwork that no longer provides rewarding aesthetic experience to many people can still be widely hailed as artistically valuable because it earlier achieved classic status and thus forms an integral, inseparable part of an influential tradition that we still greatly value. The now unappealing classic thus remains highly valued for the still appealing

[2] See further in Wilde in Chapter 13.

tradition of works that it helped inspire. This value seems clearly relational – a function of the work's place or role with respect to other works. The problem of obtaining a workable notion of intrinsic value that involves no relations will be explored in this chapter's last section.

To have artistic, as distinguished from art-historical, value, an artwork need not be historically influential; it could simply demonstrate valuable qualities of technique in a given artistic genre. This sense of value hearkens back to the old general meaning of art as a specific skill or craft. A work might be aesthetically disappointing and fail to produce rewarding experience but still have the redeeming value of demonstrating some technical skill in the artistic medium. It is at least artistically valuable to that extent. One can imagine an aesthetically dismal portrait that nonetheless showed technical skill in drawing, or a note-perfect but unexpressive and uninspiring performance of a difficult musical work. If the technical skill demonstrated is innovative or impressive enough to be influential, then such artistic value could also constitute art-historical value. But even if we cannot speak of influence, artistic value seems clearly relational, since excellence of skill or technique makes at least implicit reference to standards or paradigms of excellence that lie beyond the artwork itself. This, however, does not entail that artistic value is extrinsic rather than intrinsic, since the value is nonetheless embodied or expressed in the work itself rather than merely its external effects. As with aesthetic value, the proper appreciation of artistic value seems to require a direct experience of the work, though being told that a difficult musical performance was "note perfect" may perhaps be enough for us to accord it some degree of artistic value without having heard it. Because of this common experiential anchorage (if not also for other reasons), artistic value and aesthetic value are more often run together than distinguished.

Having distinguished these different senses of value, I do not want to claim they are clearly given as differentiated in kind either in immediate experience or as ontologically ultimate constituents of reality; they are rather products of our analytic efforts to explain the different ways we value art. In concrete experience, the various values I have mentioned tend to overlap and fuse in our appreciation of art and can only be differentiated by intellectual abstraction. For instance, recognition of an artwork's social value or political import can be integrated as a dimension of the work's meaning and thus feed back into the way we directly experience it so as to augment the intrinsic aesthetic power and appeal of that experience. In the same way, knowing that the work we are appreciating is of immense art-historical significance can inspire a sacralizing mode of appreciation that tends to promote more

powerful aesthetic experience by encouraging greater psychological invest-
ment in such experience. It seems very arbitrary, if not impossible, to try to
separate the pure aesthetic value of a revered masterpiece like *Hamlet* from
its illustrious history of valuation and from all the differing interpretations
that have made it such a meaningful and hallowed work.

3.2 Methodology

Before launching my analysis of the concept of entertainment, I need to make
some introductory points with respect to my methodology. The philosoph-
ical framework of my research is pragmatism. Because of its appreciation of
instrumentalities, relations, and contextuality, pragmatism is often accused
of denying intrinsic values. That is one of the reasons I am sensitive to the
need to maintain a notion of intrinsic value that will permit instrumentality.
If there were only instrumental values, so that everything were valued only
as a means to something else, there would seem to be no valuable end at all
to justify or ground the value of these instrumentalities. The whole structure
of our values would seem to be an empty circle of mere means with nothing
valuable to make them worth using as means.

The pragmatic position I hold with respect to entertainment is one that
I call meliorism; I have already articulated and defended a similar position
with respect to popular art (Shusterman 1992, 2000). Meliorism recognizes
the flaws and abuses of entertainment but also recognizes its value and
potential. Meliorism holds that the field of entertainment (or popular art)
needs improvement because of its many failings, but that our forms of
entertainment can be improved and are worth improving because they can
and often do achieve real aesthetic merit and serve worthy ethical and social
ends.

Pragmatism is a forward-looking philosophy that judges ideas by their
consequences, not by their pedigree. However, it recognizes that philosoph-
ical problems and concepts emerge through historical contexts and can
therefore be properly understood only through recognition of that history.
My analysis of entertainment therefore begins with some etymological study
of the cluster of terms that denote this concept, followed by a brief genealog-
ical critique of its deployment in philosophy. I then concentrate on a central
paradox of entertainment that emerges from this analysis and that, I think,
offers some important lessons for both ethics and aesthetics. Acknowledging
these lessons should produce a greater philosophical appreciation of enter-
tainment. But it will also be necessary to clarify two important concepts that
seem central to the value of entertainment but have been used as weapons to

criticize it for triviality and narrowness: pleasure and functionality for life. The chapter concludes with the issues of intrinsic and instrumental value that these concepts clearly raise.

3.3 Terminology

During its long philosophical history in the West, the concept of entertainment has been expressed through a variety of terms with slightly different but overlapping meanings. For brevity, I confine myself here to the three major European languages of modern philosophy: English, French, and German. Besides the term *entertainment*, other English words used to express this concept include *amusement, pastime, distraction, divertissement*, and *recreation*. Related words such as *play* and *game* are also sometimes used. The French mainly employ such terms as *amusement, divertissement*, and *distraction*, but they also use such terms as *rejouissance* and *passetemps*. In German, *Unterhaltung* is the most common term for entertainment, but the terms *Zerstreuung, Zeitvertreib*, and *Belustigung* are also used. The English term *entertainment* derives ultimately from the Latin *inter + tenere*, which would mean "to hold together," "to maintain," "to uphold." The earliest English usages of *entertainment* in the sixteenth century were indeed devoted to this sense of maintaining or sustaining: particularly the maintenance of persons, especially guests, and soldiers, through material provisions, and the maintaining in one's behavior of proper manners and treatment. Another early usage of *entertainment*, found in Shakespeare's *Love's Labours Lost*, is an "occupation" or "spending of time." From these earlier meanings, the principal aesthetic meaning of *entertainment* – "the action of occupying (a person's) attention agreeably," "that which affords interest or amusement," "a public performance or exhibition intended to interest or amuse" – seems to have derived. The German term *Unterhaltung* clearly parallels the English, moving from connotations of support or sustenance to the idea of occupying one's time pleasantly. The straightforward philosophical lesson implied by this etymology is that a good if not necessary way to maintain oneself is to occupy oneself pleasurably and with interest. The same idea is expressed in the term *recreation*, where one sustains oneself by reviving or recreating one's energy through pleasurable activity.

The philosophical lesson becomes more complex, however, when we consider the English and French terms *amusement, divertissement*, and *distraction*. Here instead of emphasizing the maintenance of one's self or one's guests, the focus is distracted to some other presumably far less important matter that captures our attention. The English term *amusement* derives

from the verb *to muse*, whose early meanings are to be absorbed in thought, to wonder, to be astonished or puzzled. But both English terms stem back to the French *muser*, meaning "to waste time or trifle by idly attending to light matters."[3] Amusements thus prompt us to stop the serious business of maintaining ourselves and others and instead lure us to meditate on other things. The terms *distraction, diversion*, and *divertissement* all suggest, through their root meaning of "tearing away" or "turning aside," that we are turned away from our habitual focus of attention and instead directed to something else. The German *Zerstreuung* likewise suggests that in entertainment the attentive subject is dispersed or scattered in contrast to the concentration of the self that high art demands and that Walter Benjamin denotes as *Sammlung* – a term that conveys the notion of collecting oneself or self-composure.

There is also an important philosophical lesson to be learned from this etymology of distraction, but it is more paradoxical and dialectic: To maintain the self one needs also to forget it and look elsewhere. To sustain, refresh, and even deepen concentration, one also needs to distract it; otherwise concentration fatigues itself and is dulled through monotony. These lessons, one might say, are inscribed in our anatomy of vision: We succeed in securing our physical sustenance and refreshment by looking outward, not inward. The paradoxical structure of entertainment – that binds, in a productive dialectic, the seeming opposites of focused attention and diversion, concentration and distraction, serious maintenance and playful amusement – also finds potent expression in various moments of the concept's genealogy.

3.4 Genealogy

The conceptual history of entertainment is too complex to be presented in a short, neat narrative, so I shall focus only on the most influential chapters to highlight some key points. We can begin with Plato's *Phaedrus* (276a–277a), where Socrates, in arguing against the idea of writing philosophy, draws a sharp contrast between philosophy and entertainment. Written speeches even of philosophy are only valuable "for the sake of amusement," in contrast to the truly "serious" philosophical "art of dialectic" through oral dialogue, which actively inseminates the mind "and renders the man who has it as happy as any human can be." Philosophy is thus superior to amusement not only in its education but in its pleasures. The Greek term used here for "amusement" is *paidia*, which is strikingly close to the Greek word

[3] Some link this word to the Italian *musare*, which means "to stare about, idle, loiter."

for education, *paideia*, since they both have the common root related to children, a point that Plato deploys in *Laws*, Book II. Trivialized as childish "kidding around" or playing, entertainment is contrasted with true education, which should be serious and controlled. The mimetic arts, with their strong entertainment function, are for Plato not only a childish diversion from the truth but a deceptive distortion of it and a corruption of the soul. Hence his *Republic* strongly condemns them, even to the point of urging their banishment in Book X.

Although Aristotle's *Poetics* introduced some independent criteria for assessing the aesthetic value of tragedies – the pleasures of formalist unity and cathartic release – his defense of the artistic entertainments of his time still depended on philosophy's high value of truth. Hence art's mimetic pleasures are defined as lower versions of philosophy's higher cognitive joys; Aristotle chooses to praise poetry for being "more philosophic and of graver import than history" because it describes not the mere contingent particulars of the past but rather "a kind of thing that might happen, i.e., what is possible as being probable or necessary." Hence though poetry uses proper names of particulars, "its statements are of the nature rather of universals, whereas those of history are singulars."[4] The Latin word for entertainment, *oblectatio*, which has the primary sense of an alluring diversion or distraction, also has connotations of the childish, since it is derived from the verb *lacto*, which means both "to allure" and "to take milk from the breast." The mother's breast provides the child with entertainment both in the sense of sustenance and in the sense of pleasurable comforting distraction from unpleasant feelings or anxieties. The mother's breast is probably one's first entertainment in both these vital senses. Could philosophy's haughty devaluation of entertainment be partly an unconscious rejection of man's "childish" dependence on mothers and on women more generally?

At the dawn of modern thought, Michel de Montaigne still observes the ancient distinction between entertainment and serious philosophical wisdom in his discussion of reading. However, he skeptically challenges the traditional hierarchy of serious thought and playful amusement by proudly affirming that he now reads primarily for pleasure.[5] Anticipating critique of this love of amusement, Montaigne counters: "If anyone tells me that it is degrading the Muses to use them only as a plaything and a pastime, he does

[4] Aristotle's *Poetics*, 1451b; see Bywater (1909: 27).

[5] Michel de Montaigne, *Essais (édition conforme au texte de l'exemplaire de Bordeaux avec les additions de l'édition posthume)*, ed. Maurice Rat (Paris: Garnier, 1962), Vol. 1: 447–462; Vol. 2: 237–261. The parenthetical page reference is to Donald Frame's excellent translation, which I generally adopt; see Frame (1957).

not know as I do the value of pleasure, play, and past time. I would almost say that any other aim is ridiculous" (III.3: 629).

Montaigne must not be mistaken for a lightweight, frivolous mind; the gargantuan work of intense self-study that constitutes his massive *Essays* makes this clear. He also insisted that this meditative activity "of entertaining one's own thoughts" was a form of entertainment that in a strong mind could rival all other activities in both intellectual demandingness and pleasure. However, feeling that prolonged and vigorous self-meditation could be dangerously exhausting and unsettling, Montaigne recognized his mind's need to divert itself with other pleasures in order to "settle down and rest."

Though very brief and sporadic, Montaigne's account of entertainment contains three crucial points. First, entertainment can take demanding, meditative forms that involve not merely pleasure but also the superior exercise of the mind; hence the pursuit of entertainment, pleasure, and serious intellectual activity should not be seen as inconsistent. Second, since pleasure more generally is not a trivial value, entertainment's deep connection with pleasure should not demean but rather elevate it. Third, entertainment's diversion of the mind is not a necessarily negative feature that diminishes the mind by distracting its attention, but rather, in dialectical fashion, strengthens the mind's powers by providing it with both relief and alternative exercise in changing the focus and style of its activity.

In the eighteenth century, the notion of entertainment begins to be contrasted not simply with the serious praxis of life and thought but with more serious forms of art. Thus Samuel Johnson, the key critical figure of eighteenth-century English neoclassicism, attributes to "entertainment" a specific application to "the lower comedy" and notes its growing use for denoting "an assemblage of performances of varied character, as when music is intermixed with recitations, feats of skill, etc."[6]

In Denis Diderot's *Encyclopedia*, the article on "Divertissement" suggests a somewhat similar point. After noting the more technical meaning of *divertissement* in the arts of that time – designating "all the little poems put to music, that one performs in the theatre or concert; and the dances, mixed with song, that one sometimes places at the end of comedies of two acts or one act" and "more particularly those dances and songs episodically introduced into the acts of opera" – the article more generally defines *divertissement* as "the generic term that includes particular amusements, recreations, and festivities [rejouissances]." Despite their somewhat different nuances, these four terms are claimed to be "synonyms and have distraction [dissipation]

[6] See "Entertainment" in *The Oxford English Dictionary* (Oxford: Clarendon Press, 1933), Vol. 3: 214.

or pleasure as their base." The article's closing caution that "all divertisse-ments that do not take useful or necessary things as their goal are the fruit of idleness and love of pleasure" suggests a contrast of mere entertainment with true art, "whose supreme merit," Diderot elsewhere writes, "lies in combining the pleasant with the useful." Of course, this implies neither that art itself is not a form of entertainment nor that entertainment must be confined to idle matters of useless pleasure.[7]

In Immanuel Kant's *Critique of Judgement*, the notion of entertainment is used with both "low" and "high" connotations. Though applied to the sen-sual "interested" pleasures that distinguish the agreeable from the beautiful (Book I, paragraph 7), it is later used for the unconstrained and disinter-ested (i.e., without specific purpose) entertainment of the mental faculties ("freie und unbestimmt-zweckmässige Unterhaltung der Gemütskräfte") that mark our experience of beauty.[8]

Friedrich Schiller's appreciative identification of the aesthetic with the realm of play and appearance recognizes the positive human need of enter-tainment as expressed through the concept of play: "Man plays only when he is a human being in the fullest sense of the term, and he is only fully a human being when he plays."[9] Schiller likewise insists on the ennobling value of play as both an expression of human freedom and a noncoercive, effective form of moral edification. The concept of *Schein*, which is clearly related to that of *Spiel* and to the spectacle sense of entertainment, is similarly valorized by Schiller as a locus and instrument of freedom. As Kant's *Critique of Judge-ment* maintained a fragile balance in the notion of entertainment for both interested and free pursuits, and thus a consequent bivalence of the term between the lower realm of the agreeable and the higher cognitive realm of the beautiful, so Schiller's ideal of play suggests that entertainment itself in its nobler forms provides and symbolizes the perfect equilibrium of ideal form and material life.

[7] See "Divertissement" in *Encyclopédie ou dictionnaire raisonné des arts et des métiers, mis en ordre et publié par Diderot & quant à la partie mathématique par d'Alembert*. Nouvelle impression en facsimile de la première edition de 1751–1780 (Stuttgart: Friedrich From-mann Verlag, 1966), Vol. 4: 1069; the article is written by M. le Chevalier de Jaucourt. See also Denis Diderot, "D'Alembert's Dream: Conclusion of the Conversation" in Kemp (1943: 119).

[8] Immanuel Kant, *Kritik der Urteliskraft* (Hamburg: Felix Meiner, 1974): 50 and 84 ("All-gemeine Anmerkung zum ersten Abschnitte der Analytik"); cf. In English *The Critique of Judgement*, trans. J. C. Meredith (Oxford: Oxford University Press, 1952): 53 and 88; Meredith somewhat awkwardly renders the German phrase "free and indeterminately final entertainment of the mental powers."

[9] Schiller [1794] (1982), Letter 15, 107: "der Mensch spielt nur, wo er in voller Bedeutung des Worts Mensch ist, und er ist nur da ganz Mensch, wo er spielt."

This balanced view of entertainment is decisively disturbed by Georg Wilhelm Friedrich Hegel's influential aesthetics, with its fateful spiritualizing turn toward the ideal. With Hegel, entertainment seems unequivocally identified with what is unworthy of the name of art. In his initial remarks to affirm the worthiness of art in his *Vorlesungen über die Ästhetik*, Hegel feels he must sharply distinguish between "true art" and the "servile" artistic distractions that are merely "a fleeting game in the service of pleasure and entertainment" ("ein flüchtiges Spiel ... dem Vergnügen und Unterhaltung zu dienen") and of other "external" ends of "life-related pleasantness." Entertainment thus marks the inferior realm of servitude to pleasure and its external ends. In contrast, the fine arts (*die schönen Künste*) only become true art (*wahrhafte Kunst*) when they are free of this subservience. This Hegelian attitude still, sadly, dominates contemporary aesthetics, whose idealist turn has privileged, in the realm of art, truth over beauty and pleasure, while also aesthetically privileging the realm of art high above natural splendors.

Friedrich Nietzsche presents a more complex and salutary view of entertainment and its relationship to art and thought. He can deploy the term very pejoratively to denote a trivial concern with shallow pleasure and the passing of time to alleviate boredom. On the other hand, in *Ecce Homo* ("Why I Am So Clever," Section 3), Nietzsche expresses the positive power of entertainment through the notion of "recreation" (*Erholung*), which he regards, along with choice of climate and nourishment, as essential to self-care, as what allows him to escape himself and his own self-demanding "seriousness" (*Ernst*). Nietzsche in fact claims, "Every kind of reading belongs among my recreations."[10] An intense practitioner of self-meditation like Montaigne, Nietzsche seems to affirm the productive paradox of entertainment's distraction that we earlier gleaned from etymology and from Montaigne – that the self is sustained and strengthened by being freed from attention to itself, that serious self-care also entails amusing distraction from oneself. And this paradox, I think, implies a further dialectical lesson: that the self is enlarged and improved by forgetting itself and plunging its interest in the wider world.

After Nietzsche, the dominant trend in German philosophy to denigrate the entertainment function of art reasserts itself. Martin Heidegger insists

[10] Friedrich Nietzsche, *Ecce Homo* ("Warum ich so klug bin," section 3), in *Sämtliche Werke* (Stuttgart: Alfred Körner, 1978): 320–321. Later in section 8, he suggests that recreation involves "an instinct of self-preservation" (329); cf. the English translation by Walter Kaufmann (New York: Vintage, 1969): 242, 252.

that artworks are not truly presented or preserved when they "are offered for merely artistic enjoyment," since art's defining essence is not pleasure or entertainment but "the becoming and happening of truth." Even Hans-Georg Gadamer, whose aesthetics emphasizes the notion of play, emphasizes art's ontological and interpretive revelations while neglecting its function of entertainment, and he cautions against the seductive dangers of "aesthetic immediacy" and Erlebnis.[11] The Hegelian trend in German aesthetics to privilege truth over pleasure and even over beauty is still more strikingly dominant in Theodor Adorno, who together with Max Horkheimer introduced the disparaging notion of "the culture industry" to denigrate the entertainments of popular art whose allegedly passive and mindless pleasures "fill empty time with more emptiness." For Adorno, it almost seems that the entertaining pleasures of art are starkly opposed to cognition: "People enjoy works of art the less, the more they know about them, and vice versa." In the contest of artistic values, Adorno is clear that pleasure must be sacrificed to truth. "In a false world, all hedone is false. This goes for artistic pleasure too.... In short, the very idea that enjoyment is of the essence of art needs to be thrown overboard.... What works of art really demand from us is knowledge or, better, a cognitive faculty of judging justly" (Adorno 1984: 18–21; Adorno and Horkheimer 1986: 121).

But why should it be assumed that there is an essential opposition between truth and entertainment, knowledge and pleasure? Note how one influential Anglo-American poet-critic-theorist wisely maintains the fruitful interconnection of these terms and therefore can affirm art's entertainment without denying its cognitive import. T. S. Eliot, inspired by the ideas of Remy de Gourmont, famously defined poetry as "a superior amusement," while immediately cautioning that this does "not mean an amusement for superior people." The arts constitute a superior amusement, Eliot argues, because their pleasure appeals not just to the senses but to the understanding. "To understand a poem comes to the same thing as to enjoy it for the right reasons. One might say that it means getting from the poem such enjoyment as it is capable of giving; to enjoy a poem under a misunderstanding as to what it is, is to enjoy what is merely a projection of our own mind.... It is

[11] See Heidegger (1975: 68, 71), Gadamer (1982: 58–90), Adorno (1984: 18–21). I should note that Gadamer seems much more tolerant than Adorno toward popular music, regarding it as "legitimate." But he views this legitimacy not in terms of pleasure but merely in terms of its "capacity to establish [wide] communication" and to provide material for criticism in our "thirst for knowledge." Gadamer also relates art to the notion of festival, which he understands in rather transcendental and often explicitly "theological" terms; see Gadamer (1986: 39, 51).

certain that we do not fully enjoy a poem unless we understand it; and, on the other hand, it is equally true that we do not fully understand a poem unless we enjoy it. And that means, enjoying it to the right degree and in the right way, relative to other poems."[12]

Nonetheless most cultural critics sharply contrast art and entertainment, identifying the latter with idle pleasure seeking and lower-class vulgarity. Many factors of cultural and conceptual economy have made this identification so seductive. As the notion of pleasure centrally includes pleasures of the flesh, so idealist philosophy and otherworldly Christianity have conspired to distance their realms of value from such low, corporeal taints. The Protestant ethic of work and thrift, long entrenched in North America and Europe, has also given pleasure a bad name. Moreover, the intellectual asceticism that constitutes the typical *habitus* of theorists prompts them to resist full recognition of pleasure's rich values. With modernity's secularization of the natural world and the loss of traditional religious faith, art has increasingly come to function as a locus for our habits of sacralization. Even if the sacred aura of art has been challenged by the mechanical reproduction of artworks, the desire to sustain art as a transcendental, spiritual value remains. In secular society, the classics of literature have become our sacred texts while museums have replaced churches as the place one visits on the weekend for one's spiritual edification.

But if art is to be sacralized, it must be sharply distinguished from entertainment, since the latter is associated with earthy pleasures that serve to refresh embodied human life rather than devoting itself entirely to the transcendental realm of spiritual immortality celebrated by romantic "theologies" of art. Pleasure and life – two of the crucial values that pragmatist aesthetics sees in art – are paradoxically two of the cardinal sins for which entertainment is condemned. The next section therefore brings some arguments in their defense, though common sense would think that none are needed.

3.5 Pleasure and Life

I begin with pleasure, since my aesthetics has frequently been criticized for hedonism, even though I never claim that pleasure is the only or the highest value in art and life.[13] I do however think that post-Kantian aesthetics

[12] See Eliot (1968: viii–ix; 1957: 115). This means that we should not enjoy the bad poems that we understand, "unless their badness is of a sort that appeals to our sense of humour." The subsequent quote is from Eliot (1964: 154).

[13] See, for example, the criticisms made by Nehamas (1998) and Higgins (2002).

wrongly tends to dismiss the importance of pleasure by failing to realize the complexity of its logic and the diversity of its forms and uses. This diversity is even suggested in the vast vocabulary of pleasure that far exceeds the single word. Besides the traditional contrast between sensual voluptuousness (*voluptas*) and the sacred heights of religious joy (*gaudium*), there are delight, pleasantness, gratification, gladness, elation, titillation, fun, exhilaration, enjoyment, exultation, bliss, rapture, ecstasy, and more. While fun and pleasantness convey a sense of lightness that could suggest triviality, the notions of rapture, bliss, and ecstasy clearly evoke just how profound and potently meaningful pleasures can be.

Modern empiricism understands pleasure, and experience more generally, in terms of passive sensations existing only in the private mental world of the experiencing subject. So conceived, pleasure could seem trivial. But pleasure is not such an isolated passive sensation; it is rather, as Aristotle recognized, a quality of any activity that "completes" or enhances that activity by making the activity more zestful or rewarding and thus promoting it by intensifying our interest in it. Pleasure is thus inseparable from the activity in which it is experienced. To enjoy tennis is not to experience intensely agreeable feelings in one's sweating racket hand or running feet (feelings that would distract us from the game); it is rather to play the game with gusto and absorbed attention. Likewise, to enjoy art is not to have certain pleasant sensations that we might obtain from something else like a good espresso or a steam bath; enjoying an artwork is rather to take pleasure in perceiving and understanding the particular work's qualities and meanings, where such pleasure tends to intensify our attention to the work in a way that aids our perception and understanding of it. This Aristotelian conception lies behind Eliot's view of the essential connection of poetic enjoyment and understanding.

Though a powerful Kantian tradition insists on a very specific type of aesthetic pleasure, narrowly defined as the intellectual pleasure of pure form arising from the harmonious play of our cognitive faculties, the pragmatist tradition construes aesthetic pleasure more generously. First and most simply there are the variegated pleasures of sense – rich qualities of color, shape, sound, movement, and so forth. The pleasures of heightened perception stirred by an artwork's appealing sensory qualities are part of what makes it stand out from the ordinary flow of perception as a special aesthetic experience worthy of the name of art, an experience that so absorbs our attention that it also constitutes an entertaining distraction from the humdrum routine of life. Indeed aesthetic pleasures are often so intensely delightful that they suggest metaphysical or religious transcendence to a

higher realm of reality. Indian philosophy claims the aesthetic pleasure of *rasa* (the special emotion expressed in art, most paradigmatically in drama) is "transcendental" or "unworldly" in its power and quality of "bliss."[14] The sense of divine pleasure is also clear in the original meaning of the Japanese term for entertainment (*goraku*), which indicates the receiving of hospitality from a heavenly maiden.[15] Aesthetic pleasures include the experience of intense yet well-ordered feelings, as well as the satisfactions of meaning and expression that satisfy our need for significance and communication. Such pleasures motivate not only the creative artist or entertainer but also the critic and public who engage in interpretation both to explain the pleasures they experience and to deepen them through enriching analysis.

The pleasures of meaning and expression point to another aspect of aesthetic pleasure that is often obscured – its social dimension. Too often it is assumed that the enjoyment of art or entertainment is simply subjective, hence essentially private and narrowly individualistic. But there is a radiating feature in pleasure that takes it beyond mere individual satisfaction. Pleasures are contagious; when we see a child enjoying a song, we will be inclined to take pleasure in her pleasure, even if we do not know the child and do not think that the song is especially beautiful. Aesthetic experience gains intensity from a sense of sharing something meaningful and valuable, and this includes the feeling of shared pleasures. Art's power to unite society through its enchanting pleasures of communication is a theme that resounds from Schiller to John Dewey, but the unifying power of mass-media entertainment is likewise recognized, though vilified, by the critics of popular art.[16]

Aesthetic experience, properly speaking, is never located only in the head of the human subject but always exists in the wider context that frames the

[14] See Chaudhury (1965: 145–146). The great Indian aesthetician Abinovagupta, writing in the tenth century, describes the pleasure of *rasa* as "like the relish of the ultimate reality" (see ibid.: 148). For a brief comparison of *rasa* theory to the pragmatist view of aesthetic experience and pleasure, see Shusterman (2003).

[15] This early Japanese meaning of *goraku* can be found in the Japanese literary classics *Konjaku-monogatari* (twelfth century) and *Taiheiki* (fourteenth century). The *kanji* (or character) that forms the word suggests a person's head tilted back with the mouth wide open in joyful laughter (and perhaps also some other pleasure). I thank Professor Satoshi Higuchi for instructing me about the etymology of *goraku*, based on information from the comprehensive Japanese dictionary *Nihon Kogugo Daijiten* (Tokyo: Shogakukan, 1974), Vol. 8: 433.

[16] Dewey claims "art is the most effective mode of communication that exists" (Dewey 1987: 291). Confucianism also advocates the valuable role of aesthetic pleasures in cultivating harmony and good order, not only in the individual but also in society as a whole. For more on this point, see Shusterman (2004).

subject's interaction with the object of art or natural beauty. For pragmatism, the human subject itself is but a shifting, temporary construction from the materials and energies of the larger world of nature and history. Regarding our entire universe as a realm of flux with no absolute permanence but only relative stabilities, pragmatism appreciates beauty and pleasure all the more because of its fragile, fleeting nature. By refusing to equate reality with permanence, it recognizes that short-lived loveliness or brief spasms of delight are no less real or moving or cherished because they are momentary. Indeed some pleasures of beauty, art, and entertainment are not only valuable without being everlasting but even more valuable because they are not. The beauties of cherry blossoms are cherished and savored all the more because we know they are so fleeting.

The Platonic prejudice for certainty and permanence is one reason for disvaluing the passing delights of entertainment. But the ancient prejudice against instrumentality as inimically conflicting with intrinsic value is just as powerful and just as manifest in Hannah Arendt's critique, which insists that real aesthetic and cultural values, because of their "intrinsic" worth, should "exist independently of all utilitarian and functional references" (Arendt 1961). We need to examine more closely the notion of intrinsic value and its relationship to functional or instrumental value.

3.6 Intrinsic Value

Analytic philosophy's most famous account of intrinsic value is that offered in the *Principia Ethica* of G. E. Moore (see Moore 1959, hereafter abbreviated as PE). Here Moore provides an extremely intuitive method for correctly judging the "intrinsic value" of things and their degrees of such value: "It is necessary to consider what things are such that, if they existed *by themselves*, in absolute isolation, we should yet judge their existence to be good; and, in order to decide upon the relative *degrees* of value of different things, we must similarly consider what comparative value seems to attach to the isolated value of each" (PE: 187; italics in original). Moore deploys "this method of absolute isolation" (PE: 188) to argue, against radical hedonism, that the mere conscious sensation of pleasure is neither the only value nor even the highest value. If we consider the conscious sensation of pleasure alone, isolated from consciousness of the activity in which that pleasure is expressed, and then compare the intuited value of the isolated pleasure to the value of the combined consciousness of pleasure and its associated activity, we will readily recognize that the organic whole of "enjoyment" (PE: 188) could easily be greater in value. For instance, we can see that the value of enjoying a

fine poem is more than a mere pleasurable consciousness existing in its own right without any relation to a meaningful object or activity such as reading the poem. Relying on his method of absolute isolation, Moore claims, "By far the most valuable things, which we know or can imagine, are certain states of consciousness, which may be roughly described as the pleasures of human intercourse and the enjoyment of beautiful objects" (PE: 188).

In contrast to Moore, pragmatism does not see values as existing autonomously in fixed isolation or as residing in unchanging objects, but instead regards them as pertaining to a complex, dynamic field whose relations shape the field's values. This field is broadly the behavioral field of human action, involving a plurality of communicative, active subjects facing multiple objects and choices. Moreover, the field of values is a temporally shifting field that is altered by the consequences of changing circumstances and behavior. It thus involves not only synchronic relations but also diachronic relations. As dynamically relational or in Dewey's terms *transactional*, all values are subject to change, even intrinsic values. We can speak of the beauty of a tree as being intrinsically valuable, but we should not assume that this entails some fixed set of autonomous beauty properties isolatable in the tree itself. The tree's beauty is never the same in different seasons; nor is its beauty a pure function of the tree itself but instead also involves the environing conditions, such as light and space, that frame the tree's perception and allow its beauty to show forth.

A satisfactory theory of intrinsic value is too difficult a project for me to undertake here, but let me close by briefly sketching a possible approach to answering these questions. Moore understandably takes intrinsic value to mean being valued in itself, but he then most radically construes *in itself* as "in absolute isolation." However, it also seems possible and more reasonable to regard being valued *in itself* as meaning valued *for itself* (or in its own right, for its own sake, or on its own account). We can then speak of intrinsic value when something is appreciated for itself and not simply in terms of its serving as a means to a further end that is valued. This would allow us to distinguish intrinsic value from instrumental value without implying that being instrumentally valuable is inconsistent with having intrinsic value, and vice versa. Though food is nutritious, a good meal is intrinsically valuable because a person enjoys its taste in its own right without having to think of the instrumental nourishment the meal gives. Even if we do also think of its nourishment or instrumentality, as long as we are enjoying the taste of the meal, we are appreciating the meal as intrinsically valuable.

What sense of objectivity could survive a relational account of intrinsic value? None that would ensure that things will have permanent unchanging

values that are independent of all circumstances. But we could still say that the intrinsic value of this good meal is objective in at least two senses: that it involves objective factors – that the food is of good quality and well prepared rather than rotten and burned to a crisp – and that it is manifest in objectively observable behavioral responses – zest of eating, gestures of approval or satisfaction, neurological patterns, and so on – that indicate that the meal is being directly enjoyed and not simply being endured because of its instrumental value in procuring some further end taken to be intrinsically valuable. Objective value, as Moore himself realizes, does not exclude relational accounts. A person may be objectively better than another in terms of some job description or in evolutionary terms of survival given existing circumstances. But the problem, for Moore, is that since existing circumstances or desired functions can change, relational accounts of value (though based on objective conditions) cannot guarantee the sort of absoluteness and "fixity" of value that Moore wants our intrinsic values, as our deepest or most ultimate values, to have.

In this radically internalist sense, the intrinsic value of a thing seems, strictly speaking, more correctly contrasted with a notion of extrinsic value (i.e., value that is entirely or primarily dependent on properties that are not internal to the object) than with the notion of instrumental value. The value of a winning lottery ticket, for example, would be essentially extrinsic to the internal properties of the ticket itself, such as color, shape, and size. Parallel to such an intrinsic/extrinsic opposition, we could then explain that what is strictly opposed to instrumental value is not intrinsic value but "final" or unmediated value in the sense that such value would be directly appreciated as an end for itself and not just as a means for a further end. Nonetheless, to the extent that instrumentalities obviously relate to ends, activities, and properties that lie beyond the purely internal properties of the particular object used as a means, instrumental value implies some extrinsic dimension. We can thus understand how the ideas of extrinsic and instrumental value might be identified.

Intrinsic value, as I prefer to construe this notion, does not, strictly speaking, belong permanently to isolated things in their internal autonomy, but instead belongs to the particular situations or specific fields of transaction in which those things of alleged intrinsic value play a central role. The intrinsic value of a painting, for example, depends not only on the physically colored canvas itself but also on the fact that there are people who have the sense organs and understanding to appreciate its colors and the forms and meanings to which these colors contribute. We can still speak here of intrinsic value not only in the sense that our experience of the painting is appreciated

for its own sake, but also in the sense that the pictorial properties of the canvas itself constitute the crucial focus for the appreciated experiential value in question. However, there is no pretension that all the appreciated properties of the painting, including its expressive and meaning properties, can be conceived as purely internal to the canvas and independent of any relation to things beyond it.

3.7 Conclusion

Let me conclude by returning to the notion of entertainment value. Much of my case for entertainment has been dedicated to the instrumental uses of entertainment for other ends such as the maintenance, relaxation, refreshment, and cognitive recreation of the individual and, by extension, the sustenance, harmonious cohesion, and revitalization of the society in which the individual self is situated. But besides such instrumentality, entertainment has intrinsic value in its immediately enjoyed satisfactions. The expression *entertainment value* as distinguished from the value of entertainment can more specifically connote this sort of directly experienced enjoyment that is grasped as valuable for itself rather than simply being appreciated for its instrumental value in achieving other ends. But such intrinsic value must not be confused with a permanently fixed value. The fact that values are transient and circumstantially contingent does not mean they are not real. To equate the truly valuable with the unchanging is an understandably human impulse that is linked to our desire for security and permanence. But it is an error that senselessly degrades many of our valuable but fleeting pleasures and thus sadly tends to impoverish the range of values that we realize in our experience.

References

Adorno, Theodor. 1984. *Aesthetic Theory.* London: Routledge.

Adorno, Theodor, and Max Horkheimer. 1986. *Dialectic of Enlightenment.* New York: Continuum.

Arendt, Hannah. 1961. The Crisis of Culture. In *Between Past and Future,* 197–226. New York: Viking.

Bywater, Ingram, trans. 1909. *Aristotle's Poetics.* Oxford: Clarendon Press.

Chaudhury, P. J. 1965. The Theory of Rasa. *Journal of Aesthetics and Art Criticism* 24:145–146.

Dewey, John. 1987. *Art as Experience.* Carbondale: Southern Illinois University Press.

Eliot, T. S. 1957. *Of Poetry and Poets.* London: Faber.

Eliot, T. S. 1964. *The Use of Poetry and the Use of Criticism.* London: Faber.

Eliot, T. S. 1968. *The Sacred Wood.* London: Methuen.

Frame, Donald. 1957. *The Complete Works of Montaigne.* Stanford, CA: Stanford University Press.

Gadamer, Hans-Georg. 1982. *Truth and Method.* New York: Crossroads.

Gadamer, Hans-Georg. 1986. *The Relevance of the Beautiful and Other Essays.* Cambridge: Cambridge University Press.

Heidegger, Martin. 1975. The Origin of the Work of Art. In *Poetry, Language, Thought.* New York: Harper.

Higgins, Kathleen. 2002. Living and Feeling at Home: Shusterman's Performing Live. *Journal of Aesthetic Education* 36:84–92.

Kemp, John, ed. 1943. *Diderot: Selected Writings.* New York: International Publishers.

Moore, G. E. 1959. *Principia Ethica.* Cambridge: Cambridge University Press.

Nehamas, Alexander. 1998. Richard Shusterman on Pleasure and Aesthetic Experience. *Journal of Aesthetics and Art Criticism* 56:49–51.

Schiller, Friedrich. 1982. *On the Aesthetic Education of Man,* bilingual ed. Oxford: Clarendon Press.

Shusterman, Richard. 1992. *Pragmatist Aesthetics: Living Beauty, Rethinking Art.* Oxford: Blackwell.

Shusterman, Richard. 2000. *Performing Live: Aesthetic Alternatives for the Ends of Art.* Ithaca, NY: Cornell University Press.

Shusterman, Richard. 2003. Definition, Dramatization, and Rasa. *Journal of Aesthetics and Art Criticism* 61(3): 295–298.

Shusterman, Richard. 2004. Pragmatism and East-Asian Thought. *Metaphilosophy* 35(1/2): 13–43.

FOUR

Creating Artistic from Economic Value

Changing Input Prices and New Art

Michael Hutter

4.1 Introduction

The creation of sources of cultural newness is usually credited to the individuals who wrote, performed, or shaped the artworks. The newness is attributed to their rare "genius" – the painterly genius of Manet and Cézanne, of Pollock and Viola; the filmmaking genius of John Huston; or the musical genius of Jimi Hendrix.[1] The relevance of the personal, mental, and physical contribution of artists is undisputed. This chapter tries to look beyond the personal contribution. Beyond the mental decision and its behavioral and material consequence, shifts in social circumstances take place, ranging from shifts in the immediate personal environment to shifts in the forces of society at large. These shifts change the constraints and the resources of those who are active in an artistic field. My focus will be on shifts in the availability of new resources and inputs, and on shifts in the relative prices of materials for artistic production.

At a first level, the argument uses a straightforward application of rational decision making: When the prices of goods that are relevant to artistic work change relative to the prices of other goods, the artists experience the change as a change in their financial constraints. Some options become affordable; others move out of reach. In either case, the artists, as well as those buying their works and performances, are faced with new choices. The choices lead to the use of new instruments and input materials, to new organizations of labor, and to migrations of entire artistic communities and industries.

[1] See Negus (2004) on the use of the notion of "genius" in music criticism.

I would like to thank the Getty Research Institute for support. Comments by Bernd Ankenbrand, Karl Bruckmaier, Gerhard Hackl, and Robert Jensen are gratefully acknowledged.

In the process of searching for alternatives, artists encounter materials that have new properties; these materials are results of innovative competition in other fields that have become available and affordable for artists or for the distributors of artworks.

At a second level, we observe the potential for new meaning and new interpretations that is released by artistic innovation. Such potential is contained in the variations within the existing range of art forms that are tried out in art scenes and picked up or ignored by the participants of such scenes. Innovation can take place in many dimensions: changes of visual formats, or changes of narratives, or changes in the rhythmic structure of songs. In sum, these new works and performances constitute the "richness" and "expressive force" of an art scene.

In consequence, input price changes have the power to shape the historical development of particular art forms. Input commodities for artistic work might be a painter's studio space; her canvases, brushes, and paints; or a film studio's use of electricity or air transport; or a musician's synthesizer. The expenditure on such commodities exhausts a major part of the artist's budget.[2] Therefore, substantial changes in prices for input commodities should lead to changes in artistic formats, styles, and genres.[3]

If one tries to prove this proposition empirically, the available literature is of little help. Economic studies tracing the historical price series of artistic inputs do not exist, and art historical accounts rarely go beyond individual and social circumstances. The prices of, say, pigment or electricity are ignored. Given that situation, this chapter focuses on three cases of artistic change that demonstrate the irritation or trigger effect of changing input prices on artistic innovation. The cases chosen differ in scope and art form. The case from the visual arts is split into three episodes in each of which the prices and qualities of painting media changed drastically. The case in the film industry focuses on one factor, namely, daylight, which made an entire industry migrate to a new location. The case in the music industry concentrates on the cost and performance of guitars in the 1950s.

[2] Statistical evidence is hard to come by. An extensive study of Australian artists, however, indicates that about 50 percent of expenditure across all artists' categories is taken up by materials and equipment (Throsby and Hollister 2003: Table 8.5).

[3] The argument has a certain similarity with a hypothesis put forward by Baumol and Bowen (1966). In studying the cost of orchestras in the 1960s they concluded that changes in labor prices in the arts – induced by technical progress that increases labor productivity in other sectors – lead *inter alia* to changes in musical form, in the makeup of performing ensembles, and in the performance of compositions. The focus of this chapter is on nonlabor inputs, but it could be extended to labor inputs.

4.2 Cheap Blues, Home Paints, and Flat Screens

Painters have typically worked in small workshops. During more recent times, customized and ready-to-use materials have allowed them to operate without assistants, on an individual basis. Contemporary visual artists spend more than 50 percent of expenditure incurred in art practice on materials, consumables, and equipment (see note 2). That proportion was probably even higher in earlier periods when canvases had to be cut and mounted, and pigments ground and dissolved in painting media. Again, the hypothesis is that changes in economic conditions have led to the emergence of new artistic value. In particular, the availability of new painting materials at lower prices has triggered variations in formats, styles, and media, leading to the adoption of new formats, styles, and genres in the respective art community. Given the long span of the craft's history, such effects can be observed in many epochs and places. I will report on three episodes.

4.2.1 Impressionist Style

The first episode involves the use of blue pigments in the work of Impressionist painters. Blue pigments hold a special place in the history of Western painting. Since antiquity, the pigment of choice was ultramarine, because of its intensity of color. Ultramarine was processed from lapis lazuli, a semiprecious stone found in Afghanistan and taken "across the waters," usually by way of Venice. The value of the raw material equaled its weight in gold. Its exorbitant price was scaled according to the quality grade of the pigment extracted from the ground stone powder.[4] In consequence, ultramarine became a signifier of supreme value in European painting. Its use was limited to the most venerated parts of an image, like the garments of Christ or the Virgin Mary, until late in the fifteenth century. Another, less expensive pigment is azurite, a copper carbonate, also known since ancient times. Azurite needs special treatment in order to be used with oily media. Its use declined when Prussian blue, the first synthetic blue, was discovered in 1704. Prussian blue consists of a combination of iron, nitrogen, and carbon. It is inexpensive but varies in reliability. The range of alternatives changed considerably when a binary oxide known as cobalt blue was discovered in 1802, followed in 1826 by French ultramarine, a synthetic complex composition similar to that of lazurite (natural ultramarine): "The attractions of synthetic ultramarine for artists were considerable, and by the 1870s it

[4] See Baxandall (1972).

was a standard blue for oil painting in France, and a great deal cheaper than the cobalt pigments. Its discovery had replaced the most expensive of all artists' pigments with one of the least costly."[5] Roughly, the cost of the new pigment was about a tenth that of its predecessor, albeit with better qualities of drying and higher stability.

The literature on the history of painting does not record a vast change in the use of blue pigments for traditional styles in the eighteenth and nineteenth centuries, whether in history painting, portraits, conversation pieces, landscapes, or still lifes; apparently the rules for executing traditional paintings did not permit large changes in the established color pattern. It took a new approach, experimenting with many components of painting technique, to make use of the new choices. In fact, there are numerous indications that blue pigments have a special role in Impressionist painting. Skies painted in cobalt blue are common; large quantities of cobalt blue in conjunction with artificial ultramarine account for the strongly blue tonality of works like Renoir's *Les Parapluies,* Figure 4.1) or the blue shadows in Monet's *Gare Saint-Lazare,* or Cézanne's Provençal landscapes.[6]

The impact of synthetic blue pigment on the tonal values of the new art style in the nineteenth century was the most striking. But it was not the only effect of new technological products at low prices. An entire industry of supplying painting materials to amateur painters had sprung up in the early 1800s. Other synthetic pigments were discovered, such as emerald green, chrome yellow, and vermilion. They all delivered vivid, strong hues and better process properties at a fraction of the cost of their natural substitutes. Canvases were sold in a limited number of standardized formats. From the 1840s onward, machine-ground paint that was already dissolved in painting media was sold in tin tubes. Storability and durability were greatly increased, making it possible for outdoor painting to become a popular leisure-time activity. Mass consumption reduced prices even further. The new paints also had new qualities of surface and viscosity, accounting for the thick and visible paint strokes considered typical for late Impressionism.[7]

It is moot to try to gauge the relevance of Impressionist and, more importantly, post-Impressionist painting to the self-description of twentieth-century culture. Cézanne's regular stroke patterns, recognizable in the pasty paint medium and arranged in color sequences straight from the chemical

[5] Bomford et al. (1990: 58).

[6] See Bomford et al. (1990: 57–58).

[7] "These new colors are responsible for the brittle, rough, impasto paint surface so characteristic of the painting of our time, a surface not to be found in painting before these manufactured colors came into general use." Grosser (1951: 56).

laboratory, broke the ground for the radically new styles of Modernism – from Fauvism to Cubism and Expressionism – that defined the image of the new age.

4.2.2 Cheap Home Paints

"Modern" American painting[8] is stylistically wed to a particular synthetic paint solvent called acrylic. The development leading up to this canonical status has similarities with the emergence of "impressionist blue." In the 1940s, the predominant style of museum-rated painting in North America was still determined by the traditions of European oil painting. Painters in the New York scene who either emigrated from Europe (Willem de Kooning, Adolph Gottlieb, Josef Albers) or had begun to paint in variations of Cubist, Expressionist, or metaphysical style (Barnett Newman, Kenneth Noland, Jackson Pollock, Mark Rothko) did not have a market of collectors. While income related to their art practice was nil, the large scale of the works that they tried to accomplish increased their total cost of materials. At this point, the artists discovered house paints, particularly enamel paints.[9]

Oil paints cause severe problems for painters: They react with untreated canvas, making it necessary to protect the canvas with a coating; they tend to discolor over time, leaving a brownish tint; and they take weeks to dry, making it necessary to structure the workflow around the drying periods. Enamel paints do not need oil as a binder. Instead, they use synthetic resins as a binder, either in a solution or in an emulsion. Colors can be applied directly to the canvas; they can be dispersed in very thin layers, as in some of Helen Frankenthaler's work (Figure 4.2), or, using a higher proportion of resin, in thick, physical deposits; and they dry extremely fast, leaving a "dry," cold look as opposed to the "wet," warm look of oil paintings. The new medium, cheap enough to be bought by the gallon, had another advantage: It signaled unconventionality. The coldness of the surfaces without signs of a brush stroke stood for a new system of aesthetic expression. With the help of interpretations provided by the critics of the New York scene, Abstract Expressionist works found a market of buyers who never had considered collecting artworks before.

[8] I use the term in the interpretation given by Clement Greenberg, which refers to a style called Abstract Expressionism; on his transfer of the notion of Modernism from avant-garde French painting practice to American painting, see Guilbault (1983).

[9] "The use of such paints certainly enabled artists like Pollock and Willem de Kooning to carry out more experimental application techniques than they might have attempted with expensive artistic quality materials." Crook and Learner (2000: 27).

Jackson Pollock experimented with Duco enamel, a brand based on the early resin nitro-pyroxylin. Polyvinyl acetate has the added advantage of being water-soluble and was used by painters like Burri and Noland. Acrylic resins, particularly in solution form, became the standard of choice. Since the midfifties, the paint supply firm of Bocour and Golden has dominated the market for high-end products with a paint called Magna, based on a resin called Acryloid F-10, dissolved in turpentine.[10] Acrylic emulsions such as Rhoplex were introduced for use in exterior house paint in 1953. They reached the artists' market under several brand names after 1963. Acrylic emulsions are highly stable; they look "scratchy, tough, modern, once-removed";[11] and they dry extremely rapidly, making it possible to add multiple layers in rapid succession.

It should be added that as early as 1912 Picasso had begun to use a house paint brand called Ripolin, based on alkyd resin. He continued to use house and boat paint throughout his career and frequently praised this new type of paint, but this did not have any impact on forms of painting in Europe. It took the availability of a cheap medium plus the specific economic conditions of young American artists in the 1940s to make experiments with new ways of expression affordable and fashionable. Under such conditions, the very properties of the nonart medium became the signature of a new style that soon demanded its execution in that particular medium. Once this state of recognition was instituted, a predictable pattern of quality improvements set in: Specialist firms ("colormen") developed custom-made varieties that catered to the specific needs of art painters, and to the larger budgets now available both to professionals and to amateurs.

4.2.3 Cheap Flat Screens

The last case takes us to contemporary times. Although we can observe certain price changes for artists' input commodities today, we are still in the dark as to the new artistic forms that may be triggered in the future by these price changes. Still, the available evidence points toward the most probable changes in cultural value. The first point to be noted is the decrease in the price index for communication equipment and telecommunication services. The underlying causes are well known. Visual as well as aural representation

[10] When the production of Magna paint was discontinued in the 1990s, the painter Roy Lichtenstein bought up all the supplies: "I could paint in something else but I'd have to learn to paint all over again." Crook and Learner (2000: 27).

[11] Helen Frankenthaler, quoted in Crook and Learner (2000: 29).

is increasingly processed in digital media, using electronic operations. Most of the cost goes into research, development, and market penetration. The mere reproduction of system components is cheap.

In addition to its cheapness, the new, affordable communication equipment empowers the artist to carry out many processes of image manipulation and reproduction that used to require expert artisanal or industrial assistance. What will be the probable impact on artistic practice? One piece of evidence is from a survey among Australian artists that indicates that 79 percent of all visual artists use a computer and 72 percent use the Internet in their artistic practice.[12] More generally, we can observe the emergence of new fields of visual art based on digital technology.

One of these new fields is the field of digital and digitally altered photographs. Large material formats endow the photographic prints of artists like Jeff Wall, Andreas Gursky, or Candida Höfer with the physical exclusivity of original paintings. Video artists of the 1980s and 1990s had to rely on the use of conventional television monitors, often sponsored by a hardware manufacturer. Recording techniques were analog; editing used conventional cutting and splicing techniques. Digital technology has opened access to visual resources through the Internet and to the software needed to manipulate these images.[13] Furthermore, flat liquid crystal display screens have become available at prices that make it possible to employ them as standard inputs in the work process of video artists. Bill Viola, one of the pioneers in the field, explains their use in his project "The Passions" (2002): "I always wanted bigger images. One day on the computer I realized I was immersed, the way you are with a book, where you fall into the world of the book. Experimenting with a tiny screen and using it at a reading distance, I found I could achieve a loss of the sense of self I can make a life-size image with a smooth, creamy texture like oil paint. And it's not a box!"[14] (Figure 4.3).

The reference to oil paint makes it clear that we are observing another step in the substitution of painting media. Again, the substitution is driven by changes in relative prices. This time the change did not begin at the margin of the field, among amateurs and newcomers. It was initiated by an established artist. He could have opted for a more expensive conventional medium – a choice that would serve as an entry barrier to other artists. Instead, he opted for a medium that is within the budgetary reach of every art school and

[12] Throsby and Hollister (2003: 55).
[13] Internet art has also sprung up as a new field; see Greene (2004).
[14] Walsh (2002: 203).

most individual artists. To be sure, Viola's use of flat screen devices is as yet only a variation within the artistic scene; it is not an established practice. But it has a good chance of being selected – in technically improved form – as conventional practice for a new digital artistic style, with new cultural meanings.

The link between input prices and artistic form is not limited to the visual arts, a genre that is notorious for its individualized, undercapitalized mode of production. On the contrary, more industrial modes of production tend to exert even more pressure on themes and modes of treatment in other art forms, as we shall see further later.

4.3 Cheap Light

The invention of the first film cameras and projectors occurred in a period when patent protection provided a major motivation for industrial research. Thus the first decades of the film industry were shaped by patent protection. In France, Charles Pathé held the rights necessary to monopolize film camera production and use. In the United States, Thomas A. Edison controlled the field. In 1895, Armat and Jenkins patented a film projector that permitted screenings for a larger audience. A year later, Edison bought the patent and thus had exclusive rights to film production as well as performance.

Competition in the film production and distribution market became even more constrained when Edison formed the Motion Pictures Patents Company in 1908. The producers of the Patents Company kept their studios close to the large markets, particularly New York and Chicago. Films were produced in reels with an average of 20 minutes' running time, put out on a weekly basis. They were consumed by a large urban audience that soon developed the habit of attending "motion-pictures" daily. But the time available for shooting new film was severely limited by the scarcity of sufficient light. Studios were equipped with glass ceilings because electrical light was not strong enough to substitute for natural light.

Around 1908, some studios began to experiment with sunnier locations. For a few years, Florida became the winter location for a number of studios. The same search sent production companies to Southern California, and within a few years nearly all the major companies went there for the winter season, "although the majority of them still did not have the intention of staying on indefinitely."[15] However, a rapidly increasing number of companies decided to move permanently: By 1911, ten motion-picture companies

[15] Bowser (1990: 159).

and three independent producers were operating in and around Los Angeles, and by 1915 the Los Angeles Chamber of Commerce claimed that 80 percent of the country's motion pictures were produced in the area.[16] Southern California offered (1) a stable climate with (2) a steady supply of natural light unspoiled by moisture, (3) a wide variety of landscape settings, and (4) low wages. In addition, the distance from the East provided some degree of shelter for independent companies that violated the patents of the trust. But the major reasons were the first two: the dependable availability of almost continuous, high-quality sunlight.

The migration to Hollywood influenced filmmaking in several ways. It increased the number of outdoor shootings; given the new conditions, cameras were positioned more freely, actors and animals moved deeper into space, and camera movements were split into more and shorter shots in order to catch the shifting action. In addition, the difficulty of communication with home-office company executives encouraged the directors to experiment with new ideas. "By the time the negatives were shipped back by train to the office, it was too late."[17] Furthermore, along with the short shots, extremely long shots came into fashion. Spectacle, readily provided by the California landscape, became a significant quality in establishing longer feature films. The genre that flowered best under the new conditions was the genre of "Wild West drama," which had been invented in the East Coast days of the industry. But now landscape spectacles, chases, and battles could be introduced as part of the visual repertoire. Moreover it was possible to find experienced horsemen at reasonable daily wage rates, lending authenticity to action and setting. The producers usually "took the elements of stock melodrama and comedy and transplanted them to a western setting."[18] Thus "noble and self-sacrificing behavior" was transported into a setting of "fast action, rugged landscape, and swift riding."[19]

In this medium, issues of identity for a rapidly growing nation could be explored. The Western movie that developed over the next few decades became one of the prominent artistic forms of the Hollywood film industry. In the major works of directors like John Ford, Howard Hawks, and John Houston, the Western generated a new mythical history complete with heroes and villains, with conquests and defeats both individual and collective. In the 1950s, the genre was even revitalized when a new generation

[16] Bowser (1990: 162).
[17] Ibid.
[18] Bowser (1990: 170).
[19] Bowser (1990: 171).

of directors succeeded in citing and reprocessing Western themes with an appeal to international audiences.[20]

We turn finally to the third case, which moves away from visual artistic forms and explores links between price changes and musical forms.

4.4 Cheap Steel Guitars and Digital Equipment

Two new technologies of reproduction and distribution mark the beginnings of the music industry around 1900: first the phonograph, which reproduced sound vibrations recorded and pressed onto a storage medium, and second the radio receiver, which reproduced sound waves transmitted via electromagnetic fields. During the early decades of the twentieth century, the diffusion of the second technology was by far the greater. Radio programs were recorded live, with large orchestras and extended playing times, and they were distributed to a middle-income audience that could afford the cost of radio receivers. In fact, the manufacturers of the receivers sponsored the programs in order to boost their sales. Phonograph recordings were greatly limited in length and durability, but accessible to a dispersed audience beyond the reach of radio broadcasts. The revenues of the recording industry dwindled severely in the 1930s but began to grow in the 1950s with the introduction of vinyl records. At the same time, cheap radio receivers became available. Radio stations switched their broadcasts from live performances to recorded music, providing potential buyers with demonstration versions of newly issued music, and thus boosting the sales of records.

The shift in the relevance of the reproduction medium from radio to record was accompanied by a change in the instruments chosen by young experimental musicians. Traditional orchestras mainly featured string instruments and pianos.[21] Jazz ensembles featured wind instruments, like clarinet, trumpet, and saxophone. Guitars added a new dimension. Their playing tradition derived from banjos played in black folk music and guitars played in white Western music, with the guitar less costly than the banjo to produce. In a large musical ensemble, guitars were not loud enough; however, electric amplification ended the restriction to low volume, and it ended the dependence on handcrafted wood bodies. Industrially manufactured steel frames plus amplifying equipment made an instrument available that was cheap, was easy to play without instruction, and produced a sound as

[20] See Tompkins (1993).

[21] Pianos or keyboards in general had been a low-cost substitute for larger orchestras since the eighteenth century; see Negus (1992: 30).

loud as desired.[22] The effect was the ubiquitous formation of small bands, usually consisting of lead guitar, bass guitar, voice, and drums. This lineup became paradigmatic for the emerging genre of rock music.

Three decades later, the music industry experienced yet another change in input prices: The technology of digitization made a new recording medium possible, the compact disk. The initial effect was a dramatic increase in revenues of recording companies as an entire market migrated to the new carrier medium. But as the technology progressed, digitization led to further effects. Producers exploited the cost advantages of digitally available and modifiable sounds to the point where live performance inputs became dispensable. Today, industrial pop music is engineered with an arsenal of electronic sound samples and programs that transform them into new patterns. By the 1990s, prices had declined to a level that made digital equipment affordable for individual musicians and small studios. Today, music tracks can be composed and performed without musicians able to play any instrument. The price decline benefited consumers as well. They have gained access to equipment that provides them with high-quality, virtually costless copies from any source material.

The probable outcome of these changes is musical recordings with a new combination of "digital" and "analog" sounds and consumption patterns that move from combined tracks (albums) to personal compilations of single tracks. Since changes in artistic valuation progress slowly, the effects will be first noted on the periphery of the market, in the niches of the experimental music scene.

4.5 Conclusions

In this chapter, cases from the fields of painting, film production, and music recording were discussed. The results confirm the hypothesis that price and quality changes for input commodities of artists are a relevant trigger for variations in style, content, and modes of expression in art fields.

In the episodes discussed, economic valuations remained quite distinct from the aesthetic valuations in the artistic circles of Paris, New York, or Hollywood. The issue did not concern high prices for outputs, which might have induced artists to change their work as a result of such external objectives. In all cases, the internal values remained intact: Excellence was sought in expressing color values of atmosphere, or in reducing theatrical

[22] The first products, such as the Rickenbacker, were available as early as 1935. But the breakthrough occurred in the early 1950s with the Fender Telecaster and the Gibson.

movement to a digital panel, or in making the music as loud as possible. The issue concerned low prices for new inputs. The new alternatives were selected on an experimental basis. The experiments were successful once the new input could be connected with an internal, aesthetic meaning, like the airiness of cobalt blue, or the roughness of acrylic on raw canvas, or the endlessness of Western landscapes.

Such successful aesthetic changes are not causal in a strict sense. A change of price ratios due to the appearance of new input products changes the probabilities for new work that irritates and fascinates the valuation system employed by artists, art critics, dealers, publishers, music producers, film directors, and all those who make up their audience and pay for their products.

Economic and aesthetic valuations are distinct processes. Their very distinctiveness demands their interdependence. Artistic activities depend on economic transactions; changes in input prices are just one dimension of that dependence. Conversely, economic activities depend on artworks and artistic activity in their environment. The new meanings discovered have many applications in markets, either as attributes of the agents or as content of products. The scope of the impact of artistic productivity on the development of today's information-centered economies is yet to be explored.[23]

References

Baxandall, Michael. 1972. *Painting and Experience in Fifteenth Century Italy: A Primer in the Social History of Pictorial Style*. Oxford: Oxford University Press.
Bomford, David, Jo Kirby, John Leighton, and Roy Ashok. 1990. *Art in the Making: Impressionism*. New Haven, CT: Yale University Press.
Bowser, Eileen. 1990. *The Transformation of Cinema 1907–1915*. New York: Scribners.
Crook, Jo, and Tom Learner. 2000. *The Impact of Modern Paints*. London: Tate Gallery Publishing.
Greene, Rachel. 2004. *Internet Art*. London: Thames and Hudson.
Grosser, Maurice. 1951. *The Painter's Eye*. New York: Reinhart.
Guilbaut, Serge. 1983. *How New York Stole the Idea of Modern Art*. Chicago: University of Chicago Press.
Hutter, Michael. 1992. Art Productivity in the Information Age. In Ruth Towse and Abdul Khakee, eds., *Cultural Economics*, 115–124. Heidelberg: Springer.
Hutter, Michael. 2001. Structural Coupling between Social Systems: Art and the Economy as Mutual Sources of Growth. *Soziale Systeme* 7(2): 290–313.
Negus, Keith. 1992. *Producing Pop: Culture and Conflict in the Popular Music Industry*. London: Edward Arnold.

[23] Apart from some of the chapters in this book, see Hutter (1992) and Hutter (2001).

Negus, Keith, and Michael Pickering. 2004. *Creativity, Communication and Cultural Value*. London: Sage.

Throsby, David, and Virginia Hollister. 2003. *Don't Give Up Your Day Job: An Economic Study of Professional Artists in Australia*. Sydney: Australia Council.

Tompkins, Jane. 1993. *West of Everything: The Inner Life of Westerns*. New York: Oxford University Press.

Walsh, John, ed. 2002. *Bill Viola: The Passions*. Los Angeles: Getty.

PART TWO

THE CREATION OF VALUE
IN ARTISTIC WORK

FIVE

The Creation of Value by Artists

The Case of Hector Berlioz and the *Symphonie Fantastique*

David Throsby

5.1 Introduction

Consider an artwork such as a painting, a novel, a symphony, a musical performance, a play, or some other work created by an artist. Much of the contemporary debate about the value of such a work focuses on the comprehension of value by the consumer (viewer, reader, listener, etc.). That is, value is brought into being by the interaction of the individual consumer and the work. In making their evaluations and reacting to their experience of consumption, people may be influenced by many factors, including the social, political, and cultural context within which the work is received; the historical tradition from which it derives; and the known or imagined assessments of others. But the essential feature is that value is a social construct deriving from individuals' reactions to the work of art. This interpretation of value underlies most of the economic modeling of the valuation of cultural goods, as evidenced in studies of demand for the arts, price formation in art markets, and the economic valuation of cultural heritage.[1]

An alternative interpretation of the origins of value with a long provenance in the history of art is that value is somehow intrinsic to the work itself. In other words, it exists whether or not it is perceived by anyone. Under this tradition, art obeys certain fundamental principles, which are absolute rather than relative and define a pure purpose for art expressed in terms of concepts such as beauty, truth, mystery, and spirituality (Etlin 1996).

Either way, there is a question as to how the value originated. Artworks are created by artists with a purpose, often referred to vaguely as pursuit of an "artistic vision," so presumably the motivation of the artist does play some

[1] For a collection of relevant literature on these matters, see Towse (1997), Parts III, V, VII.

role in generating value. If so, how important are the artist's intentions in influencing how value is perceived? Such a question takes us to the core issue of creativity and the conditions under which art is produced. In this chapter I discuss these matters in an economic context, putting forward a model of artistic production based on the motives of the artist and suggesting an interpretation of the transactional processes by which a value is arrived at for the works produced. I apply these theoretical ideas to a practical case study – the music of the great French romantic composer Hector Berlioz (1803–1869) and the value attributable to one of his major works, the *Symphonie Fantastique* (1830).

5.2 The Production of Art

I make a distinction at the outset between two types of value that might be generated by or embodied in a work of art.[2] The first is the work's *economic value* as measured by certain economic indicators or by various processes of economic assessment. The simplest such assessment is a market test – what is the work's price when it is bought or sold. But there may be other elements to the work's economic value arising outside the market and measured, for example, as the summation of individual willingness to pay for whatever public-good properties the work might possess. However these various economic valuations are derived, they can be added together using a common unit of account – money – to give a composite economic value for the work.

In an individualistic model of the world, where society is no more or less than the aggregation of the individuals constituting it, economic value as defined here could be thought of, in principle at least, as providing a complete account of a work's value. Such a proposition is based on the assumption that individual utility is all that matters, and that all elements of value recognized by the individual can be expressed in monetary terms as willingness to pay for market-related or for nonmarket benefits. However, I draw attention to a second interpretation of value, *cultural value*, which reflects assessments of the significance or worth of the work judged against aesthetic and other artistic or cultural criteria that may transcend individual valuation and/or may not be expressible in financial terms. I argue that although individual judgments based on such criteria may influence market or nonmarket prices for artworks, these judgments cannot be fully reflected in financial assessments and indeed may lie beyond the scope of measurement altogether. Unlike for economic value, no common unit of

[2] See further in Chapter 1.

account exists for cultural value, although some progress can be made by deconstructing it into its component parts, at least some of which might be capable of quantitative or qualitative evaluation.[3]

These two concepts of value can be used in the construction of a model of artistic production as follows. Given what we know about artists and how they regard their chosen profession, we could interpret "pursuit of an artistic vision" as a process of producing works of cultural value in the terms defined earlier. Indeed, a rational decision-making version of what they do could be framed in terms of maximizing the output of cultural value from their labors. Such a model could in fact provide a *complete* explanation of the behavior of artists if they were completely oblivious to money or were fortunate enough to be able to produce their art free of the mundane demands of daily life, that is, if they had independent financial means and did not have to worry about where the next meal was coming from. However, in most cases artists do have some concern for money and do have to earn at least sufficient income to pay for food, clothing, and shelter. Hence, if the model is to provide a complete picture of their behavior, it has to be extended to account for the financial consequences of their actions.

This can be accomplished in two ways. First, it can be acknowledged that artists can have multiple sources of revenue, including income from their creative practice (from sale of works produced, as in the case of visual artists, writers, composers, etc., or from sale of their labor, as in the case of performers); income from other arts work such as teaching within their art form; income from working outside the arts altogether; and income from other sources such as grants, investments, and support from patrons, partners, spouses, and others. These various sources of income can be explicitly incorporated into the model. Second, it can be specified that, whatever happens, some minimum amount of revenue must be forthcoming in a given week, month, or year in order for the artist to stay alive; if so, this is likely to impose a constraint on the extent to which an "artistic vision" can be pursued without regard for the financial consequences.

The model of artistic production can now be specified more precisely as one in which the individual artist has to decide how much working time to allocate to his or her pure creative practice and how much to other work, subject to the overall constraint that a minimum amount of income, whatever its source, must be derived over a given period. In the model, creative artistic work can yield both economic and cultural value defined

[3] See further in Throsby (2001), Ch. 2; for a discussion of the limitations of economic assessments of the value of cultural goods, see Throsby (2003).

as earlier, whereas other work yields only economic value. The motive of the artist in the model can be interpreted as the maximization of a joint function of the production of economic and cultural value.

Different artists are likely to attach different weights to the economic and cultural value components of their overall objective functions. Those in whom the artistic drive is paramount and who are willing to survive on the barest minimum of worldly goods could be interpreted as attaching stronger weight to cultural than to economic value as a motive for production. The opposite will apply to artists interested solely or mainly in the income-producing possibilities of an artistic career. The majority of artists are likely to lie somewhere in between.[4] To summarize so far, I have argued that the value of an artwork, however it is ultimately received, is initially brought into being by the conscious productive decisions of creative artists.[5] These decisions may in some circumstances be "pure" in the sense of being driven solely by artistic motives (in our terminology, focused solely on the creation of cultural value). However, in many cases these production decisions are influenced by economic considerations (in our terminology, the creation of economic value), and thus the ultimate value of the work will be affected. In the following section of this chapter, I look at how the specifically cultural value of an artwork might be determined once the work has left the artist's studio and has been placed at the disposal of the public.

5.3 Determining Cultural Value in the Marketplace for Ideas

Artworks exist both in embodied form (i.e., the physical substance of a painting, a novel, etc.) and in disembodied form (i.e., in the form of an idea – I use the singular for simplicity, though of course most artworks convey multiple ideas). The physical work can be traded on a market and will fetch a price that may represent a reasonable approximation to the work's economic value, at least in direct use-value terms at that point in time. At the same moment, the idea conveyed by the work is released into what we could call the marketplace for ideas. In this market many ideas are circulating. They are consumed, exchanged, considered, and discussed by interested persons, and in these processes consumers determine their individual valuations of the cultural worth of any given idea. Their evaluations might be singular or might relate to multiple aspects of the idea's worth. Since the idea is a pure

[4] For a formal elaboration of this model see Throsby (2001: Ch. 6), and for a variant of it, see Bryant and Throsby (2006).

[5] A model of the artistic production process that includes creative talent as one of the inputs is put forward and estimated empirically in Throsby (2006).

public good, the aggregation of individual valuations could be thought of as comprising the total cultural valuation of the idea within its sphere of circulation.

In other words, I am suggesting that artists supply a dual market, a market for physical works and a market for ideas. The former determines the work's economic value and the latter its cultural value. The two markets are closely related and influence each other in many subtle and not-so-subtle ways. The economic and cultural prices determined in the two markets for a given work are specific to a point in time and may change over time as further assessment of the economic and cultural worth of the artwork occurs.[6]

Does the intention of the artist influence the outcome of these transactional processes? First, in the *goods market*, artists who place greater weight on the generation of economic value will presumably orient their work toward commercially more promising lines of development. Thus the intentionality of the artist could be a strong influence on the economic value created. Of course it may also happen that such artists, motivated by economic incentives, may also turn out work of significant and lasting cultural value (Cowen 1998). By the same token, artists striving solely to make a cultural statement without any thought for possible financial reward may be surprised if their work fetches high prices. Whatever the circumstances, the intentions of the artist are likely, in one way or another, to have some effect on the work's performance in the physical goods market.

Second, in the *marketplace for ideas*, there has been a long history of fascination with the intentionality of the artist as an important element in the interpretation of works of art. To some, including some artists, such fascination is irrelevant; artworks once created have a life of their own, and the manifold ways in which they can be received are simply a testament to the power of art to mean different things to different people. Other critics, however, seek to uncover what the artist really meant in making a particular work or in pursuing a particular line of artistic development. Thus, drafts of novels, sketches for paintings, original manuscripts of musical scores, and so on, are scrutinized minutely, and the autobiographical writings of the artists concerned are analyzed, in order to uncover their intentions in creating their work. Over time, discussions of the intentionality of artists have had a profound effect on critical debate about the cultural and artistic value of their creations.[7]

[6] This dual market hypothesis is discussed in more detail in Throsby (2000, 2001).
[7] For an extensive discussion of the role of intentionality as a factor affecting critical evaluation of the work of a range of visual artists from nineteenth-century American landscape painters to twentieth-century superstars such as Sol Le Witt, Jackson Pollock, Francis Bacon, and Joseph Beuys, see Kuspit (1984).

In the present day, the linking of artists' intentionality with the critical and commercial reception of their work is rather more obvious and immediate than it has been in the past. Critical debate in the contemporary arts frequently includes consideration of the circumstances in which artworks are produced, and aesthetic discussions relating to particular works do refer explicitly to the artist's intentions. To take just one example, the recent rise in the number of literary festivals held around the world has seen the emergence of writers as celebrities, with authors encouraged to feed debate about their work by discussing their creative life and by giving an inside account of what their novel or poetry is really about. In so doing, artists make their intentions clear, presumably with the hope that doing so will influence both the critical reception and the economic prospects of their writings.

One particular aspect of the relationship between artistic intention and value on which I wish to focus is the matter of innovation. In the economics of the firm, creativity is supposed to lead to innovative ideas, which lead in turn to new products. The motive for innovation in these circumstances is the generation of profit and competitive advantage for the firm. In the arts, creativity may also lead to innovation that may on occasion be significant enough to extend the boundaries or change the direction of development of an art form. Such groundbreaking innovation is brought about sometimes by a single artwork, sometimes by the body of work of an individual, sometimes by a group of artists with common interests or objectives. Whichever way it happens, valuation of the significance of an innovation can hardly avoid being influenced by the intentions of the artist or artists involved. For some artists, such innovation is an explicit goal, not for economic reasons (because truly innovative work in the arts is rarely profitable for the artist), but for artistic or cultural reasons. Other artists may not be self-consciously or intentionally innovative, and yet may create work that profoundly influences the development of their art form. Either way it would seem appropriate that in judging the cultural value of their work as innovation, we should regard their motives as important.

To put this discussion into the context of the model sketched out above, it can be suggested that in the marketplace for ideas, innovation is the speculative stock. In other words, people in the market who are exchanging valuations of a given idea are likely to regard innovation as a risky prospect; it may repay its investors handsomely in cultural terms, or it may leave them penniless. At the time the innovation happens, knowledge of the artist's intentions may enlighten such investors, or it may mislead them. It is only in the longer term, as the cultural price is negotiated, that the value of a particular innovation can be seen more clearly. At this point, an understanding

of the intentions of the artist may indeed make an important contribution to the formation of that value.

5.4 A Case-Study

The work of the composer Hector Berlioz provides a particularly apt case-study for illustrating the preceding theoretical discussions. Berlioz was above all an innovator. He reacted against the musical conventions of his time and forged new directions in the development of symphonic music. Indeed the "newness" of his music is an enduring characteristic that strikes the listener even today and even after many hearings (Johnson 2002: 109). His works not only stand as testament to a highly individualistic musical persona, but also have had a wide-ranging influence on musical thought. To put it in the terms discussed earlier, his works, both musical and literary, have always generated much discussion and controversy in the marketplace for ideas.

Moreover, he is an ideal subject for an inquiry into artistic intention-ality, because he left behind memoirs, letters, and many critical writings that provide a rich insight into the workings of a unique artistic mind.[8] Of course interpretation of the written record has to be approached with some caution. If, as Kurt Heinzelman points out in Chapter 7, artists see the archive of their works, including their writings about themselves, as contributing to their reputation, assessment of the autobiographical record of artists must proceed with care (Kris and Kurz 1979).[9] In Berlioz's case, his *Memoirs*[10] – part factual, part autobiographical, part critical opinion – cannot be taken unquestioningly as a historical document. Many commentators have drawn attention to exaggerations, contradictions, and inaccuracies in Berlioz's account of various aspects and stages of his life. For example, Pierre Citron (2000: 137) points out that the composer sometimes "carefully embroiders the facts, minimizes his adroit self-publicity, or otherwise gives himself the leading role." Nevertheless, Citron concludes that on the whole the *Memoirs* give us "a faithful portrait of the man and his work." Certainly for our present purposes the insight into intentionality provided by Berlioz's writings can be taken in broad terms at face value.

[8] In addition to the written accounts of Berlioz's life, there exist a number of portraits and other likenesses of the composer, usefully compiled in Braam (2003), that enable us to juxtapose the words and the music with an image of the man himself.

[9] Similarly with *biographies* of artists, where repeated retelling of stories of doubtful authenticity may endow them over time with a status as fact that they do not deserve; see Kris (1953: 65–66).

[10] See Newman (1966).

Berlioz was clear from an early age that he wanted nothing else but a career in music. As a young medical student in Paris in the early 1820s, he wrote to his father: "I am being dragged involuntarily towards a magnificent career (there is no other epithet fitting for a career in the arts)" (*Letters*, 15).[11] He was driven by a passionate commitment to music, much to the disapproval of his father, a middle-class country doctor, on whom the young Berlioz depended for his financial survival. He was obliged to supplement his meager allowance with earnings from teaching, critical writing, and employment in a number of minor positions, while he worked hard to have his music performed. In order to survive, he lowered his minimum income requirements by moving to cheaper lodgings, giving up eating in restaurants, and subsisting on a diet of bread, prunes, and raisins (Cairns 1989: 169). He was constantly in debt in these early years, and although in later life as a successful composer and performer he made a reasonable living, he was never far from financial disaster.

Nevertheless he declared that in the production of his artistic work he paid little or no heed to the economic return his work might yield and focused virtually exclusively on what we have termed its cultural value:

My passion for music . . . is always at white heat, and never satisfied for more than a moment or two. With this passion love of money has never, under any circumstances, anything to do; on the contrary, I [have] had never any difficulty in making any kind of sacrifice in pursuit of the beautiful, or in keeping clear of the miserable commonplaces which are the delight of the crowd. Offer me a fortune to compose some of the most popular works of the day and I should refuse it angrily. (*Memoirs*, 486)

Despite this declaration, there were one or two occasions when it seems the need for money did influence Berlioz's musical choices. For example, in his attempt at the Prix de Rome in 1829, he displayed the "obstinate honesty of the true artist" and composed a work that was entirely at odds with prevailing Parisian taste. As a result he did not win. The composer Boïeldieu advised him to be more sensible on his next attempt. Given that the prize involved not just status but a guaranteed income for five years that would relieve him of his financial dependence on his father, the poverty-stricken Berlioz took this advice and won the prize in 1830 (*Memoirs*, 95–96; Bloom 1981; Carson-Leach 1987: 47–48).

Nowhere is the assertion of Berlioz's creative genius through his musical composition more apparent than in his *Symphonie Fantastique*, a work to which he gave the subtitle *Épisode de la vie d'un artiste*. Berlioz saw this

[11] See Macdonald (1995).

symphony as being autobiographical, depicting the course of his "infernal passion" for the Shakespearean actress Harriet Smithson, with whom the young composer had fallen hopelessly in love. She is represented throughout the work by a recurring theme, the *idée fixe*. Berlioz wrote a detailed descriptive program for the symphony and distributed it at performances, describing it as "indispensable to the full understanding of the dramatic plan of the work."[12] The first movement depicts an artist's indefinable longing for an unknown beloved. In the second movement he sees her at a ball; then, in the country, he thinks obsessively of her as two shepherds call to each other on their flutes. He takes opium, inducing a vivid dream in which he is condemned to death for killing his loved one. He is marched to his execution. This is followed in the final movement by a wild nightmare of demons, witches, and a grotesque parody of the *Dies Irae*. The work was conceived on a vast scale and Berlioz approached its first performance in 1830 with some trepidation that the "cold-blooded Parisians" would not understand it.

In the event, the work was received with a mixture of high praise and outright contempt. The critic F. J. Fétis, writing in *Revue Musicale* on December 11, 1830, described it as "a most extraordinary composition . . . the idiom is personal and is expressed outside the normal language of music. Generally, however, the music excites astonishment rather than pleasure."[13] An anonymous critic in a review of the work in *Le Temps* on December 26, 1830, wrote: "M. Berlioz, if he carries on in the way he has begun, will one day be worthy to take his place beside Beethoven."[14] Other critics were much less favorable, labeling the work as "confused" and "incompetent." Berlioz himself drew attention subsequently to the wide range of critical reactions but observed that "only two or three writers have discussed me with intelligent self-restraint. It is not easy, even nowadays, to find critics who possess the requisite knowledge, imagination, feeling and impartiality to pass a sound judgment on my works, and to appreciate my aims and the tendencies of my mind" (*Memoirs*, 115).

In the years that followed its first performances, the *Symphonie Fantastique* was heard in many countries of Europe, with Berlioz either conducting or

[12] The full program is reproduced in the foreword to the Eulenburg Edition of the score of the *Symphonie Fantastique* (London: Ernst Eulenburg, 1977: xvi–xxiii). See also many analyses of the music itself, for example, in Holoman (1989: 99–110), Macdonald (1991: 90–92), Langford (2000: 53–57).

[13] Manuscript from the Richard Macnutt collection, Tunbridge Wells, quoted in Arts Council of Great Britain (1969: 57).

[14] See Rose (2001: 42).

present in the audience as honored guest. The work was generally received with great enthusiasm. A performance in St. Petersburg in December 1867 is typical. Berlioz wrote: "It was an enormous success; there was applause after every movement and the fourth one had to be repeated. At the end I was overwhelmed with embraces, handshakes, vivats, etc." (*Letters*, 457). Berlioz's fellow composers took the work seriously, responding to it in one way or another. On the one hand Rossini is reputed to have said, "What a good thing it isn't music."[15] On the other hand, Franz Liszt regarded the symphony so highly that he made a piano transcription of it in 1834, and Richard Wagner wrote in 1841: "No one who hears this symphony . . . can fail to think himself confronted by a marvel without precedent. The power of a colossal inner richness, a heroic imagination, erupts in a mass of passions as from the crater of a volcano. . . . Everything is monstrous, daring, but infinitely painful."[16]

After the composer's death, the symphony continued to be performed and discussed. During the first half of the twentieth century in England, the work fell out of favor – it seems that Berlioz's confrontational style was too much for the conservative tastes of the time (Elliot 1938: 136). But the occurrence of its composer's bicentenary in 2003 was marked by a renewed concentration of interest in his life and work (Bloom 2003), including a reassertion of the importance of this symphony in the musical canon.

What can we say about the intentionality of the artist in contributing to the cultural value of the *Symphonie Fantastique*? It is apparent that a number of influences were at work in its composition. First, Berlioz's intense emotional feeling deriving from his infatuation for Harriet Smithson was clearly a major driving force; this has meant that the work has always been valued as an example of a powerful personal statement made through art. Second, there is a clear narrative intention, made the more explicit by the composer's own provision of a program explaining the unfolding story.

Third, Berlioz was, as we noted earlier, a musical innovator, driven by a desire to react decisively against the musical fashions of his time, even though he knew this would affect the work's immediate reception.[17]

The principal reason for the long war waged against me lies in the antagonism existing between my musical feeling and that of the great mass of the Parisian

[15] Quoted in Holoman (1989: 109).

[16] From Wagner's collected letters, published in Leipzig in 1914 and quoted by Rose (2001: 116).

[17] Nevertheless, it is easy to infer that he thought, or at least hoped, that in the longer term the worth of the work would be recognized.

public. Many looked upon me as a madman, because I considered them children or simpletons. All music deviating from the beaten track of the manufacturers of *opéras-comiques* necessarily seemed to these people the music of madmen, just as Beethoven's Ninth Symphony and colossal pianoforte sonatas are to them the compositions of a lunatic. (*Memoirs*, 484)

But it was not only that he set himself in opposition to prevailing taste; he also searched for new forms of musical expression of innovative importance in their own right. "My great crime," he wrote in a letter to his friend Humbert Ferrand in 1827, "is that I'm trying to do something new" (*Letters*, 42). In the event, the innovative characteristics of the *Symphonie Fantastique* had a very direct effect on later composers. The invention of the "dramatic symphony" laid the foundations for programmatic developments in musical expression by composers such as Liszt and Richard Strauss. But the most influential of Berlioz's innovations, traceable directly to the *Symphonie Fantastique*, was undoubtedly the *idée fixe*, the unification of a large symphonic work by continual repetition and transformation of a recurring theme. As Langford (2000: 68) notes, "hardly a composer in the later nineteenth century, from Wagner to Mahler, could be said to be free of this basic principle of Berlioz' musical construction."

The fourth and final aspect of intentionality that can be discerned in the *Symphonie Fantastique* has to do with external influences on the composer. Works of art often reflect the social and political circumstances of their time, mediated by the attitudes and responses of the artist. The *Symphonie Fantastique*'s first performance in December 1830 followed on the heels of the July revolution of that year, which overturned the regime of Charles X. While Berlioz's symphony is by no means political in intention (as were works produced in the same year by other French artists such as Victor Hugo and Eugène Delacroix),[18] it can be seen as reflecting Berlioz's defiant championing of artistic freedom, a matter that was a significant political issue at that time.[19]

Although this discussion has concentrated on the matter of intentionality as revealed in a single work, the foregoing observations can be extended to the evaluation of Berlioz's music in general. Perceptions of his character and personality as they shaped his musical expression have influenced both popular and critical reaction to his work. Even so, assessments of Berlioz's contribution to musical history illustrate the fact that evaluations of cultural

[18] Hugo's play *Hernani* and Delacroix's painting *La Liberté guidant le peuple*.

[19] For a detailed account, see Bloom (1989). See also Crabbe (1980: 42–47) and Murphy (1988: 27–28).

worth are likely to change over time in the constantly dynamic marketplace for ideas. Berlioz's reputation has always been "volatile and precarious" (Bloom 1998: 191), and this volatility is likely to continue in the future, including in France.[20]

But to return finally to an assessment of the *Symphonie Fantastique* itself two centuries after the birth of its composer, we can note the judgment of two of Berlioz's biographers. First, David Cairns writes:

The Fantastic Symphony survives not because it tells the story of a fatal and at times lurid obsession with a particular woman but because it expresses, in a musically coherent form and with a beauty and vividness of imagery and an originality of sonic invention that remains fresh and vital, the agonies and ardours, the dreams and nightmares, of the young imagination. Its power, and its eternal youthfulness, come both from its mastery of large-scale musical narrative and from the undimmed intensity of recollected emotion that the composer poured into it. (Cairns 1989: 337)

Second, in the foreword to a recent edition of the score, Hugh Macdonald notes that

it was not simply in a spirit of progressive experiment that Berlioz devised these still strikingly modern sonorities, it was the natural result of expressing feelings and experiences and the activity of an intensely fervid imagination not in words but in music. . . . In the nineteenth century it was generally assumed that all music had meaning; some composers were at pains to inform their audiences what that meaning was, as Berlioz was with the programme of the *Symphonie Fantastique*; others remained silent. The key was in Berlioz' favourite word "expression," and if we wish to establish how far this music "succeeds," it is in its capacity to express what was in his mind that an answer must be sought. (Macdonald 1977: vi)

These assessments sum up the ways in which, in respect to this one work, the intention of the artist in creating a work of art can shape the evaluation of the work's artistic and cultural worth.

5.5 Conclusion

In this chapter I have examined the role of artistic production processes in conditioning the reception of artworks and hence in affecting the way value of whatever sort is assigned to those works. I have been concerned to recognize the economic context within which creative output is produced, indicating the ways in which economic motives and constraints mediate

[20] France is the country in which Berlioz most wished to be received and understood; see Cairns (1999: 774–779).

artistic production. In particular, I have drawn attention to the drive toward innovation in the arts, contrasting it with the impetus to innovation in economics. This has led to the question: How important is an understanding of the intentions of the artist (or group of artists) in assessing the cultural value of particular works or the significance of major shifts in valuation within artforms over time? I have suggested purely artistic motives as the stimulus toward innovation in the arts, but it would be interesting to investigate whether cases exist in which purely economic motives have led to genuine artistic innovation (as distinct from simply great works of art).

It remains to be acknowledged that the empirical application of these ideas to a single case-study hardly constitutes a thorough test of them, although the Berlioz example does serve to illustrate a number of the propositions discussed, particularly the matter of innovation, where Berlioz's clearly expressed objectives have had an important influence on the way his music has been judged over time. More fundamentally, however, further progress would seem to require a much clearer articulation of what constitutes cultural value when incorporated in a model such as that presented in this chapter.

References

Arts Council of Great Britain. 1969. *Berlioz and the Romantic Imagination*. London: The Arts Council.

Bloom, Peter. 1981. Berlioz and the *Prix de Rome* of 1830. *American Musicological Society Journal* 34(2): 279–304.

Bloom, Peter. 1989. Berlioz in the Year of the *Symphonie Fantastique*. *Journal of Musicological Research* 9(2/3): 67–88.

Bloom, Peter. 1998. *The Life of Berlioz*. Cambridge: Cambridge University Press.

Bloom, Peter, ed. 2000. *The Cambridge Companion to Berlioz*. Cambridge: Cambridge University Press.

Bloom, Peter, ed. 2003. *Berlioz, Past, Present and Future: Bicentenary Essays*. Rochester, NY: University of Rochester Press.

Braam, Gunther. 2003. *The Portraits of Hector Berlioz*. Kassel: Bärenreiter.

Bryant, William D. A., and David Throsby. 2006. Creativity and the Behavior of Artists. In V. Ginsburgh and D. Throsby, eds., *Handbook of the Economics of Art and Culture*, 507–529. Amsterdam: Elsevier North-Holland.

Cairns, David. 1989. *Berlioz*. Vol. 1: *The Making of an Artist, 1803–1832*. London: Cardinal.

Cairns, David. 1999. *Berlioz*. Vol. 2: *Servitude and Greatness*. London: Allen Lane, The Penguin Press.

Carson-Leach, Robert. 1987. *Berlioz*. London: Omnibus Press.

Citron, Pierre. 2000. The *Mémoires*. In Bloom, ed. 2000, 127–145.

Cowen, Tyler. 1998. *In Praise of Commercial Culture*. Cambridge, MA: Harvard University Press.

Crabbe, John. 1980. *Hector Berlioz: Rational Romantic*. London: Kahn and Averill.

Elliott, J. H. 1938. *Berlioz*. London: J. M. Dent

Etlin, Richard A. 1996. *In Defense of Humanism: Value in the Arts and Letters*. Cambridge: Cambridge University Press.

Holoman, D. Kern. 1989. *Berlioz*. Cambridge, MA: Harvard University Press.

Johnson, Julian. 2002. *Who Needs Classical Music? Cultural Choice and Musical Value*. Oxford: Oxford University Press.

Kris, Ernst. 1953. *Psychoanalytical Explorations in Art*. London: George Allen and Unwin.

Kris, Ernst, and Otto Kurz. 1979. *Legend, Myth, and Magic in the Image of the Artist: A Historical Experiment*. New Haven, CT: Yale University Press.

Kuspit, Donald. 1984. *The Critic Is Artist: The Intentionality of Art*. Ann Arbor, MI: UMI Research Press.

Langford. Jeffrey. 2000. The Symphonies. In Bloom, ed. 2000, 53–68.

Macdonald, Hugh. 1977. Foreword to Eulenburg edition of the score of Hector Berlioz, *Symphonie Fantastique*. London: Ernst Eulenburg.

Macdonald, Hugh. 1991. *The Master Musician: Berlioz*. London: J. M. Dent.

Macdonald, Hugh. 1995. *Selected Letters of Berlioz*. London: Faber and Faber.

Murphy, Kerry. 1988. *Hector Berlioz and the Development of French Music Criticism*. Ann Arbor, MI: UMI Research Press.

Newman, Ernest. 1966. *Memoirs of Hector Berlioz from 1803 to 1865*. New York: Dover.

Rose, Michael. 2001. *Berlioz Remembered*. London: Faber and Faber.

Throsby, David. 2000. Economic and Cultural Value in the Work of Creative Artists. In Erica Avrami et al., eds., *Values and Heritage Conservation*, 26–31. Los Angeles: Getty Conservation Institute.

Throsby, David. 2001. *Economics and Culture*. Cambridge: Cambridge University Press.

Throsby, David. 2003. Determining the Value of Cultural Goods: How Much (or How Little) Does Contingent Valuation Tell Us? *Journal of Cultural Economics* 27:275–285.

Throsby, David. 2006. An Artistic Production Function: Theory and an Application to Australian Visual Artists. *Journal of Cultural Economics* 30(1): 1–14.

Towse, Ruth, ed. 1997. *Cultural Economics: The Arts, the Heritage and the Media Industries*, 2 vols. Cheltenham: Edward Elgar.

SIX

Art, Honor, and Excellence in Early Modern Europe

Elizabeth Honig

In all my doings, spendings, sales, and other dealings in the Netherlands, in all my affairs high and low, I have suffered loss, and Lady Margaret in particular gave me nothing for what I gave her and did for her.
 – Albrecht Dürer, Journal, May 1521[1]

For one evaluates pictures differently from tapestries. The latter are purchased by measure, while the former are valued according to their excellence, their subject, and number of figures.
 – Peter Paul Rubens, letter to Sir Dudley Carleton, June 1, 1618[2]

6.1 Introduction

By 1521, when being feted by admiring colleagues on his journey through the Netherlands, Albrecht Dürer had good cause to think of himself as a bit of a superstar in the European art world. A century later, when Peter Paul Rubens was bargaining with a potential client in England over what would be an immensely lucrative deal for him, he had even better reason to be secure in his status as one of Europe's greatest cultural figures. The hundred years that separate these famed artists and their business transactions is a century during which, by most accounts, paintings and prints – the art forms produced by these two – were consolidated in the status of being products for a market. Although an urban art market in which pictures were treated as ordinary commodities can certainly be found earlier than this, it is really in the course of the sixteenth century that the market grows to such proportions that it affects the very status of art itself. No longer produced on commission

[1] See Fry (1995: 95).
[2] See Magurn (1955: 67).

by a craftsman for a patron, or by privileged makers allied with a court, the work of art is by Dürer's time becoming an object whose worth is primarily determined in market terms, and has by Rubens's time become a commodity whose market value can be described and assessed by a definite calculus. Or so Rubens seems to think.

The triumph of the market as the locus of value-creation for works of art is usually presented in historians' accounts as having been broadly beneficial to the producers of those works. More artists could make better livings in fashioning a greater diversity of products; Art with a capital *A* is also a beneficiary in the competition for market niches and the expansion of the consumer base. Accounts of the booming artistic economy in Renaissance Italy or slightly later in the Low Countries are on the whole optimistic tales with many winners and attractive illustrations.[3] I have written such an account myself and so it was with that narrative in mind that I approached the task of surveying the art literature of the early modern period, hoping to trace the terminology of valuation during this period of the commodification of painting. But contemporary art writing, as often happens, does not neatly follow the narrative we have created for the history of art. When I looked for terms not just of general praise but of how excellence could be translated into monetary terms, I did not encounter a discourse related to the developing market; or perhaps the relationship that did exist was indirect to the point of being inverse. Discussions of value occurred only in certain circumstances and seemed on the whole to be deliberately unconnected to the art market.

This chapter explores what I see as an antimarket discourse of valuation during the sixteenth and seventeenth centuries. I will argue that as the market became the dominant means of assigning value to works of art, writers were less concerned to describe and articulate that reality and more concerned to shore up an alternative mode of value-making, which they perceived (correctly) as being threatened by the market. The people who felt this most keenly were precisely those most likely to articulate in writing their own ideas about value: artists with a more scholarly inclination or more self-consciousness about their status as artists, or artists who had cause to think of themselves as having received, or deserving to receive, a very high level of recognition and acclaim for their art. People, in fact, like Dürer and Rubens.

[3] On Italy see the already classic work by Goldthwaite (1993) and more recently Fantoni et al. (2003). On the Netherlands see Honig (1998), Vermeylen (2003), North (1999). These are only the most recent of many studies to explore the Dutch economy of artistic production, beginning even with some of the work of W. Martin in the early part of the twentieth century and continuing with the works of the economic historian John Michael Montias.

6.2 The Honor System as an Alternative Site of Value-Creation

So what was Dürer's problem in the Netherlands? The journal of his trip there is a good place to start this inquiry, for in it he recorded with great precision all of his business dealings; it is a record of expenses and income, interspersed with comments on the works of art he viewed and the people he met. The social side of the journal is inextricable from the business side, for Dürer's new acquaintances, landlords, dinner companions, and all their families are all his potential partners in trade. That trade does not simply consist in selling the generous supply of his prints that he had taken along. Dürer's personal economy is still very much one of barter and of gifts. He receives many gifts from admirers: works of art, naturalia, curiosa from exotic lands; textiles and wine and candies; a parrot. And he gives gifts, constantly, prolifically – whole books of prints, series and single leaves, woodcuts and engravings. He even makes paintings and gives them away. Transactions that we would probably call simple sales are also described in terms of the exchange of gifts: "I presented a 'St. Nicolaes' to the largest and richest guild of merchants at Antwerp, for which they have made me a present of 3 Philip's florins."[4]

But to operate in a "gift economy" is a long way from being Santa Claus; Dürer is a calculating giver. He is often well aware of the monetary value of what he gives: A statue and a bundle of prints for the Portuguese factor are worth five florins, while a painting of *Veronica* and a group of prints for Herr Bannisis are worth seven florins.[5] To Lazarus of Ravensburg he gives "a portrait head on a panel which cost 6 stivers, and besides that I have given him eight sheets of the large copper engravings, eight of the half-sheets, an engraved *Passion*, and other engravings and woodcuts, all together worth more than 4 florins."[6] And like all gifts in such an economy, Dürer's *demand* reciprocation. The exact return need not be the equivalent of the gift's market value: "I have made a very fine and careful portrait in oils of the treasurer, Lorenz Sterk; it was worth 25 florins. I presented it to him, and in return he gave me 20 florins."[7]

The more important the recipient of Dürer's gifts, the higher the stakes of reciprocation become, and the more urgent his interest in establishing some claim to return. A key recipient of these more coercive gifts is the regent of

[4] Fry (1995: 74).
[5] Ibid.: 46, 51.
[6] Ibid.: 68.
[7] Ibid.: 83.

the Netherlands, Margaret of Austria.[8] To her, Dürer gives first a copy of his engraved *Passion* (Figure 6.1) and then a full set of all his printed works. On top of that he bestows upon her two fine drawings on parchment, probably watercolors that would have been elegant collectors' items.[9] All of this, he calculates, is worth fully 30 florins. But no return gift is forthcoming from Lady Margaret. Finally some months later, when she is showing him her own collection, Dürer gets up the nerve to ask her for a book by Jacopo de' Barbari. She replies that it has been promised to "her" painter, presumably one associated with her court.[10] Hence his complaint, cited at the beginning of this essay, about his losses in the Netherlands, with the chief of these caused by the regent herself, who gave nothing in return for all his uninvited presents to her.

Dürer has been trying to play between two systems for the valuation of artworks and by his own estimation has ended up the loser. There is the market system, one that he understands and is accustomed to – as a printmaker, especially, he already considers the market the natural site where his products receive their worth, the one by which he also privately values his wares. But there is a second system, which he expects will offer him rewards that are in some sense greater than those the market has offered. This is a system in which he is not a seller but a giver, not a recipient of any "just price" but the recipient of fine gifts. This is a system in which his artworks are not commodities but rather are reifications of social relationships. And even though somehow this system is not working for him and does not give him the return on his labor that he would anticipate from the market, he nonetheless insists upon performing within it and is frustrated by its refusal to operate as he wishes.

This second site of value-creation, which I will call the honor system, is akin to what Martin Warnke has portrayed as the "court system," but it is broader than what he describes and endures long after artists have stopped looking to the court as their main source of patronage.[11] It comes to encompass forms of discourse that evolve in the Renaissance to validate

[8] On the coerciveness of courtly gifts see Klein (1997: 459–493).

[9] Fry (1995: 48, 54).

[10] Ibid.: 91.

[11] See Warnke (1993). Warnke argues that only at court could the value of art be liberated from the medieval craft tradition and gain some notion of "excellence" because at court the *maker* had a value independent of his labor and its products. On the whole I find this a very compelling argument and wish largely to expand its explanatory scope and consider why this system endured into the period of art as commodity. On the growth of a Renaissance notion of "genius" see Soussloff (1997).

the status of the artist, but it also incorporates complex modes of social behavior that are in themselves means of negotiating status. The objects that circulate in this system cannot and indeed must not be translatable into a purely monetary value, for they are signifiers of power, honor, and obligation to those who exchange them. They are exchanged by all members of the society, but the person who *makes* valued objects may claim thereby a special place as the creator of socially crucial signs, the inventor of things that have immense social value.[12] The honor system needs to be preserved and protected as a locus of value because within its compass artists of outstanding talent and ingenuity can receive recognition of a type not easily generated by the market: personal esteem, social elevation, acknowledgment of aesthetic achievements.

In the honor system, even when money is used as a means of compensating a maker for his product, it will not register what we would term the "price" of his work. Rather the money will represent a balance between a notion of the maker's personal worth or honor as an artist and the honor of the work's recipient as a generous patron, prince, or friend. Inflecting these dual claims to personal honor in establishing the "value" of an exchanged object will be the particular nature of the relationship between the two parties, a relationship that may alter as a result of the gift exchange.[13] The artist makes his bid for honor by presenting a work that is artful and excellent and will reflect well upon the taste and glory of its recipient; the prince or client makes his or her bid for honor by demonstrating liberality in bestowing upon the artist a gift of sufficient munificence to impress the rest of the court, or simply a more extended group of friends.[14] Ideally, there will be a significant and positive difference between the gift and the object's potential market value (not part of the calculus, but now extant); the degree of that difference will depend not only upon pure liberality, but upon the relationship that has been or is being established between the two parties in the transaction. A gift exchange may initiate a patron–artist relationship but it may also enact and refine an ongoing established relationship. The exchange also has the potential to elevate the artist into a relationship with

[12] See Hyde (1999).

[13] With this I mean slightly to modify Warnke's description of courtly transactions: "The agreed price was a compromise between the artist's sense of his own worth – which depended upon his reputation – and the personal taste of the purchaser, who at the same time had to show himself a generous patron." Op. cit. 150.

[14] "Liberality" was advocated as a secular virtue for the wealthy (especially, but not only, for princes) throughout this period; for a good recent look at the value of "liberality" in Renaissance France, see Zemon Davis (2000: 17–19 and passim).

his social superior that is something approaching friendship.[15] At the very least, it establishes connections and obligations that are not the distanced, quantifiable ones of the market, but are all the more enduring and valuable for being social.

Once an artist has established a persona of honor with a wealthy patron, he can use that connection in ways that circumvent the market to his own advantage. Titian paints an *Annunciation* for the church in Murano, but when it is completed its commissioners do not want to pay the 500 crowns "which Tiziano was asking." That is to say, no price had been agreed upon in advance, but Titian deems his work to be worth this amount.[16] When that price is refused, Titian simply sends his painting to Charles V, who had nothing to do with the original commission but is a steady supporter of Titian's. Charles loves the painting and makes Titian a gift of 2,000 crowns: This is not a payment, but a princely token of appreciation for the gift Titian has given to him. The fact that this gift is four times what Titian had originally asked for the work says nothing about the painting's value and everything about the emperor and his relationship with and esteem for Titian. This transaction involved an emperor, but the ideals of the honor system can be brought into play in more straightforwardly commercial transactions too. When Michelangelo sends the *Doni Tondo* to the man who had commissioned it, he includes a bill for 70 ducats, again his estimation of the picture's worth and not a previously agreed price (Figure 6.2).[17] Doni refuses to pay such a large sum and Michelangelo is deeply offended. He lets it be known that he feels insulted by Doni's behavior. Doni backs down, Michelangelo continues to be frosty, and eventually the poor patron gives him twice the original price of the painting. Here, honor has been translated directly into money: The final price does not represent the value of the painting, but the artist's personal worth and its recognition in a social transaction.

6.3 Giving as Strategy

Perhaps Dürer loses out with Lady Margaret because he has failed to establish that preliminary social relationship (which she enjoys with another artist) that would enable him to practice the negotiations that the honor system

[15] On the way that gifts were increasingly associated with friendship in the sixteenth century, see ibid.: 19–20.

[16] This story is recounted by Giorgio Vasari (1912–1915: Vol. 9, 167–168).

[17] Ibid.: Vol. 9: 19.

necessitates. The deployment of gift giving as a means to social positioning and the acquisition of wealth was not a straightforward matter; it demanded a specific form of discourse. That is why George Puttenham covers courtly gift etiquette in his *Arte of English Poesie,* a curious book that may be described as a manual of rhetorical tropes for use by the aspirant courtier in making his way through the treacherous situations presented by court life.[18] In his section on decency and decorum, a point where the conformity of behavior to social status is addressed, Puttenham mentions the possibility that a philosopher at court (for whom we may substitute any liberal artist) may be given a massive gift by the king.[19] Is this proper? It is a problem: The king may give the gift without impoverishing himself (so it is proper) but the philosopher–artist will be excessively enriched by receiving it (which is improper). Gifts, in other words, have the potential to alter financial status radically beyond what social status allows.

But the situation is more complicated than this. For of course the artist cannot refuse a gift, since refusal would be "some empeachement of the kings abilitie or wisedome." Nor should we in fact think of the transaction in terms of the exchange of wealth, "since Princes liberalities are not measured by merite nor by other mens estimations, but by their owne appetits and according to their greatnesse." So in this ritually deeconomized transaction, immense wealth may be bestowed upon the artist, but (Puttenham adds) with one huge caveat: that he not ask for it. What will be called for will be a hint but not a supplication, a gesture of refusal (perhaps a protest of unworthiness) but eventual acceptance. Vasari, in an aside in his *Lives,* offers similar tips to painters on how to handle patrons known for their liberality (discreetly) or those who are "miserly, unthankful, and discourteous" (a bit more bluntly).[20] If the artist plays his cards right, the eventual gift will be massive in size. And it will be entirely detached from the value of anything its recipient has produced, which is why we can so easily substitute "artist" for Puttenham's philosopher: The gift-reward is not about objects, but about persons.

Dürer may have lacked the social connections or skills to work this system, but some of his contemporaries were adept at strategies of gift and obligation. Cellini, in his highly self-serving autobiography, appears to be as much a master of this art as that of goldsmithing. He does not always benefit from the system in terms of profit because his enemies connive against him, but

[18] On Puttenham see Javitch (1978), especially chapter 2.
[19] Puttenham (1968: 234), facsimile reprint.
[20] Vasari (1912–1915: Vol. 5, 71).

in terms of honor he always wins. In one dispute over payment, the duke's secretary asks Cellini how much he would ask for his statue of Perseus (Figure 6.3).[21] Cellini professes to be "dumbfounded and astonished" and replies "that it was not my custom to put prices on my work." He explains to his readers, "Now I had hoped not only to gain some handsome reward, trusting to the mighty signs of kindness shown to me by the Duke, but I had still more expected to secure the entire good graces of his Excellency, seeing that I never asked for anything, but only his favor." Cellini understands that not asking for compensation is a key strategy here. It puts the burden of gift giving squarely on the shoulders of the patron, who must demonstrate his own liberality by providing a payment worthy of his own status, not of the object's value. Over and above that, "good graces" or general favor will flow to Cellini in return for his correct etiquette.

The good grace in this case translates as an annuity that is promised to Cellini, but the duke's evil secretaries neglect to pay it. When the artist complains about this, the duke flies into a rage at his greed: Now Cellini has broken the honor code and asked for money. The duke threatens in retaliation to remove Cellini's product from the honor system and return it to something closer to the market system: He will have the statue valued and will pay what the experts (presumably other artists) think it is worth, which they will judge by comparing it to other works of art. This would be in every way a catastrophe for Cellini: Whatever the valuers say, he will have been dishonored, his work demoted to a "common" level and assessed just like any commodity. He himself will become less than the duke's favorite and intimate, will be just the equal of a group of "experts." That is why Cellini's first reaction is to protest, "How is it possible that my work should be valued at its proper worth when there is not a man in Florence capable of performing it?" – that is, he scrambles to separate himself from the other craftsmen. This is a losing gambit, however, for an individual call upon honor transparently based on egotism cannot work in a system that is inherently dialogic in its structure. So Cellini beats a hasty retreat: "Your approval is really all I desire," he now protests. By repositioning himself as one who asks for no material gain, and who wishes no judgment other than that of his patron, he provokes in the duke that desired sense of princely obligation and liberality, and the duke instantly declares, "I shall pay you more for the statue than it is worth." We sense here that the patron is still feeling edgy about value – usually, notions that the artwork is "really worth" some amount are

[21] This story can be found in Cellini (1948: 387–391).

not mooted in the honor system. Nonetheless, the duke has been cornered by Cellini's rhetoric and has to respond in a way that preserves his own honor.

A clever extension of this sort of maneuvering is carried out by the architect Giuliano da San Gallo, who is offered gifts by the king of Naples – horses, clothing, a silver goblet, and hundreds of ducats.[22] He accepts the goods but turns down the money, saying he cannot accept payment but only gifts. At this moment of honorable refusal, he is actually able to make a request for what he really wants: some antiquities from the king's collection. The king gives him several statues, which San Gallo turns around and gives to his patron Lorenzo the Magnificent back in Florence. Lorenzo "expressed vast delight at the gift, and never tired of praising the action of this most liberal of craftsmen, who had refused gold and silver for the sake of art."[23] Thus San Gallo has transformed himself from a gift receiver into a gift giver. He has established the fact that, like his principal patron, he appreciates the great art of antiquity. He has demonstrated his own "liberality" and, in so doing, has pushed himself up the social ladder and secured his bond to the Florentine duke.

Art writers, not surprisingly, tend to emphasize the reprehensible behavior of any patron whose illiberality appears to insult an artist. Honor and shame are the fundamental axes of negotiation here. A patron who knows he is giving too little for a work feels "ashamed."[24] Potential patrons agonize over the proper way to reward an artist so as not to insult him. Malvasia cites a letter of 1602 from Agucchi to Dolcini asking how he should approach Ludovico Carracci in hopes of receiving a painting from him. He begs his friend "to tell him very freely what role he should play, and whether instead of money it would be better to send Ludovico some elegant gift that would truly please him, but that if it was to be money, would Dolcini tell him how much, because it is all too easy to go completely wrong at every single step."[25] Ludovico's cousin, Annibale Carracci, who cared little for money, is nonetheless horribly shamed by the inadequate payment he receives for the Farnese gallery.[26] The pope gives Michelangelo substantial presents in apology after

[22] Vasari (1912–1915: Vol. 4, 194).
[23] Ibid.
[24] Ibid., Vol. 5: 116.
[25] Summerscale (2000: 256).
[26] Bellori (1968: 52–55); he blames this on the petty conniving of a Spaniard in Farnese's court: see later on Hollanda's disparagement of the very unliberal Spanish patrons.

every occasion when he loses his temper and insults the artist's honor.[27] Art writers without handy local examples cite instances from antiquity of dishonored artists being given generous presents to redeem the patron's (or culture's) former lack of appreciation.[28]

6.4 Worth and Value

In an honor system transaction, then, worthiness is added to *persons* through the correct operations of gift exchange. The object that is created and then exchanged does not have a "value" that can be in any way separated from its social situation. Because its meaning and worth are entirely bound to the status being formulated by its maker, it is not truly alienable and can never be considered a commodity. Therefore, according to the tales of art writers, the best patrons – those with the most money and the greatest appreciation of art – have no idea of the value of objects. Instead of knowing the *value* of things, they understand the *worth* of Art and its makers.[29] This is the ideal to which the Portuguese writer Francesco da Hollanda is appealing when he criticizes Spaniards as lacking in true understanding of art: They will sing a picture's praises "but press them further and they have not the spirit to order or pay for the slightest work; and what I consider viler still, they are amazed if you tell them of the great sums given in Italy for works of painting, for they do not seem to me in this to act up to their boasted nobility."[30]

Hollanda comes from a society where both the honor system and the market system had singularly failed to establish a high value for art-objects, an elevated appreciation for artists, or a sense of the worth of Art in general. Because he wishes to remedy this situation, prices and market values are discussed quite a lot in his text and are interwoven in unusual ways with appeals to gentlemanliness and liberality. At one point he asks Michelangelo, with whom he is ostensibly conversing throughout the book, to explain to him how works of art should be valued. The ploy here is, of course, to co-opt

[27] Vasari (1912–1915: Vol. 9, 39).

[28] For instance, van Hoogstraeten (1678: 314).

[29] A nice example is Van Mander's anecdote of how the emperor, who wants Antonis Mor's portrait of Mary Tudor, has to ask Cardinal Granvelle's advice on what he should give Mor to show his appreciation of what will certainly be given to him at his request. Granvelle, Mor's backer, names a huge sum of money, but Van Mander's point is also that to a truly elevated patron, artworks have no determinate *value* – the return to Mor will be about the emperor's appreciation of a great artist, not about owning this painting. Van Mander (1994: fol.231r).

[30] Hollanda (1928: 56–57).

the voice of an artist widely recognized as "divine" and to have him explain value to the clueless Iberians. Michelangelo replies:

What do you mean by valuing? . . . Would you have the painting of which you and I speak valued in terms of money or that any one should be able so to value it? For, as for me, I value as of the highest price the work done by a great painter, even if he have spent little time over it; for if he has spent much, who is there who could tell its worth? And I value very little that which an unskillful painter has painted in many years of work . . . for works are not to be judged by the amount of useless labor spent on them, but by the worth of the skill and mastery of their author.[31]

Michelangelo wants us to keep price and value separate. A valuation of fine art by the common market is, he implies, quite inappropriate – not just anyone can truly "value" art, and measuring that value in money is a somewhat unnatural thing. In other words, art should not acquire value as other commodities do. Hollanda's Michelangelo then makes a further argument, that it is not labor that determines value in artworks but rather "the worth of the skill and mastery" of the artist. Artists need protection from a standard economic means of assigning value to objects, the cost of the labor involved in their production. The *object* is not, in Michelangelo's calculus, what the notion of "value" should focus on; Value should remain with the person of the artist, and in particular with his possession of skill or talent. When pressed to detail the determination of price, Michelangelo returns to the principles of the honor system instead.

Concepts of the artist's worth and talent as valued in and of themselves, which the honor system had fostered, are threatened by the absorption of art into the leveling mechanisms of the market. Throughout Europe, but especially in Italy and especially during the sixteenth century, art literature tries to buffer artists and prevent their works from being valued as commodities. The market may work for ordinary beings, but they are not the concern of art literature; writers interested in maintaining a high status for art and a social valuation of aesthetic quality describe great artists who are attributed with an excellence that simply evokes its own financial rewards. For example, in discussing Michelangelo's vast income, Vasari is at pains to emphasize that it issued not from "trafficking or exchanges" but from "the labor and thought of the master"; that is, he earned money not for products he made, but for being a special creative being.[32]

[31] Ibid: 58–59.

[32] Vasari (1912–1915: Vol. 9, 110). I have used here the text from the version edited by E. H. and E. W. Blashfield and A. A. Hopkins, 1911. On Michelangelo's actual (and very considerable) income, see Hatfield (2003: 195–201).

It was especially in cultures where the overall status of artists was less secure, where talent really was not recognized and rewarded, that art writers were most anxious to erase "labor" altogether as a component of the value calculus and to keep the locus of value firmly in the mind of the maker. Nicholas Hilliard, working in England, protests at the way all artists there are paid the same amount per piece completed.[33] This, he explains, discourages talent from manifesting itself because artists are rewarded for working quickly rather than for working well. The solution he puts forward is to limit the art of painting to wealthy gentlemen, those who need not work for profit and who therefore will not be tainted by the structure of the market. Only amateurism can save Art from mediocrity. Hilliard's good artist is an experimenter ("trying conclusions") who, when he has made something particularly excellent, "will give it awaye to some worthy personage for very affection, and to be spoken of."[34] To Hilliard, social relations, honor, and fame are the proper context in which art receives its value.

6.5 Problems of the Market

It is all very well to give art away in the honor system; there, such gestures are part of an expected practice of gift, obligation, and countergift. In the honor system, each such transaction is individual, unique, and open to play; therefore even quite egregious manipulations are reported by writers with nods of approval. But the market system is based on commonality, on a certain equality between one exchange and the next by which value is determined. It is therefore not easy for the two systems to coexist: Social actions that have meaning in one register are nonsense in the other. Giving away your products, for example, makes no sense in the market system. Yet Renaissance art literature is filled with tales of painters who did so, following on the ancient example of Zeuxis, who felt that his works were beyond price and would be dishonored by the market.[35] In northern Europe, where writers

[33] Hilliard (1983: 15–16). This is not an unfamiliar complaint even in societies where talent was completely appreciated. Van Mander often admits that working fast is a profitable, useful skill even for a great painter (speaking of Frans Floris; see Mander, 1994, fol.241v) and that artists who spend too much time on their works are just not going to make a good living (speaking of Aertgen van Leyden, fol. 237v, but this comment is made about other artists too).

[34] Ibid.: 41.

[35] Pliny, *Natural History* XXXI.36.62, cited by Warnke (1993: 152). Michelangelo cites this example in Hollanda (1928: 59–60). An example of an artist who followed the example of Zeuxis is Sebastiano del Piombo, who apparently believed that "no price was large enough to pay for his works." Vasari (1912–1915: Vol. 6, 183).

tend to be less squeamish about market values, such behavior is considered quite odd: Van Mander takes Joos van Cleef's notion that "no money could ever fully pay for [his works]" as a manifestation of his insanity.[36]

Gradually in the course of the seventeenth century some writers become willing to trust in the market and grow suspicious of the social/discursive modes of value-creation. Writing about Tintoretto in 1642, Ridolfi recounts an episode in which the painter, asked by the Signori "what recompense for his work would please him," replies that he will ask for nothing but will rely on their favor, for which tactful reply they reward him handsomely.[37] This makes manifest good sense according to the honor system and indeed seems to have worked for Tintoretto, yet Ridolfi registers puzzlement as to why the artist would have behaved in a way so contrary to market sense. Moreover, he reports that Tintoretto's fellow painters hated his way of carrying out business. They felt, he says, that Tintoretto's lack of "decorum" had "damaged the reputation of art."[38] A form of behavior that exemplifies decorum in Puttenham's courtly world begins, to painters for the market, to seem entirely *dis*honorable. Likewise Samuel van Hoogstraeten disparages artists who "chat up" their works to convince buyers to pay a higher price, because discourse unsettles the firm judgments (*vaste oordeelen*) that have been created by the market and may cause lesser works to be momentarily valued too highly.[39] The market price is the truth here, and any intervention by the artist acting individually will falsify its judgment. The tables have been turned entirely on the social values of the honor system.

Hoogstraeten's belief that the market registers a correct value for the work of art is unusual and is not consistent even within his own writings. Although he is very much concerned with "worthiness" in art, for instance, in his famous ranking of artistic genres by their relative "worth," he never tries to

[36] Van Mander (1994: fol.226v).

[37] Ridolfi (1984: 69).

[38] To explain Tintoretto's behavior, Ridolfi is forced to fall back on the explanation that Tintoretto worked only for his own satisfaction and was clueless about money and value, when in fact that is not at all what the tale demonstrates. But Tintoretto's haplessness about money is a general theme of this *Life*: see Ridolfi (1984: 22, 70). Even though his anecdotes suggest that Tintoretto was really a very savvy mover, Ridolfi feels obliged to contradict this impression and to say that Tintoretto did not understand how to produce works the public would value.

[39] Hoogstraeten (1678: 312–313). He remarks, "Het is niet onnatuurlijk, dat veele konstenaers hunne eygen werken voor de beste houden; maer men plach altijts aen die den prijs te geven, die van elk meester in de tweede plaets nae zijn eygen werk gestelt wiert; daer de verstandige de zelve nu behoorden waerdich te achten, die met den grootsten yver vervolgt worden."

connect artistic worth with monetary value. Whole sections of his book are devoted to the exchange-value of artworks, but those chapters are separate from the ones about artistic worth and the ranking of subject matter. It does not seem to matter to him that the form of painting most highly priced in society – portraits – is not the most "worthy" form of art on aesthetic grounds. Since the market's valuation of paintings often failed to match art theory's (not only portraiture, but also still life, were priced far too highly for their artistic worthiness), it is not surprising that Van Hoogstraeten fails to use market values to bolster his case for the worthiness of different subjects.

Indeed in northern art theory a focus on monetary value – however it is determined – sometimes seems less like praise for aesthetic value than a substitute for it. That is to say, there is a choice between recognizing an artist's *artistic* talent and his talent for making money. Van Mander, writing at the turn of the seventeenth century, tends to be most eloquent about prices when he finds the artist to be aesthetically uninteresting. The biography in which immense income has the most emphasis is that of Antonis Mor, portrait painter to the elites of Europe (Figure 6.4).[40] Yet in Mor's biography, the aesthetic qualities of his art are hardly mentioned. In contrast to this stands Van Mander's short but quite detailed life of Pieter Bruegel, Mor's exact contemporary (Figure 6.5). This biography is entirely about aesthetics and never mentions prices at all. The reader might be forgiven for thinking that Mor was just financially successful and Bruegel was not, but by all indications Bruegel was no starving artist himself and had patrons of considerable wealth and generosity. To Van Mander, I think, there is a subtle way in which the worth of the greatest art must be registered apart from monetary value. Talking about prices, while all very well in terms of raising the status of art or praising a successful portraitist, would be somewhat demeaning to an artist whose contribution to painting is aesthetically important. Likewise in the life of Bartholomaeus Spranger, while Van Mander recounts at length the praises his friend's art has received, he never mentions anything about monetary value. Rather, he is concerned to define the terms of the painter's excellence. "Worthy of admiration," "masterfully handled," "subtle" and simply "beautiful" – these are the concepts that can move between court and city (as did Spranger), securing worth and honor in both.[41]

[40] Van Mander (1994, fol.230v–231v).
[41] The terms in Dutch are *verwonderlijck, Meesterlijck ghehandelt, aerdich, schoon,* and *heerlijck.*

6.6 Excellence and the Market System

Little more than a decade after Van Mander's book was published, Rubens would offer to Dudley Carleton a succinct, confident, and level-headed equation as to how paintings should be valued: not by size (which would register labor) but rather according to "excellence, subject, and number of figures." The latter two terms are fairly easy to explain: A greater number of figures will demand a greater exercise of the artist's talent in determining the composition,[42] while "subject" seems to imply that Rubens, unlike Hoogstraeten, felt that a more elevated type of subject matter should translate into higher monetary value.[43] The first term, though, is the most abstract and the most extraordinary: *excellence*. By this, Rubens indicates his belief that aesthetic quality attaching to an individual work of art can be quantified and translated into monetary terms. What Cellini wished to prevent from happening to his works – having them judged against other objects, their price comparatively determined – Rubens accepts as the natural fate of his. He can be this phlegmatic because he is in an exceptional situation. Rubens is not writing as a painter for the market. In the relatively small circle of elite connoisseurs in which he and Carleton move, there is some consensus about what "excellence" is in a work of art; moreover there is agreement that Rubens's works possess that quality.[44] It is this "excellence" adhering to all works produced by Rubens that will most surely separate his products from the realm of tapestries, valued according to labor, and allow them to be judged according to other criteria.

But agreement on excellence is extremely elusive in the broader market world of early modern Europe. Without a widespread critical discourse with which to secure an equation of aesthetic worthiness to market valuation, artists – especially ambitious and successful ones – had no assurance that their efforts would meet with the rewards they deserved. The older honor system had allowed for forms of personal intervention into the production

[42] This is somewhat particular to Rubens, whose compositional drawings are always entirely about bodies and never include other aspects of the image, but certainly he means this as a way of gauging the conceptual difficulty of the piece being judged.

[43] This is not altogether an accurate reflection of reality on the ground in Antwerp at this time, however. Although Rubens's works were the most highly valued, the still lifes and landscapes of his compatriot Jan Brueghel ran him a good second, and in Amsterdam, at least by later in the century, the still lifes of the Antwerp master Frans Snyders were valued the most highly. See Montias (1991: 367, table 10b). Again, the market's determination of value does not match the values that painters attribute to their art.

[44] The most recent overview of the cultural context of Rubens's and Carleton's exchange is Donovan (2004).

of value because that value accrued directly to the artist and not to circulating objects. The honor system had produced established methods of securing recognition and had created a discourse of artistic worth and a behavioral pattern of gift and obligation through which the artist could make his bid for reward. The honor system bound social advancement to artistic achievement in a way that the market in general now failed to do. The rituals of gift exchange on which the honor system operated thus had distinct advantages over the market system. And even as the market became the dominant way in which artworks circulated and were valued, writers on art clung to the discourse of honor because value *meant* something bigger and better in that world. It meant a type of personal value that artists had struggled for, a separation from the realm of craftsmen and the exaltation of individual genius. The market threatened to return art to the level of craft by making paintings or prints commodities among other commodities, popularly judged by criteria over which the maker had no control. Although fewer and fewer artists experienced the sudden glories of the honor system, it remained in artistic discourse as an ideal site where the value of the artist, rather than the value of the commodity, could be preserved.

References

Bellori, Giovanni Pietro. 1968. *The Lives of Annibale and Agostino Carracci*, trans. Catherine Enggass. University Park/London: Pennsylvania State University Press.

Cellini, Benvenuto. 1948. *The Autobiography*, trans. John Hoddington Symonds. New York: Doubleday.

Donovan, Fiona. 2004. *Rubens and England*. New Haven, CT, and London: Yale University Press.

Fantoni, Marcello, Louisa C. Matthew, and Sara F. Matthews-Grieco, eds. 2003. *The Art Market in Italy, 15th–17th Centuries*. Ferrara: Panini.

Fry, Roger, ed. 1995. *Dürer's Record of Journeys to Venice and the Low Countries*. New York: Dover.

Goldthwaite, Richard A. 1993. *Wealth and the Demand for Art in Italy 1300–1600*, Baltimore: Johns Hopkins University Press.

Hatfield, Rab. 2003. The High End: Michelangelo's Earnings. In Marcello Fantoni, Louisa C. Matthew, and Sara F. Matthews-Grieco, eds., *The Art Market in Italy, 15th–17th Centuries*. Ferrara: Panini.

Hilliard, Nicholas. 1983. *The Art of Limning*, ed. Arthur F. Kinney and Linda Bradley Salamon. Boston: Northeastern University Press.

Hollanda, Francisco da. 1928. *Four Dialogues on Painting*, trans. Aubrey F. G. Bell. London: Oxford University Press.

Honig, Elizabeth. 1998. *Painting and the Market in Early Modern Antwerp*. New Haven, CT: Yale University Press.

Hoogstraeten, Samuel van. 1678. *Inleyding tot de Hooge Schoole der Schilderkunst*. Rotterdam: F. van Hoogstraeten.

Hyde, Lewis. 1999. *The Gift: Imagination and the Erotic Life of Property*. London: Vintage.

Javitch, Daniel. 1978. *Poetry and Courtliness in Renaissance England*. Princeton, NJ: Princeton University Press.

Klein, Lisa M. 1997. Your Humble Handmaid: Elizabethan Gifts of Needlework. *Renaissance Quarterly* 50:459–493.

Magurn, Ruth Saunders, ed. and trans. 1955. *The Letters of Peter Paul Rubens*. Cambridge, MA: Harvard University Press.

Mander, Karel van. 1994. *Lives of the Illustrious Netherlandish and German Painters* (1604), ed. Hessel Miedema. Doornspijk: Davaco.

Montias, John Michael. 1991. Works of Art in Seventeenth-Century Amsterdam. In David Freedberg and Jan de Vries eds., *Art in History, History in Art*. Santa Monica, CA: Getty Center.

North, Michael. 1999. *Art and Commerce in the Dutch Golden Age*. New Haven, CT: Yale University Press.

Puttenham, George. 1968. *The Arte of English Poesie* (1589), facsimile reprint. Menston: Scolar Press.

Ridolfi, Carlo. 1984. *The Life of Tintoretto* (1642), trans. Catherine Enggass and Robert Enggass. University Park and London: Pennsylvania State University Press.

Soussloff, Catherine M. 1997. *The Absolute Artist: The Historiography of a Concept*. Minneapolis and London: University of Minnesota Press.

Summerscale, Anne. 2000. *Malvasia's Life of the Carracci* (1678). University Park: Pennsylvania State University Press.

Vasari, Giorgio. 1912–1915. *Lives of the Most Eminent Painters, Sculptors, and Architects*, trans. G. de Vere. London: Medici Society.

Vermeylen, Filip. 2003. *Painting for the Market: Commercialization of Art in Antwerp's Golden Age*. Turnhout: Brepols.

Warnke, Martin. 1993. *The Court Artist: On the Ancestry of the Modern Artist*. Cambridge: Cambridge University Press.

Zemon Davis, Natalie. 2000. *The Gift in Sixteenth-Century France*. Madison: University of Wisconsin Press.

Rubbish and Aura

Archival Economics

Kurt Heinzelman

7.1 Worth and Value

The central theoretical issue of this chapter is neatly laid out by David Throsby in his recent book *Economics and Culture*: "At some fundamental level, the conceptual foundations upon which both economics and culture rest have to do with notions of value" (Throsby 2001: 14). The problem is that in determining "cultural value... no metric for combining the various components of value exists," the way the price–cost metric does in cases of economic value.[1] Moreover, there is "a tendency for an economic interpretation of the world to dominate" a strictly cultural one because of "the ubiquity and power of the modern economic paradigm" (Throsby 2001: 41).

I take these assertions to be axiomatic. The most important thing not mentioned by Throsby, however, is that one of the "conceptual foundations" upon which "value" rests is strictly linguistic. On the first page of *Capital*, Karl Marx says that the crux of the issue is semantic, a matter of inherent verbal ambiguity complicated by cultural preferences for certain types of usage. "In English writers of the 17th century," Marx notes, "we frequently find 'worth' in the sense of value in use, and 'value' in the sense of exchange-value. This is quite in accordance with the spirit of a language [English] that likes to use an Anglo-Saxon word [*worth*] for the actual thing, and a Romance word [*value*] for its reflexion" (Marx 1967, I: 36n). Marx is trying to be precise, though his precision may be hard to hear at this late date, and that is in part the point of my chapter. Exchange-value, for Marx, is

[1] See Throsby (2001: 40). A much less nuanced way of putting this occurs in the advertising copy for the lecture "Economics" created for the prestigious Teaching Company of Washington, D.C., by Prof. Timothy Taylor of Macalester College and managing editor of the *Journal of Economic Perspectives*: "We are all economists – when we work, buy, save, invest, pay taxes, and vote."

a chimera – a metaphor, a reflection, a romantic figure of speech. Worth is literal and inherent, the real thing. The modern paradigm, which we all at some level implicitly participate in, is different. It does not undo this polarization of metaphor versus literal but simply switches the directionality of the terms. Economic or exchange-value becomes the literal foundation or prime indicator, while worth, or let us say cultural value in general, becomes the metaphor, the measure of a value beyond price. I could refine this point, but everyone knows what it means, as when a publisher says, "Sure, it's a good book, but it won't sell." My point is that logically speaking, when terms such as *worth* and *value* can be as easily polarized in one direction or another – a reversal of the semantic field that Marx suspected had already occurred in 1867 – then the central problem is that the polarized terms were not discursively discrete enough to start with. They did not contain all the logically necessary possibilities.

So, in an expression my mother liked to use whenever she needed to cut across what she never would have called "competing discourse formations," let us get down to brass tacks. Take a recent *Thadeus & Weez*, the cartoon strip done by Charles Pugsley Fincher (see Figure 7.1). In 2003, shortly after Massachusetts joined Vermont in giving the same economic rights to single-sex marriages as to heterosexual ones, there was the predictable outcry about how this would lead to legalizing a whole spate of other "unnatural" couplings. In the cartoon, a preacher standing in front of stained-glass windows exclaims with rising vehemence: "Brothers and Sisters, I oppose the marriage of ideas. / And I oppose the marriage of words and music . . . and the marriage of tradition and innovation . . . / And the marriage of music and dance . . . and the marriage of painting and poetry . . . and the marriage of companies." Then, in the final panel, he places his hands together and says more quietly: "Because, Brothers and Sisters, marriage is between a man and a woman." What the cartoon challenges is the very notion of giving literal priority or privilege to a rhetorical term – in this case *marriage* – that is intrinsically metaphorical. The term *value* is, in this regard, like *marriage*. In the context of economic discourse, value has a literal and almost always literally recoverable meaning, even when the rhetoric of economics becomes either highly anecdotal or highly mathematical. In Aristophanes' *The Clouds*, Sophocles tries to explain the cultural significance of prosody to the farmer Strepsiades, but the latter can grasp the value of poetic measures only in terms of the values of commercial exchange. Insofar as modern life is conditioned by economics, this economic meaning of value is with us, always. But there is no inherent reason why *value*, a word that is fundamentally a metaphor, should have as its sole literal meaning an economic one.

Focusing on what I call "archival economics," I will propose three cases, which stretch the definition of value simultaneously in aesthetic and in economic ways so as to test the bipolarity of the term *value* itself. These three limiting cases, though cultural in nature, are not outside the realm of economic analysis but in the middle of them by virtue of their association with institutional archives. The acquisition of an author's archive is one still point in the turning world of creative process, where that process has palpable economic value (even if, as is usually the case, the price of the archive is not disclosed to the general public). What I am going to address directly is how archives are created and valued by their creator, and indirectly how the archival institution wittingly and unwittingly promulgates the value thus created. All of the authors or artists I will be talking about have collaborators, often their spouses. So, I will be talking about *marriage* in three senses:

- Marriage of writer or artist and collaborator;
- Marriage of creator and collecting institution, archive, or museum; and
- Marriage of cultural and economic interests.

It is not facetious, I trust, to say that none of these is a natural coupling. In addressing these marriages I will show the creator to be a conspicuous producer whose productive process creates a lot of junk. That is, rubbish may not be only a by-product of creativity but also, at least for certain consumers of art, part of its aura. What I will not address, at least not overtly, is the price metric of archival collecting and purchase as measured against the real maintenance, cataloging, and access costs that archival institutions incur, though this measuring is certainly part of what a full definition of "archival economics" would mean.

7.2 Christo and Jeanne-Claude

The artists who for me most significantly make the economic meanings of value a subject of discussion, while engaging with great aesthetic success in the work of cultural production, are Christo and Jeanne-Claude. Born in Bulgaria, raised under Communist rule, an expatriate to Geneva, then to Paris, and at last a citizen of the United States, Christo has made it clear that his work is the antithesis of collective. Although he has had to manage a very large production company in order to effect later works, the company is entrepreneurial and hierarchical in structure, not socialistic: The head of operations is a single entity – officially since 1994, but effectively since 1961 – namely, the corporate marriage called Christo and Jeanne-Claude, his wife.

Even Christo's early work engages immediately the question of economic and cultural value. I am thinking especially of a work like *Package 1961* (Figure 7.2). Christo was by no means the first artist who wrapped things, but he makes the wrapped things resonate in both a strictly economic sphere as well as the realm of gift exchange. One reason to wrap something is to conceal its identity to increase the enjoyment of the one who receives it, as a gift, for example. The act of hiding whatever is inside heightens pleasure, according to the ancient libidinal paradox of prolonging pleasure by delaying it. The assumption is that the thing inside accords with what the receiver will perceive as desirable. The package literally folds itself around and into a secret. The package may not be inherently attractive, but one expects the secret to be.

What happens to secrecy as predicated in the usually open act of gift giving if the object itself is not a gift but a piece of art – something that is for sale? Well, if you buy something that has been packaged, you hope that there is something of value in it. In Christo's case, though, there may not be anything "in" the package. Indeed, we are not particularly encouraged to imagine, for instance, that what is inside might even be rubbish, for wrapping is often what one does when one wants to discard something. Christo has a later work that dramatizes the irrelevance of "the inside" to the artistic package. A work like *Wrapped Book 1973* (Figure 7.3) declares its content through its visual shape as explicitly as a customs statement and asserts at the same time that the content is meaningless as to value. We do not care what book is inside (or even, really, whether there is one); that is not where the artistic value resides.

The value is not entirely on the outside either, despite Christo's assertions that these packages are not just found objects or made up of whatever kind of paper or cloth or twine – that is, junk – seems ready to hand but have been carefully and willfully constructed. If the value of the Christo-wrapped package is neither in its content nor in its form (though one may respond viscerally to a work like *Package 1961* that it is so overwrapped as to be disturbing), then how is one to define that value? I would say that the value is in its "aura," a term derived from Walter Benjamin and used here to mean the peculiar value that cultural works accrue to themselves by virtue of their originality (Benjamin 1973). I mean *originality* in both senses: how new or innovative the thing is and what its origins are, its "coming-into-beingness." The aesthetic value of Christo's objects occurs in the intersection between gift-giving economies and commercial-exchange economics. If one can ask whether these packages are figurative gifts that are born out of the artist's individual creativity and that happen to have a price, then one can also ask

whether they are commercial objects that look like and in some ways act like presents freely given to the public by an individual artist. They act in both ways at once. Or at least when they are admired – purchased – they are no longer mere wrapping – discardable stuff, one might say, or rubbish – but art.

Christo's most famous works are sometimes called "environmental art" and sometimes called "land art," large-scale outdoor works that since 1961 he has executed in collaboration with Jeanne-Claude. These works are by definition not possessable by any individual, and yet, as Christo explains, they arise from an immense individualistic desire: "Nobody asked us to spend million of dollars at these sites. This is about our unstoppable desire to do these works. They are irrational and absolutely unnecessary. There is no justification for them. Yes, they are totally irresponsible. This irrationality is linked to freedom, which is a very important part of our work" (Donovan 2002: 53). The Christos' interviewer goes on to suggest that such works are "basically a gift," and Christo replies, "The very basic premise [is] that [they] cannot be bought, cannot be commercialized, no one can charge tickets. Everybody can go to see them. The projects will go away and nobody owns them" (p. 53).

True, but in our culture the wrapping of commodities, even very large objects like the Reichstag or islands in the Bay of Biscayne, is a sign that both disrupts the commodity status of the wrapped thing and alters its value. That is why wrapped gifts of money are so embarrassing. The cloaking does nothing to refigure the status of the cloaked object.[2] When you wrap buildings, islands, shorelines, and parts of the countryside, as Christo and Jeanne-Claude have done, you certainly create an unpossessable thing, for the wrapping, it is understood, will be removed and the production disman-tled forever. But this event, which is not only very expensive to produce but counter to all economic price–cost logic, directly and inherently engages for that very reason the intersections of nature, landscape, and property. That is its aura – to make these socioeconomic categories coexist with the cul-tural. Indeed in the case of the Reichstag, for example, collateral businesses popped up around the wrapped building in which food, drinks, souvenirs, and other objects were sold.

Let us look at one example of these mammoth works in more detail, a project that was four years in the making, from 1972 to 1976. It was an 18-foot-high fence of pale, translucent, and supple fabric strung on steel poles

[2] Another way of saying this might be that money is already a cloaking device, a numerical packaging of value, but that is another story.

across 24.5 miles of Marin and Sonoma Counties in northern California (Figure 7.4). Called *Running Fence*, with its American Indian–sounding name, this work was a three-dimensional line that asserted an unusual aesthetic propriety even as it crossed a host of invisible but real property lines. Traversing fields owned by various private ranchers, the fence as the Christos first conceived it would terminate in the shoreline of the sea, which in this case was owned by the state.

To acquire access and use-rights to the various sites, Christo and Jeanne-Claude invented the aesthetic equivalent of the wrap-around mortgage. To start with, there was a contractual limit on what might be called fence-time. The structure was to be temporary and effaceable – more like an old-fashioned snow fence, say, than one of barbed wire or stone masonry. The collateral that the Christos offered for property-use was the stuff they used in making the fence – the lightweight but extremely durable nylon, the steel support beams, and the mounting hardware. This expensive and reusable material was turned over to the property owners when the fence was dismantled. That is, as the fence components became rubbish as aesthetic objects, they acquired use-value for the ranchers to whom they were given. Fundamentally, though, what Christo and Jeanne-Claude offered both the ranchers and the general public was the pleasure of seeing a mutable and even outlandish piece of engineering and artistic design cross a landscape already crisscrossed with claims of ownership. Their great economic innovation was to create a public good without cost to the public, an innovation, incidentally, with sociopolitical implications.

In effect, the Christos gave away what they made their art of in exchange for the private property it used. They also agreed not to disrupt the landowners' real economy. Grazing cattle, for example, would be allowed to pasture at will in places where the cattle thought they had a proprietary right to pasture. Here, the fence "runs" high above the feeding herds (Figure 7.5).

One of the Christos' curious failures was their inability to strike a bargain with the state over access to public lands, and this coincides with the central design problem that they faced: how to negotiate closure. Where does a running fence end? In the sea, they reasoned (Figure 7.6). The fence would simply run out to sea, getting smaller as it entered the water as a perspectival line does when it nears the horizon. But the technical problem of embedding and suspending support posts as the fence plunges from steep and lofty cliffs into the stony surf of the Pacific was nothing compared to negotiating with the government for access to these so-called public lands. Christo and Jeanne-Claude finally gained the slimmest advantage. In the bureaucratic twilight zone between the time when Christo and Jeanne-Claude were

advised that they would not be able to erect their fence on preserved seashore land and the time when a court injunction was issued against them, workers managed to run the fence into the sea and to record it on film. They beat the injunction by minutes but then of course had to dismantle the offending sections two weeks later. The furious legal maneuvers, strategic delays, and temporarily asserted squatters' rights all had the feel of a nineteenth-century land rush, like the one that virtually created nearby San Francisco.

It is crucial to the Christos' aesthetic that the fence be perceived as beautiful, which in this case means the product of capacious and arbitrary human design. As the fence changes colors with the changing light and volatile atmospheric conditions, it seems to bring out of nature "charm" or "color," almost in the physicist's sense of these words, that would not otherwise be noticeable or even "there." In these moments aesthetic pleasure seems mysterious, a value impervious to commodification – in short, as Christo himself likes to call it, a gift.

Christo and Jeanne-Claude's so-called land art is only partially experiential, however; finally, it all comes down to recording and archiving the experience. That is, the Christos' work finesses the notion of the site of value by showing that durable value is only in the archive. By *archive*, I mean here everything that memorializes the production, and this usually involves methods of mechanical reproduction. The vast majority of those who experience the fence do so only through photographic images.

In an interview, Christo and Jeanne-Claude were asked, "How do you see the museum's role in relation to your work?"

JEANNE-CLAUDE: They [museums] are very important to us. . . . For instance, it is only in museums that we can show the documentation exhibitions of our projects after they are completed. For us, it is important to make the public aware of what we have done, especially in places where we intend to do something next, so that the public is aware of how we work, how the project has been done, and the beauty of it.

CHRISTO: And, of course, the museum as a collection; they buy works. In this they help us to do our project. At the same time, the museum has an educational capacity beyond the galleries. For us, because these projects happen far away for only fourteen days, the system of the museums – through the books, the films, and lectures – explains the quality of the project. (Donovan 2002: 52)

The museum or archive is a repository of both cultural and economic value, a site of education as Jeanne-Claude says, but also a site of economic advantage. Here images are displayed and the engineering designs mounted as if they were art-objects (Figures 7.7 and 7.8). The notes preparatory to the event and the economic negotiations that made the installment of the thing possible

Rubbish and Aura

113

can here be examined by scholars, and the pictures and books and films can be sold to the public. My point is that Christo and Jeanne-Claude parlay into museum commodification everything about their outdoor installations except the finished product.

This is not to denigrate what the Christos have achieved. On the contrary. A work like *Running Fence* is not just another somewhat eccentric example of landscape art, but a kind of running commentary on how representation and perception, topography and property, forms of beauty and forms of use, aesthetics and economics remain functions of one another. Where the commentary comes together is in the museum, or more precisely in the archive, where the back-stories about the construction and promulgation of the fence can be laid out. Finally, the archive is where Christo and Jeanne-Claude's work finds the economic value of its cultural merit.

7.3 Zukofsky

We will next look at an artist, one as far removed as possible from the Christos in terms of renown, but whose view of archiving also engages the polarities of cultural versus economic value with the idea of making the two kinds of value mutually convertible. As with the Christos, the site of valuation/evaluation is the museum or archival library, in this case the Harry Ransom Humanities Research Center. Harry Ransom, the founder of the center, was one of the first to specialize in collecting authorial archives, particularly of the modern period. That is, his method contrasted sharply with that of old-fashioned rare-book collectors such as Henry Huntington or Pierpont Morgan whose aims are here characterized by Frederick Jackson Turner, speaking of another such collector, John Carter Brown: "No one but the collector who sends his agents far and wide with eager eye for the spoils of famous libraries brought to the auction-block and for stray wanderers in old shops, and who knows how keen and sharp was the contest for possession of each of these gems, can appreciate what it meant to bring together into such a noble assembly this elite of the original sources with all the dignity upon them."[3]

That "contest for possession" may still drive archival acquisitions, but the nature of "the original sources" has changed. By his term "these gems," Turner meant rare books – the beautiful and/or culturally significant objects with what Walter Benjamin would call the "aura" of authenticity about them. For Benjamin, "aura" identifies an almost mystic quality that cannot survive

[3] Quoted in Basbanes (1995: 13).

replication: "That which withers in the age of mechanical reproduction is the aura of the work of art" (Benjamin 1973: 223).

But we must be careful here. To site "aura" as a cultural value for itself alone is only one economic remove from a kind of cabalistic practice or hagiography. Whether or not that was ultimately Benjamin's intent, he was also using the term to articulate the relationship between cultural and exchange-value. *Aura* was his bipolar term for assessing the value of original works – that is, works that go back to some historical origins and carry with them traces of that cultural tradition. But the modern idea of "an original" was changing even as Benjamin was writing in the 1930s, and Harry Ransom's vision of archival acquisition was in keeping with that modern or Modernist idea.[4] Aura no longer resided alone in the beautiful finished product – the first edition of James Joyce's *Ulysses*, for example, in its three different printing states. Rather, aura was also coming to reside in the mysterious process by which an original work like *Ulysses* comes about in spite of a world of mechanical reproduction. And for that you need an archive, because to find out the nature of Joyce's originality you cannot merely look at his use of Homeric themes; you must recognize that the roots of originality are in the narrative of its own creation – that is, in the rubbish, the notebooks, the cancelled drafts, the radically revised page proofs, the stemma with its demystified plot scheme, and even marketing strategies. This was Cyril Connolly's joke, made back in 1962, when he spoke in the *Sunday Times*[5] of an unnamed American university – it was the University of Texas, in the person of Harry Ransom – that was willing not only "to pay for what an author has written but what he has tried to throw away; his note-books, correspondence, [and] false starts" (Basbanes 1995: 319–320).

Archival economics has its own dynamics, which are slightly different from museological ones. When you buy an archive you acquire a whole body of work. It is not like purchasing a Frida Kahlo painting or a first edition of *The Great Gatsby* with its famous dust jacket in mint condition, where there are benchmark prices, however volatile those may be, as well as other economic factors of scarcity and celebrity compounding the cultural issue of a work's significance and value. Each archive is almost by definition *sui generis*, so there is no standard or measure against which to judge, say, the archive of a midcareer prolific American poet against that of an Australian prose writer of limited but stellar production who is near

[4] For further discussion of the Modernist idea of "the new" as meaning "having origins" versus the usual sense of "being without origins," see Heinzelman (2003: 131–134).

[5] *Sunday Times*, April 15, 1962.

the end of her career. Unlike other commodities, even individual artworks, archives are rarely resold. You cannot really deaccession them. Thus they have no exchange-value beyond the initial purchase price. After being acquired, archives only go on incrementally costing money to preserve, catalog, exhibit publicly, and make available for the research uses of patrons. Moreover, in the case of modern archives, they are largely rubbish.

If you are not persuaded that the economics of the modern archive must be based in some measure on "rubbish theory,"[6] consider the following hypothesis: What would happen if we had just a little Shakespearean rubbish – not perhaps a discarded manuscript page from *Hamlet* that shows the playwright's wrestling with several versions of the "To be or not to be" soliloquy, but even one manuscript leaf in Shakespeare's own hand? To start with, it would help put the whole "who-really-wrote-Shakespeare's-plays?" cultural industry out of business once and for all.

We do not have discarded drafts by Shakespeare, but we do have a remarkably "complete" archive belonging to the twentieth-century American poet Louis Zukofsky, for whom Shakespeare turned out to be a crucial figure in launching his archival economics. Zukofsky did what very few other writers prior to the modern period did. He kept an archive of himself, a meticulously self-maintained record of the genesis and development of his entire poetic opus, including what is certainly his masterpiece, an 800-page poem in 24 movements called "*A*," and including the work that was unwittingly the economic key to his publishing career, a study of Shakespeare called *On Bottom*. It is an archive that is almost painstakingly overwrapped, as a fairly typical manuscript leaf reveals (Figure 7.9). As in Christo's *Package 1961* there is more than enough string here; working in a longhand world before computers, Zukofsky included all his saved discards, his unemptied trash. The first question is, Why – why did he save all this stuff? And the second is, Why would one want to buy it? Why should we care at this point about the archive of a poet whom you will recognize only if you are a very, very serious student of twentieth-century American poetry?

It is because Zukofsky demonstrates, in what I call the economic trajectory of his career, the same intersections of exchange and cultural values that I would claim are central to Christo, though the intersections in Zukofsky's case are laid out on a completely different kind of matrix and without the international frenzy of renown. The history of both Zukofsky's own archival practices and the literal disposing of his literary archive into a cultural

[6] For the full version of a theory that explores the migrations of value of commodities from transient to durable status, see Thompson (1979).

institution will require us once again to develop a bipolar vision capable of seeing of how a metric of cultural value functions as an economic one as well. Zukofsky himself identified the bipolarity I am addressing by noting a double discursive field of physics as well:

> Light-wave and quantum, we have good proof both exist:
> Our present effort is to see how this is: to
> Perfect the composition of a two-point view,
> The economists have a similar problem.
> (Zukofsky, 1978: 49)

One might say that Zukofsky's ethnic origins enforced "a two-point view" from the start. The only American-born child of Yiddish-speaking immigrants from what is now Lithuania, the husband of a composer and the father of a concert violinist, Louis Zukofsky valued language, music, and family. Perhaps because of this outsider's perspective, his poetry shows a fascination with the musical aspects of language, its aurality, even at the expense of sense. Although the surface or sonic pleasures of Zukofsky's language are always available to us, certain passages are elusive because they simply were not written for us. He referred in print to his wife ("Blessed/Ardent/Celia") as his "one reader," making her both his BAC[H] and his St. Cecilia, patroness of music, and there is this sense of allusive hermeticism to much of his work, as if it were written in a private language we can never fully understand.

By the same token, the work is capacious. Zukofsky calls *"A"* the "poem of a life / – and a time." If the life as represented in the poem is at times obscurely intimate, the "time" of the poem's composition spans half a century, from the 1920s to the 1970s, with elaborate motifs based on Henry Adams, J. S. Bach, Calvalcanti, Spinoza, and Marx's *Capital*, including even a condensed history of the world. One can guess perhaps, without reading a word he wrote, the difficulty of marketing Zukofsky's work.

And yet, after a brief moment of fame in the late 1920s, Zukofsky persevered through almost complete indifference from publishers and readers, supporting his life-long writing practice with jobs for the Works Progress Administration (WPA) as a technical editor, and for many years as a teacher at the Brooklyn Polytechnic Institute. In the crucial Depression years, when Zukofsky had just turned 30 and was making those major career decisions that people make in their thirties, he held two jobs. The first, which he worked on at night, was the composition of a writing textbook, a task that continued to occupy him for almost five years from 1935 to 1940 and was not published for eight more years after that. The textbook, *A Test of Poetry*, teaches by juxtaposing various examples of poetic craft from the history of

world poetry, sometimes without attribution or author or date. The idea is for the student–reader to use these comparisons to arrive at a standard "for judging the values of poetic writing." The textbook lays out no a priori standards: Those must be adduced by the "interested" reader. There is almost no critical commentary. The only guidance given the reader is the selection and arrangement of the comparative texts by the compiler, Zukofsky. It is as if the composition of the textbook is a function of arrangement alone, as if Zukofsky's cataloging or archiving of prior acts of creativity by others were the equivalent of creating in writing a new set of pedagogical standards.

His day job was as an indexer, in effect an archivist, creating as he put it, "a graphic survey of American decorative arts and crafts from the earliest Colonial days to the beginnings of large-scale production" (Nadel 1997: 112). It is important to understand how this job, which engaged him from 1936 to 1940, was, like the cataloging and arranging done for *A Test of Poetry*, integral to his notion of how a poet worked. The WPA's *Index of American Design* was focused on objects of use-value, decorative arts and crafts with everyday utility. This was the center of Zukofsky's own poetics – the life lived – and that life was now clearly the life of someone who writes or, to use his own preferred verb, who composes poems. Composition and indexing are equivalent labors, he discovered. Arranging is creating. Therefore an index is not merely a list; it "reassembles and permits access to the details of the text in a new and often unexpected fashion, while establishing categories and structures of value in the work" (Nadel 1997: 117). The last thing Zukofsky ever wrote was the index to his own poem *"A."* He had originally wanted to index only the words *the*, *a*, and *an*, but his wife, Celia, persuaded him to permit a larger set of subjects and names, which she then compiled and he edited. Just as the *Index of American Design* had been a collaborative work of WPA writers, so it became clear that the value of Zukofsky's own poetic work was owing to the creative partnership with his wife. Creativity was not an act of individual expression but a marriage of values. Celia's musical arrangement of one of Louis's poems, like her indexing of the whole of *"A,"* was a collateral act of composition, equal to the making of the poem.

Between the WPA *Index* and the index to *"A"* occurs the acquisition of the entire Zukofsky archive by the University of Texas in 1963. Up to that point Zukofsky had published any number of books and pamphlets, but they were either self-published, as in the case of the mimeographed version of *"A"* 1–9, or published by very small ephemeral presses in places like Prairie City, Illinois. The Ransom Center probably did not want Zukofsky's own individual creative work so much as it wanted his extensive correspondence

with Ezra Pound and William Carlos Williams. On the other side, Zukofsky desperately wanted to publish his two-volume study, done with Celia, on Shakespeare. A deal was struck in which the Ransom Center would publish the Shakespeare volumes under a jerry-built imprint series called the Ark Press of the Humanities Research Center, in exchange for which Zukofsky would sell his library and archive, including all future additions to it, to the university.

The point is that the self-maintained archive of Zukofsky's own work was always a site of self-evaluation for him. As the decades had passed and no major audience was found for his work, this archive of detritus, emendations, sidebars, reading notes, correspondence, and random musings had become his alternative to publishing. That is why, I assume, he saved so much.

The acquisition of the Zukofsky archive gave him his first sustained critical acclaim ever, the most public attention since he was in his twenties. Now, in 1965, with Zukofsky aged 61, W. W. Norton became the first commercial press to publish his work, a volume misleadingly called *All: The Collected Short Poems*, for they were not "all" there by any means. In 1966, Zukofsky was able to retire from teaching. What followed were some of his most important publications to date, including his collected essays and culminating in the complete text of *"A"* from the University of California Press in 1978. Rather than being an alternative to commercial publication, the archive became after 1963 a form of economic exchange for publication. Even so, Zukofsky is undoubtedly the last of the major twentieth-century American poets to receive full critical attention.[7] If there is to be a sustainable cultural aura to Zukofsky's work, it will postdate the economic valorization of his archival practices, a complete reversal of the usual dynamic.

7.4 "Woodstein"

"One of the foremost tasks of art has always been the creation of a demand which could be fully satisfied only later" (Benjamin 1973: 239). Here is yet another attempt by Benjamin to define in quasi-economic terms the aura of a cultural artifact. Cultural historians, however, seem largely unaware that Benjamin may very well have derived this definition of *aura* from the explicitly economic language of Charles Baudelaire, a poet about whom Benjamin had written numerous monographs. In his "Advice to Young Littérateurs," Baudelaire said, "As for those who devote themselves to poetry with talent, I

[7] The closest thing to it is Mark Scroggins's critical study, to which my essay is indebted throughout; see Scroggins (1998).

advise them never to abandon it. Poetry is one of the arts that brings the best return, but it is a type of investment that produces no interest until later – though at a very high rate, I might add. I challenge those who are envious to point out to me good verses that have ruined a publisher."[8] Another name for the projective demand that Benjamin speaks of is *secrecy*. Or rather, *secrecy* is a synonym for the cultural aura whose effect is delayed satisfaction. To see how this future demand is created in a way economically far removed from the Zukofsky experience, I turn to an archive that is not artistic at all. And yet I would argue that this limit case is almost an allegorical model of how an archival economics in the humanities might work.

The archive I am referring to is that of Bob Woodward and Carl Bernstein, the two *Washington Post* reporters who first broke the news stories associated with the 1972 Watergate break-in that led to the resignation of President Nixon and the conviction of his two top advisers and his attorney general, among others. This archive was purchased on April 7, 2003, also by the Harry Ransom Center, for $5 million, with $500,000 of that donated in turn back to the institution for future academic conferences, symposia, scholarly visitations, and guest lectures associated with the content of this "Watergate Archive."

The way in which this archive came to have the price it did is part of why this is a limit case for the concept of value. Originally, Woodward's papers seemed to have been promised to Yale University, his alma mater. And indeed, the non-Watergate part of his archives may very well end up there. But it was suggested to Woodward and to Bernstein by Harry Middleton, a former journalist himself, speechwriter for President Johnson, and until quite recently director of the LBJ Presidential Library and Museum in Austin, Texas, that these men, now in their seventh decade, should think of their work as being as much a part of the story of Watergate and its historical record as any of the people they reported on. Or at least this is the story recounted by the New York book dealer Glenn Horowitz, who eventually brokered the transaction: It is the story of the cultural origin of an economic action.[9]

Like Christo and Jeanne-Claude, like Zukofsky and his wife, Celia, Woodward and Bernstein acted very much as in a marriage of interests and values, both in their reporting of Watergate and in their subsequent archival arrangements. Whatever value either man's archive had, it had

[8] Quoted in Paz (1991: 137).

[9] Alicia Shepard (2003: 2–12). All subsequent quotations pertaining to the buying and selling of the Watergate Archive are from this article.

more as a joint stock venture, a corporate merger – "Woodstein," if you will. Woodward has explained that the sale "was Carl's idea. He was going to do something by himself. The feeling was the papers should be together." Bernstein even expressed interest in expanding the marriage. "The truth is," Bernstein has said, "I would hope that Ben [Bradlee, the editor of the *Washington Post*], in particular, would add his papers."

Bradlee, however, has raised another question, not of cultural propriety but of economic property: "Who owns the notes?" No journalist to whom I have spoken can remember a journalistic archive being sold by the journalist. Bradlee has opined, "I think Carl needed the dough. For those of us who have been in those shoes, that's perfectly understandable. [But] I don't think Bernstein and Woodward own the notes. I believe, and most lawyers I talk to believe, that the notes are the property of the newspaper. But we chose – not me, I had nothing to do with it – not to exercise that right of ownership in this case." For his part, Bernstein has declared, that "the reason to sell them [the Watergate papers] was a business decision. People ought to be compensated for their work." Why, though, did Woodward reverse his apparent agreement with Yale? According to Bernstein, "I think Bob was skeptical that they [i.e., the University of Texas] would pay the amount of money they did." For his part, Woodward has asserted that the curatorial attention as well as "display value" (his words) that Texas could give the archive were deciding factors.

The explanations given by Woodward and Bernstein are entirely plausible. They did not want their archive to go to an institution with any sort of political agenda; they reasoned that this research had originally been done in the name of objective investigative reporting, for the public good, not for partisan gain. Let us leave aside for a moment the issue of economic gain, whether the Library of Congress would have paid $5 million for two *Post* reporters' notes in the way the National Library of Ireland recently paid $11 million for the last remaining cache of James Joyce's papers in private hands. The implication of Woodward and Bernstein's logic is that this Watergate archive ought to be studied with scholarly detachment, with the same sort of ardent objectivity that characterizes the study, say, of literary archives.

Whether or not Woodward and Bernstein would put it this way, the effect of housing their papers in the same institution with those of D. H. Lawrence, William Faulkner, George Bernard Shaw, and T. S. Eliot bestows a cultural aura on them. Moreover, there are several compelling reasons to regard this archive in a literary/cultural light. To start with, the archive contains what most literary scholars can only dream of – a kind of Rosetta Stone allowing creativity to be translated back to a point of pure historical origin. There are

in the archive a file dated "Jun 17.72" and a note in Woodward's hurried hand recording a break-in – "5 men arrested at Dem Nat headquarters" and followed by two names and phone numbers (Figure 7.10).

But the Watergate archive, more so perhaps than even a literary one, is also literally full of rubbish, if by rubbish one means what was not fit to print or what could not be printed. This last point takes us directly to one aspect of this archive that helps explain its economic valuation: The archive contained one of the best-kept secrets in modern political history namely, the identity of "Deep Throat," the source who helped Woodward and Bernstein break the case open and "modern journalism's greatest unsolved mystery . . . , the most famous anonymous person in U.S. history" (O'Connor 2005: 89).[10] Because the University of Texas is a public institution and is therefore answerable to the Open Records Act, which gives agents like newspapers access to otherwise secret materials, part of the Watergate archive had to be withheld from delivery to the Ransom Center pending the death of persons who had some contact, witting or unwitting, with the figure of "Deep Throat." Originally, it was thought that the material withheld would total 8 to 10 percent of the entire archive; it turned out to be rather more than twice that.

What accounts for the economic value of the Watergate archive is in part the element of secrecy, in part the anticipation of a future disclosure, and in part what Woodward calls its display value, for this archive, like Benjamin's work of art, creates a demand that can only be fully satisfied later. Moreover, when the archive is completely in place and open to scholarly scrutiny as well as public display, the archive will have established, indeed will have underwritten, this very same scholarly activity about itself, thanks to the half-million dollars of the purchase price that was set aside precisely for this purpose.

Here, then, is an archive that has created both economically and culturally its own kinds of remuneration. A substantial purchase price has translated into an economic mechanism that will maintain not only future demand for the commodity but ongoing public discussion for years to come about the cultural and political value of the commodity.

[10] Since this essay was written, not only has the archive been opened and the first public symposium held but, of course, the identity of Deep Throat also has been revealed. As predicted, this revelation seems only to have enhanced the scholarly *and* economic value of the archive. "Secret's end is a boon for UT [University of Texas]," announced the headline in the local paper, followed by a well-calculated fiscal metaphor, "Far from solving a mystery and deflating interest, [W. Mark] Felt's surprise disclosure that he was the secret source who leaked Watergate information has compounded interest in one of the pivotal periods in American political history" (Lisheron 2005: 1).

7.5 Summary and Conclusions

Let me summarize briefly and then even more briefly conclude. In the case of the Christos we found a creative process that needed physically to return from the field to the museum in order to discover the work's full economic returns. For Zukofsky, the lifelong practice of indexing his own creativity as a substitute for publishing became an opportunity to publish his work more extensively. In the case of the Watergate archive, the public importance of the journalists' work gave their raw manuscript material a narrative with its own cultural interest and value. In the Watergate case we knew "who done it"; the untold history was how those who disclosed who done it did it. This second narrative, about constructing a narrative of disclosure, is not less important than the first narrative of wrongdoing in the Nixon White House. Culturally, in fact, the second may prove more valuable to us.

What is worth noting, however, is that the economic value of the Watergate archive rests upon a principle of secrecy not unlike what made the Watergate investigation necessary in the first place. Nixon's White House of course did not want its secret disclosed, for it would have shown the Nixon circle to be craven; Bernstein and Woodward certainly did want theirs disclosed, but in keeping with the demand-value of art – the cultural aura that their papers have acquired – they wanted disclosure only to occur, as it always does in archives, later.

Jacques Derrida in his provocative work called in English *Archive Fever* implies that the desire to establish an archive is the memorial wish to find and possess a moment of origin. Carolyn Steedman adds, in her provocative critique of Derrida called *Dust*, that "the grammatical tense of the archive is…the future present, 'when it will have been.'"[11] Archival economics work the same way, as is made wonderfully vivid in the case of the Watergate papers. That archive memorializes a moment of pure origin and contains a promise, carefully crafted into the contractual terms of the archive's acquisition, of a future-present disclosure of historical secrecies.

The three examples I have highlighted are all slightly odd, but none is weird. What makes them odd is that the cultural aura of these different writers and artists resides in some significant way in what common sense would call rubbish. By examining this oddness we may see how cultural values perplex and disturb the economic paradigm that helps to construct them. More importantly, we can see that disturbance at the very moment when it happens – in the institutionalization of the archive. Because economic

[11] Derrida (1996) and Steedman (2001: 7).

discourse is, historically, least theorized when talking about rubbish, and because rubbish is commonly understood to be the exact opposite of cultural value, it is very odd indeed to imagine rubbish as having the utmost economic significance in understanding how human endeavor produces some of its most enduring monuments.

So here is the rub. Even if economic discourse is the dominant one in assessing value, it does not efface all the others, for they are not competing but complementary discourses. The analogy is to the discourse of marriage. Even if a society decides that one meaning of marriage – that of a man and woman – will be the literal and dominant one, the value of the idea will actually lose much of its resonance if we block out, ignore, or diminish the complementary uses that inform it.

References

Basbanes, Nicholas A. (1995). *A Gentle Madness: Bibliophiles, Bibliomanes, and the Eternal Passion for Books*. New York: Henry Holt.

Benjamin, Walter. 1973. *Illuminations*, trans. Harry Zohn. Glasgow: Collins/Fontana.

Derrida, Jacques. 1996. *Archive Fever: A Freudian Impression*, trans. Eric Prenowitz. Chicago: University of Chicago Press.

Donovan, Molly, ed. 2002. Christo and Jeanne-Claude in the Vogel Collection, exhibition catalog. Washington, DC: National Gallery of Art, and New York: Harry N. Abrams.

Heinzelman, Kurt. 2003. "Make It New": The Rise of an Idea. In K. Heinzelman, ed., *Make It New: The Rise of Modernism*, 131–133. Austin: Harry Ransom Center and University of Texas Press.

Lisheron, Mark. 2005. Secret's End Is a Boon for UT, "Deep Throat" Episode Likely to Boost Interest in Watergate Papers. *Austin American-Statesman*, June 3, p. 1.

Marx, Karl. 1967. *Capital: A Critique of Political Economy*, trans. Samuel Moore and Edward Aveling, Vol. 1. New York: International.

Nadel, Ira B. 1997. A Precision of Appeal: Louis Zukofsky and the Index of American Design. In M. Scroggins, ed., *Upper Limit Music: The Writing of Louis Zukofsky*, 112–126. Tuscaloosa: University of Alabama Press.

O'Connor, John D. 2005. I'm the Guy They Called Deep Throat. *Vanity Fair*, July, 89.

Paz, Octavio. 1991. *The Other Voice*, trans. Helen Land. New York: Harcourt Brace Jovanovich.

Scroggins, Mark. 1998. *Louis Zukofsky and the Poetry of Knowledge*. Tuscaloosa: University of Alabama Press.

Shepard, Alicia. 2003. Off the Record. *The Washingtonian*, September, 2–12.

Steedman, Carolyn. 2001. *Dust*. Manchester: Manchester University Press.

Thompson, Michael. 1979. *Rubbish Theory*. Oxford: Oxford University Press.

Throsby, David. 2001. *Economics and Culture*. Cambridge: Cambridge University Press.

Zukofsky, Louis. 1978. *"A."* Berkeley: University of California Press.

PART THREE

CONTINUITY AND INNOVATION

EIGHT

Value in Yolngu Ceremonial Song Performance

Continuity and Change

Steven Knopoff

8.1 Introduction

The Yolngu are an Aboriginal society of a few thousand people who reside on their traditional land in Northeast Arnhem Land in Australia's Northern Territory (see Figure 8.1). My interest as an ethnomusicologist has focused on the public ceremonial songs of the Yolngu community in and around Yirrkala, one of four large Yolngu settlements and currently the home or supply base to about 1,200 Yolngu people. As someone raised in a society where the most prevalent way of regarding music is as mere entertainment or spectacle (or in the case of classical music, as something transcendental, a distinction that nonetheless separates the idea of music from the main business of society), I have been pleasantly shocked to encounter a culture in which most forms of knowledge, including cosmology, law, history, science, and kinship, are fully integrated and embodied within song, and where ceremonial and musical leaders are also the de facto political leaders of the society.

Because of the centrality of songs in traditional Aboriginal societies, the notion of cultural value takes on a particular significance when applied to Aboriginal song performance. The value of song and dance performance to Yolngu people is of critical importance, both because of value ascribed to particular content within performance, and because of the general value that performance has as an important site for the creation and maintenance of sacred knowledge and group relations. Thus, although it is possible to assess some aspects of Yolngu musical performance in economic terms, its value is expressible primarily in its cultural context, and hence the main focus of this chapter is on an assessment of the cultural value of this music. In the chapter I shall consider a range of contextual and identity-related variables that have an impact on the valuation of Yolngu song and dance performance, looking

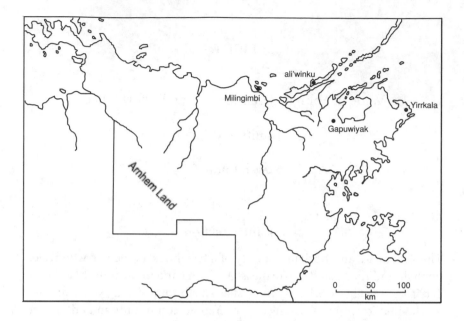

Figure 8.1. Map locating Arnhem Land in Australia's Northern Territory.

especially at changes in value over time in the transition from traditional to contemporary modes of performance, and at differences between the valuation perspectives of Yolngu and non-Yolngu people.

At the outset it is necessary to describe in some detail the nature of Yolngu *manikay*, or "clan songs," the song and dance genre that is most widely used in traditional ceremonial performance.

8.2 Yolngu Clan Songs

Musicologists use the term *clan songs* to refer to public ceremonial songs because each clan (or patrilineally defined family grouping) owns a repertoire of songs, which, in terms of its musical and thematic content, is distinguished from the repertoires of other clans. There are about 14 patrilineal clans in the Yirrkala area ranging in size from fewer than 20 to more than 200 people. The songs of each clan are understood to have been bequeathed to the clan's ancestors at the beginning of time. Clan songs are used primarily in public/open ceremonial contexts such as funerals and male circumcisions. They are also regularly performed in nonreligious contexts such as building dedications, homecoming welcomes for family members, school functions, and staged performances for non-Yolngu audiences. The songs are sung by one or more male singers who accompany themselves on clapping sticks, and further accompanied by one male didjeriduist; they are performed both with and without women's and/or men's dancing.

The songs are organized into large series consisting of two dozen or more song subjects clustered around key ancestral events and spirit-beings. For example, in the song series focused on the Morning Star there are many smaller spirit-beings that are sung – butterfly, praying mantis, Morningstar ghost-spirits, various birds, and so forth – all of which played a role in the first Morning Star ceremony at the beginning of time (see Figure 8.2). The smallest performable units of clan songs are short verses ranging from 15–20 seconds to one to two minutes in length. Hundreds of these short verses are strung together to form a performance that may last two to three hours or more. Sung texts include multiple names for specific spirit-beings, verbs describing idiomatic forms of action or movement, and adjectives that refer to the appearance of particular things related to an ancestral being or event. In this way, texts allude to rather than narrate a story, but because the events described in sung verses change over a number of verses, there is a level of implied narrative over the course of a performance.

Particular song series, song subjects, and key song words will be shared among multiple clans within the same moiety (or half of society), but the total configuration of subjects and words that each clan uses is unique. In a similar way each clan maintains a unique skeletal melodic structure, which is used to generate improvised melody; a unique repertoire of clapstick patterns; and certain unique characteristics of didjeridu accompaniments. During performance, elements from each of these "component repertoires" (comprising song subject, text, melodic shape, clapstick pattern, and didjeridu rhythm) are extemporally combined in accord with multileveled protocols.

One important feature of Yolngu ceremonial performance is that it provides for contemporary song creation alongside ancestral song content. This occurs through the creation and performance of *yuṯa manikay*; this is translated literally as "new song," but I translate it as "newsong verses" to dispel notions of completely new creations. In essence *yuṯa manikay* are rearrangements of extant ancestral songs performed in limited contexts within religious ceremonies. The creation of a newsong verse is inspired by some event in everyday life. These events are often but not necessarily associated with an element of "worry," as, for example, in a case where a couple became lost driving home through the bush and worried about their children waiting for them back at camp. The contemporary event is juxtaposed with an ancestral song subject (in this case with the Ancestral Dingo, who by nature wanders lost in the bush). The new song arrangement will in the main be based on the text and music of an existing ancestral song (in this case, Dingo) but may include certain sorts of newly conceived elements, such as a new-sounding vocal rhythm or didjeridu rhythm (or both), a new clapstick pattern, or some newly added text (usually just a few words). Many *yuṯa manikay* make use of a textual/musical refrain. Regardless of whether new text is incorporated, oral tradition ensures that listeners will know what the contemporary event is or was, even in the case of newsong verses that remain in ceremonial repertoire for many years.

Yolngu do not regard the practice of composing or performing *yuṯa manikay* as something new but rather understand this practice to have been a part of tradition from ancestral times. The use of newsong performance during ceremonies is restricted to the long stretches of informal performance when there is no specific ritual business apart from music performance being attended to. During informal performances, attendees are most free to dance, socialize, or come and go as they please (see Figure 8.3). By contrast, newsong verses are never used during stretches of formal performance, that is, at times when music performance accompanies specific ritual acts such as the movement of a coffin from one place to another, or during a ritual smoke purification. In this way, Yolngu performance practice can both accommodate contemporary elements and proscribe these elements during more important segments of a ceremony.[1]

[1] One example of newsong verse – out of hundreds of old and new *yuṯa* arrangements currently in circulation in ceremonial performance – dates from the early 1930s. This particular newsong verse was inspired by an occasion in which the composer's infant son was crying inconsolably. The composer juxtaposed his son's crying with the mournful call of Dhududhudu, the ancestral Tawny Frogmouth. The newsong verse features an added vocal/musical refrain that includes added text *yawu gathu* ("oh! son"), an updated

8.3 The Value of Ceremonial Songs and Dances

8.3.1 Components of Value

The value of ceremonial song performance can be seen to derive from the meaning it embodies and conveys for all participants as a core element of the Yolngu religious and social system. The various elements of performance, including particular sequences of song subjects, songs texts, and dance movements, can be ascribed different meanings (value) at different times or simultaneously, depending on one's level of knowledge. Because the choice and ordering of material in performance are partly extemporal, ceremonial leaders are in effect manipulating the multiple levels of meaning that participants are presented. The ability to control the flow of multiple levels of meaning in appropriate ways during a ceremony is one of the most highly valued skills of ceremonial song leaders.

A clan's song repertoire is valued for its ancestral sacredness – with some items and styles of performance regarded as more sacred than others, depending on the power and importance ascribed to particular sung spirit-beings – and for the correspondingly authoritative claim that a clan places over its estate by the maintenance (performance) of this repertoire. In a very different way, one of the values associated with newsong verses also relates to a core feature of the Yolngu religious system; though they are only performed during "informal," ritually less-sacred portions of ceremonies, newsong verses are valued for their ability continually to juxtapose the everyday events and evolving aesthetics of the contemporary world on the unchanging foundation of the *wangarr* (Dreamtime).

Ceremonial songs can also be valued for an interrelated range of spiritual, psychological, aesthetic, and moral qualities. For example, dances of a certain class, called *gakal*, are imbued with exceptional spiritual power; when Yolngu perform these dances they become the spirit ancestors that they are dancing. The growing intensity of ceremonial performances staged over longer spans of time is associated with the highly prized spiritual/aesthetic effect referred to as "brilliance" (*bir'yun*).[2] Songs are also valued for their

rhythmic feel in the vocal and didjeridu parts, and a generic clapstick pattern used with many newsong verses. Most of the words and the basic melodic structure are performed just as they would be in purely ancestral versions of the song. For further discussion of *yuṯa manikay* see Knopoff (1992).

[2] For discussion of aesthetic "brilliance" in the context of Yolngu ceremonial painting, see Morphy (1989) and, in the context of ceremonial song performance, see Toner (2001: 124–128).

contemplative qualities. Mandawuy Yunupingu, for example, has spoken of the philosophical value he derives from thinking about the deeper implications of his Gumatj clan's inland song series (personal communication 1990).[3]

Performances of songs and dances are valued for a variety of spiritually functional qualities within religious ceremonies, for example, as a means of sending off the good aspect of the deceased's spirit to its ancestral resting place, and, correspondingly, as a context for driving the malevolent aspect of the deceased's spirit away from the community. In conjunction with a *man'tjarr* smoke ceremony, songs and dances provide the basis for purifying those who have had contact with a corpse. At a more personal level, ceremonial performance is valued for the psychological comfort it can give both to the grieving – accommodating expressions of both personal anger and sadness as well as respect for the deceased and his clan – and to the dying.[4] The value of chanting words of an especially powerful type called *likan* (literally "elbow" or "crescent moon") stems from their ability to connect Yolngu to their spiritual wellsprings deep in the ground or water of their clan's country.[5] The allusions and metaphoric meanings built up with more mundane types of song words are also prized elements in ceremonial performance.

There are many ways in which aesthetic qualities in ceremonial songs and dances can be valued by Yolngu and non-Yolngu alike. For example, the use of poetic metaphor is particularly developed in Yolngu song. Other examples include the lyrical prowess of particular singers and technical virtuosity of particular didjeriduists. Beyond all of the spiritual and psychological values mentioned, ceremonial performance is also valued as a means of providing an evening's entertainment and an enjoyable context in which to socialize with kin.

As noted in the introduction, and as is clear from the foregoing discussion, the primary value of traditional ceremonial performance can be assessed in cultural rather than economic terms. Nevertheless, some economic values can be associated with the traditional ceremonial sphere. Repertoires of songs and dances have traditionally been used as objects of cultural and

[3] Mandawuy Yunupingu is a song leader and elder of the Gumatj clan and is also the founder and leader of the Yolngu rock band Yothu Yindi (see further later).

[4] The singing of totemic songs frequently occurs around a death bed. Warner (1958) discusses an example of relatives' singing the song of the ancestral dolphin as a dying man spends his last moments acting as his totem – i.e., by mimicking the thrusting movements of the dolphin dance.

[5] For discussions of *likan* see Morphy (1991), Keen (1994), and Toner (2001).

economic trade. Various sorts of nondirect economic values have also been associated with ceremonial songs and performance. For example, as the de facto political leaders of their clans, song leaders maintain and increase their stature through their activities organizing and running ceremonies; in the past this stature could increase one's ability to obtain multiple wives, which, in turn, would lead to greater security in one's old age, as a result of the size of the family that would provide food and other support. Today as in the past, active participation as a singer, dancer, or didjeriduist in ceremonies continues to yield indirect economic benefits; key performers are provided for during ceremonies and need not involve themselves in daily hunting or food preparation. In the contemporary world too, ceremonial songs continue to serve as objects of economic and cultural exchange, as will be seen further later.

8.3.2 Maintenance of Value in a Changing Social Environment

During the past several decades, Yolngu society has undergone great change brought about by engagement with non-Aboriginal religion, law, economy, and culture. Specific events associated with this change include the establishment of a Methodist mission, which operated from 1934 through the early 1970s, and the establishment of a large bauxite mining operation and mining township in the Yirrkala area in the 1960s. For most Yolngu, embracing Christianity has not meant a decline of involvement in traditional beliefs or ceremonies, though some aspects of ceremonies have undergone modification since missionization. However, the presence of the nearby mining town of Nhulunuby, with a non-Aboriginal population near 4,000, attendant pubs and sale of liquor, and a full range of Western cultural models, has led to significant change in Yolngu social life. New opportunities as well as challenges have also followed the integration of government schools and health and welfare services into the Yirrkala community, extensive use of automotive and air transportation, and access to mass media.

Throughout this period of change, traditional ceremonies have undergone significant modifications but remain an integral element in Yolngu society; the basic components of song and dance performance have proved to be among the most resilient elements of ceremonial life. One example of ceremonial adaptation will serve as illustration. In the past, Yolngu funereal rites involved a set of three ceremonies over a long period. The first of these ceremonies would occur immediately after death and would conclude with the placing of the paper-bark-wrapped corpse upon an open-air tree platform. Some months later, a second ceremony would involve collection,

ritual painting, and storage of the remaining bones. Still later, a final ceremony would be enacted involving participation of the largest number of people, concluding with placement of the bones in a painted hollow log coffin, which was placed into the ground. One direct influence of the missionaries has been that the Yolngu have adapted this ritual into a single-ceremony funeral, which concludes with in-ground burial of the body in a coffin.[6]

These changes represent some of the most striking modifications of ceremonial activity, but it can also be demonstrated that the modifications have been introduced in ways that preserve the underlying meanings associated with the ceremony. In the earlier three-phase funeral, the third ceremony was the longest and largest event because by this point in time there was no longer a body as such that needed to be dealt with, and because desired participants, some of whom would have been traveling long distances, would have had ample time to congregate at a designated ceremonial place. In the contemporary context regular use of the refrigerated morgue in the Gove District Hospital allows ceremonial leaders to extend the single ceremony for several weeks if necessary, in order to allow for the attendance of key participants. Thus the earlier brief and immediate initial ceremony is no longer needed, while the single current ceremony has expanded to match the size and importance of the earlier third ceremony.

This type of change in ritual structure has not resulted in correspondingly significant changes to musical or choreological practice. One reason for this is that certain chunks of clan song subjects are adaptable to a range of contexts in which the metaphoric meanings implied by the songs are appropriate. For example, Dhuwa moiety songs and dances that allude to raging floodwaters flowing into the saltwater of a bay, and the emergence from these intermingled waters of the Ancestral shark looking for a place to make its home, are just as appropriate to concluding portions of ceremonies today as in the past (see Figure 8.4). In both cases, the movement of the water symbolizes the movement of the deceased's spirit back to its ancestral home, and the home of the shark, deep in the water, represents that ancestral home and destination of the spirit. In the modern context these songs and dances are used both in conjunction with final removal of the coffin from the ceremonial ground to the burial site and during the music-and-dance-accompanied transportation of the coffin by motor vehicle from the district hospital morgue to the Yirrkala township.

[6] See Peterson (1976) for a discussion of Yolngu premissionary mortuary rites.

The preceding example illustrates the stability of song performance within the context of externally influenced changes in social and ceremonial practices. It should also be noted that the core elements of song performance have also resisted aesthetically motivated change. For example, no new instruments have been added to the traditional mix of voices, clapping sticks and didjeridu, and the traditionally variable tuning of voices and didjeridu has not been modified to correspond to Western musical intervals, as has happened in the musics of many small cultures around the world.

Given the stable nature of songs and dances, ceremonial performance is one of the more resilient elements of Yolngu culture and society. One reason for the stability of song performance relates to the high value that Yolngu place upon the ancestral nature of performance. By not altering core structural elements of performance, Yolngu ensure that the ancestral and hence authoritative quality of song performance is maintained. At the same time Yolngu have incorporated some new elements into ceremonial performance practice in ways that do not interfere with the conservative maintenance of core elements. One example of this relates to the frequent incorporation of a brief Christian service near the end of Yirrkala-area funeral ceremonies. This service may include a musical component such as one or two Christian songs performed by a mixed-gender youth group accompanying themselves on guitars. The important considerations here are, first, that Christianity itself is seen as an addition to and not a replacement of traditional beliefs and, second, that the brief Christian sermon and musical elements are clearly distinct from clan songs and dances, so they do not interfere with the maintenance of core traditional elements.[7]

Another example of a recent addition to ceremonial performance practice relates to the Yolngu use of consumer recording technology. Over the past 15–20 years it has become a common practice to record ceremonial song with an audio cassette player. Recordings may be valued for archival purposes as "correct versions" of a clan's oral history, or as keepsakes to

[7] The Christian songs I have seen are sung in Yolngu dialects, generally involve Pacific Island–influenced three-chord style, and are often performed with accompanying "action dances." Occasionally (but not usually) the melody of a Christian song will incorporate direct influences from clan song melodic structure, and on some occasions I have seen Christian songs performed simultaneously with performance of ancestral songs and dances near the end of a funeral. Nonetheless, the very specific, circumscribed points at which Christian songs are performed, the distinctive makeup of the performing groups, the use of nontraditional instrumentation and other stylistic elements of the music and dance, all help to maintain a separateness about Christian funereal performance. For discussion of the relationship between Christian and traditional ancestral elements in contemporary Yolngu culture and performance, see Magowan (1994, 2001).

pass to relatives not in attendance, and for pedagogical reasons; didjeridu players, for example, may learn particular patterns and styles from recordings. Importantly, the incorporation of these self-made recordings does not impede the conservative maintenance of the core elements of performance.[8]

One of the challenges to the maintenance of traditional culture is that it can sometimes be difficult to ensure full community participation in ceremonial activity, particularly in the case of funerals during the many days of performances prior to the conclusion of the ceremony. Some of the factors that impact on ceremonial attendance include conflicts with attendance at paid employment and school, alternative forms of entertainment via mass media, and – for an unfortunate minority – problems with alcohol and other substance abuse. Employers and schools at Yirrkala tend to be flexible with hours during funerals because they recognize the value and importance that these ceremonies hold for the community. Some ceremonial leaders have on occasion incorporated the ceremonial activities associated with a closed men's camp as a form of "detention" for juvenile delinquent boys. Closed men's camp ceremonies may be conducted on their own but in the Yirrkala area can also be an adjunct to public funerals. Boys in attendance at the men's camp spend the days engaged in age-graded learning of songs, dances, and other ritual knowledge and in the evenings contribute to the public performances of clan songs at the funeral. These activities are all traditional, but in the contemporary context, they also provide a specific make-work setting for these boys.

8.3.3 Value in Non-Aboriginal Society

One positive outgrowth of extended contact with non-Aboriginal society has been the opening up of opportunities for performance of clan songs and dances outside religious ceremonies. Most commonly this involves the staged performance of excerpts of ceremonial songs for non-Aboriginal audiences. In these nonceremonial contexts, Yolngu have demonstrated a willingness to adapt or modify many aspects of traditional performance in ways that would be unacceptable in ceremony but suit the nonceremonial context. One example of this is the building up of short performances from bits and pieces of different song series, which would not be combined in ceremonies. Oftentimes the particular songs chosen for use in public staged performance are those that have the most visually appealing dances.

[8] For additional observations concerning Yolngu self-made recordings both inside and outside ceremonies, see Knopoff (2004).

For a small number of Yolngu, the performance of clan songs in this nonceremonial sphere provides an occasional source of income. It should be emphasized that the amount of money involved in staged performances is very small in comparison to that associated with the Yolngu visual art industry, which has developed around the production of bark paintings for sale.[9] Nonetheless, Yolngu song and dance troupes regularly perform for audiences at music-cultural festivals and other public events both within Australia and overseas, and some payment is generally made to performers for this work. In all the cases of which I am aware, the main reasons for becoming involved in staged performances relate to a desire to share their culture with outsiders, as opposed to interest in a modest economic benefit.

In a very few instances, a performer has been able to derive a substantial income from other activities related in one way or another to traditional ceremonial performance. For example, at various times since the early 1990s, Djakapurru Munyarryun has served as a lead performer and cultural consultant for the Sydney-based contemporary Indigenous dance company Bangarra Dance Theatre, and the didjeridu virtuoso Djalu Gurruwiwi has acquired an international reputation as an instrument maker (his family has sustained a cottage instrument-making industry for many years) and as a teacher in workshops held periodically both in the Yirrkala area and overseas.

Consideration of non-Aboriginal valuation of Yolngu performance is important for two main reasons. First, in the context of staged performances, and to a lesser extent through the consumption of compact disks, non-Aboriginal audiences are stake holders whose aesthetic expectations can be expected to have some impact upon certain aspects of performance. Second, in the context of institutional financial support for Yolngu culture, valuation of performance by non-Aboriginal people can impact on the level of interest and support for both traditional performance in particular and traditional culture more generally.

Looking at the first of these issues, we can note that many people within Australian society are at least peripherally aware of the existence of Yolngu songs and dances, whether they attend staged performances or not. The songs are valued both as a form of Indigenous culture and more generally as a distinctively Australian form of cultural expression. When non-Aboriginal people consume ceremonial songs in staged contexts, the immediate visual and aural-aesthetic appeal takes on a primary importance. Some traditional aspects of Yolngu performance will mesh well with the ingrained aesthetic

[9] See further Chapter 2 by Terry Smith and Chapter 12 by Neil De Marchi.

values of non-Aboriginal audiences, while in other cases the fit may not be so good. Three examples will illustrate this point. First, although outsiders can appreciate the skill, grace, energy, and beauty of Yolngu dances when encountered in a staged setting, they do not have the opportunity to know or appreciate the ceremonial performance context in which the greatest aesthetic intensity is achieved only over multiple performances spanning days, weeks, or months. Second, Westerners may have a strong appreciation of the musical skill of didjeridu players but lack an understanding of Yolngu performance practice; hence they have a tendency to overvalue the importance of these performers. Yolngu, on the other hand, are certainly appreciative of didjeriduists' consummate skills and artistry but will not lose sight of the fact that the role of the didjeridu (usually played by young men or teenagers) is as accompaniment to elder song leaders, who hold and create more highly valued knowledge and meaning in the course of their sung performances. Third, in comparison with familiar musical aesthetics, certain normal aspects of Yolngu performance can strike a Western audience as either uninteresting or "unprofessional." Examples include the periods of conversation between each short verse of song, and the dancers' practice of ending their performance slightly before the music comes to a halt.

On the whole it can be suggested that Yolngu have done well to cater to outside audiences, on the one hand, while maintaining separate ceremonial practices, on the other. Yolngu awareness of non-Aboriginal aesthetic taste clearly has an impact on the presentation of songs in staged contexts, yet the range of accommodations made here such as the edited selection of songs and dances or the more Western-theatrical approach to ending a verse would seem to have had only slight impacts upon the manner of performing songs and dances in ceremonial performance contexts.

The second reason mentioned for considering non-Aboriginal valuation of Yolngu performance relates to the long-term survival of the overall musiccultural tradition. When audiences consume staged performances, a positive aesthetic impression will help to raise their general valuation of Yolngu culture, creating a sympathetic climate for public and private support for traditional culture. One of the clearest examples of this may be seen in the success of the Yothu Yindi Foundation in attracting corporate funding for projects that promote and protect traditional culture. The foundation itself was started by the Yolngu rock band Yothu Yindi, and there is no question that corporate interest in the foundation is linked to the familiarity with the band's tradition-influenced repertoire within Australian popular culture.

Despite the intercultural importance of staged performance, it cannot be overemphasized that the real driver of clan song performance practice has

been and continues to be ceremonial, not staged contexts. The reason for this is simply that so many of the meanings and values associated with songs and dances are directly applicable only to the execution of lengthy, myth-bound series of songs yoked to the attendance of particular groups of people (clans) who join in particular ceremonial contexts. As aesthetically satisfying as staged performances can be, the deeper layering of meaning cannot be sustained solely on the basis of brief staged performances excerpted from the long series of songs associated with religious ceremonies.

8.4 Conclusion: Challenges for the Future

Earlier in this chapter I argued that ceremonial song performance does not seem to be in any immediate danger of extinction and that, on the contrary, it may be regarded as one of the strongest, most robust Yolngu cultural elements, helping to sustain Yolngu society at a time of considerable pressures. This may not always be the case, however. Looking toward the future, it is conceivable that if the realm of ceremonial activity were to shrink (say, as a result of increasing strain from workday hours or a general decreased willingness of Yolngu to engage in lengthy periods of ceremony), it is possible that the ceremonial contexts that have produced clan songs for centuries could dissipate beyond a level of viability. At that point, one would have to ask whether other motivations (cultural or economic) would be adequate to sustain performance and new creation within the genre. More importantly, even if the performance of songs and dances could be maintained, would the loss of the richly layered sets of values associated with ceremonial performance render these songs less meaningful in some way? The world is rife with small cultures in which the loss of traditional performance contexts has resulted in the end of a musical genre; for example, one musician explains quite simply why an earlier rural Bolivian genre is no longer performed: "because the previous authority systems have been lost."[10]

How does our consideration of the cultural and economic value of Yolngu performance shed light on these possible future developments? It can be suggested that although the various sources of economic value associated with staged performance are only a minor aspect of the overall value of Yolngu cultural traditions, they are likely to be important in the future in providing resources to sustain the continuation of ceremonial practice. These sources of economic value derive both directly from revenue earned

[10] Translated by Michelle Bigenho and quoted in Bigenho (2002: 210).

when Yolngu performers present their art to the outside world, and indirectly via support for Aboriginal cultural institutions channeled through public and private funding bodies. For those institutions and individuals who claim to care for and value cultural survival, it is important not to lose sight of the fact that the real strength and value of clan song performance lie in its role within religious ceremony, and to foster ways in which our interaction with Yolngu performance can serve to support the long-standing ceremonial traditions that continue to evolve within Yolngu society.

References

Bigenho, Michelle. 2002. *Sounding Indigenous: Authenticity in Bolivian Music Performance*. New York: Palgrave Macmillan.

Keen, Ian. 1994. *Knowledge and Secrecy in an Aboriginal Society*. Melbourne: Oxford University Press.

Knopoff, Steven. 1992. *Yuta Manikay:* Juxtaposition of Ancestral and Contemporary Elements in the Performance of Yolngu Clan Songs. *Yearbook for Traditional Music* 24:138–153.

Knopoff, Steven. 2004. Intrusions and Delusions: Considering the Impact of Recording Technology on Ethnomusicological Research. In Michael Ewans, Rosalind Halton, and John A. Phillips, eds., *Music Research: New Directions for a New Century*, 177–186. London: Cambridge Scholars Press.

Magowan, Fiona. 1994. *Melodies of Mourning: A Study of Form and Meaning in Yolnu Women's Music and Dance in Traditional and Christian Ritual Contexts*. Ph.D. Thesis, Oxford University.

Magowan, Fiona. 2001. Syncretism or Synchronicity? Remapping the Yolngu Feel of Place. *The Australian Journal of Anthropology* 12(3): 275–290.

Morphy, Howard. 1989. From Dull to Brilliant: The Aesthetics of Spiritual Power among the Yolngu. *Man (N. S.)* 24:21–40.

Morphy, Howard. 1991. *Ancestral Connections: Art and an Aboriginal System of Knowledge*. Chicago: University of Chicago Press.

Peterson, Nicholas. 1976. Mortuary Customs of Northeast Arnhem Land: An Account Compiled from Donald Thomson's Field Notes. *Memoirs of the National Museum of Victoria* 37: 97–108.

Toner, Peter J. 2001. *When The Echoes Are Gone: A Yolngu Musical Anthropology*. Ph.D. Thesis, Australian National University.

Warner, L. Lloyd. 1958 [1937]. *A Black Civilization: A Social Study of an Australian Tribe*. Revised ed. Chicago: Harper and Brothers.

NINE

The Ritual and the Promise

Why People Value Social Ritual

Lourdes Arizpe

9.1 Introduction

Anthropology and economics have very different approaches to the question of value. While economists look for methods of evaluation in transactions on the basis of what is being exchanged, anthropologists have always given attention to the way agents think about value in the whole range of transactions they are involved in, but at another level they look for the value of underlying structures for society. Exchanges are basic to society but anthropology has shown that there are other mechanisms also at work – descent, affinity, memorialization, among others – in organizing collective life. Psychoanalytic, structuralist, semiological, and anthropological interpretive theories have shown how elusive and mysterious questions of value are in different societies. The notion of value in terms of underlying structures of societies is far from the simplistic rendering of this notion as narrow moral rules in current political discussions. It is also much broader than the notion of value as equivalence in economizing exchanges.

It is quite significant that in the contemporary world in which markets have become the dominant organizing principle in liberalized economies, there has been simultaneously the emergence of a multiplicity of cultural movements. In many cases, such movements become visible through resignified rituals or the invention of new ones. What is the value of such rituals for people? Why are Mexican migrants now revitalizing the ritual of the Day of the Dead, which they celebrated back in their villages in Mexico, in their neighborhoods in Chicago; why have highly mobile Caribbean migrants created a new musical culture, Rastafarianism, steeped in Ethiopian history and culture? A frequent explanation is that they are reclaiming an identity in foreign lands. But then, why are nonmigrant Islamists reverting to strict observance of Islamic ritual dispositions? Why are Hindus celebrating their

puja ritual in the Internet site they created for that purpose? The easy answer is that there is a religious revival. But then, why are nonreligious, New Age spiritual and environmental rituals proliferating? Why are Americans resignifying Thanksgiving as a major national ceremony? Why are Ugandans reinvesting animistic rituals with power? It is said to have to do with the rise of environmentalism, the renewal of nationalism, and the breakdown of the state and the society in some countries. This may be true, but then why are middle-class professional Europeans enthusiastically reinventing Celtic culture and rituals? Why are middle-class urban Mexicans dancing a reinvented Aztec ritual to welcome the spring equinox atop the Pyramid of the Sun in the archaeological site of Teotihuacán? Something beyond identity politics, beyond religious revivals, beyond nationalistic political mechanisms, beyond a fearful return to old traditions, beyond revalorizing intangible cultural heritage is happening in our contemporary world.

In this chapter I contend that the imperceptible worlds that are lit up by being involved in a ritual reflect the promise of all those touched by it to be together and act together in a world of increasing uncertainties and insecurity. In this chapter I will analyze an institution, the ritual of the Day of the Dead in Mexico, to show how the value of such an institution connects to so many other aspects of people's lives that it cannot be understood merely in terms of its exchange-value or individual maximizing behavior. Rituals, among other centripetal cultural practices, are reactivating the potential of commitment to provide identity, shelter, and common purpose. When people become involved in rituals they may give and receive large amounts of money, work, emotional connections, aesthetic pleasure, and psychological support. I argue that there is a broader principle involved, overarching these particular gains, that is the representation of the *commitment* that cultural agents make visible in participating in such rituals. It is the promise, the potentiality of commitment, that is most important in ritual, as opposed to simple participation in festive occasions or sports events. To begin, I discuss in the following section the way ideas about value evolved in anthropology through the twentieth century.

9.2 Anthropological Theories of Value

It is appropriate to begin with the work of Bronislaw Malinowski, who took up the question of value in his famous study of the Kula Ring whereby Trobrianders exchanged shell bracelets and necklaces between islands (Malinowski, 1922). This extremely elaborate system of exchange, he argued, was not trade because it was public and ceremonial, had permanent

partners, was not done out of need, and was based on credit. Although the actual exchange between "big men" was highly competitive in its equivalence, Malinoswki considered that the value of the exchange system was sociological. His argument, however, was addressed to the narrow reading of Adam Smith in which social and political contexts of economic sentiments were left aside, to highlight only the maximizing of gains as the natural behavioral inclination of men, including primitive men.[1] Malinowski argued against this position by pointing out that the value of the Kula exchange derived from the human skills that were involved in carving the necklaces and bracelets and in organizing the elaborate ceremonies in which the exchanges took place. Nevertheless, it could be argued that since such skills were not plentiful, this would not necessarily contradict the economic view that it is scarcity, the exercise of preferences, and the multiplicity of ends that create value. Indeed, as Raymond Firth (1946) said a few years later in his study of Malay fishermen, when a man chooses social gains rather than economic gains he is still choosing between alternative ends. The fact that the observer would have done it differently does not make his behavior noneconomic. These first functionalist explanations of value were not conclusive, but they did establish the ground for the substantivist-formalist debate of later years (discussed further in the following).

It is worth mentioning that in the United States in the 1940s Clyde Kluckhorn did attempt to place values at the center of anthropological theory. His central assumption was that values are "conceptions of the desirable" that play a role in influencing choices people make or more specifically what they *ought* to want.[2] However, his Rimrock study, which looked at the "value orientations" of five different groups, failed in that it ended up reporting values that were highly idiosyncratic, making a systematic comparison impossible. The lack of results, in the words of David Graeber (2001: 4), "was all the more frustrating because Kluckhorn saw his project in many ways (as) a last ditch effort to rescue American anthropology from what almost everyone perceived as the theoretical doldrums."

Karl Polanyi's (1944) classic book *Great Transformation* then set the new terms of the debate on "forms of integration" in society, focusing on values, motives, and policy. He gave his famous two definitions of economy: One, *substantive*, refers to the relationship between human and nature, to

[1] In recent years a new reading of Adam Smith by several authors, among them Emma Rothschild (2001), highlights the implications of Smith's mention of sentiments and freedoms in economic decision making as embedded in social and political contexts.

[2] The discussion of Clyde Kluckhorn's Rimrock study is taken from the excellent summary by David Graeber (2001).

material needs; the other, *formal*, is related to the logic of rational action, to a mechanism of the mind. Formal analysis, he stated, works for price-making market systems of Western economies because all goods and services have a price. The empirical economy is an "instituted process" that encompasses ecological, technological, and social concepts enmeshed in institutions. The recurrence in the process leads to three different forms of integration: reciprocity, redistribution, and exchange. Only the latter needs markets, while in the first two, social institutions fix the rate of exchange, not the market. Further distinction was then made between "gift" and "commodity" economies.

Polyani's ideas set the terms of reference of the debate in anthropology between substantivists (Raymond Firth, George Dalton, Paul Bohannan) and formalists (Robbins Burling, Scott Cook). For substantivists, economic motivations were trumped by social priorities in assigning value and exchange mechanisms, and their ethnographies provided evidence for this. For formalists, on the other hand, exchanges were still based on issues of scarcity and choice of alternatives, and goods exchanged could be considered a form of capital. The debate, which went on in the fifties and sixties, was laid to rest when it became evident that goods that are meaningful always have a quantifiable value – even if this is expressed in social or ritual terms – but that anything that has a price will have variations in its price according to the meaning attached to it. Nevertheless the main issues were never resolved but were reconceptualized in other discursive debates.

Introducing power into the discussion, Marshall Sahlins (1965) showed that chiefs and priests did not acquire prestige by consuming but by distributing surplus and that social inequality is brought about by economic roles rather than by differential accumulated wealth. A similar point was being made in the 1960s and 1970s in Mexican anthropology in relation to the "cargo system," a structure of hierarchical positions – topil, mayordomo, fiscal, and so on – through which surplus was redistributed in local village economies. The value of this system, I noticed in my own fieldwork, was that it allowed a redistribution not only of surplus but also of labor and balance of gender in residency among families within the community. In other communities, in which the subsistence economy slowly shifted toward cash crops, as in Amilcingo, the cargo system has become an institution that finances the cultural and religious life, fulfilling the symbolic needs of the community.

"Symbolic capital" was Pierre Bourdieu's (1979) contribution to the debate. In societies that do not have self-regulating markets, such as the Kabyle of Algeria, symbolic capital consists of norms of honor, gossip,

embodied codes, and other forms of cultural language. Bourdieu insisted that symbolic capital is much more important than economic capital, in spite of the fact that economic calculation extends to all these material goods as well.

According to David Graeber (2001: 26), the debates in anthropology were mainly about exchange in the 1960s, about production in the 1970s, and about consumption in the 1980s. He sets these shifts in the context of the dissolution of the vast social movements in the 1960s (except for feminism), the political rout of the Left beginning in the early 1980s, and the global rise of neoliberal ideologies. The emphasis on consumption during the 1980s drew attention to objects, to things as repositories of value, and fostered a new wave of "material culture studies." Inquiry then focused on the way objects become invested with what Annette Weiner (1994) called "dense" sociocultural meaning and value. Arjun Appadurai (1986) suggested that part of this value was given not only by Marx's idea that the labor invested in commodities gave them their essential value but also by the degree of desire that a person has for the object. This "politics of value" breaks down the gift/commodity opposition, since such a multiple value is to be found in things circulating in all societies irrespective of their economic regime. Value is to be found, then, in the "biography of things." However, it may also be subject to "slippage," as Fred Myers argues (2001: 5): "Indeed, the contrast between value as produced in organizations of difference ('qualitative' value) and value as a measure of relative price in transaction ('quantitative' value) may underlie significant dynamics within structures of social action." He goes on to analyze the value of art, which he considers has been situated in the West as a category of redemptive value, distinct from money and discrete from other sociocultural values. In parallel to the deconstruction of the gift/commodity opposition, the nonmonetary concept of art has been particularly visible, Myers argues, in the arena of cultural politics and class hierarchy within the West and may also be extended to regions beyond the West. "Clearly, the complexities of a global economy are shattering the conceit of art's autonomy from other spheres of social life" and of political values (2001: 8). He concludes that, particularly at present, because of the rapidity with which objects move through space and time, value is never simply defined but is always involved in global as well as local circuits of exchange, display, and storage.

By the end of the 1980s, anthropological perspectives had shifted to understanding the circulation of objects in multiple and broader systems of exchange pertaining to other domains. The value of things being exchanged, Annette Weiner (1992) went on, far from depending solely on calculations of

equivalence, was also related to "keeping-while-giving." That is, as an object was kept out of circulation, it accumulated higher desire for its possession and therefore increased in value. Marilyn Strathern (1992), on the other hand, focused on the way in which societies construct the importance or meaning ascribed to objects, particularly those used in ritual. As this author mentions, taking further Lisette Josephides's point that the value of objects includes the background labor of all those involved producing it, mainly women, she argued that value in nonindividualistic societies, such as those in Melanesia, is perceived as deriving from social relationships. The identity and value of objects and of persons are seen to arise from the way others in that society perceive them and build meaning collectively.

How do they build the meanings that give value? In answering this question, Nancy Munn (1986) broke new ground, overcoming problems of structuralist interpretation. She argued that value is always transformational, always a potential that is realized through actions. Instead of only looking at the way objects circulate in systems of exchange, she defined "levels of value" that allow those who participate an increase in degree of control over "intersubjective time" in social relations. The value is not captured in the object that is exchanged but in the "act of giving" an object. The latter is only the artifact through which those engaged in giving achieve their creative potentiality.

Structure in this sense is not a set of static principles but the way in which change is patterned, or, as Frederik Barth, Victor Turner, and other anthropologists would put it, the "invariable principles that regulate a system of transformations" (Graeber, 2001: 259). Graeber proposes a dialectical approach to defining things not in terms of what one imagines them to be in a certain abstract moment outside time, but partly by what they have the potential to become, a potential that they can only realize within a larger social whole. He contrasts this perspective with market theory, which starts out with the assumption that we are all unique individuals who have unlimited desires. The key move in market ideology, he states, is to extract all the most fundamental questions of desire from society so that it is possible to conceive of happiness largely as one's relations with objects, or, at best, people one treats as objects. Apparently, consumption becomes a solitary pleasure of consuming by oneself. In the model he proposes, consumption is the outcome of creativity in coordination with others. Only thus, he insists, do potentials turn into value.

To summarize, debates on value in anthropology have been grounded in the attempt to explain why societies differ in the ways they value different things and practices. In developing models to explain such diversity, the debates with economics have been particularly useful but inconclusive. The

new perspectives in anthropology, especially those of Marilyn Strathern, Nancy Munn, and David Graeber, have shifted attention to the social webs in which transactions occur, as realizations of creative potentialities.

9.3 Performing Rituals

We turn now to the central concern of this chapter – rituals and how they are valued. Ritual has been an important concern for anthropologists, mainly as one component of larger sets of behavior. I refer to ritual as a discrete cluster of actions performed for explicit ends related to biological, social, or religious events. These observable actions have been interpreted as a psychological and social mechanism to ease the human fear of the unknown (Malinowski) or as external symbolizations of collective ideas that periodically reinforce social cohesion (Durkheim). Ritual is declarative (Leach): it states something, thus distinguishing it from technical ceremonies, which do not state anything. Rites of passage, a classical theme of analysis, are a specific form of ritual that have been found to conform to remarkably similar patterns among widely dispersed cultures in ceremonies performed at birth, puberty, marriage, and death.[3] Each ceremony has a specific protective, propitiatory, acquisitive, purificatory, productive, or predictive purpose.

A ritual, in fact, makes beliefs, values, and sentiments visible, audible, and tangible, according to Victor Turner (1967), one of the most influential authors in contemporary analysis of ritual. Seen in this light, all physical movements and ritual objects used in the ritual are carriers, embodiments of ideas that constantly recreate symbols. The most important dimension of ritual, Turner argues, is the effect on the actor, the exegetical interpretation of a set of symbols that are "storage units" of knowledge. Rituals can then be seen as "Forests of Symbols," the title of his pioneering study looking for hidden symbolic meanings in ritual practices that could be interpreted by identifying patterns of color, gender, and body movements. Other authors have given primacy to the effect of rituals on social behavior. For example, Gluckman (1962) used it in this sense when he proposed that ritual serves to differentiate roles in multiplex social relationships. The greater the multiplicity of undifferentiated roles, the more rituals are used to distinguish among them.[4] In the end, he emphasizes the role of rituals in social etiquette, in regulating different forms of behavior outside the ritual space.

[3] The classic study on this topic is Van Gennep (1960).

[4] Rites of solidarity were widely associated with clans and other segmentary descent groups, one of whose multifunctions was to identify group members and set one group off from another. See further in Harris (1971).

All these authors were intent on explaining ritual by referring to its functions and to the metaphorical meaning of their symbols. Structuralists focused instead on the messages conveyed by rituals at the deeper level of unconscious structures. Basic mental structures, according to Lévi-Strauss (1963, 1975), could be discovered in all cultural manifestations, be they language, marriage rules, or rituals, since they are all forms of communication. For him the symbol is universal only because of its syntagmatic position, not its metaphorical sense. Other structuralist interpretations, such as those of Louis Dumont (1966), focused on structures related to political status, territory, ceremonial status, or gender roles.

Clifford Geertz (1973) proposed a more interpretive approach by looking at three components of rituals or feasts: their immediate dramatic shape, their metaphoric content, and their social context. He used the term *cultural performances*, considering them as "art forms" that generate and regenerate the subjectivity they pretend only to display. "Quartets, still lifes, and cockfights are not merely reflections of a preexisting sensibility analogically represented. They are positive agents in the creation and maintenance of such a sensibility" (Geertz 1973: 451). Having said that, he could see he had touched upon an irresolvable dilemma, and so he added the following footnote to the previous statement:

All this coupling of the occidental great with the oriental lowly (the Balinese cock-fight) will doubtless disturb certain sorts of aestheticians as the earlier efforts of anthropologists to speak of Christianity and totemism in the same breath disturbed certain sorts of theologians. . . . In any case, the attempt to deprovincialize the concept of art is but part of the general anthropological conspiracy to deprovincialize all important social concepts . . . and though this is a threat to aesthetic theories which regard certain works of art as beyond the reach of sociological analysis, it is no threat to the conviction, for which Robert Graves claims to have been reprimanded at his Cambridge tripos, that some poems are better than others. (ibid.)

This dilemma has cropped up ever since in discussions on the value of cultures in development. In the 2000 *World Culture Report* we took the view that while not all components in cultures may be valuable and worth conserving, all cultures have something that is of value (Arizpe et al. 2000).

At present, ritual is discussed mainly as performance, as embodied actions that create communication among performers and public. But Graeber (2001: 259) argues that ritual-patterned actions are elusive "because social performance is usually considered truly artful and accomplished . . . largely to the extent that it can make those structures – the templates, or schemas, or whatever you wish to call them – . . . that lie behind it disappear." He claims that a ritual performance creates a kind of power, a "ghostly reflection of

one's own potential for action." These forms of imaginary totalities, made up of "creative potentialities," he says, "tend to end up inscribed in a series of objects that, insofar as they become media of value, also become objects of desire." He goes on to say that this potential cannot realize itself, at least, not in any particularly significant way, except in coordination with others. "It is only thus that powers turn into value."

As the discussion in the previous pages has shown, the richness of anthropological contributions to the understanding of value and ritual makes it difficult to narrow down the focus with which to analyze the case to be discussed in the remainder of this chapter. I will therefore center my analysis in ritual as a constantly evolving art form whose total meaning cannot be apprehended, either by insiders or by outsiders, although both have access to different "levels of value" of the ritual. I will also make the assumption that the value of the ritual must be sought in the relations it creates among those involved in it, rather than uniquely in its objects and displays, and in the meaning that is created collectively.

9.4 The Day of the Dead

The case I will analyze is the valorization that local people give to the ritual of the Day of the Dead in Amilcingo, a rural village two hours away from Mexico City, located on the slope of the Popocatepetl volcano. Old people in the village still speak Nahuatl, the Aztec language, and the community still reveres Emiliano Zapata, the peasant leader who lived in a nearby region. The ritual, which has Aztec and Catholic roots, has evolved into a Mexican ritual that is now observed by all social groups and even by Mexican migrants in the United States. Rural villages in the region of Amilcingo, however, have a special night a week earlier than the Day of the Dead, called the Day of the Slain (Dia de los Matados). On this day, October 28, starting at 12 a.m., the families who have lost one of their members during that year as a result of murder, or in some cases an accident, set up an arch of reed and flowers at the entrance of their home and receive visitors carrying an offering (*ofrenda*). Usually the younger women of the household or nieces step out to the arch and receive the vase (see Figure 9.1) and bid the newcomer welcome, then they both enter the room where the altar has been set up. The kind of offering given is strictly prescribed by degree of kinship or ritual friendship (godfathers and godmothers, or godchildren), but also by the income level of the giver. The former give a pitcher with all the flowers and a candle. Those further away in kinship or friendship give only flowers and candles and no pitcher. People are expected to give a quantity equivalent to their

economic status, but it is regarded as very bad for people to give too much, since this is taken to mean that they are showing off, a fault that is doubly disapproved in the context of relations with the dead. If a young child or teenager gives the *ofrenda*, a clear message of detachment is sent; if instead the elders of the family give the *ofrenda*, it is a sign of great deference. The offerings consist of earthenware vases filled with marigolds (*cempoalxochitl*, which means "twentyflower" in Nahuatl), flowers of a deep orange and yellow, or flowers of dark, gnarled mauve; white gladiolus flowers; and light green stems with tiny white flowers aptly called "clouds" (*nube*). Women are responsible for arranging and placing the flowers in the home, taking care to create a harmony in the colors, in the placement of the candles, and in the display of foodstuffs and fruits.

The preparations for setting up the altars in the houses, however, begin the night before. In families that are relatively affluent, many kinspeople and friends are invited to join in the making of the tamales (maize bread) – the women – and in cutting up the meat – the men. The children rush about on errands, or work at small tasks, or play. The evening goes far into the night and its products, tamales and other savories, are piled up on the altar. Altars have a strict code of display, which may be enriched by the quality of items presented in each space (see Figure 9.2). Colored cutout paper may frame the altar, which has, at the highest and most central spot, the photograph of the *difunto*. The closest equivalent of this term in English is "departed." In Spanish, the word *muerto* means "dead," but it refers indistinctly to all who have died; it is generic and implies nonexistence. *Difunto*, instead, refers to an entity that continues to exist after it has died. People speak of the Difunta Emiliana or Difunto Pedro as someone who still has a personality, who is still active in family affairs. A woman stunned by the recent death of her husband simply spoke about him as if he were still there, and during the night at the cemetery she was laughing with others in joking about how he would become angry at the songs they were singing. When I visited her a year later, on the Day of the Dead, it was only then that you could see she had finally come to terms with his death. And, again, she was encircled by the members of her extended family.

The person receiving the offering takes the visitor into the main room, where the altar is, and turns to speak to the dead person saying, "Look, Pedro [the name of the dead person], *aqui te trae Lencha* [the name of the person offering the flowers] *estas flores*" ("Pedro, here Lencha brings you some flowers"), or alternatively tamales, or loaves of the special Day of the Dead bread, or other foodstuffs or candles. Among the people in the household there is a strict protocol of who receives, escorts, and chats with

the visitors. By gender and age groups they have specific roles to play. Girls run around inside doing chores; boys run around outside doing errands. They watch closely and slowly learn the protocol. By moving up into the vertical templates that mark their conduct at every age, they grow into the society as they grow into their bodies. The protocols give form to the progressive embodiment of the ritual in their own lives, giving them a sense of who they are, what is expected of them, and who everybody else is. The conduct of every person during those days of ritual becomes a mirror for everybody else – a mirror of the potential help, solidarity, and commitment, or, to the contrary, of detachment and indifference, that can be expected of them.

The visitors stay for a moment, speak to members of the household, then leave. If they are next of kin they are expected to stay longer, sometimes just sitting in the room, without saying a word. And they expect to be offered a special kind of tamale without any other foodstuffs. All actions and attitudes are clearly codified. This goes on the whole day. The same scene is repeated three days later beginning on November 1, the night of the "Tiny Dead" (*Los Muertos Chiquitos*), that is, the children who died. At 12 a.m. families who have lost a child to illness or whatever other cause set up the altar in their houses and may receive offerings. The same scenario is repeated on November 2, the night of the adult dead.

The photograph of the *difunta* or *difunto* is a new feature of the altars. So are cigarettes or Pepsi or tequila bottles, that is, anything the *difunta* or *difunto* liked. Their favorite dishes are also cooked and placed in the second tier of the altar; it is said that the *difuntos* eat the dishes through the aroma and vapor they send out.

The altar is itself called an *ofrenda* to the *difunto*. The bereaved speak of the beauty of their altar with great pride, as a symbol of how much they loved the person. But those from outside the household also judge the beauty of the *ofrenda* in relation to the relative wealth of the family. Poorer families will have more modest *ofrendas*. But this is where the commitment of the extended families and kin comes in. If a person was greatly admired or loved in the community, offerings will be plentiful. In this case money is used to express feelings for the departed or solidarity with the family.

When I asked a question that I knew was both indiscreet and out of order, that is, how much money the *ofrenda* for the *difuntos* had cost, people were confounded. They are not accustomed to thinking in terms of adding up toward total costs of anything, much less a ceremony dedicated to a higher purpose. Yet, at the same time, they are keen on judging the *ofrendas*. Relatives and neighbors visit several *ofrendas* during four days and are able to

rank them clearly. The ranking is expressed in aesthetic terms: *la del difunto Pedro quedo muy bonita* ("the one of the *difunto* Pedro is very pretty") or *la mas bonita, pero bonita deveras, fue la de los Sanchez* ("the prettiest, but, really, the most beautiful, was that of the Sanchez"). The term *bonito* ("pretty") is actually a blanket term to cover many valuations: of the aesthetic quality, the money invested, the number of offerings, the care that went into preparing the altar, the special touches put into it. The assessment will clearly contribute to the family's social standing, their political status, and perhaps their economic level. But most of all, the relative "prettiness" of an altar reflects the number of people willing to contribute and so reflects the potential commitment that that family, or that person who died, could call on. This is what gives power and standing and prestige to a family.

On November 2, the Day of the Dead itself, people take offerings to a house and stay on into the afternoon. Drinks are passed around, and talk about the *difunto* or community matters goes on for hours. Teenagers come and go; children disrupt constantly. As the sun sets and night begins to fall, the more people in the house the better. Nancy Munn[5] would say it shows the whole village the breadth of their control over the intersubjective time of a large number of people. This becomes very visible because they all go in procession to the cemetery. Each person takes two or three vases of flowers and slowly walks toward the cemetery behind the "godparents of the cross" (*los padrinos de la Cruz*), who must pay for a brand new cross for the tomb every year. As dusk falls, processions cross through the village, candles all lighted, silently, with only the shuffling of feet to be heard, watched by everyone out in the street. Again, the amount of information carried in these processions is enormous: who is loved and who is not, who is loyal to what family, which daughters or sons walk with their parents, and, very importantly, who is missing and why. As they go by, everybody assesses the number of people and of offerings; in effect they are assessing the degree of commitment of those in the procession and the degree of prestige of the family concerned.

At the entrance of the cemetery there is a big, bright fair, contrasting with the solemnity of the processions. Teenage boys stand in one corner, eyeing the girls and defying traditions with their stuck-up gelled hair and their American rap shirts bought by their brothers in the United States. All processions enter through the flowered arches of the cemetery walkway, which ends at a centrally placed simple altar. Then they break out toward the tombs of the *difuntos*. The tombs have been cleaned of weeds – except a significant few – so the *padrinos de la Cruz* set about arranging the flowered

[5] See, for example, Munn (1992).

vases in agreeable patterns on the tombs. Then they light the honey-colored candles and the cemetery becomes enchanted. The suffused lights are caught in the dense orange petals of the *cempoalxochitl* and the wisps of white as shadowy figures move around the tombs (see Figures 9.3, 9.4, and 9.5). One enters into a state of otherness, away from the reality of colors into a softer, somberly lighted almost otherworld. Yet, there are so many people. Children race around the tombstones, make Halloween masks with the clay pots, and light fires, and no one minds. Elderly women sit on tiny chairs, with infants taking turns to sit on their laps. Chatting creates a constant hum, broken when the mariachis encircle a tomb and sing for the departed. In one tomb, with only one flowered pitcher, a lonely woman sits, with a daughter lying in the dust. As one walks around, suddenly among the tombs there is a darkened space with tangled weeds where no one is chatting with the departed. "Those are the tombs of the brothers, of those who have separated," a woman explains matter-of-factly. She is referring to the Evangelists, whose numbers have grown in recent years in the village and who deliberately stay away from villages' rituals and fiestas.

9.5 Interpreting the Ritual's Value

A monetary estimate of the value of the Day of the Dead ritual can certainly be made in terms of the quantity and quality of the materials used. It is my contention, however, that the value of the *ofrenda* is more appropriately assessed in terms of the *commitment* of people making the offering. This special "level of value" reflects, on the one hand, the free will – *la voluntad* – of members of the extended family to ensure that the altar, the *ofrenda*, the setting of the *ofrenda* in the tomb, are aesthetically beautiful and reflect their economic standing. It means that the sisters, daughters, nieces, cousins, and women friends with the help of the children have given extra care in framing and displaying the *ofrenda*, and that the men have pitched in to pay for the immediate families' *ofrendas* and meals. Significantly, neither the widow nor the widower partakes in the work involved but is expected, nevertheless, to greet and receive the condolences of all those who arrive. It also includes the labor put in by kin, ritual kin, friends, and neighbors, mainly in spending the previous night preparing the food, as a sign of commitment toward the family.

When the family is poor, people may comment that *esta pobrecita la ofrenda* ("the offering is poor") but will refrain from further criticism. However, if it is considered that the family does have enough money, especially the sons and daughters, to pay for a better *ofrenda* and that they did not, then criticism falls harshly, because this indicates a failure of will. When I asked an elderly woman why she thought the *ofrenda* in a house was not

beautiful enough, she replied, *Es falta de voluntad, es egoismo, y Dios los va a castigar. Porque Dios le da a quien da y le quita a quien no da* ("It is a failure of commitment; it is selfishness and God will punish them. Because God gives to him who gives and takes away from him who does not give").

Commitment is also expected from the extended families linked through affinity or ritual kinship and from other families in the village linked through ritual kinship, favors (such as help given in difficult times), and debts. The degree of popularity or of love and affection for the *difunta* or *difunto* is also important, but close observation shows that this person-to-person commitment adds only a minimal variation to the overall level of value of the family's *ofrenda*.[6] In a society that emphasizes collectivity rather than individualism, it can be said that it is the family's standing rather than the personality of the *difunta* or *difunto* that is assessed in the ranking of the *ofrenda*.[7]

The question of commitment also extends to the aesthetic dimension of the entire ritual. Beauty is deliberately sought, in the framing of the ritual, in the forms of display, in the combination of colors, in the softness of speech, in the music, in the serenity of sitting, in the ceaseless movement of children. "What do you think of this fiesta?" I asked during the long shadowy vigil at the cemetery. "Oh, this year it is very beautiful, more than last year," a woman answered, "because people all brought much flowers and much candles; look how pretty they look. And there is much music." Another woman interjected, "Yes, this year there was more money." But the point is that people could have used that money alternatively.

The long biography of rituals in anthropology and my analysis of the ritual of the Day of the Dead in Amilcingo now lead me to reverse the initial question in this chapter. Asking why people value rituals is to reify both

[6] They choose the colors of the cutout paper, the flowers, the napkins, the plates, and the vases that are set on the altar. In the case of new *difuntos*, all items have to be new. The *ofrenda* is framed in a certain way by placing it against a wall or in the corner inside the main room of the house, which may also be the main bedroom, or in an outside terrace. They first place the vases and the candle holders in strategic ways. Then they are careful to display the items in a certain order, i.e., first the food, then the bottles of liquor or soft drinks, then specific things the *difunta* or *difunto* liked, such as cigarettes of their preferred brand. Then they set the new mats on the floor, on which they, the women of the house and only they, place the *ofrendas* to be given by kin and friends.

[7] Analysis could be extended on this point but for the purposes of this chapter suffice it to say that there are basically three forms of prestige for individuals and families in the village. The highest value is given to social prestige, which is earned through giving service to the village, creating an intense web of giving and receiving by the male head of the family based on the social connectivity and labor of the women in his household. Second, prestige is usually also connected with political standing, when local and municipal office is held. The third way of gaining prestige is with wealth.

people and rituals as if they exist independently of each other. This is, I believe, a basic flaw in economic thinking, which always takes "people" or "individuals" as a given without asking how they came to be constituted. Anthropology, instead, starts out by asking how they come into existence as "individuals" or "people." That question also reifies value as something that can be placed on something rather than as something that is created through thought, performance, or action. Thus I would now restate the question as, How do rituals create value that makes people think of themselves as individuals or collectivities? I contend that a collection of persons cannot think of themselves either as individuals or as a collectivity unless they feel they belong and have reciprocal loyalty and commitment toward others in their immediate and larger group of reference. Realizing this potential loyalty and commitment is possible only by participating in social practices such as ritual. This would explain the sudden proliferation of rituals of all kinds in a globalizing world in which lone individuals, supposedly happy with consuming more and more, are rushing toward reconstructing identities and social ties. A ritual such as that of the Day of the Dead structures intersubjectivity so that sentiments of belonging and loyalty are reinforced, making each individual renew his or her commitment to the networks of kin and community by performing expected roles and, very importantly, sustaining the promise that such loyalty will continue in the future. But I would also say that if you exchange the word *loyalty* for the word *love*, you will be closer to what actually is exchanged in such rituals. In the case of the rituals of the Day of the Dead the added dimension is the iteration of narratives about death and the "beyond" (*el más allá*).

The preceding analysis suggests, as Marilyn Strathern (1992: 190) posited, that value is always transactional. The ritual of the Day of the Dead is ephemeral. If you walk around the cemetery a few weeks later, you brush against dusty dried flowers and crushed pots, but the strengthening of ties is still there and is extremely important in lessening intracommunity conflict, facilitating conflict resolution, and alleviating bereavement. This is why changes to it that may seem inauthentic to an outsider are not important. I witnessed a spirited debate between two 15-year-old girls who were participating in a contest of decorated altars organized by the school. One argued heatedly that the altars had to be decorated "as the ancients did them, and Pepsi-Cola did not exist at the time of the Aztecs."[8] And the other replied,

[8] "Se tiene que hacer como lo hacian los antiguos y en el tiempo de los Aztecas, voy a creer que habia Pepsis." "Pero ahora ya la gente les pone Pepsis y si eso es lo que toman, eso es lo que toman. Tampoco les ponian cigarros." "Pero si tenian tabaco, habria que ponerles hojas de tabaco!"

"But people today put Pepsis in their altars and if this is what they drink, this is what they drink." As I asked other adults about this, they simply did not think it made a difference, as long as the major components (the special flowers, vases, and candles) were there.

Outsiders are now taking a greater interest in this ritual because the loss of intersubjective forms of relating in a market-driven urban society, which people usually refer to as "loss of culture or tradition," produces a nostalgia that sends people in search of seemingly authentic cultures. Authenticity is becoming important because of the financial intentions of outsiders, especially the media and some transnational companies. People in the Mexican communities now know that a video of their rituals and celebrations can earn millions in the media or in commercial advertisements, and they are very angry about it. To that must be added cultural tourism, which creates a dilemma: Impoverished villagers or cultural groups need the revenues from tourism, but tourists want something that looks nice and not poor, authentic and uncontaminated. So the rituals are, in a sense, cleaned up. Those used for such purposes are now acquiring a value that is tied to what outsiders want to consume.

So the Day of the Dead ritual will have, at the very least, four different "levels of value." First there is the basic value of the ritual as a realization of the promise of commitment for members of a village or community. Second, it has a value as an icon of Mexican culture that is being revitalized as a representational emblem in the context of globalization. Third, the ritual has a commercial value as entertainment for tourists or as events that can be sponsored by, say, beer or soft-drink companies to further the selling of their products and their hold on culture as image. The fourth level has just been inaugurated by the inclusion of the Day of Dead in the UNESCO list of Masterpieces of Oral Traditions and Intangible Heritage, where it has acquired a new metonymic value alongside other masterpieces of all regions of the world.

9.6 Conclusion

This chapter has discussed the differences between anthropological and economic interpretations of value and has explored alternative approaches to the valuation of ritual in the context of the Day of the Dead ritual in Amilcingo, Mexico. In one sense the contrast between the cultural and the economic value of this ritual might be seen in the way in which people either construct a value for their own purpose or flatten the ritual into an image that has value in the market. But my contention is that the cultural value

of the ritual could be recognized in something that I would call *interaction value*, defined as the creation of value through the interaction between individuals or communities that creates or reinforces commitment, understanding, and tolerance. As such, it is not instrumental in that it is not geared toward achieving a particular goal. It is the interaction itself that is the goal, understood as the basic substance that society is made of. Nor is it strictly an exchange since there is not necessarily a give and take; rather it might simply consist of listening or talking, or just being there but together. Rituals have been called "meditations on a difficult reality" (Graeber 2001). I would then call the Mexican ritual of the Day of the Dead a "meditation on life and death."

Thus, to put it succinctly, the attempt of economics to comprehend the value of culture is futile because there is so much more in culture that lies outside the realm of exchange and valuation. If economics is about doing business, and art is about doing society, I would say that culture is about doing life: that is, how life, in a social sense, is created and sustained and, therefore, how living persons are constituted.

References

Appadurai, Arjun. 1986. *The Social Life of Things*. Cambridge: Cambridge University Press.

Arizpe, Lourdes. 2001. Cultural Heritage and Globalization. In Erica Avrami et al. eds., *Values and Heritage Conservation*, 32–37. Los Angeles: Getty Conservation Institute.

Arizpe, Lourdes et al. 2000. Diversity, Conflict and Pluralism. In *World Culture Report*. Paris: UNESCO.

Arizpe, Lourdes. 2004. Intangible Cultures Heritage: Diversity and Coherence. *Museum International* 221–222:130–137.

Barth, Frederik. 1966. *Models of Social Organization. Royal Anthropological Institute Occasional Paper 23*. Glasgow: Royal Anthropological Institute.

Bourdieu, Pierre. 1979. *Outline of a Theory of Practice*. Cambridge: Cambridge University Press.

Dumont, Louis. 1966. *Homo Hierarchichus: The Case System and Its Implications*. Chicago: University of Chicago Press.

Firth, Raymond. 1946. *Malay Fishermen: Their Peasant Economy*. London: K. Paul, Trench, Trubner.

Geertz, Clifford. 1973. *The Interpretation of Cultures*. New York: Basic.

Gluckman, Max. 1962. *Essays on the Ritual of Social Relations*. Manchester: Manchester University Press.

Graeber, David. 2001. *Towards an Anthropological Theory of Value*, 2–5. New York: Palgrave.

Harris, Marvin. 1971. *Culture, Man, Nature*. New York: T. Cromwell.

Lévi-Strauss, Claude. 1963. *Structural Anthropology*. New York: Basic Books.

Lévi-Strauss, Claude. 1975. *La Voie des Masques*. Paris: Flamarion.

Malinowski, Bronislaw. 1922. *Argonauts of the Western Pacific: An Account of Native Enterprise and Adventure in the Archipelagoes of Melanesian New Guinea*. London: Routledge.

Munn, Nancy. 1986. *The Fame of Gawa: A Symbolic Study of Value Transformation in a Massim (Papua New Guinea) Society*. Cambridge: Cambridge University Press.

Munn, Nancy. 1992. The Cultural Anthropology of Time: A Critical Essay. *Annual Review of Anthropology*, 21:93–123.

Myers, Fred, ed. 2001. *The Empire of Things*. Santa Fe: School of American Research Press.

Polanyi, Karl. 1944. *The Great Transformation*. New York: Rinehart.

Rothschild, Emma. 2001. *Economic Sentiments: Adam Smith, Condorcet and the Enlightenment*. Boston: Harvard University Press.

Sahlins, Marshall. 1965. Sociology of Primitive Exchange. In Michael Banton, ed., *The Relevance of Models for Social Anthropology*, 139–236. New York: Praeger.

Strathern, Marilyn. 1992. Qualified Value: The Perspective of Gift Exchange. In C. Humphrey and S. Hugh-Jones, eds., *Barter, Exchange and Value: An Anthropological Approach*, 169–191. Cambridge: Cambridge University Press.

Turner, Victor. 1967. *The Forest of Symbols*. Ithaca, NY: Cornell University Press.

Van Gennep, Arnold. 1960. *Rites of Passage*. Chicago: University of Chicago Press.

Weiner, Annette. 1992. *Inalienable Possessions: The Paradox of Keeping-While-Giving*. Berkeley: University of California Press.

Weiner, Annette. 1994. Cultural Difference and the Density of Objects. *American Ethnologist* 21:2391–2403.

TEN

"More than Luther of These Modern Days"

The Construction of Emerson's Reputation
in American Culture, 1882–1903

Richard F. Teichgraeber III

10.1 Introduction

Contemporary historians are routinely asked to explain how certain ideas, individuals, and practices happen to gain great cultural value. They often respond by employing the concept of "social construction." In explaining why Ralph Waldo Emerson (1803–1882) has been such a highly revered figure in American culture, this chapter traces the outlines of a story that not only has taken place in time, but has also entailed construction in the literal sense – an actual assembly of various parts of the story in particular stages, as well as a temporal process in which later stages were built upon, and out of, earlier stages.

All construction stories are guided by the concept that value is never just a matter of natural ability or talent. Yet, as Ian Hacking (1999)[1] has pointed out, this apparently simple concept allows for various grades of commitment. The most controversial argues that we should abandon the notion of evaluation as a neutral account of objective qualities and accept in its place one that sees evaluation as invariably contingent on personal interests and needs. Less contentious is a historical grade of constructionism wherein intellectual historians (among whom I number myself) employ the concept of social construction as a heuristic device. They view enduring reputations more as empirical phenomena than as objects of suspicion. And the stories they tell about enduring reputations typically include careful reconstructions of a dynamic process made up of distinct stages, as well as discussions of what objective factors over time would justify the reasons for endurance.[2]

[1] My understanding of the possibilities and limitations of construction stories is much indebted to Hacking's (1999) provocative account.

[2] Among many possible examples of this approach, see Collini (1991).

Reputations endure in various ways and for different reasons; hence not all construction stories are the same. What interests me about the history of the construction of Emerson's reputation is the powerful light it sheds on the much larger story of how Americans have gone about the work of building a national culture. I leave it to others to speculate about whether the prominent role Emerson long has played in this work is cause for celebration or complaint.[3]

10.2 The Emerson Centenary

"The pathos of death," William James (1842–1910) observed at the start of his address at the celebration of Emerson's centenary in Concord on May 25, 1903, "is that when the days of one's life are ended, those days that were so crowded with business and felt so heavy in their passing, what remains of one in memory should usually be 'so slight a thing.'" But the Emerson who remained in James's memory was an obvious exception to this rule – not "so slight a thing," but one of a select few whose "singularity gives a note so clear as to be victorious over the inevitable pity of such a diminution and abridgment." A living, embodied figure who once walked Concord's streets and country roads, awaiting "the beloved Muse's visits" in its fields and woods, had departed some 20 years earlier. But his "soul's note" and "spiritual voice," James proclaimed, still rose "strong and clear above the uproar of the times" and seemed "destined to exert an ennobling influence over future generations."[4]

Certainly James knew that an Emerson centenary celebration held in Concord's Town Hall was hardly the occasion for doubt concerning Emerson's posthumous reputation. Optimistic forecasts about his staying power also must have looked like a safe bet in 1903, since an important part of what made Emerson a still active presence in American culture – numerous well-placed Americans across the country who could say (like James) that they had actually seen Emerson, or spoken with him, or in some fashion experienced his "ennobling influence" – had yet to pass from the scene. Even so, the particular terms James used in characterizing what he remembered of Emerson's "singularity" deserve some scrutiny: the immediate identification of Emerson as the pride and ornament of Concord (then

[3] On the construction of Emerson's reputation during his lifetime, see Teichgraeber (1995, 1999).

[4] "Address of William James," in *The Centenary of the Birth of Ralph Waldo Emerson as observed in Concord, May 25, 1903* (Social Circle in Concord: Cambridge, 1903) 67.

already well-established as America's first shrine of literary tourism), the subsequent omission of any mention of his remarkably long public career as a lecturer and writer, and the identification of Emerson as a reclusive "artist" and "spiritual seer." These qualities, according to received scholarly accounts, must be regarded as characteristic elements of a late-nineteenth- and early-twentieth-century view of Emerson that centered in a reverent idealization of his personality and life. At that time, Emerson's authority rested apparently on what Charles Eliot Norton (in his Concord centenary address) called the "consistent loftiness" of his character. And James's invocation of the "ideal wraith" of Concord seems to reinforce a still familiar two-part story about the ascendancy of Emerson as America's first secular saint and an accompanying delayed recognition of the full complexity of what he had accomplished during his lifetime.[5]

While these sentiments have some measure of truth, Emerson's enduring reputation can also be explained by his status as a "reformer" and his ubiquitous presence in mass-marketed publications during the two decades immediately following his death. "It was in college that I read [Emerson's] books and reread them," and "came gradually to recognize him as being what he was, the most resolute reformer not excepting [William Lloyd] Garrison, whom our nation has produced." Putting Emerson at the head of the long line of nineteenth-century American reformers is only the more conspicuous of two important factors discussed here. William James had mentioned in passing that the struggle against slavery had "appealed" to Emerson. Anyone listening closely to his remarks, however, heard nothing of the many books Emerson published over the course of his lifetime, let alone of the flood of inexpensive new editions of his work that had appeared during the two decades following his death.

The author of this text-driven and more politically charged characterization of Emerson was Thomas Wentworth Higginson (1823–1911), who immediately preceded James on the stage in Concord. Some 19 years older than James, Higginson was himself something of a long-standing American reformer. In the 1850s he had led demonstrations in Boston against the Fugitive Slave Law and was part of the "Secret Six" cabal behind John Brown. After the Civil War, during which he commanded the first regiment of freedmen in the Union army, he had become a vocal advocate of women's rights as coeditor of the *Woman's Journal* (1870–1884). In recounting Emerson's record as a reformer, Higginson emphasized that he had been "not merely a technical reformer, but stood to the world as a vital influence and represented the

[5] For a recent restatement of the standard account, see Mitchell (1997).

general attitude of reform." It was "Emerson, and he only" who was "more than Luther of these modern days." The picture of him that lingered most vividly in Higginson's mind was not that of a reclusive artist, but rather that of a passionate fellow abolitionist whose writings, early in the Civil War, had inspired freed slaves under Higginson's own command.

Higginson's Concord address, it is worth noting, repeated more widely circulated remarks he had published two days earlier on the front page of the *Boston Daily Advertiser*, where he also had complained that Emerson's identity as one of America's preeminent democratic reformers appeared to be fading from sight. Underlining what he took to be the generally conservative character of the two most popular biographies of Emerson – those by Oliver Wendell Holmes and James Elliot Cabot – Higginson voiced his distress over their "constitutional reticence" in discussing Emerson's once prominent role in both the antislavery and women's movements. He faulted Cabot's biography in particular for failing to mention the "well-known fact" that Emerson had spoken several times at woman suffrage conventions, "and this cordially and sympathetically."[6]

Higginson's remarks hint at the more eventful narrative I trace in this chapter. They do so inadvertently, however, because no elaborate historical investigation is needed to show that there was little ground for the complaint Higginson voiced in the *Boston Daily Advertiser*. Nine days before the Concord celebration, for example, in a testimonial commissioned by the editors of *Harper's Weekly*, William Dean Howells had proclaimed that Emerson stood "next after Lincoln" as chief "interpreter of the American spirit." Similar sentiments were voiced at Emerson centennial celebrations outside Concord. In Boston's Symphony Hall, Harvard's president, Charles W. Eliot, praised Emerson as an early advocate of many of the reforms that had come to define the progressive reform movement. Similarly, John Dewey argued in a paper at the Emerson Memorial Meeting held at the University of Chicago that he was best remembered as "the Philosopher of Democracy." Emerson had stood for "restoring to the common man that which in the name of religion, of philosophy, of art and of morality, has been embezzled from the common store and appropriated for sectarian and class use." Finally, alongside Higginson and William James on the stage at the Concord celebration were two other figures who certainly had not forgotten Emerson's services to the cause of reform. The Wellesley College president, Caroline Hazard, reminded listeners that "the dignity" that Emerson "gave to the individual with his call to awake and arise – this splendid call to personality – sounded

[6] *Boston Daily Advertiser*, May 23, 1903, p. 1. On Higginson's career, see Edelstein (1968).

not only for men but for women." Similarly, Moorefield Story, onetime sec-
retary to the venerable abolitionist senator Charles Sumner, and by then a
well-known leader of various reform movements and spokesman for Negro
rights, used the occasion to condemn the persistence of racism in American
society, telling the Concord audience that it could be viewed as a failure to
express a "living faith" in the ideas of the man they had gathered to honor
(Howells 1903).[7]

This list of prominent examples could easily be extended. What is inter-
esting here, however, is not simply the fact that Emerson's popular iden-
tity as a champion of democratic reform was not, as Higginson feared,
fading from sight in 1903. Rather it is that even among Emerson's most
well-placed admirers, the broader question of what made him a figure of
enduring value invited responses that hardly seem compatible. How could
Emerson have been essentially both an artist and a democratic reformer?
An angelic presence and a committed abolitionist? An "ideal wraith" who
hovered over Concord and the "more than Luther" of the entire mod-
ern era? The contrast between these characterizations also serves as my
point of departure in exploring neglected peculiarities in the construc-
tion of Emerson's posthumous reputation. This chapter does not pre-
tend to offer a full survey of various interpretations of Emerson's life
and writings in the late nineteenth and early twentieth centuries, still less
an analysis of his "ennobling influence" in this period. Instead, it aims
to draw attention to certain decisive developments within the institu-
tional organization of American culture that allowed Emerson to remain
a highly valued figure during an era of fundamental cultural and economic
change. It also attempts to account for some of the substantially differ-
ent reasons why various groups and individuals continued to find value
in "Emerson" as they attempted to secure or negotiate their own cultural
identities.

10.3 First Stages in the Construction of Emerson's Posthumous Reputation

During the decades immediately following Emerson's death, there were three
successive stages in the relationship his name and writings had with various
culture-bearing entrepreneurs and institutions of that period. The first was
that in which the iconic status of his name was sustained and enhanced by
the activities of a variety of individuals and groups, ranging from personal

[7] See further in Eliot (1926) and Dewey (1929).

friends and admirers who made Emerson into a cultural cause – "Emerson-idae," James Russell Lowell called them – to newspaper and magazine editors for whom reporting about Emerson's career and work simply remained a form of popular entertainment. During the 1880s and 1890s, Emerson was what one contemporary called an "accepted fact" in American life, a figure who seemed to stand entirely on his own and whose "magic touch" in various ways had helped countless "thoughtful people" grapple with the great problems of life.[8] That Emerson continued to have some currency in this way well past the turn of the century – he was, essentially, America's first great cultural sage – raises some important questions about standard notions of how the social construction of his reputation has worked over time.

During the second stage, Americans were invited to consider Emerson's significance against the backdrop of a sudden and explosive growth in the available supply of his writings. While late-nineteenth- and early-twentieth-century views of Emerson were considerably less text centered than our current understanding, a considerable variety of evidence shows that it was during the late 1880s that his essays and poems first became available in anthologies, books, and pamphlets that were priced and distributed for sale on every level of the American literary marketplace.

The third stage was that in which widespread classroom study and academic specialization began to figure in the building of Emerson's reputation, as he was now increasingly identified as a figure whose career and writings had helped to give rise to the tradition of "American literature." His presentation as a founding author of distinctively American literary texts depended on a variety of new cultural institutions and practices, ranging from steady expansion of enrollments in American public high schools to the establishment of English departments at elite American colleges and universities. By the turn of the century, dozens of literary anthologies and textbooks were carrying Emerson directly into American classrooms, where he has remained a fixture ever since.

There is not space here to explore each of these stages in detail, or to discuss how they overlapped chronologically. But if asked to choose which was the most important in enhancing Emerson's reputation, I would pick the second one. Broadly speaking, one can speak of this development as Emerson's posthumous ascendance in a new cultural domain created in the late 1880s and early 1890s by inexpensive books and also (although to a lesser extent) by mass circulation magazines. The section that follows explores this stage in some detail. The chapter concludes with a brief explanation of why I believe

[8] See Bellows (1876).

that early efforts to promote professional academic study of "American literature" initially played a limited role in maintaining Emerson's hold on the American public.

10.4 Emerson and the Rise of Mass Print Culture

We have come to see the last decades of the nineteenth century as a time when a new kind of culture was forming in America. For simplicity's sake, historians speak of this transformation as the creation of a mass print culture – a sweeping change that saw the mass production of books, magazines, and newspapers flourish for the first time, and ordinary and affluent Americans alike come to live in an environment increasingly permeated by the printed word and the printed image. Such a culture, to be sure, had begun to form during the antebellum era, when, thanks to the development of the telegraph, New York newspapers like the *Herald* and the *Tribune* reprinted stories for readers around the country. By midcentury, books also were available everywhere, and in growing numbers. Initial press runs of 10,000 were not uncommon, and some first editions even went as high as 100,000. Between 1840 and 1856, the value of books made and sold in the United States tripled. With an accompanying drop in price, the sheer number of books in circulation increased even more substantially.

The emergence of a national audience habituated to reading newspapers and books inspired the development of new print media produced for a national marketplace. Important technological developments included the development of groundwood paper for books and more rapid methods of papermaking, which did not appear until the Civil War had ended. Beginning in the mid-1870s, these innovations allowed for dramatic reductions in prices of printed publications, which in turn prompted an even more sweeping cultural orientation that took shape as an enormous flood of cheap books – in both paperback and hard covers – swept through American society during the 1880s.

Precipitated by a steep decline in the price of paper after the war, the flood of cheap books began with a sudden proliferation of new "libraries" of paperbound, uncopyrighted British and French novels. Low prices were supported by other developments, including the physical uniformity of the books (all were in quarto, with two or three columns of very closely printed type on each page), elimination of royalties on books that either were in the public domain or were left unprotected by the absence of an international copyright law, and, perhaps most importantly, the fact that cheap reprints issued books for which regular publishers had already created a

national market. By the mid-1880s, with most cheap books selling for as little as 20 cents at news dealers or in dry goods stores across the country, the number of books in circulation began to reach astronomical figures. "Libraries" of inexpensive books also continued to grow in size, with nearly 1,500 titles added in 1886 alone. Their widespread sales persuaded some regular publishers to issue their own new series of paperbacks. In 1886, the peak year of what had become a fiercely competitive market in paperback publications, there were some 26 cheap libraries available to the American public, which included thousands of titles by both American and European writers. Growth in the actual numbers of books printed was even greater. One of the most successful of the first cheap library series – George Munro's "Seaside Library," launched in 1877 – delivered 5.5 million books to news dealers during the first two years of its existence. When the company was taken over in 1890, it is estimated that an inventory of nearly 30 million volumes had been sold.[9]

The historical emergence of American mass print culture during the last decades of the nineteenth century can also be traced by examining data on the sudden growth and development of America's first national magazines.[10] When passage of the International Copyright Law in 1891 brought an end to the large-scale production of cheap paperbacks, the nation's leading monthly magazines – *Atlantic, Harper's, Century*, and *Scribner's* – were all produced by leading publishing houses. They sold for a quarter or 35 cents. *Century* was the best-seller of the group, with a top figure of 200,000 for a single issue. Two years later, in the middle of the economic panic of 1893, a quick sequence of events ushered in a new era of magazine publishing.

The "magazine revolution of the nineties" began abruptly in July 1893 when S. S. McClure brought out a new copiously illustrated monthly designed to compete with the established "quality group" and marketed at the unprecedented price of fifteen cents. *McClure's* boomed from its inception and within two months also prompted several other existing magazines to cut prices. First was *Cosmopolitan*, which dropped its price to 12.5 cents. Two months later *Munsey's* went down to ten cents a copy. By 1895 both *McClure's* and *Cosmopolitan* followed *Munsey's* down to ten cents, where, joined by several other general monthlies, magazine prices remained for the next ten years. While exact circulation figures for the many ten-cent magazines born in the mid-1890s are unreliable, it is certain they too reached unprecedented levels. In the year of Emerson's centenary, for

[9] See further in Shove (1937). For more detailed accounts of the "cheap books" phenomenon, see Tebbel (1975).

[10] See Schneirov (1994) and Ohmann (1996).

example, *McClure's* boasted a circulation of 377,000; *Cosmopolitan*, 350,000; and *Munsey's* about 600,000. (Meanwhile, circulation for the leading elite magazine, *Century*, had declined to 150,000.) By 1905 there were some 20 mainstream monthly magazines with circulations of 100,000 or more, reaching an audience of some 5.5 million readers.

The sudden success of national magazines offered a diverse bill of fare. In their effort to challenge the dominant position of the respectable monthlies, editors of mass circulation magazines attracted many thousands of new readers with stories about contemporary social and political developments, as well as with an abundant supply of illustrations and photographs. But they also continued publishing the same eclectic blend of literary genres that had been concocted by the elite monthlies. Stories about the newly rich and powerful ran side by side with articles on American and European artists and features on American and European novelists and poets of the past. The practical consequence of this mixing of genres, as Matthew Shneirov (1994) has pointed out, was an innovative blurring of the boundary between high and popular culture.

All this is well known to historians who have studied changes in the institutional organization of American culture during the late nineteenth century. What precisely does it have to do with building Emerson's posthumous reputation? Still largely untraced by modern bibliographers, discussions of and references to Emerson are not hard to find in the pages of America's first mass circulation magazines. One example will suffice here. During the last months of 1893, shortly after *Cosmopolitan* cut its price to 12.5 cents, the magazine published a series of glowing, abundantly illustrated articles on various aspects of the World's Columbian Exposition in Chicago, popularly known as the World's Fair in the "White City." One of the last articles in this series – "A Farewell to the White City," by Paul Bourget, then a well-known French literary and cultural critic – enlisted Emerson's authority and language to explain the particular "promise" the Chicago World's Fair had left to Americans. The extraordinary popularity of the White City's "palatial monuments of human achievement," Bourget observed, had demonstrated the existence of a "feverish, often touching craving for culture" that was driving Americans in "bewildering haste towards the libraries, theaters, and museums of Europe." But he also stressed that the Beaux Arts "palaces" in fact had not realized "the absolute originality of Emerson's dream" of American culture, a dream that still specifically beckoned his countrymen to act on their own capacity to build their own new and more "durable counterparts" to the White City's now demolished structures.[11]

[11] See Bourget (1893).

Other examples are easy enough to find. But it would probably be an exaggeration to describe Emerson as a fixture in the new world of mass magazines. The American magazine revolution of the 1890s did not undermine his reputation, but it probably did not do much to enhance it either. Emerson's centenary, it is worth noting, appears to have gone unmentioned in the pages of the major national monthlies. Even so, in the absence of a systematic bibliographical survey, it would be a mistake to offer any broader pronouncements about what further research might reveal.

What bearing did the cheap-books phenomenon have on the making of Emerson's reputation? Here the evidence speaks more plainly. Emerson's writings seem to have appeared first in New York and Chicago in the mid-1880s, when they were reprinted by John B. Alden and Thomas D. Hurst. Following the common practice of marketing inexpensive books in library series formats – "Brilliant Books," in Emerson's case – Alden published new editions of *Nature*, *Essays* [First Series], *Essays* [Second Series], and *Representative Men*, with prices of individual books ranging from 20 to 50 cents.[12] He also used his new book plates to produce separate pamphlet publications of several individual essays, pricing them between three and five cents. Two years after Alden launched his inexpensive reprints of Emerson's writings, Hurst & Company produced the first of several cheap editions of *Essays* [First Series] and in the late 1880s and early 1890s went on to publish new editions of *Essays* [Second Series], *Poems*, *Representative Men*, *English Traits*, and *The Conduct of Life*. Hurst marketed Emerson's work in its "Arlington Edition" of popular twelvemos, which included over three hundred bound volumes of both standard and popular works. Listed at one dollar each, books in the series sold at retail for much less. Hurst also leased his plates to the United States Book Company, which printed its own cheap editions of *Essays* [First Series] and *Essays* [Second Series].

Alden and Hurst were perhaps the most influential popularizers of Emerson's writings during the 1880s, but they were hardly alone. Several other New York and Chicago publishers known chiefly for issuing cheap books – such as John B. Lovell, A. L. Burt, and Richard Worthington – also produced inexpensive new editions of his writings. We know too that while New York and Chicago were the chief centers for production of cheap books, numerous other now largely forgotten publishers and printers across the country were in the business of publishing inexpensive books. It seems likely that they too helped to put Emerson's writings into the hands of

[12] In this chapter, my account of the publishing history of Emerson's writings between 1882 and 1903 draws from Myerson's (1982) invaluable volume.

ordinary Americans. English publishing houses with offices in New York also produced their own cheap book editions of Emerson for sale in the American market. The first of these – George Routledge and Sons' double-columned, 643-page edition of the *Works of Ralph Waldo Emerson* – seems to have been the most successful, appearing first in 1883 and selling some 40,000 copies before going out of print in 1905. Routledge also marketed Emerson's writings in its popular "Morely's Universal Library" series, reprinting *Essays, Representative Men,* and *Society and Solitude* in double columns in a three-volumes-in-one format.

All this said, we should not ignore the fact that there are problems involved in determining how American and British cheap-book editions of Emerson's writings may have helped to sustain or reshape his reputation. Many of these editions have no publication date, and there is often scant information about the numbers of individual books that were actually produced. Those who took notice of the cheap-book editions of Emerson's writings when they first appeared marveled at the fact that his work had suddenly become available at prices that the "poorest could afford." One observer remarked that Emerson, along with great European writers such as Thomas Carlyle, George Eliot, Victor Hugo, and Walter Scott, was now being "read in the backwoods of Arkansas and the mining camps of Colorado."[13] And yet, while it is easy enough to gather evidence that late-nineteenth-century Americans could find Emerson's writings in a wide variety of formats and settings, it is quite another matter to attempt to read over the shoulders of Arkansas farmers and Colorado miners who encountered Emerson reprinted in quarto with his poems and essays formatted in two or three columns of closely printed type to the page. Did the inexpensive quarto editions dilute Emerson's significance or somehow integrate him into the lives of people who could never have afforded his books, and probably would never have read them had it not been for the price? Was Emerson read carefully (and with some squinting) for instruction and edification, or simply skimmed through as entertaining filler? It is hard to resist the conclusion that we will never know.

Even so, several things can be said with confidence about these issues. First of all, the mere fact that Emerson's writings were widely available as cheap books during the 1880s and early 1890s tells us that during those years he was not the exclusive property of influential personal friends and admirers or other new elite custodians of American culture. No single group of admirers controlled Emerson's image during these years. Likewise, the familiar notion that Emerson in this time was valued more "for his manner

[13] As quoted in Shove (1937: 41).

than for anything he actually wrote" ought now to be put to rest. Clearly the circulation of his writings grew exponentially in this period, and the producers and buyers of cheap editions of his work suggest a grassroots interest in Emerson that earlier students of this phase of his posthumous career have overlooked entirely. Finally, while it may be too much to say that "cheap book" editions of Emerson's writings made his reputation for a new generation of readers in the 1880s and 1890s, they very likely did prompt Houghton, Mifflin – the American publisher most actively concerned with promoting Emerson's reputation during this era – to develop various new formats that placed his writings in every level of America's burgeoning book market.[14]

Perhaps the best known of these remains the 1883 "Riverside Edition of the Complete Works," marketed in two different formats that allowed Emerson to appear as both a staple item for new middle-class home libraries and a collector's item in a new *de luxe* edition. Houghton,Mifflin also published Emerson's books in several other less expensive formats, all designed to present them as the work of a potentially popular author. Among the more successful were the "Cheap Edition" of *Essays* [First Series], priced at 15 cents and reprinted several times in 1884 and 1885, and the "Popular Edition" of *Essays First and Second Series*. Printed and priced in two different formats – cloth, one dollar; wrappers, 50 cents – this two-volumes-in-one edition of the essays was reprinted several times between 1889 and 1898. Houghton, Mifflin also continued to publish Emerson in two formats initially developed by James R. Osgood in the late 1870s: the nine-volume "Little Classics Edition," launched in 1876 and still in print as late as 1923, and the two-volume collection of miscellaneous essays first marketed in the 1882 "Modern Classics" edition, which remained steady sellers to the end of the century.

Houghton, Mifflin's most remarkable marketing innovation in the late nineteenth century – and perhaps its most important service in helping to secure Emerson's reputation in an era of mass publishing – would occur when he was first added to the list of American writers reprinted in its new Riverside Literature Series. Driven partly by the firm's desire to capture a more substantial share of the rapidly expanding textbook market, Houghton, Mifflin began to reissue its formidable list of American classics as texts for high schools in the late 1880s. The successful inclusion of Emerson among those who were confidently identified as giving ordinary

[14] On the role of Houghton, Mifflin in establishing the first version of the American literary canon, see Brodhead (1986: Ch. 3).

Americans their existence as a people gave him another new measure of force in American national culture. Priced mostly at 15 cents and marketed nationwide, each of the several different Riverside Literature Series editions of Emerson's poems and writings had sold in the tens of thousands by the time of his centenary.

A full survey of the publishing history of Emerson's writings during the last quarter of the nineteenth century would extend well beyond the boundaries of a single chapter. What we have considered here, however, suggests plainly enough that during America's first great boom in mass publishing his work did not disappear into a rarefied cultural space. In fact, by the turn of the century, Emerson's writings were everywhere, selling in the hundreds of thousands and perhaps even in the millions, in cheap pamphlet and paperback reprints as well as in *de luxe* multivolume cloth editions. These books could be found on the shelves of public libraries as well as in the parlors of middle-class homes, in books produced for high school students as well as for rare book collectors. Put another way, during the decade immediately following his death, Ralph Waldo Emerson, a figure who during the course of his life had pursued a many-sided career as lecturer, essayist, poet, and reformer, quite suddenly assumed another cultural identity: author of writings that were now a major publishing commodity in the burgeoning Anglo-American literary marketplace.

10.5 Emerson and "American Literature"

My understanding of how late-nineteenth- and early-twentieth-century Americans valued Emerson differs in three different but related ways from that usually told by cultural and literary historians. It stresses that the precise nature of Emerson's significance for American culture remained an unsettled issue well past his centenary in 1903. It argues as well that, thanks to the "cheap-books" phenomenon, it was during the late 1880s and early 1890s that Emerson's writings first gained high standing among ordinary Americans across the country. I also believe the nearly forgotten success of American and British cheap-book editions of Emerson's writings provides the historical background for a better understanding of the third and final stage of the development of Emerson's reputation in the late nineteenth and early twentieth centuries: the emergence of "American literature" as a new and ultimately dominant construct for shaping popular understanding of his career and writings.

Literary historians have a tendency to speak of the creation of Emerson's reputation as if it were, by the turn of the century, a single, fully accomplished

process. It was not. It is more accurate to speak of two parallel efforts to institutionalize the study of Emerson and other New England writers as American classics. The first played itself out within the now relatively well-mapped history of English departments at American colleges and universities, the other in the much larger yet almost entirely unexplored terrain of countless high school classrooms across the country. Because publishers very rarely differentiated between college and high school textbooks in this era, we know that college and university professors figured centrally in both domains. Only in the second, however, can we say that the publications of the professors enjoyed any notable success before the late 1920s.

What explains the discrepancy? Within the English departments of American colleges and universities, it was primarily the prominence of philology that made for the very slow and uneven progress of efforts to establish separate courses in American literature. Philology was Europhilic and Anglophilic, and its practitioners in English departments generally assumed that American literature had been and remained simply a branch of English literature.[15] The story was much the same in professional meetings and scholarly publications sponsored by the philologically top-heavy Modern Language Association, where, for several decades after the association's founding in 1883, papers and articles on American literature were scant. While it is true that by the turn of the century courses in American literature were offered at most American colleges and universities, these were limited to a modest handful of general survey courses for undergraduates. At the graduate level, efforts to institutionalize the study of American literature were almost a complete failure. In 1900, scarcely a dozen (less than 10 percent) of the country's 150 universities had developed graduate programs in American literature. Only four Ph.D.s in that field had emerged. The first doctoral dissertation on Emerson did not appear until 1896. Only eight more would be completed over the course of the next 30 years.[16]

Why, in contrast, did the first efforts to institutionalize the study of American literature enjoy such remarkable success in high school classrooms? The ready commercial accessibility of the late-nineteenth-century American literary canon surely had something to do with it. So too did the more rapidly expanding realm of American secondary education, which invited open expressions of cultural nationalism. For high school teachers, the value of

[15] On the slow progress of "American literature" within the new American university system, see Graff (1987) and Levine (1996).

[16] See Woodress (1962).

American literature rested chiefly in its service as an agent of acculturation. Collectively, Emerson and the other great New England writers had created the channel for disseminating the ethos that gave Americans their identity as a people, and above all the means by which a now burgeoning population of immigrant outsiders could be drawn inside it. American literature, as Richard Brodhead (1986: 60) has put it, was taken literally to be that which "Americanizes," and it was in such terms that hundreds of thousands of new readers began to find their way to Emerson in the mid-1890s.

This curious mix of condescension and reverence had several consequences for the ongoing construction of Emerson's reputation. Given the broader argument I have been developing in this chapter, two stand out. First, far from revealing some widely shared agreement about Emerson's value, the mixed results of early efforts to institutionalize the study of American literature reflected a long-standing and continuing division of opinion. Intent on serving two related yet distinct cultural causes – professionalization and acculturation – the first generation of academic specialists in American literature were unable or (in many cases) simply unwilling to present themselves as something other than students of a provincial branch of British culture, hence, their failure to open up Emerson to widespread and sympathetic professional academic study. Within American culture at large, however, it seems fair to say that Emerson's slow start in the university was largely offset by his quick success in high schools. The national marketing of Emerson's writings among school texts promoted as "American Classics" created a mass reading audience for his work. As we have seen, during the 1880s, it was cheap books that first put his writings within the physical and financial reach of ordinary Americans across the country. But there can be no question that mass-produced school texts proved a more reliable vehicle for securing Emerson's place in the public cultural domain.

A final point. The story about Emerson told in this chapter bears some resemblance to that first sketched by one of the "Emersonidae" at the time of the centennial. As it appeared in the May 1903 issue of *The New Englander*, George Willis Cooke's concise assessment of Emerson's posthumous career ran like this:

The two decades that have passed away since Emerson's death have clarified our judgment of him, and have given him a more assured and a loftier place than he occupied when he departed from us. There is no indication that he is losing his hold upon us or that his fame will wane any time in the future. What remoter generations will say of him we cannot foresee, but that he will be outgrown or suffer neglect we cannot think.

Cooke's verdict is not precisely the one I have tried to support, but it is close. While I believe the question of Emerson's cultural value remained unsettled in 1903, the emergence of mass print culture had resulted in his gaining an "assured" place in the public cultural domain. My story is also more complex than Cooke's, because it recognizes that the explosive growth in the supply of and demand for his writings has to be set against the background of other new institutions and practices that sought to define public understanding of the significance of the man and his writings and ideas, and especially important among these was a two-sided effort to enshrine Emerson as the founder of American literature.

That said, Cooke's refusal to speculate about what future generations might say about Emerson can serve as an important reminder that the immediate results of efforts to promote the study of American literature did not fully match the high hopes its earliest promoters invested in these efforts. Just as importantly, it can serve as a reminder that during the 1880s and 1890s, the continuing phenomenon that was Emerson was not shaped primarily by the ambitions and interests of a new class of academic professionals. The essential development in these decades was simply a dramatic expansion of America's public cultural domain, making it one in which Emerson's essays and poems now found their way into the hands of an increasingly broad range of men and women, who could and did enlist him to serve their particular purpose. Little wonder, then, that Cooke saw no indication that Emerson was losing his hold on the American public. His hold, in 1903, was tighter than ever before.

References

Bellows, J. A. 1876. Mr. Emerson's New Book. *Liberal Christian*, January 22, 3–4.

Bourget, Paul. 1893. A Farewell to the White City. *The Cosmopolitan*, November, 135–138.

Brodhead, Richard. 1986. *The School of Hawthorne*, Ch. 3. New York: Oxford University Press.

Collini, Stefan. 1991. *Public Moralists: Political Thought and Intellectual Life in Britain, 1850–1930*, 311–341. Oxford: Clarendon Press.

Dewey, John. 1929. Ralph Waldo Emerson. In J. Ratner, ed., *Characters and Events*, 74–75. New York: H. Holt and Company.

Edelstein, Tilden G. 1968. *Strange Enthusiasm: A Life of Thomas Wentworth Higginson*. New Haven, CT: Yale University.

Eliot, Charles W. 1926. Emerson. In W. A. Nielson, ed., *Charles W. Eliot, the Man, and His Beliefs*. New York: Harper and Brothers.

Graff, Gerald. 1987. *Professing Literature: An Institutional History*, Chs. 4–7. Chicago: University of Chicago Press.

Hacking, Ian. 1999. *The Social Construction of What?* 21–22. Cambridge, MA: Harvard University Press.

Howells, W. D. 1903. Impressions of Emerson. *Harper's Weekly*, May 16, p. 784.

Levine, Lawrence W. 1996. *The Opening of the American Mind: Canons, Culture, and History*, Ch. 4. Boston: Beacon Press.

Mitchell, Charles. 1997. *Individualism and Its Discontents: Appropriations of Emerson, 1880–1950*, Ch. 1. Amherst: University of Massachusetts Press.

Myerson, Joel. 1982. *Ralph Waldo Emerson: A Descriptive Bibliography*. Pittsburgh: University of Pittsburgh Press.

Ohmann, Richard. 1996. *Selling Culture: Magazines, Markets, and Class at the Turn of the Century*. New York: Verso.

Schneirov, Matthew. 1994. *The Dream of a New Social Order: Popular Magazines in America, 1893–1914*. New York: Columbia University Press.

Shove, Raymond. 1937. *Cheap Book Production in the United States, 1870–1891*. MA Thesis, Urbana: University of Illinois Library.

Tebbel, John. 1975. *A History of Book Publishing in the United States. Vol. 2: The Expansion of the Industry (1865–1919)*, 486–507. New York: R. R. Bowker.

Teichgraeber, Richard F. 1995. *Sublime Thoughts/Penny Wisdom: Situating Emerson and Thoreau in the American Market*. Baltimore: Johns Hopkins University Press.

Teichgraeber, Richard F. 1999. "Our National Glory": Emerson in American Culture, 1865–1882. In C. Capper and C. Edick Wright, eds., *Transient and Permanent: The Transcendentalist Movement and Its Contexts*, 499–526. Boston: Massachusetts Historical Society.

Woodress, James, ed. 1962. *Dissertations in American Literature, 1891–1955: With Supplement, 1956–61*. Durham, NC: Duke University Press.

PART FOUR

APPRECIATION AND RANKING

Quantitative Approaches to Valuation in the Arts, with an Application to Movies

Victor Ginsburgh and Sheila Weyers

Last year I gave several lectures on "intelligence and the appreciation of music among animals." Today I am going to speak about "intelligence and the appreciation of music among critics." The subject is very similar.

Eric Satie, quoted by Machlis (1979: 124)

11.1 Introduction

The aesthetic evaluation of artworks (paintings, literature, movies, musical compositions or interpretations, etc.) is and always has been a very controversial exercise. Philosophers, starting with Plato, are not the only ones who keep arguing about beauty. Mathematicians (including Leibnitz, Euler, Helmholtz, and Weyl), physiologists (Fechner), biologists (Rashevsky, the founder of mathematical biology), and economists (Bentham and others) have also tried to contribute to the field, and no obvious path-breaking or definitive view has emerged. We find it convenient to follow Shiner (1996) and distinguish between philosophers who suggest that beauty lies in the artwork itself and those like Hume (1757: 6) who believe that "beauty is no quality in things themselves: It exists merely in the mind which contemplates them; and each mind perceives a different beauty."

We identify three ways in which beauty of a work of art can be evaluated: as an attribute of the work, as determined by experts, and as confirmed by the passage of time. We begin this chapter with a brief discussion of these three approaches.

11.1.1 Beauty as an Attribute of a Work

Trying to break an artwork into attributes (also called properties by analytic philosophers, and characteristics or qualities by economists) is as old as

179

Aristotle, who suggests in his *Poetics* that an object is defined by its essential attributes. Tragedy, for instance, consists of six attributes, epic only shares some of these, while comedy consists of the imitation of inferior beings. The French art theorist Roger de Piles (1635–1709) pushes to its limit the idea of attributes. His *Cours de peinture par principes* (1708) includes what he calls a *balance des peintres* in which he decomposes painting into four fundamental attributes (composition, drawing, color, expression) that he rates on a scale between 0 and 20 for 56 painters from his and previous times. Rembrandt, for example, is very low, while Michelangelo is very high on drawing. De Piles thus goes almost the whole way: He defines[1] attributes, rates them, but stops short of discussing how to aggregate the ratings, and therefore he makes no general value judgment.[2] This is consistent with Vermazen (1975: 9–10), who supports the idea that works of art can be described by properties, but since these may be incommensurable it is impossible "to rank [works] with respect to the degree of two different independently valued properties."

Beardsley (1958), Dickie (1988), and some other "generalist" philosophers claim that there are general standards that make a work good.[3] According to Beardsley, for example, there exist three general properties, unity, intensity, and complexity, such that if *one* of them is present in an artwork, the artwork is better. There may be other properties that are "secondary" and that will make a work better in a certain context or worse in another. "Singularists," on the other hand, maintain that there exist no such general standards, and that every property is contextual.

De Piles's, Beardsley's, or Dickie's approaches can be considered close to the one taken by the contemporary economic theory of product differentiation, which distinguishes vertical and horizontal qualities in goods.[4] Vertical qualities are those on which every consumer agrees that more is better than less (other considerations, including price, being equal). The power of the engine in a car is a vertical quality. But some consumers prefer a blue car; others prefer it red. Therefore, the color of a car is a horizontal quality. The price of an object such as a car can be considered as a weighted sum of the prices[5] of the vertical qualities or characteristics. However, the aesthetic

[1] Note that these definitions already existed before de Piles.

[2] See Ginsburgh and Weyers (2006b), who show that de Piles's analysis has not lost any of its sharpness.

[3] See Hutter and Shusterman (2006) for details.

[4] See Gabszewicz (1983).

[5] These prices are often called "implicit" prices, since there exist no markets for individual characteristics, and therefore no price can be quoted for them. Such prices can, however, be retrieved indirectly. See Rosen (1974).

evaluation of a car will obviously take into account horizontal characteristics as well, and some consumers may be willing to pay more for a red car, and others for a blue one.

In the early 1760s, the economist Adam Smith had already taken a similar view, distinguishing "differences of things which no way affect their real substance" but yield pleasure, guide choices, and drive "the whole industry of human life": color, figure (form), rarity and variety, and imitation (which enables artists to remain natural).[6]

The mathematician Birkhoff (1933) devotes a book to aesthetic value and feeling, where he assumes aesthetic experience to be composed of three successive phases: a preliminary effort of attention, which increases in proportion to the complexity (C) of the object; the feeling of value (M) that rewards this effort; and finally a realization that the object is characterized by a certain harmony, symmetry, or order (O), which seems necessary to obtain the aesthetic effect. He then suggests that within each class of objects, aesthetic measure M is a function of the order to complexity ratio.[7] Therefore, if the value of O and C can be determined, M can be computed, so that judging the aesthetic quality of objects in a given class and ranking them are made possible. Birkhoff does not leave it at that, and the various chapters of his 200-page book investigate how O and C can be measured not only for polygonal forms, ornaments, tylings, or vases, for which one has the feeling that this is possible, but also for melody and musical quality in poetry.[8] In his book on symmetry, the mathematician Weyl (1952) discusses the feeling of beauty that results from this quality. Recent experimental research on "beauty" in human beings and attractiveness in animal species also stresses the importance of symmetry, an obviously objective and measurable characteristic.[9]

11.1.2 Beauty as an Overall Assessment by Judges

Other art philosophers "locate the ground of judgments of taste, not in some object which is the target of the judgment, but in the maker of the

[6] Quoted in De Marchi (2002).

[7] This is very close to Adam Smith, for whom "uniformity tires the mind, [but] too much variety, too far encreased, occasions an overgreat dissipation of it." See De Marchi (2002).

[8] See also Simonton (1980, 1998), for whom the properties of musical compositions that form the classical repertoire "can be predicted using variables derived from a computerized content analysis of melodic structure."

[9] See Etcoff (1999: 161–164, 185–187).

judgment,"[10] and seem to reach a minimal agreement on the following arguments already developed in Hume's (1757) classic essay on tastes. First, it is agreed that quality assessments should be left to specialists who are familiar with the experience of works of art. Hume (1757: 17–18) states that "though the principles of taste be universal...yet few are qualified to give judgment on any work of art, or establish their own sentiment as the standard of beauty.... Some men in general, however difficult to be particularly pitched upon, will be acknowledged by universal sentiment to have a preference above others," though the question of how to find such people is, as he writes, "embarrassing." Second, the qualities of such judges can be described, again in Hume's words (1757: 17), as "strong sense, united to delicate sentiment, improved by practice, perfected by comparison, and cleared of all prejudice; and the joint verdict of such is the true standard of taste and beauty."

Some philosophers and art critics thus put the burden of proving quality on experts, while economists often argue that the choice should be left to consumers, especially when it comes to state intervention in the arts. The economic approach is well illustrated by Bentham (1789), who thinks that art critics reduce the choice of consumers: "These modest judges of elegance and taste consider themselves as benefactors to the human race, whilst they are really only the interrupters of their pleasure – a sort of importunate hosts, who place themselves at the table to diminish, by their pretended delicacy, the appetite of their guests."[11]

11.1.3 Beauty Confirmed by the Passage of Time

We can draw a distinction between the success that a work of art may enjoy at the time or shortly after it has been produced and the success that according to Savile (1982: 32) accompanies a "work [if it] attract[s] our attention and admiration from a viewpoint that precisely *transcends* the dominant ideal or style of a period." Only time makes it possible to separate fashion from art. Hume (1757: 9) makes this clear also:[12] "Authority or prejudice may give a temporary vogue to a bad poet or orator.... On the contrary, a real genius, the longer his works endure, and the more wide they are spread, the more sincere is the admiration which he meets with." By this last remark,

[10] Shiner (1996: 237).
[11] Quoted by Goodwin (2006).
[12] Note that this idea was probably floating around at that time. Nicolas Boileau (1636–1711) wrote somewhere that posterity alone can judge the merit of a work. See also the essay on this question by Savile (1982).

Hume extends the test of time to the "test of space." To make both points clear, he explains (1757: 9) that "envy and jealousy have too much place in a narrow circle; and even familiar acquaintance may diminish the applause due to [the artist's] performances: but when these obstructions are removed, the beauties immediately display their energy; and while the work endures they maintain their authority over the minds of men." Note that time is not considered a criterion, but an indicator of value (Levinson, 2002: 235). Time makes it possible to reduce some of the noise due to fads, fashion, "envy and jealousy" that is present in evaluations made shortly after the work is produced, clearing the way for transcending works.

Philosophers stress the importance of time. Though this point is seldom raised by economists, it seems very natural and is also present in the judgment of scientific ideas. The 2004 Nobel Prize in chemistry was given to its three recipients for a paper that they had written 25 years earlier. The 2004 Nobel Prize in economics was given to Fynn Kidland and Edward Prescott for two papers they had produced in 1977 and 1982. In the essay "What Is a Classic?" Coetzee (2002: 18) provides a very useful link between the philosophical and the economic arguments. He writes that "the criterion of testing and survival is not just a minimal, pragmatic... standard. It is a criterion that expresses a certain confidence in the tradition of testing, and a confidence that professionals will not devote labour and attention, generation after generation, to sustaining [artworks] whose life-functions have terminated." This is also expressed by André Breton (1965: 11) in a very incisive and concise way: "The paintings that I love... are those that survive famines."

Obviously, in all three approaches to the assessment of beauty, judges are needed to produce evaluations. One may however suggest that if works are thought to contain properties, evaluation could proceed in a more "objective" way, since each property could be rated and the overall evaluation obtained as a weighted average of individual ratings. This process also leads to a better understanding of the overall evaluation than in the case in which only overall evaluations are made. But experts are prone to judgment errors and, as will be made clear, have an influence on economic outcomes.

In the remainder of this chapter we consider quantitative approaches to the evaluation of art works. In Section 11.2 we show how characteristics, together with overall valuations of artworks (or artists), could be used to infer the weight given to each property in an overall judgment, thus bypassing the "incommensurability" problem mentioned by Dickie and Vermazen. These weights can then be used to value other comparable works of art, once their content in properties is established. In Section 11.3, we examine the

judgments by critics and consumers in the case of movies and show that their opinion at the time the artwork is produced often does not stand the test of time. Short-term judgments, even if they are consistently based on properties, thus seem far from being perfect predictors of long-term aesthetic quality. When the time span between production and evaluation increases, judgments gain in stability and lead to what is often called canons. Section 11.4 is devoted to some concluding remarks.

11.2 The Characteristics Approach

The characteristics or properties approach introduces a view of aesthetics that "may be thought of as either breaking up beauty into its parts or supplementing beauty with additional concepts."[13] This is of course the very same idea as the one expressed by economists, in particular Lancaster (1966), according to whom a commodity can be thought of as a bundle of characteristics purchased by consumers not for itself but for the value it provides by combining such characteristics.[14] This suggests that the "value" of a good (a movie or an automobile) can be obtained by adding the values of all the characteristics embodied in the good (such as best actor and screenplay for a movie or speed and number of doors for a car); each value is itself the product of the unit value of the characteristic or its weight β_i, times the number x_i of such units. If the good can be fully described by, say, two characteristics its total value V is simply:

$$V = \beta_1 x_1 + \beta_2 x_2. \tag{1}$$

We illustrate the idea using movies for which we do observe both a rating of total value V and the ratings of a certain number of properties, focusing on the 270 movies, both nominated and awarded the Oscar for "best picture" by the Academy of Motion Picture Arts and Sciences between 1950 and 2003.[15] In each year, five movies are nominated by the academy and one of these wins the race ("...and the winner is..."). For each such movie, we also collected all other nominations and distinctions awarded by the academy for a certain number of awards: actor in a leading role, actress in a leading role, director, screenplay, and so on.[16] The properties that seem to matter

[13] Dickie (1997: 3).

[14] For example, a car is not bought for itself but for the services it provides in terms of speed, comfort (number of doors, air-conditioning, length, width), cost (miles per gallon), etc.

[15] The data are available on http://awards.fennec.org.

[16] See Simonton (2002, 2004a, 2004b) for closely related work.

for motion pictures may look quite different from the much more general and abstract ones, such as unity, intensity, and complexity, postulated by Beardsley, for example, but there is no reason to think that they contradict each other.

Using regression analysis, it is possible to determine the weights β_1 and β_2 in an objective way. The data consist of rates or scores of the overall value and of each property: V, the overall value, is dichotomous, with value 1 if the movie was awarded the Oscar for best picture, and 0 if it was nominated but failed to win the Oscar.[17] Each property (say, "actor in a leading role") can fall into one of three categories: The movie was awarded the Oscar, or it was nominated but failed to win the Oscar, or it was not nominated.[18] A movie is thus represented by an array of numbers, the first of which is V (1 or 0) while the others are variables that also take values 1 or 0 according to whether or not they fall into one of the categories.

Since the number of observations is rather small (270), we tried to find a model that was as parsimonious as possible in the number of properties used. Among the 18 different Oscars that are awarded (actor or actress in a leading role, original screenplay, cinematography, original song, etc.),[19] only five seem to matter: actor in a leading role, director, screenplay, costume design,[20] and film editing. It is quite clear that some properties embody many other underlying characteristics, such as genre, violent or sexual content, or sequel status, but we wanted to remain as close as possible to the properties selected by the academy and base our equation on these properties only. Our purpose is not to predict which movie will be given the best picture award,[21] but to analyze whether the choices made by the members of the academy are consistent, and thus whether the overall rating of a movie is obtained in a consistent way.

Table 11.1 displays the results concerning two equations that include the same set of five properties but that differ since equation (1) includes the

[17] We ignore here all the movies produced in any given year that were not nominated as best pictures by the academy.

[18] For instance, there will be three variables for "screenplay": The first takes the value 1 if the movie was awarded the Oscar and 0 otherwise; the second takes the value 1 if the movie was only nominated and 0 otherwise; the third takes the value 1 if the movie was not selected and 0 otherwise.

[19] See http://awards.fennec.org for a complete list.

[20] The reason for which the Oscar for costume design, for instance, appears as explaining the Oscar for best picture may be a sign of the magnificence or the exotic character of the production.

[21] Given the explanatory variables that we use, prediction is anyway not possible, since all the awards are announced during the same evening. Predicting the best picture before the award ceremony takes place obviously needs another set of variables.

Table 11.1. *Regression results for movies*

	Equation (1)		Equation (2)	
	Coefficient	Standard error	Coefficient	Standard error
Oscar for actor in a leading role				
Nominated	−0.210	(0.367)		
Awarded	0.611	(0.416)	0.668*	(0.357)
Oscar for director				
Nominated	0.153	(0.571)		
Awarded	2.528**	(0.586)	2.342**	(0.318)
Oscar for screenplay				
Nominated	0.415	(0.710)		
Awarded	1.437**	(0.691)	1.157**	(0.301)
Oscar for costume design				
Nominated	0.599	(0.370)		
Awarded	1.279**	(0.407)	1.059**	(0.341)
Oscar for film editing				
Nominated	0.672	(0.423)		
Awarded	1.132**	(0.456)	0.614*	(0.337)
R square	0.701		0.678	
Number of movies	270		270	

Notes: Given that V is a variable that can take only two values (1 if the movie was awarded the Oscar for best movie, and 0 otherwise), we use a probit model.
** = significantly different from 0 at the 5% level; * = significantly different from 0 at the 10% level.

possibility that a nomination (without Oscar) can affect the overall value, while equation (2) includes only Oscars.[22] The results of equation (1) show that a nomination without Oscar has no significant impact on the overall value. Only Oscars matter, and that leads us to equation (2).[23]

Using the weights that appear in this equation, it is easy to calculate the overall value of a movie whose properties have been valued. To clarify the idea, we provide an example for four movies in Table 11.2. Their overall value is obtained by

$$V = \beta_1 x_1 + \beta_2 x_2 + \beta_3 x_3 + \beta_4 x_4 + \beta_5 x_5, \tag{2}$$

[22] The results are taken from Ginsburgh and Weyers (2006c).
[23] Note that this is at odds with some results obtained by Simonton in which nominations may carry more information than Oscars. This may be due to the fact that we only deal with movies that were nominated for or received the Oscar for best picture, ignoring those that were nominated for or received the Oscar in other categories but were not nominated for best picture.

Table 11.2. *Rating the overall value of four movies*

	Weights	All About Eve (1950)	An American in Paris (1951)	Cabaret (1972)	A Streetcar Named Desire (1951)
Actor in a leading role	0.668	–	–	–	–
Director	2.342	O	–	–	–
Screenplay	1.157	O	O	–	–
Costume design	1.059	O	O	O	–
Film editing	0.614	–	–	–	–
Overall value		4.558	2.216	1.059	0.000

Note: An O indicates that the movie was awarded the Oscar for this property.

where the β are weights and the various x_k take the value 1 when the Oscar was attributed to the property, and the value 0 otherwise. *All About Eve*, for example, was awarded Oscars for direction (weight: 2.342), screenplay (1.157), and costume design (1.059). Its overall value is equal to 4.558. Similar calculations can be made for the three other movies, leading to the overall values in the last row of the table. The values have not much meaning in absolute terms, but they allow us to infer a complete ordering (ties are of course possible). In particular, they show why in 1951 *An American in Paris* was preferred to *A Streetcar Named Desire*.

More generally, one can compute the ratings of each of the 270 movies nominated and awarded during the 54 years. These can then be used to determine the movie that has the highest rating in each year and compare it to the movie that received the best picture Oscar. The two match in 45 out of the 54 years, classifying correctly 252 of the 270 movies.

Table 11.3 shows that without such weights it is much more difficult to assess the ranking of the four movies. The remarkable results are, first, that even if they make overall judgments, experts (here the members of the Academy of Motion Picture Arts and Sciences) implicitly use a weighting scheme of individual properties to determine the overall value, and, second, that such implicit weights can be recovered using simple econometrics.

The "predictions" discussed are performed on movies that were used to estimate the weights, suggesting that we may be engaged in circular reasoning. However, the weights can be used to provide the overall value of a movie, and thus its rank, once properties have been rated. For example, applying the estimated weights to the Oscars for 2004, the year after the last year in our sample, correctly predicts *Million Dollar Baby* as best picture. This

Table 11.3. *Can one assess the ratings without weights?*

	All About Eve (1950)	An American in Paris (1951)	Cabaret (1972)	A Streetcar Named Desire (1951)
Actor in a leading role	F	F	N	N
Actress in a leading role	N	F	O	O
Actor in a supporting role	O	F	N	O
Actress in a supporting role	N	F	O	O
Director	O	N	N	N
Screenplay	O	O	N	N
Cinematography	N	O	O	N
Art direction/set decoration	N	O	O	O
Costume design	O	O	O	N
Score	N	O	N	N
Original song	F	F	F	F
Film editing	N	N	N	F
Sound mixing	O	F	N	N
Special effects	F	F	F	F
Number of O ratings	5	5	5	4
Number of N ratings	6	2	7	7
Number of F ratings	3	7	2	3

Note: O: the movie was awarded the Oscar; N: the movie was nominated but did not receive the Oscar; F: the movie was not nominated.

movie's "value" is calculated as 2.342 (Oscar for best director); other movies from the same year – *Aviator* (costume design and film editing), *Sideways* (adapted screenplay), *Ray* (actor in a leading role), and *Finding Neverland* (no Oscar among those selected in the equation) – are worth 1.673, 1.157, 0.668, and 0, respectively.

11.3 Judgments by Critics and the Test of Time

In this section we examine whether such choices, even if they are made in a rational and consistent way, are good predictors of long-lasting aesthetic quality. We rely on judgments made by movie critics at the time or shortly after the works were produced, and we use the test of time to check whether such judgments remain "good," or whether they are influenced by style, fashion, and other motives. In other words we ask the question, Are the works that were distinguished shortly after they were produced still the best when judged at later times?

The test of time has been used by Milo (1986) in his analysis of eighteenth-century French painting; he concludes that painters who are recognized

today were already famous during their lifetime. Landes (2004) uses a similar approach to analyze how early twentieth-century American art survives in 2000. Ginsburgh and Weyers (2006a) show that the contemporary Italian Renaissance canon of artists was formed very early: Almost all painters who are known today were already described 400 years ago by Vasari (1568) in his *Vite*, though relative rankings of artists have to some extent changed over time.

To examine this question in the present chapter, we look again at best movie nominees and winners selected by the Academy of Motion Picture Arts and Sciences (Oscars), this time using data for the years from 1950 to 1980,[24] but add information concerning other awards as well: the Golden Globes, the New York Film Critics Circle, and the National Board of Reviews. Movies that were not selected by one of these awarding groups are not considered. However, for each award (say, the Oscars), movies that were selected by other groups (Golden Globes and others) are included, and so are all the largest box office hits[25] in every year. Therefore, there are always three groups of movies: winners, nominated movies, and other movies. However, it should be realized that this group of 1,616 movies is only a small selection (and probably the upper tail of the quality distribution) of the many thousand movies produced during the 31 years under scrutiny.

For each movie, we take as a *short-term quality indicator* the choices made by experts who award prizes shortly after the movies are released or distributed. We then derive a *long-term quality measure* based on three "100 best movie lists" issued in the late 1990s: A movie that is chosen in one, two, or all three lists receives a rating of 1, 2, or 3, while others are rated 0. Only 77 movies have a positive rating. Since economists believe in consumers' sovereignty, we also look at box office hits.[26]

A first indication of the fact that original (short-term) awards do not necessarily go to the best (long-term) quality movies is based on comparing award-winning movies with those that appear on the top-100 lists. Details are given in Table 11.4. While 65 percent (20 of 31) of the movies that appear on at least one of the top-100 lists have received an Oscar, only

[24] Note that here we only examine movies produced until 1980. It would indeed make little sense to invoke the "test of time" if we did not leave at least 20 years between a first and a second rating of a work. Of course, compared with the judgments that can be passed after so many years on Homer, Michelangelo, or Mozart, the time interval that we use here – 20 to 50 years – can be considered very short.

[25] Box office results are measured by rentals, that is, the amounts paid by movie theaters to distributors or studios that produced the movies. Pure box office numbers are usually not available.

[26] See Appendix for further details, including some indications concerning the respectability of experts as "good judges."

Table 11.4. *Prizes and best movie lists (number of movies)*

Number of best movies lists	Three	Two	One	None	Total
In best movies lists	24	16	37	–	77
Oscars					
Winners	8	6	6	11	31
Other nominated	8	7	15	94	124
Other	8	3	16	–	–
Golden Globes					
Winners	6	5	9	45	65
Other nominated	11	6	10	210	237
Other	7	5	18	–	–
NBR					
Winners	2	3	4	22	31
Other nominated	13	8	14	230	265
Other	9	5	19	–	–
NYFC					
Winners	4	8	2	15	29
Other	20	8	35	–	–

Notes: Twenty-four movies are present in three best movies lists, 16 in two lists, 37 in one list; a total of 77 movies. Thirty-one Oscars were awarded of which 8, 6, and 6 are present in three, two, and one list; 11 appear in no list; etc.

Oscars: There are always five nominees, and a unique winner ("the Oscar").

Golden Globes: There are usually two winners, though there was only one in 1950 and 1953, and there were three in 1955, 1958, 1959, 1960, and 1961. The number of nominated movies varies between 1 (in 1953) and 16 in 1962. Since 1964, there are 10 nominees. One movie (*1776*), which we could not find in Maltin (1997), was nominated in 1972. It was ignored.

National Board of Reviews: In 1961, the award went to *Question 7*, a movie that is not listed in Maltin (1997) and was ignored; in 1975 and 1983, two awards were distributed.

The New York Film Critics Circle gives one award and has no other nominated movies; 1960: two awards; 1962: no award; in 1972 and 1974, the awards went to foreign movies (*Cries and Whispers* in 1972, *Amarcord* in 1974). These years are not taken into account here.

26 percent appear in all three lists. However, these numbers could be misleading because there may be good years with several highly rated movies; since there is only one possible winner, not all highest-quality movies can be awarded. In 1950, for instance, two movies (*All About Eve* and *Sunset Boulevard*) appear in all three best movies lists, but only one could be awarded the Oscar.

Nevertheless, a more detailed breakdown shows that this factor does not explain the failure of prizes to identify long-term quality. This is documented in Table 11.5, the first column of which gives the quality rating (0, 1, 2, or 3, according to the number of lists in which the movie appears) of the best movie produced in every given year, while the second and third columns

Table 11.5. *Oscar best movies failures (ratings and number of movies)*

	Long-term ratings by critics			Number of movies better than Oscar
	Best movie	Oscar	Best nominated	
1950	3	3	3	–
1951	2	1	2	1
1952	3	0	2	3
1953	2	2	1	–
1954	3	3	1	–
1955	2	0	0	1
1956	3	0	1	2
1957	2	2	0	–
1958	3	0	0	2
1959	3	1	0	2
1960	3	2	0	1
1961	2	2	1	–
1962	3	3	1	–
1963	1	0	0	1
1964	3	1	3	1
1965	1	1	1	–
1966	1	0	0	1
1967	3	0	3	3
1968	3	0	0	1
1969	3	3	1	–
1970	2	2	1	–
1971	2	1	2	1
1972	3	3	0	–
1973	1	0	0	1
1974	3	3	2	–
1975	3	2	3	1
1976	2	1	2	2
1977	3	3	3	–
1978	3	3	0	–
1979	3	0	3	3
1980	3	0	3	2

Note: In every year the Academy nominates five movies and gives the Oscar to the unique winning movie.

give this rating for the winning movie (the Oscar) and for the best-rated nominated-but-not-winning movie. The last column gives the number of movies produced in a given year that have a better rating than the one to which the Oscar was awarded. The academy missed the movie that is now considered best in 18 years out of 31, and 29 movies are now considered to be better than those that were awarded the Oscar.

Table 11.6. *Failures by various awarding bodies (number of movies)*

	Oscars	Golden globes	NBR	NYFC
Number of winning awards	31	65	31	29[a]
Number of years with				
Awards	31	31	31	29
Misses of best movie	18	26	26	21
Number of movies better than				
winning movie	29	50	57	39

Note: [a] Foreign movies were rewarded on two occasions and dropped here. See also notes to Table 11.4.

Some illustrations may be useful. In 1952, *Singing in the Rain*, which appears in all three lists, was not even nominated, while *The Greatest Show on Earth* (which appears in no such list today) won the Oscar. In 1959, *Ben Hur*, another nonlisted movie, received the Oscar while two movies appearing in all three lists, *North by Northwest* and *Some Like it Hot*, were produced during the same year. In 1968 the academy failed to choose as best movie *2001: A Space Odyssey*, which is the only production of that year that appears on all three lists.

Still, the National Academy does much better in terms of choosing high-quality movies than do other organizations such as the Golden Globes (of 65 winning movies, only six make it to all three best movie lists, while 45 are rated in no list), the National Board of Reviews (2 out of 31 winning movies in all three lists), or the New York Films Critics Circles (4 out of 29). More information can be found in Table 11.6. Calculations show that with the exception of the academy, other organizations missed the best movie in more than half of the years. *2001: A Space Odyssey*, missed by the National Academy, was missed by all three other organizations as well.[27] Five movies (two Golden Globes, and one by each other organization) received awards in 1968; none of these makes it to any of the three lists. The worst overall result is obtained by the Golden Globes, since, though they have given out 65 awards (more than two every year), they still missed 50 movies that are now considered to be better.

The preceding results suggest that when it comes to movies there is reason to doubt that prizes are successful in identifying movies that survive the test of time. Do consumers make better choices? This issue is considered in

[27] The movie was nominated by the National Board of Reviews but did not win the award.

Table 11.7. *Box office successes and best movie lists (number of movies)*

Number of best movies lists	Three	Two	One	None	Total
In best movies lists	24	16	37	–	77
Oscars winner	8	6	6	11	31
Golden Globe winner	6	5	9	45	65
NBR winner	2	3	4	22	31
NYFC winner	4	8	2	15	29
Box office rank					
1	5	1	6	19	31
2	2	2	4	24	32
3	1	2	4	24	31
4	1	2	–	31	34
5	1	–	2	25	28
6–10	6	2	7	147	162
> 11	9	7	14

Note: Because of ties, there may be more (and therefore, fewer) than 31 movies with the same box office rank.

some detail in Table 11.7, which crosses box office results and long-term evaluations and compares the various award winning movies with those that were the largest box office hits in every year. The choices made by the National Academy (Oscars) are obviously better than those made by consumers, but consumers make better choices than the Golden Globes (once account is taken of the fact that they awarded 65 movies in 31 years) and the National Board of Reviews. Results are inconclusive for the New York Film Critics Circle. Finally, it is interesting to note that in 31 years only two movies that were awarded a best movie Oscar were first ranked box office successes and appear on all three best movie lists nowadays: *Lawrence of Arabia* (1962) and *The Godfather* (1972).

Does this mean that the 100 best movies lists that we used constitute the movie canon? Probably not, if only for the reason that, unlike Italian Renaissance paintings, movies are still produced and new productions will obviously enter the lists, driving out others that are older or make longer lists. But it is reasonable to think that many of the movies that are on all three lists today will indeed belong to a possible 1950–1980 movie canon. It is hard to imagine that *Sunset Boulevard, Singin' in the Rain, On the Waterfront, Some Like It Hot, North by Northwest, 2001: A Space Odyssey,* or *Apocalypse Now* will disappear. Nor can one believe that movies such as Fritz Lang's *M* (1931), Eisenstein's *Potemkin* (1925), or *Modern Times* (1936), *Gone With the Wind* (1939), *Citizen Kane* (1941), *Casablanca* (1942), or *The Third Man*

(1949) – not considered in our chapter since they were produced before 1950 – will possibly be removed one day.

11.4 Concluding Comments

Our results suggest two conclusions to be drawn from the two parts of the chapter. First, experts seem to be reasonably consistent in their evaluations: The characteristics (or properties) approach shows that the evaluation of properties and the overall value are linked. The economic logic of value characteristics (Section 11.2) would imply that experts evaluate single features first, and then make a global judgment: Characteristics "cause" the overall value. However, the logic actually used by experts and critics may proceed the other way around: An overall judgment may be made first, and only afterward is the choice justified by describing which characteristics make the work good, or better than other works. But either way the link is there, and this is what the example of movies shows.

Alternatively, consistency of valuation in the movies example may be the result of the voting procedure that is used, and it is useful to describe it briefly here. Eligible films are listed in a "reminder list of eligible releases" distributed to voters (active and life members of the academy). Best picture nominees are chosen by all academy members, while nominations in other categories (acting, direction, screenplay, etc.) are picked only by members of each discipline: Only actors nominate actors, for example. Winners are selected in a second vote on nominated pictures only, using the same procedure. In both cases the vote proceeds by secret ballot. The two interesting characteristics are that both nominees and winners result from a voting procedure that includes a large number of movie experts (5,600 in 2003) and that only experts of the discipline choose the nominees of the discipline, while the best picture Oscar (overall value) is chosen by all the members of the academy. The voting procedure smooths out idiosyncratic shocks, or erratic behavior by some critics. However, there are also aggregate shocks due to fashion or innovation, such as new "special effects." Such shocks influence all voters and can hardly be eliminated by the voting procedure. Only the "test of time" (Section 11.1) can help here, given that the aggregate shock at the time of the first evaluation will tend to disappear in the long run. Of course, nothing prevents voters from being influenced by a different aggregate shock, but idiosyncratic shocks will again be eliminated.

The test of time also affects valuation in another way, insofar as narratives by art critics and historians play a prominent role in assessing long-run value

(or its absence). The more that is written about Michelangelo and Picasso, the less it is likely that they will be demoted in artistic rank (Silvers 1991).

An interesting question is whether art experts are more prone to errors than experts in other fields, or whether valuing art is more difficult. The answer seems to be negative on both counts. Here are some examples. Ratings of wine experts do not predict in an efficient way the prices of mature Bordeaux wines, because they do not (or are unable to) account for all the relevant characteristics (Ashenfelter and Jones 2000). Restaurant experts cannot refrain from taking into account elements other than cuisine, such as the look of the venue or the choice of wines in the cellars, while they claim that they rate the food only (Chossat and Gergaud 2003). In their assessments about whether to sue, settle out of court, or plead guilty to a lesser charge, American lawyers' judgment shows no predictive validity (Koehler et al. 2002). In diagnosing health conditions, properly developed statistical procedures based on the rating of explicit characteristics perform much better than clinical methods, which rest on implicit mental processes (Dawes et al. 2002; Meehl 1996).

Are economists able to provide some prescriptions and help experts in deciding what makes an artwork good? Here are some examples in which economic insights, or the tools that economists and statisticians use, can help. Bauwens and Ginsburgh (2000) provide some evidence that auction house experts do not take into account all the characteristics of a work when they set their presale price estimates; this is very easy to correct since experts could also consider the results of models such as the one discussed in Section 11.2. The case of a musical competition analyzed by Flores and Ginsburgh (1996) and Ginsburgh and van Ours (2003) also provides some insights. These authors find that the ranking of finalists in the Belgian Queen Elisabeth piano competition is correlated with their order of appearance in the finals; since this order is randomly chosen in the very beginning of the competition, this implies that the final ranking is (at least partly) also random. It is easy to imagine ways to prevent such malfunctions. Since the competition is organized in several stages, it is easy to change the order of appearance across stages. Since musicians play several pieces and several musicians play each evening, they could be shuffled, instead of playing all their pieces in a row.

These are all cases in which critics provide a dichotomous judgment that proves to be correct or false in the long run. A clear benefit of the characteristics approach, which judges the (art)work by rating its properties, is that it makes it possible to analyze in some detail the reasons for which an evaluation succeeded or failed.

APPENDIX

Data Sources

The dataset includes 1,616 movies produced between 1950 and 1980 for which one of the following criteria was fulfilled: nominated by the Academy of Motion Picture Arts and Sciences (Oscars), or the Golden Globes, or the National Board of Review, or the New York Film Critics Circle; or included in one of the following three Best Movies Lists: the American Film Institute America's 100 Greatest Movies, or the 100 Must-See Films of the 20th Century by Leonard Maltin, or Mr. Showbiz Critics Pics: The 100 Best Movies of All Time; or included among the movies that made rentals worth more than $1 million in every year. Movies that were not produced in the English language are excluded, since they cannot be nominated for the "best movie" awards by the National Academy. So are cartoons produced by Walt Disney studios since their box office is very much influenced by children.

Awards: Oscar awards (Web site: awards.fennec.org): 31 winners and 124 other nominees;[28] Golden Globe awards (Web site: awards.fennec.org): 65 winners and 236 other nominees;[29] National Board of Review awards (Web site: www.goldderby.com/nbr/index.asp): 31 winners and 266 other nominees;[30] New York Film Critics Circle awards (Web site: goldderby.com/nyfc/index.asp): 29 winners, there are no other nominees.[31] Note that there may be fewer than 31 winners (one per year) since in some years, there was no winner or a non-English-speaking movie was awarded.

Long-term quality ratings: American Film Institute America's 100 Greatest Movies (www.filmsite.org/afi100films.html): 56 movies between 1950 and 1980;[32] Mr. Showbiz Critics Pics: the 100 Best Movies of All Time (www.filmsite.org/mrshowbiz.html): 51 movies between 1950 and

[28] The National Academy describes its activity as "three quarters of a century of recognizing excellence in filmmaking achievement" and not of recognizing commercial success. Its judges consist of "the most gifted and skilled artists and craftsmen in the motion picture world." The academy also warns its judges that they "may be importuned by advertisements and other lobbying tactics" and emphasizes "that excellence in filmmaking is the ONLY factor [to] consider in casting [their] votes" (http://www.ampas.org/academyawards/index.html).

[29] The Golden Globes are awarded by the Hollywood Foreign Press Association.

[30] The board claims to be "the first group to announce its award champs every year."

[31] This organization claims to be "the oldest respectable rival to the Oscars."

[32] The selection bills itself as "a definitive selection of the 100 greatest movies of all time, as determined by more than 1,500 leaders from the American film community."

1980;[33] The 100 Must-See Films of the 20th Century by the American movie critic Leonard Maltin (www.filmsite.org/maltin2.html): 34 movies between 1950 and 1980. If a movie is chosen in one, two, or all three lists, it receives a rating of 1, 2, or 3. Otherwise, the rating is 0. For the years 1950–1980, 77 different movies are rated.

Rentals: Box office data, also called grosses, which represent ticket sales, are scant and incomplete. We had to do with rentals, which are much lower than grosses (some 50 percent of grosses, but this may vary across movies and producers; they are usually smaller for well-known or "powerful" producers or distributors, and above 50 percent for others) and represent the amount of money paid to distributors of a film by those who rent it. They were collected mainly from Christopher Reynolds's (1995) and Susan Sarkett's (1996) books and completed with data available on the following Web sites: www.worldwideboxoffice.com/source.html and www.imdb.com/top/.

References

Ashenfelter, Orley, and Gregory Jones. 2000. The Demand for Expert Opinion: Bordeaux Wines. *Les Cahiers de l'OCVE* 3:1–17.

Bauwens, Luc, and Victor Ginsburgh. 2000. Art Experts and Auctions: Are Pre-Sale Estimates Unbiased and Fully Informative? *Louvain Economic Review* 66:131–144.

Beardsley, Monroe. 1958. *Aesthetics: Problems in the Philosophy of Criticism.* New York: Harcourt, Brace.

Bentham, Jeremy. 1962. *The Works of Jeremy Bentham* (1789), ed. John Browning. New York: Russel & Kessel.

Birkhoff, George D. 1933. *Aesthetic Measure.* Cambridge, MA: Harvard University Press.

Breton, André. 1965. *Le surréalisme et la peinture.* Paris: Gallimard.

Chossat, Veronique, and Olivier Gergaud. 2003. The Recipe for Success in French Gastronomy. Does Creativity Matter? *Journal of Cultural Economics* 27:127–141.

Coetzee, J. M. 2002. What Is a Classic? In J. M. Coetzee, ed., *Stranger Shores: Essays 1986–1999.* London: Vintage.

Dawes, Robyn M., David Faust, and Paul E. Mehl. 2002. Clinical versus Actuarial Judgment. *Science* 243: 1668–1673. Reprinted in Thomas Gilovitch, Dale Griffin, and Daniel Kahneman, eds., *Heuristics and Biases: The Psychology of Intuitive Judgment,* 716–729. Cambridge: Cambridge University Press.

De Marchi, Neil. 2002. Reluctant Partners: Aesthetic and Market Value, 1708–1871. Manuscript, Department of Economics, Duke University.

[33] This list is compiled by the responses of critics asked to vote for their ten best movies of all the time. The institution claims that the films were "chosen 18 months before the American Film Institute announced its own list."

De Piles, Roger. 1989. *Cours de peinture par principes* (1708), ed. Jacques Thuillier. Paris: Gallimard.

Dickie, George. 1988. *Evaluating Art.* Philadelphia: Temple University Press.

Dickie, George. 1997. *Introduction to Aesthetics: An Analytic Approach.* New York: Oxford University Press.

Etcoff, Nancy. 1999. *Survival of the Prettiest.* New York: Anchor Books.

Flores, Renato, and Victor Ginsburgh. 1996. The Queen Elizabeth Musical Competition: How Fair Is the Final Ranking? *Journal of the Royal Statistical Society (The Statistician)* 45:97–104.

Gabszewicz, Jean. 1983. Blue and Red Cars, or Blue Cars Only? *Economica* 50:203–206.

Ginsburgh, Victor, and Jan van Ours. 2003. Expert Opinion and Compensation: Evidence from a Musical Competition. *American Economic Review* 93:289–298.

Ginsburgh, Victor, and Sheila Weyers. 2006a. Persistence and Fashion in Art: Italian Renaissance from Vasari to Berenson and Beyond. *Poetics* 34(1): 24–44.

Ginsburgh, Victor, and Sheila Weyers. 2006b. On the Contemporaneity of Roger de Piles' Balance des Peintres. In J. Amariglio, S. Cullenberg, and J. Childers, eds., *The Aesthetics of Value.* London: Routledge.

Ginsburgh, Victor, and Sheila Weyers. 2006c. Comparing Artistic Values: The Example of Movies. *Empirical Studies of the Arts* 24:163–175.

Goodwin, Craufurd. 2006. Art and Culture in the History of Economic Thought. In Victor Ginsburgh and David Throsby, eds., *Handbook of the Economics of Art and Culture,* 25–68. Amsterdam: Elsevier.

Hume, David. 1965. On the Standard of Taste. In *On the Standard of Taste and Other Essays* (1757). Indianapolis: Bobbs-Merrill.

Hutter, Michael, and Richard Shusterman. 2006. Value and the Valuation of Art in Economics and Aesthetic Theory. In Victor Ginsburgh and David Throsby, eds., *Handbook of the Economics of Art and Culture,* 169–208. Amsterdam: Elsevier.

Koehler, Derek J., Lyle Brenner, and Dale Griffin. 2002. The Calibration of Expert Judgment: Heuristics and Biases beyond the Laboratory. In Thomas Gilovitch, Dale Griffin, and Daniel Kahneman, eds., *Heuristics and Biases: The Psychology of Intuitive Judgment,* 686–715. Cambridge: Cambridge University Press.

Lancaster, Kevin. 1966. A New Approach to Consumer Theory. *Journal of Political Economy* 74:132–157.

Landes, William. 2004. The Test of Time: Does 20th Century American Art Survive? In Victor Ginsburgh, ed., *Economics of Art and Culture,* 143–164. Amsterdam: Elsevier.

Levinson, Jerrold. 2002. Hume's Standard of Taste: The Real Problem. *The Journal of Aesthetics and Art Criticism* 60:227–238.

Machlis, Joseph. 1979. *Introduction to Contemporary Music.* New York: W. W. Norton.

Meehl, Paul E. 1996. *Clinical versus Statistical Prediction.* Northdale, NJ, and London: Jason Aronson.

Milo, Daniel. 1986. Le phénix culturel: De la résurrection dans l'histoire de l'art. *Revue Française de Sociologie* 27:481–503.

Reynolds, Christopher. 1995. *Hollywood Power Stats.* Valley Village, CA: Cineview.

Rosen, Sherwin. 1974. Hedonic Prices and Implicit Markets: Product Differentiation in Pure Competition. *Journal of Political Economy* 82:34–55.

Sarkett, Susan. 1996. *Box Office Hits.* New York: Billboard Books.

Savile, Anthony. 1982. *The Test of Time. An Essay in Philosophical Aesthetics.* Oxford: Clarendon Press.

Shiner, Roger. 1996. Hume and the Causal Theory of Taste. *Journal of Aesthetics and Art Criticism* 53:237–249.

Silvers, A. 1991. The Story of Art Is the Test of Time. *The Journal of Aesthetics and Art Criticism* 49:211–224.

Simonton, Dean. 1980. Thematic Fame, Melodic Originality, and Musical Zeitgeist: A Biographical and Transhistorical Content Analysis. *Journal of Personality and Social Psychology* 38:972–983.

Simonton, Dean. 1998. Fickle Fashion versus Immortal Fame: Transhistorical Assessments of Creative Products in the Opera House. *Journal of Personality and Social Psychology* 75:198–210.

Simonton, Dean. 2002. Collaborative Aesthetics in the Feature Film: Cinematic Components Predicting the Differential Impact of 2,323 Oscar-Nominated Movies. *Empirical Studies of the Arts* 20:115–125.

Simonton, Dean. 2004a. Film Awards as Indicators of Cinematic Activity and Achievement: A Quantitative Comparison of the Oscars and Six Alternatives. *Creativity Research Journal* 16:163–172.

Simonton, Dean. 2004b. Group Artistic Creativity: Creative Clusters and Cinematic Success in Feature Films. *Journal of Applied Social Psychology* 34:1494–1520.

Vasari, Giorgio. 1981. *Les vies des meilleurs peintres, sculpteurs et architectes* (1568). Edited by André Chastel. Paris: Berger Levrault.

Vermazen, Bruce. 1975. Comparing Evaluations of Works of Art. *Journal of Aesthetics and Art Criticism* 34:7–14.

Weyl, Hermann. 1952. *Symmetry.* Princeton, NJ: Princeton University Press.

TWELVE

Confluences of Value

Three Historical Moments

Neil De Marchi

12.1 Introduction

Can artistic, cultural, and economic valuations ever be determined on common ground? The economist is inclined to say yes, in principle; as in an hedonic regression, artistic and cultural worth may be thought of as factors that help to explain variations in market price.[1] However, this presupposes not only that artistic and cultural value can be scaled suitably, but that economic value somehow encompasses the other two sorts. Focusing solely on the latter point, the inclination of art theorists and cultural anthropologists is to assert that just the opposite is the case. Philosophers of aesthetics contend that artistic value is intrinsic, bound up in the experience of art, and is not reducible to some external use- or pleasure-value.[2] Cultural anthropologists for their part argue that cultural value turns on meanings, whose implications extend to personal and group identities, which in turn are simply incommensurable with price. Moreover, identities are often threatened by markets, which arbitrarily alter and displace them without being able to substitute for the losses.[3] Despite such difficulties, conversations about artistic worth, cultural meaning, and market value take place, as they must, in any context where limited financial resources are allocated to the support of art or culture. And, whether we like it or not, in those conversations tacit agreements are reached about relative values in each sphere. Of course such outcomes may be dismissed as no agreements at all, but merely disguised

[1] On the concept of a hedonic regression applied to art objects see Chanel, Gérard-Varet, and Vincent (1996), especially pp. 138–139, and for applications to paintings see Chanel, Gérard-Varet, and Ginsburgh (1996).
[2] See, for example, Budd (1995: Part I).
[3] See many of the contributions to Phillips and Steiner (1999); also see Myers (2002).

I wish to thank Michael Hutter for sympathetic readings and very helpful suggestions.

impositions by the representatives of the economic, which at the moment happens to be the dominant force in choices almost everywhere. I shall argue nonetheless that there are instances of common ground reached with the help of economic forces but where these were not an overbearing influence. Such examples can help to clarify the circumstances under which convergence without dominance might be possible.

I shall explore briefly three instances, all involving paintings. The first involves the valuation of altarpieces in fifteenth-century central Italy. The artistic worth of the painting had to be decided, but along with it a payment for the artist. Aesthetic and economic values had thus to be determined in a single process. My second example is from early eighteenth-century Paris. A dealer there, François-Edme Gersaint, bent on extending the range of his clients, modified the accepted approach to evaluating paintings. He made the pleasure of the viewer an important consideration, along with the traditional categories in terms of which artistic worth was then discussed and assessed: design, composition, coloring, and expression. Gersaint invited potential buyers to choose among clusters of artists offering comparable, though differently bundled, pleasure-yielding characteristics. At presale viewings buyers could determine which paintings within a cluster gave them equal pleasure for the (likely) price, then bid at the auction according to their means. In this process acquisitions were determined by a mix of prevailing visual culture, price, budget, and viewer pleasure.

The third context we will look at is contemporary – the very young international market in Australian Aboriginal paintings. These paintings are discussed sensitively by Terry Smith in Chapter 2, from an aesthetic and cultural perspective. I propose to accentuate the economic, but to stress a point also made by others, namely, that the market in these paintings has drawn significant strength from the application to them of a Modernist aesthetic, something quite foreign to Australian Aboriginal culture. A result, though unintended, is that Aboriginal culture has been sustained in ways that would have been unimaginable without this odd form of market intervention.

I shall argue that these three instances are linked: We observe a temporal progression toward greater transparency and simplicity in aesthetic valuation, a progress in which markets played a key, though strictly facilitating role.

12.2 Valuing Altarpieces and Pricing Artists

A typical fifteenth-century Italian contract between a commissioning body and an artist required the artist to realize an agreed-upon conception using

high-quality materials and competent artisans.[4] The artist might be asked to supply tools and brushes and often to purchase the necessary pigments. Panels and carved frames had to be acquired, and the artist was held responsible for assembling the whole and, in the case of altarpieces, for their remaining in good condition (joints tight, warping and splitting minimal, etc). A contract might include a clause binding the artist to see to the good condition of the work for as long as ten years.

The artist's responsibilities show that he – normally he – was regarded both as artistic executor and as the overall and hands-on project supervisor, even if frequently there was an independent oversight committee formed to follow and see to the progress of the work. The concept behind the painted compositions themselves might originate with the commissioning body or an individual patron, and in the fifteenth century it became usual for artists competing for a contract to supply a physical model of the idea. Agreement on both concept and model occurred prior to the signing of a contract. But because the basic idea did not necessarily originate with the artist, it was not considered something for which a reward had to be given. Contemporary individual patrons, especially, often claimed the idea or invention behind a work as their own.[5] At the same time, inventive flair – *ingegno* – was expected of an artist in the outworking of the model. Often prices were set as a maximum that could be lowered if the end-product was found artistically "insufficient," or as a minimum to which might be added a "bonus" for particular ingenuity or inventiveness over and above what the model required. Frequently, in other words, the artist's exact fee was a residual, determined after the deduction of other costs and dependent on an appraisal of the finished work. Payments normally were staggered so that the final payment could easily be adjusted upward or downward, depending on the assessment.

Once a contract was signed, the relationship between commissioning body or patron and contracted artist in fact was one economists think of as bilateral monopoly, one buyer and one seller, with the power of rejection or nonpayment resting with the former and legal appeal or deliberate delay (though at the risk of being found in breach of a contract conditions) being open to the latter. Where each party to such arrangements has knowledge

[4] Throughout this section I will follow closely the detailed analysis of contracts given by Hannalore Glasser (1977). Her interests were primarily legal, but that background is essential to understanding how valuations of altarpieces were derived. A very accessible analysis of the same material, from a synthetic and art-historical standpoint, is Baxandall's *Painting and Experience in Fifteenth-Century Italy*, 2nd ed. (1988).

[5] See Syson and Thornton (2002: Ch. 4).

of the other – each has a public history, as was almost always the case in a tight-knit community such as Florence – and the balance of power is roughly equal, one would expect repeated plays to be anticipated, and both parties therefore to gravitate immediately toward an equable, almost cooperative division of the surplus above costs, even in the initial contractual interaction. Roughly speaking, this conforms to the results of experiments designed to test whether bargaining between equally knowledgeable parties who will meet again settles quickly on the competitive solution: No surplus (special "rent") goes to either party. It is also the solution typical of contracts between gallerists and beginning artists today – a 50-50 split of sales prices after costs, though the split improves in favor of the artist as success is achieved.[6] Of course, with powerful individual patrons, or in a court setting, the balance of power in fifteenth-century Italy was invariably against the artist, yet the division usually reflected an artist's reputation for excellent work and relative standing, sometimes modified by particular circumstances – a commission in the artist's hometown, for example, might be one in which he would take less than his own going rate. There were complaints by artists, but to judge from surviving documents a majority concerned the wage of artist-retainers, or slowness of payment, not the fee in a one-off altarpiece contract.

This brings us to the essential message bound up in this historical example. Appraisal teams often though not always included "experts"; more importantly, however, there was a common aesthetic language shared by all parties. Michael Baxandall (1988) has argued that where hand gestures and body language are concerned, it is presumptuous to think we can recover just what contemporaries had in mind. But the task is less fraught when it involves not gestures, for which we possess only visualizations, but notions of beauty and propriety, which are spelled out both visually and in contemporary books and commentary. This is not to say that we can unravel summary contemporary judgments of the artistry of different painters, nor is that our task.[7] We need only point to the language in contracts and match it with the terminology in contemporary (or older) discourses about painting.

To illustrate, acceptable altarpieces were to be "beautiful" and they were expected to be executed "better" than the accepted model. More specifically,

[6] For such arrangements see Plattner (1996: 141–142) and Velthuis (2002: 69).

[7] The duke of Milan, in 1490, thinking to employ some artists, had his agent in Florence report on several there. The agent wrote that Sandro Botticelli had "a virile air." By comparison, the "air" of Filippino Lippi was "sweeter," and Perugino's "angelic" and "sweet," while that of Domenico Ghirlandaio was simply "good" (Baxandall 1988: 26–27). The precise intended meanings here elude us.

Madonnas and accompanying angels, it was insisted, should be *gentile* and *belo*.[8] As to "beauty," it was in part strictly material – in a negative sense a painting could not be beautiful if high-quality blue pigment and gold leaf had not been used – and the measure of quality here was unequivocal: cost per ounce. Flair too was given a largely technical definition: Had the artist improved the model by the introduction of novel elements? Had he overcome identifiable difficulties in the process? *Belo*, it is true, embraced a wider range of connotations – fine, beautiful, fair, and graceful, for example – but the term also had a history in both the doctrine of improved nature and Roman rhetoric. Writers aplenty had explored it within both traditions. Pliny, for example, linked beauty with *pulchritudo, amenia*, and *grazia*, meaning broadly the ineffably lovely, harmonious, and graceful, while Alberti, in *On Painting* [1435], redefined it for moderns as having to do with the "composition of surfaces" such that "elegant harmony" is produced "and grace in bodies, which they call beauty."[9] In Alberti's analysis of painting, combining surfaces in a painting was equivalent to laying out of an argument or to disposition in classical rhetoric. In relation to painting or architecture he attempted to capture this under the notion of *concinnitas*, or "the critical sympathy of the parts."[10] This quality, he claimed, is abundantly represented in nature, involves neatly effected elegance, can in certain cases be artificially produced as excellence-by-rule, and, whether natural or artificial, generates pleasure through the senses.[11] The fundamental property of "sympathy" is the source of nature's "dignity, charm, authority, and worth," a worth that is reproducible in art.[12]

In short, without pretending that we know exactly what the less stabilized meanings were, it is clear that the terms used to define fineness, harmony, beauty, and grace in painting had a delimited *range* for contemporaries, sufficient to enable any group so concerned (commissioning body, appraisers, and artist for a particular project) to employ them meaningfully as items for negotiation in a contract pertaining to a given subject and concept. Since bargaining took place before signing and in most cases again after completion of the work, my reading is that we have to do here with a process in which pricing and distribution issues were addressed along with artistic values, and that the latter were not viewed as so ineffable or the former so commercial as to prevent discussion and agreement on both together.

[8] Glasser (1977: 36, 82–83, 108, 115).
[9] Alberti (1972 [1435]: 71).
[10] Ibid. Book II and *On the Art of Building in Ten Books* (1988 [1486]: 302–303).
[11] Ibid.: 305.
[12] Ibid.: 303; cf. Alberti (1972: 89).

To aid in the resolution of issues to be negotiated there were institutions, including the contract itself, along with allied conventions such as legal obligation and redress and the practice of measuring quality of pigments and gold leaf by price, plus oversight bodies, appraisal teams, and physical models. But though there was an implicitly recognized distinction of kind between the artistic and the economic, the task was manageable primarily because the parties took to the table a common aesthetic *and* a common understanding that the realities of economic life for artists also had to be respected. Those realities, as surviving letters from artists attest, of course involved the need to survive, but also a proper acknowledgment of an artist's standing relative to that of other artists.[13]

Artistic value, it was understood, was the output of labor, and the latter was counted as an expense necessary for obtaining the former, though it was also the contribution of a person with his own talents, identity, and place in society. This basic understanding forged a sense that, while multiple notions of value were involved, value as such was a cultural entity in common, and in principle fungible. It could be apportioned among claimants according to what was artistically and socially appropriate, even if measured in a common unit, money. Nobody found it odd that artistic ends were sought within an explicitly legal and economic framework, or that labor services gave rise to artistic worth and both had to be appraised in monetary terms.

12.3 Adding Viewing Pleasure to the Criteria of Desirability in Paintings

The dealer and auctioneer Gersaint was an innovator in the art market of early eighteenth-century Paris. One among many surprising changes he introduced was to appeal to the cohort of viewers to challenge the assumed right of the comparatively few connoisseurs to establish artistic worth.[14] He did not dispute the importance of book knowledge and accumulated comparative viewing experience to the proper appreciation of paintings. At the same time, whereas those accorded the title of connoisseur in early eighteenth-century Paris were principally leisured aristocrats, Gersaint insisted that anyone, whatever his or her means and available time,

[13] For an instance in which the former was of concern see the letter from Filippo Lippi to Giovani di Cosimo de' Medici (1457) in Gilbert, ed. (1980: 7–8), and for an example of the latter, that of Francesco del Cossa to the duke of Ferrara in 1470 (ibid.: 9–10).

[14] This section is based on collaborative work with the art historian Hans J. Van Miegroet. For details, an illustration using paintings in the Italianate landscape family cluster, and references, see De Marchi and Van Miegroet (2005).

might learn to appreciate paintings, in the first instance not through priv-
ileged – and, for many, unattainable – learning but in terms of sensory
pleasure.

In this Gersaint was building on the ideas of the English portraitist and
critic Jonathan Richardson, whose 1719 essays on criticism and connois-
seurship he owned. Richardson claimed for connoisseurship the title of
science. To that end Richardson borrowed and expanded the "Balance of
Painters" of the French critic Roger de Piles. De Piles's *balance*, appended
to his *Cours de peinture par principes* (1708), was a table in which artists
were ranked on a scale of 1 to 20 – effectively only 1 to 18, which he deemed
perfection – along the dimensions noted earlier and that were thought at
the time to define the art of painting: design, composition, coloring, and
expression. Richardson focused less on artists' oeuvres than on numerical
scoring as a scientific way of ascribing artistic worth to individual paintings.
He added new dimensions, such as "handling," "invention," and "grace
and greatness," to de Piles's four basic properties. Richardson also urged
that individual genres – portraiture, for example – should have a distinct,
supplementary assessment. And he applied a subjective ranking on top of
the numerical scorings to indicate whether a painting merely pleased the
senses (as with coloring) or was also elevating or afforded "advantage" to –
"improved" – the viewer (as was the case with grace and greatness). With
this framework transferred to the pages of a notebook, a person was ready
scientifically to judge any painting he or she might happen to encounter.
And, where instruction accompanied full notebooks, any individual might
consider himself or herself a connoisseur. In this conviction Richardson was
at one with Gersaint; both shared a common Lockean approach to education
and a belief in the right of individuals to decide for themselves.

For all that, Gersaint had no use for Richardson's subjective "advantage"
scale. A major reason for this was that he felt customers needed to be weaned
from notions of improvement based on such connoisseurial conceits as a
hierarchy of genres and subjects and a concern with attribution. This was
essential to giving individuals the freedom to enjoy paintings sensorially. Not
that Gersaint rejected head knowledge, but certainly he gave equal weight
to sensorial viewing pleasure. In accord with that stance, he devised a novel
way of presenting paintings and advising potential buyers. Recall that his
advice involved first identifying the pleasing characteristics present in the
paintings of a particular artist, then finding other artists – perhaps just one
or two – who offered comparable properties, even if different artists bundled
these in slightly different ways. The works of artists within such "family"
clusters were to be thought of as substitutable one for another. A painting

by any one of them would please; moreover, any one would be satisfactory in terms of quality. He, Gersaint, educated and informed dealer that he was, vetted them for that. The next step was for viewers to select from works in a family cluster that subset of paintings that gave them *equal pleasure for the price*. By "the price" we should understand likely prices at auction, based on the record of prior sales plus Gersaint's knowledge of availability and current buyer interest. In a final step, viewers could bid for one (or more) paintings from this subset whose (likely) prices made them affordable. Via this procedure, buyers could become collectors even though their means were modest and their education in paintings minimal at the start.

From the perspective of our broader concern – whether there are circumstances under which aesthetic and market value can find common ground – with Gersaint we have taken a giant step toward lowering the barriers. The commissioning bodies of fifteenth-century altarpieces had a triple task; they had to price what they had commissioned, to ensure that prevailing standards of artistic excellence were sustained, and to settle upon fees for their chosen artists. Gersaint, however, operated in the resale market for paintings, and this situation greatly simplified his tasks. He was neither required to price the paintings by the artists he sold nor to decide the pay of any artist. The market itself ranked paintings by price, while artists' fees for the paintings he handled, in the absence of any rule such as the more recent artists' resale right, were already decided at the point of initial sale, that is, in the primary market. Gersaint's role was confined to judging whether any particular painting in an upcoming sale met the threshold for quality, according to contemporary norms. And in making that determination he had the benefit of existing collections, not only in Paris but also in the southern Netherlands and in the Dutch Republic, many of which he knew firsthand. He had only to bring to bear his knowledge of contemporary collecting culture and of the market.

In addition to enjoying these simplifications compared with the fifteenth-century situation, however, Gersaint took important practical steps toward making valuation itself less complex. Without dethroning prevailing connoisseurial notions as to what constituted excellence in the art of painting – design, composition, and so on – he made personal viewing pleasure the ground of preference. Not the be-all-and-end-all, note, but the ground. This initiated his new multistage, but nonetheless simpler, valuation process as outlined earlier.

By giving buyers the freedom to take viewing pleasure seriously, Gersaint removed an education barrier to collecting – hence also barriers of wealth and leisure – while his recommended procedure for choosing a painting

made the process simpler and more transparent. But he also made use of the secondary market itself to render valuation less uncertain. He shared with potential buyers his knowledge and expertise, including information: about availability and past prices, prevailing quality standards, and so on. He also offered them presale viewing and, in the sales catalogs he prepared and had printed, comparative descriptions and assessments (in terms of contemporary aesthetic criteria). Moreover he used the auction mechanism itself to help buyers adjust their private valuations in the light of a shared sense as to what a painting was worth. His auctions were leisurely – some took a month – allowing ample time for participants to discuss with others and assess the strength and direction of their interests in relation to their own. Finally, Gersaint used the open-outcry, ascending-bid method, whereby information on others' valuations is conveyed as part of the bidding process itself.

In Gersaint's hands the market – the secondary market, with informative marketing and a transparent selling mechanism – became a means to facilitate aesthetic valuation. Compared to the largely unarticulated insider valuation process used on altarpieces in the fifteenth century, artistic valuation under his influence was made more inclusive and less daunting, simpler and more certain. Importantly, however, he achieved these gains without shunting aside contemporary aesthetic standards. He introduced external use-value and pleasure-value into the connoisseur's realm of intrinsic valuation, showing in the process that coexistence was possible and advantageous.

It may seem irrelevant to claim that an extension of the market and applications of market knowledge and practice facilitated improvements in aesthetic valuation. After all, ensuring greater access, transparency, and certainty in the valuation process is an external and public achievement that neither adds to nor subtracts from the aesthetic quality of an experience of art, which is inherently private and individual. That at least is the traditional response of defenders of the view that aesthetic value is intrinsic. But two qualifications to that severe position seem in order. First, for most of us, that art exists (survives) and is available to be appreciated is a function of its having become physically public in important degree. Second, there is an irreducible core of common knowledge about art even in the private experience of it, which means that even intrinsic valuation cannot be a wholly personal business, even if it is undertaken privately. By helping to ensure that there would be art and knowledge of it, and on a more extended – thus more viable – scale, Gersaint was strengthening both the possibilities for and arguably also the quality of aesthetic experience, narrowly defined. As we shall now see, a somewhat similar link has occurred in the sphere of

Australian Aboriginal paintings; this one, however, has occurred between aesthetic experience and the survival of larger cultural values.

12.4 "Modernizing" Australian Aboriginal Paintings

The international market in Australian Aboriginal paintings involves some parallels with the previous historical example. There is a strong resale component to the market, and visual pleasure is generally thought to count for a great deal in determining buyer choice and market value. Here, however, the survival of a culture is bound up with the processes by which aesthetic and market values are determined. The connections in this instance are partly accidental, though even then they are inseparable from (dealer-assisted) buyer influence, so this third example moves us still further in that direction.

For tens of thousands of years Australian Aboriginals have made ceremonial body and sand paintings and cave drawings. During the much shorter period spanned by white settlement, they have also produced bark paintings and within living memory in one well-known instance, watercolor paintings on paper. In the last 20 years, however, something new has emerged, a full-fledged retail and secondary market in (mostly) acrylic paintings on canvas or cloth, though originally composition board was used as a support, and sometimes natural pigments and binders have been employed. I shall speak here about just one type of acrylic painting, those produced at the Papunya settlement some 250 kilometers west of Alice Springs, and at nearby outposts. Papunya was established in the late 1960s, some of its residents taken out of the desert and a nomadic lifestyle. Acrylic paintings began to be made there in the early 1970s, though painting soon began also in other settlements. For years the dominant model in these centers was that of a managed market, with local arts advisers purchasing outright, on behalf of the federal government, paintings made by members of the artists' cooperatives they managed. Some direct sales were made to collectors and dealers, but arts advisers were by no means convinced that a free market was desirable. This situation has changed only since the late 1980s, with institutional shakeups that affected the channels through which funds were made available and with the promulgation of government funding guidelines that emphasized greater cost-effectiveness. Cooperatives remain – there are at least 50 operating – and a tremendous variety of paintings is now produced. New media have been and are being tried in various places. Moreover other factors such as gender, location (urban versus outback in this case), generational succession, and the specific land areas associated with an individual artist's tribal

mythology and his or her own birthplace and rights to specific sites and shared Ancestral histories contribute to an astonishing diversity of styles. Clearly the Papunya story is only a part of a much larger and more complex whole. Nevertheless, it is perhaps the best documented and analyzed.

How paintings came to be made at Papunya in the first place is a story told by others, including Terry Smith in Chapter 2. I shall extract from his account just a few of the interpretative points he makes, starting with his remarks about cultural meaning. It is uncontroversial to assert that meaning and identity infuse Papunya artists' work, as they do the paintings made by most other Australian Aboriginals. Smith draws attention to aspects of this that are particularly relevant to the original group of artists at Papunya. One intention of the early artists there – though there are parallels at other places – was to proclaim their links to, and thus cultural claims upon, specific sacred sites and land areas. In another early instance, paintings were used to make a case by some of those lodged at and near Papunya to be allowed to return to their tribal lands. Few paintings carried such immediate social or politicolegal messages; very many nonetheless articulated events or stories stemming from the travels and actions of Ancestor Beings. These stories are often fragmentary and have distinct though overlapping significance to different groups. Retelling, in paintings, of the travels and actions of Ancestors keeps locations and their significance alive for younger generations who may have resettled far away or in an urban setting, or who for other reasons may not have received traditional initiatory instruction of a sort that would have occurred under the old lifestyle. Much of that knowledge is privileged, and access differs even within specific tribal and language groups; men and women, for example, have access to different sorts of knowledge. Some sorts of knowledge acquired through disciplined struggles at initiation are held "dear" – hard won, costly – while some are strictly secret.

By common agreement, much of such Aboriginal knowledge as may be shared with the "whitefella" is conveyed in disguised form. The paintings thus act as barriers to shared meaning even while they are also bearers of it within and beyond the tribal setting. In all cases, nonetheless, an Aboriginal artist embodies part of his or her identity and personal links with the Aboriginal past in what he or she paints. As a consequence, though the paintings may be sold to non-Aboriginals, they remain instantiations of group and personal identities and can never be wholly alienated from their makers. For practical purposes this seems unlikely to result in future restrictions on private collectors, though a recent claim was made for the return of some (older) bark paintings held by a foreign museum, and copyright is not sold with a painting.

Some ethnologists and cultural anthropologists worry that the very rise of a market in the paintings puts the Aboriginal cultural heritage at risk. Their concern is that the incentives and differential rewards offered by the market will inevitably lead to behavior that clashes with and undermines norms within Aboriginal culture, such as group sharing. There is evidence from other situations around the world, however, that market interactions with local cultures are complex and may, but do not always, or inevitably, have this consequence.[15] A nuance has also been added recently by a leading student of Aboriginal art and culture, Fred Myers, who has argued in his book *Painting Culture* that there are inherent resistances to the market and its universalizing tendencies in Australian Aboriginal paintings: They constantly refer to particular locations and specific events in their makers' individual Ancestral histories. These particularities are both advertised and reinforced by the existence and distribution of the paintings via the market.

Here, briefly, are some indicators of the growth and shape the market has acquired. In 1981, paintings on cloth or canvas constituted less than 5 percent of Aboriginal arts and crafts sales in Australia.[16] A couple of years earlier annual sales of paintings are thought to have amounted to about $A2.5 million.[17] The market for Aboriginal arts and crafts is now estimated at something over $A100 million a year,[18] of which paintings make up at least half.[19] But the market has also bifurcated, with arts and crafts being sold at outlets near production centers and at tourist locations around the country, while paintings increasingly are sold through specialized galleries in the main population centers and as "fine art" in auctions in Sydney and Melbourne. The major international auction house Sotheby's is involved, plus a varying number of domestic firms, one of which holds specialized paintings sales while others include Aboriginal paintings in more general sales. Over the past 15 years, paintings in the lowest price range have constituted a decreasing fraction of specialized auctions, with the market buoyed by solid foreign buyer interest, which one observer recently put as high as 80 percent of the total, split equally between the United States and Europe.[20] The number of Aboriginal painters is not known with accuracy, but estimates converge

[15] The histories in Phillips and Steiner (1999) contain various positive adaptations along with negative influences.

[16] Myers (2002: 206–207).

[17] Hutak (2000). I am indebted to Lynh Le for this reference.

[18] Marx (2005).

[19] Based on auction sales results for 2004.

[20] Sales in various price ranges, 1991–2004, from Le (2005); the estimated foreign presence in the market is in Wakelin (2005). I owe this reference to Lynh Le.

around 6,000, or roughly 15 per 1,000 of the Aboriginal population, a ratio much higher than for other Australian artists, and higher than historical estimates for artists in major European centers of artistic production in the early modern period.

I turn now to the subject of main interest here, namely, how this extraordinary growth and in particular the emergence of an international market occurred. If non-Aboriginal buyers, institutional and individual, have been crucial, that takes us back to issues of cultural value and valuation. I will approach these almost solely from the side of Western viewers and buyers. An early critic, writing in response to seeing some Papunya Tula paintings in Gallery A, Sydney, in 1982, judged it "the strongest and most beautiful show of *abstract paintings* I have seen in a long time [my emphasis]."[21] He went on, however, to suggest that there is a gap between the originating impulse or intention and the reception of the artist's message. Accepting this gap as unbridgeable for non-Aboriginals, he simply attempted to convey his own response in words: the artist's "imaginative investment, his belief, gives the work an energy, an aura, an urgency that can be sensed *regardless of his specific meanings* [my emphasis]." The conjunction in this commentary of the characterization "abstract" with words like *belief, aura, energy,* and *urgency* captures precisely the mixed criteria that Westerners have consistently applied to Aboriginal paintings. Unable to bridge the meaning gap, they nonetheless find attractive qualities that go beyond forms, color, and structure, even if they remain elusive. There are repeated allusions to something ineffable, to the paintings as "statements of meaning beyond ordinary sight," as the anthropologist and guest curator of the successful 1988 Asia Society exhibition in New York, Peter Sutton, put it, looking back on that show.[22] The publicity for that exhibition also spoke of "extraordinary vitality" and of "creative energy," language echoed by the Sydney gallerist Christopher Hodges.[23]

The Western viewer is in a strange position: What can be the source of the value such viewers, having only "ordinary sight," plus the dispiriting awareness that there is other knowledge that can never confidently be accessed, ascribe to these paintings? Inevitably one move by the Western viewer has been to focus mainly on the visual impact of a painting, not its meaning. Ironically, this selectivity has been reinforced by the strategy adopted early in the history of Papunya by the artists themselves. As Myers and Smith both

[21] Terence Maloon, *Sydney Morning Herald*, August 25, 1982, cited by Myers (2002: 197–198).
[22] Myers (2002: 251).
[23] Ibid.: 223, 281.

discuss, early on some Aboriginals in another community voiced displeasure with the Papunya artists for representing and allowing public showings of things that should be viewed only by other Aboriginals. The offending artists quickly devised a compromise response, expunging from future work most direct manifestations of Ancestral figures. This meant the suppression of animal forms and natural phenomena (e.g., rock formations, waterholes, lakes) in representational mode. Sacred designs might be similarly disguised. What remained, or was most visible, was a strong formal structure, built entirely of circles, crescents, squares, lines, and dots. Details that earlier had been subsidiary were moved forward to fill out the painting, so that the surfaces began to be dominated by signs for rocks, water and waterholes, sand hills, campsites, lines of travel, and so forth. As Terry Smith nicely puts it, this amounted to a turning inside out of formal conceptions: The important knowledge – the hard-won/"dear," and the secret – receded into ambiguity, and the less important and the less specific acquired prominence. Color, motion, visual logic, and form replaced meaning – as far as non-Aboriginals could see.

The change can be observed clearly in a comparison of two of Smith's illustrations (Figures 2.3 and 2.4). The inversion involved the change just noted, but there was also a complex move toward an abstraction that incorporated two conflicting tendencies. On the one hand, there was abstraction in the unusual sense that it was *away from* the general. The things of cosmic significance gave place to "*particular* sighting[s] of place," to borrow once more Sutton's words. On the other hand, these sightings were shown only as lines, circles, and so on, and grids linking them. These symbols and this visual grammar allowed for multiple meanings and therefore privileged ambiguity and vagueness over specificity and precision.

This obscure particularization unintentionally fed Western buyers' interest in the creativity and individuality of style of individual artists[24] – not an emphasis that has a place in Aboriginal culture – since artists' styles have become more recognizable even while meaning has been rendered more remote. In this recognizability, too, there is something that promoters can use as a marketing tool, something that matches the preferences of many non-Aboriginal buyers, or so anecdotal evidence suggests. Western collectors of contemporary art appear to like owning paintings by successful artists. The evidence for this are the highly skewed prices and share of sales revenue enjoyed by a relatively few artists, a phenomenon of the success-breeds-success sort, but that might also be accounted for in this particular market

[24] Myers (2002: 222; cf. 189).

by the absence of traditional Western criteria for evaluating merit. However that may be, in the Aboriginal paintings market, the phenomenon itself is exaggerated. The *Australian Art Sales Digest* list of the top ten prices achieved in each year's sales has just three artists, Rover Thomas, Emily Kngwarreye, and Johnny Warangkula Tjupurrula, holding six to nine of these places in each year for the last decade.[25]

Turning to more anecdotal evidence, the dealer Christopher Hodges has stated that "some of our best collectors aren't interested at all in the stories. They look at the work."[26] This is in line with the early-established dominance of aesthetic criteria in the resale market for Aboriginal paintings. Thus, the New York dealer John Weber, for example, who was successful in selling an Aboriginal painting to the Metropolitan Museum, hangs Aboriginal paintings with the name of the artist, a title and date, but no specific information about content. There is also an intriguing sleight of hand – or at least a potential for self-deception – lurking here. Once aesthetic criteria dominate meaning, and a recognizable artist's style is present, it becomes possible for non-Aboriginal viewers and buyers to make self-delusory claims. Of this sort is the comment of the *New York Magazine* art critic Kay Larson on the Asia Society exhibition in 1988. Larson wrote: "Modernism has allowed us to *comprehend* the Aboriginal point of view."[27]

Such commentary is also consistent with the separation of the market into "tourist" and "museum quality" paintings. Tourists, Myers suggests, unlike Hodges's "best collectors," do buy paintings as a mnemonic: They value them precisely for the remembrance they elicit of a visual impact experienced at a certain time and place. Correspondingly, for such buyers the meaning or story within a painting is more important than its intrinsic properties.[28] There are in fact hints that meaning counts even in the international market, though the evidence is ambiguous. Much attention is paid by dealers to certified descriptions of a painting, often supplied by an artists' cooperative, and based on things shared by the artist with an arts adviser or dealer. This suggests that dealers are hedging their bets: They believe there is value to collectors in the meaning of these paintings, even if neither they nor buyers can really pin it down. That there is a certificate of origin that goes with a painting is also noted in auction sales catalogs, but rarely is much said in these about meaning. The implication seems to be that "authenticity"

[25] *Australian Art Sales Digest*, "Top Ten Sales by Artist." My thanks to Lynh Le for this information.
[26] Myers (2002: 223).
[27] Ibid.: 282 (my emphasis), and 318.
[28] Ibid.: 215.

matters but that this has little if anything to do with meaning. At a surface level, Aboriginal artists appear to have adapted to these market quirks.

Myers sees in the attachment of Aboriginal artists to land and specific locations a certain level of meaning, one that is both attractive and accessible to Western viewers and that supplies a basis for joining the two poles in a discourse about "aesthetic originality."[29] "The appeal of the paintings is not . . . as ineffable as the best critics suggest."[30] Nonetheless, as Myers is the first to acknowledge, Modernism *has* supplied a convenient framework for Westerners to appropriate Aboriginal paintings, and the Modernist discourse is the prevailing one.

There is also more to be said about meaning. At the same time as color, form, line, and internal relationships (visual logic) began to dominate figure and (Aboriginal) meaning, those other properties noted by the critic Maloon in 1982 – vitality, energy, urgency, inventiveness – remained, or rather became more apparent through the reordering undertaken to satisfy others in the Aboriginal arts community. In part, this shift too was aided by the very ambiguity painters had begun to build into their work. As with any work of art, redundancy of interpretive possibilities supplies both the possibility and an incentive to viewers to add value as they perceive it. In the case of Australian Aboriginal paintings, moreover, even when they are interpreted with the aid of a Modernist aesthetic, they retain vibrancy and energy in part because they are not in fact reactive. Reinforcing this straightforward observation is the superb analysis by Smith (Chapter 2 and elsewhere) of the various levels at which these paintings operate, and the remarkable sketches by Myers showing the multiple variants that were created at Yayayi (42 kilometers west of Papunya) in just two years, 1973–1975, combining the simple elements of circle, line, dot, rectangle, square, and diagonal.[31] In terms of mathematical permutations, of course, the generative potential in this mix far exceeds Myers's limited sample of sketches of paintings actually made.

It is worth emphasizing in closing that the market itself did not create the potential just noted or the change that moved these paintings in directions that probably made them more accessible and pleasing to non-Aboriginal buyers. In the first instance, the latter change was an unintended consequence of intracultural concerns. The potential, moreover, is a matter of the visual logic that grew to dominate many Papunya paintings after the early change – thus itself a consequence of the initial unintended consequence.

[29] Ibid.: 261.
[30] Ibid.: 301 and Ch. 10 passim.
[31] Ibid.: 88 ff.

Because so much of what constitutes market value in this instance is a product of unintended consequences, or, perhaps better, of the confluence of such consequences mixed with the imposition of a Modernist aesthetic by critics, dealers, and non-Aboriginal buyers, this instance teaches us less than we might wish about how to find common grounds for the determination of cultural, artistic, and economic valuations. What remains, nonetheless, is the intriguing fact that these paintings are valued at auction, for reasons that include both the artistic and – probably – the cultural, and that, in a unique way, the market and its values constantly reaffirm and spread something of the Aboriginal aesthetic and cultural values that intermediaries and buyers continue to find elusive yet desirable.[32]

12.5 Reprise

My three examples are linked. There is a historical progression within them, and it involves a steadily greater role for the market. The lesson I draw, however, is that this larger role has actually facilitated the process and enhanced viewer engagement and skill in valuation, as in my second example. Moreover, the market has given more exposure to Aboriginal culture and has thus rendered it more viable than would have been thinkable in its absence.

In this progression, my first example serves largely as a point of departure. Fifteenth-century altarpiece valuation was an insider matter, with both commissioners and artists drawing on shared norms concerning beauty and propriety, norms they constructed by superimposing humanist notions on older religious conventions governing the visual representation of sacred subjects. The process worked but it was not well articulated or transparent, and its results were relatively uncertain compared with those in which the secondary market, and knowledgeable dealers such as Gersaint, were involved.

Gersaint made it his business to invite potential buyers to base their choices on their own viewing pleasure, but he insisted on the need to join this initial ground of preference to subsequent education in paintings. Thus he did not overthrow conventional notions of artistic worth, but rather expanded the

[32] There exists the possibility of testing just how much of market value is contributed by elusive cultural meaning in Aboriginal paintings in a novel form of artists' cooperative. The Jirrawun Aboriginal Arts Center at Kununurra in Western Australia has an adviser who is not averse to introducing the artists to Modernist Western art movements (Marx 2005). If this is considered by buyers a dilution of essentially Aboriginal value in the paintings, the prices of paintings produced by this cooperative should fall behind the general rate of increase of prices in the market.

pool of those making judgments about paintings much beyond the narrow few connoisseurs at the time. And he involved the secondary market. This relieved him of having to assign a market value to paintings and artists alike; he used the ascending bid auction to allow buyers to adjust their private aesthetic valuations by learning about which and how much others valued the same objects as they; and he fashioned a procedure that even novices might follow in moving from a preference to an affordable purchase. Aesthetic valuation, in Gersaint's hands, was simpler and more personal yet also less idiosyncratic than in the case of fifteenth-century altarpieces.

I also argued that the related expansion of the scale of collecting and the increase in the publicness of the valuation process should be considered as having improved the quality of aesthetic valuation, even if we grant that aesthetic or intrinsic valuation is in the first instance a private experience. Gersaint's sales and his marketing techniques, on the one hand, extended demand and thereby enhanced the possibility that individuals could have aesthetic experiences involving paintings. On the other hand, his expertise and advice also enlarged the knowledge essential to such experiences, both by making more paintings available and by encouraging viewers in the practice of experiencing them sensorially. Meanwhile the auction mechanism helped bidders to adjust their private valuations by listening to others on paintings of interest to them and by observing how they bid, thereby fashioning transmittable public aesthetic experience, some of which must also go into private valuations.

The market for Australian Aboriginal paintings gives still more weight to viewer pleasure and simplifies the aesthetic valuation problem even further. The viewer-buyers of Aboriginal paintings are mostly non-Aboriginals, and the cultural meanings in what they see and buy are largely inaccessible to them. But in place of speculating about meaning, buyers, assisted by dealers and critics, have chosen to view – and value – these paintings through the familiar lens of a Western Modernist aesthetic. The market has grown enormously, fueled by the artistic pleasure the paintings generate, part of which, it seems likely, involves some imputed meaning. Ironically, this process has given more exposure to Aboriginal culture and has resulted in a greater likelihood that it will persist than if no market had come into existence. Whereas in eighteenth-century Paris the market simplified aesthetic valuation and rendered it more certain, here a completely alien aesthetic, working through the market – both primary and secondary in this instance – has strengthened cultural values. This was nobody's intention, but dealers, critics, and buyers themselves quickly made the process their own.

Instances such as those we have looked at prove nothing, but they force us to acknowledge that there have been cases of positive interaction between market influences and cultural (including aesthetic) valuation. They also help us determine where to look for and identify such interactions. In a discourse largely driven by one-sided disciplinary perspectives, that is something worthwhile.

References

Alberti, Leon Battista. 1972. *On Painting* (1435), translated from the Latin by Cecil Grayson. London: Penguin Books.

Alberti, Leon Battista. 1988. *On the Art of Building in Ten Books* (1486), translated from the Latin by Joseph Rykwert, Robert Tavernor, and Neil Leach. Cambridge, MA: MIT Press.

Australian Art Sales Digest. www.aasd.com.au/Top10_Menu.cfm (accessed April 24, 2005).

Baxandall, Michael. 1988. *Painting and Experience in Fifteenth-Century Italy*, 2nd ed. Oxford: Oxford University Press.

Budd, Malcolm. 1995. *Values of Art: Pictures, Poetry and Music*. London: Penguin Books.

Chanel, Olivier, Louis-André Gérard-Varet, and Stéphanie Vincent. 1996. Auction Theory and Practice: Evidence from the Market for Jewellery. In V. A. Ginsburgh and P.-M. Menger, eds., *Economics of the Arts: Selected Essays*, 135–149. Amsterdam: North-Holland.

Chanel, Olivier, Louis-André Gérard-Varet, and Victor Ginsburgh. 1996. The Relevance of Hedonic Price Indices: The Case of Paintings. *The Journal of Cultural Economics* 20(1): 1–24.

De Marchi, Neil, and Hans J. Van Miegroet. 2006. Transforming the Paris Art Market, 1718–1750. In Neil De Marchi and Hans J. Van Miegroet, eds., *Mapping Markets for Paintings in Europe 1450–1800*. Turnhout: Brepols 391–410.

De Piles, Roger. 1989. *Cours de peinture par principes* (1708), ed. Jacques Thuillier. Paris: Gallimard.

Gilbert, Creighton E. ed. 1980. *Italian Art, 1400–1500: Sources and Documents*. Evanston, IL: Northwestern University Press.

Glasser, Hannalore. 1977. *Artists' Contracts of the Early Renaissance*. New York: Garland.

Hutak, Michael. 2000. www.hutak.com/articles/aboriginal_art_worth_com_2000.htm (accessed April 22, 2005).

Le, Lynh. 2005. An Empirical Study of the Australian Aborigine Paintings Auction Market, 1991–2004 (mimeo). Durham, NC: Duke University Press.

Marx, Eric. 2005. For Aboriginal Artists, Western Ideas from City Maverick. *New York Times*, June 1.

Myers, Fred R. 2002. *Painting Culture: The Making of an Aboriginal High Art*. Durham, NC: Duke University Press.

O'Malley, Michelle. 2005. *The Business of Art: Contracts and the Commissioning Process in Renaissance Italy*. New Haven and London: Yale University Press.

Phillips, Ruth B., and Christopher B. Steiner, eds. 1999. *Unpacking Culture: Art and Commodity in Colonial and Postcolonial Worlds.* Berkeley: University of California Press.

Plattner, Stuart. 1996. *High Art Down Home: An Economic Ethnography of a Local Art Market.* Chicago: University of Chicago Press.

Povinelli, Elizabeth A. 2002. *The Cunning of Recognition: Indigenous Alterities and the Making of Australian Multiculturalism.* Durham, NC: Duke University Press.

Richardson, Jonathan. 1719. *An Argument in behalf of the Science of a Connoisseur.* London: W. Churchill.

Syson, Luke, and Dora Thornton. 2002. *Objects of Virtue: Art in Renaissance Italy.* Los Angeles: J Paul Getty Trust.

Velthuis, Olav. 2002. *Talking Prices. Contemporary Art, Commercial Galleries, and the Construction of Value.* Ph.D. dissertation, Erasmus University, Rotterdam.

Wakelin, Monique. 2005. Art for Profit and Pleasure. Database: *Business Source Premier.* Money (Australia), issue 1 (accessed March 4, 2005).

The Intrinsic Value of a Work of Art

Masaccio and the Chapmans

Carolyn Wilde

The economic value of a work of art is dependent on a variety of factors, only one of which may be what might be described as the intrinsic aesthetic interest or value of the work. Through comparing and contrasting two very different works of art from widely different times within the Western tradition of art, I aim in this chapter to distinguish this intrinsic value in terms of each work's distinctive acuity to its own times.[1]

13.1 Taste, Judgment, and Culture

In the work published under the title *Lectures and Conversations on Aesthetics, Psychology and Religious Belief,* Ludwig Wittgenstein is reported as saying: "The words we call expressions of aesthetic judgment play a very complicated role, but a very definite role, in what we call a culture of a period. To describe their use or to describe what you mean by a cultured taste, you have to describe a culture" (Wittgenstein 1970: Section 25, p. 8). In speaking of a *cultured* taste here, Wittgenstein is drawing attention to

[1] The word *aesthetic* here, used to demarcate some intrinsic or noninstrumental value, is, of course, fraught with its own difficulties, since it is itself a philosophical term under much contention. In one way it is used in contrast to *artistic* values, where these are matters of skill or craftsmanship. In another, it is used to distinguish interests in the sensual pleasures of things from more cognitive interests. And in yet another, particularly within twentieth-century art theory and philosophical aesthetics, the term misappropriates Kant's notion of disinterested attention, or "purely aesthetic" contemplation, to perpetuate some narrowly formalist account of art. (See further in Shusterman's Chapter 3.) I do not use it in any of these senses, for my interest in the aesthetic is cognitive, related to the way the work of art may be *understood* through its artistic, sensible, representational, or more formal properties.

I thank Victor Ginsburgh and Michael Hutter for their helpful and constructive comments in clarifying and furthering the argument of this chapter.

the fact that an aesthetic judgment is in some way informed or even made intelligible by the culture within which the judgment is made. But before asking what this can mean, I want first to focus briefly on the other word Wittgenstein has used here – for he speaks of a cultured *taste*. To speak of an aesthetic judgment as a matter of taste is problematic, for it seems to commit us to the view that aesthetic judgment is merely subjective, a matter of personal liking based on purely sensible pleasures. Yet we also speak of good and bad taste, as though there are standards of judgment independent of personal preference. So the word Wittgenstein has chosen to use in this passage itself embodies a central problem of aesthetic judgment. Can such a judgment ever be more than the expression of personal preference?

The problem was focused in these terms in the eighteenth century in response to a crisis in thought about the nature of beauty, within a culture increasingly dominated by the natural sciences. Since the formation of the academies in the sixteenth century, the fine arts had appropriated various classical ideas of beauty based on objective principles of proportion and harmony, discernible by the intellect. The fine – or beautiful – arts were thought capable of embodying such principles. Painting, for example, had been defined as the art of representation that aimed at beauty. This could simply mean that it was the art of depicting beautiful things, so that the value of the work would depend on the beauty of the object depicted and the skill of the artist in making this apparent. This aspect is still, of course, a source of pleasure and criterion of value in many works of art. But more sophisticatedly, it meant that a fine painting would represent a serious and elevating subject, which in itself might be painful or disturbing, but it would do so in a beautiful way. Through well-considered design and composition, which put the various figurative and expressive elements in harmonious play, the successful work offered not only sensuous and imaginative gratification but also thoughtful reflection about human pleasure and vicissitude. But against the increasingly dominant idea of objective judgment as it is employed within the natural sciences, the idea of beauty as a property of things independent of human sensibility, becomes problematic. In the new modern context, judgments of beauty are thought of as arising subjectively, from those feelings that a human being is susceptible to in response to the pleasurable appearances of things. If this is so, however, it is easily noted that different people find pleasure in different things.

One response to this crisis of judgment within the academic tradition was the attempt to identify and list explicit criteria informing the good judgment of the connoisseur, and even to offer some quantitative analysis of

the criteria.[2] But such criteria were not commonly agreed, and to many the attempt to apply a quantitative model derived from empirical or scientific contexts to the qualities of a work of art seemed crude and artificial. Thus, since evaluative judgments about art are not regulated in ways that provide for any clear distinction between a correct and incorrect answer – as are, for example, calculations about the distance of things or rates of exchange – it might seem we have to admit that aesthetic judgments about works of art are matters of subjective preference, transient fashion, or mere *taste*.

When Hume and Kant took up this issue in the second half of the eighteenth century, they both started from the assumption that aesthetic judgments were based on subjective response, in the sense that they were not based on qualities of things existing independently of human sensibility or subject to empirical evidence, demonstration, or proof.[3] Yet neither conceded that they were *merely* subjective. Although they each acknowledged that there are no rules or criteria determining the agreement of others in matters of aesthetic evaluation, they both rejected the assumption that such judgments are therefore based merely on personal preference. Hume spoke of the ways in which experience and a delicacy of sense facilitated finer discrimination in judgment.[4] However, to speak of good taste as a personal refinement does risk identifying it as a privileged virtue of the educated and leisured classes, and on such a basis the economic value of a work of art easily becomes a function of impressive provenance, intellectual reputation, or social esteem and aspiration. Yet even if sustained or educated exposure to art does not necessarily refine a person's judgment, and even though there can be no demonstrable rules of expertise, there must be something in Hume's claim that informed experience of art can deepen attention to what we see and allow keener discrimination. Kant, more searchingly, sought to make the logical conditions of aesthetic judgment explicit. Insofar as aesthetic judgments are, in the sense he specified, disinterested judgments, they can call upon the agreement of others, for the ability to bring the understanding together in free play with the imagination, an ability central to aesthetic attention, is in principle an ability shared by all. Nevertheless, although both philosophers aimed in these different ways to show that aesthetic

[2] For a more detailed treatment of this idea in the context of the writings of de Piles, Richardson, and Gersaint, see the chapters by Ginsburgh and Weyers (Chapter 11) and De Marchi (Chapter 12).

[3] See Hume (1757) and Kant (1790).

[4] Compare Wittgenstein in a note from 1947 collected in *Culture and Value*: "Some people's taste is to an educated taste as is the visual impression received by a purblind eye as that of a normal eye. Where the normal eye will see something clearly articulated, a weak eye will see a blurred patch of colour" (Wittgenstein 1980: 64e)

judgment is normative, they both discussed the matter in terms of "taste," and Wittgenstein's use of that term owes something to that tradition.

When Wittgenstein speaks of a *cultured* taste, however, he is speaking also in the context of the later German idealist tradition, which emphasizes the cultivation of the mind or spirit. Although this idea of cultivation, as the term implies, has some origin in extending the idea of the cultivation of plants to processes of human development through socialization and learning, it also involves a substantially evaluative sense of culture. Wittgenstein, under the influence of his reading of Spengler, distinguishes between "culture" and "civilization." This is a critical idea of culture in which the arts atrophy or degenerate in the face of mechanization and social fragmentation. Within broader terms, however, without committing to any such specific idea of cultural development or degeneration, Wittgenstein's remarks on culture do offer a useful idea about the distinctive role of the arts. In a note from 1949 in the collection *Culture and Value* Wittgenstein writes, "Culture is an observance, or at least presupposes an observance." That is, culture can be thought of as that part of social and personal life that is reflective; it is through the culture of a society that the experiences, actions, and events of human life can be objectified, represented, and observed. A significant source of the value of art is the fact that art is a major site of cultural observation.

However, applying experience to social or personal self-consciousness reflection in such cultural practices as art, ritual, or ceremony is not merely an observation, for through cultural representation, events and experiences can be reshaped or realigned. I understand culture in its widest sense as comprising those practices, institutions, or artifacts within and through which meaning and value are articulated, communicated, and challenged. Meanings in this broadest sense are not only articulated symbolic or representational systems, they are also embodied in such things as gestures, habits, or merely the way things are ordered. On this basis I propose that we can helpfully think of culture, of which art is but one complex and stratified part, as a site of meaning. Yet it is not merely the site where new meanings are put in focus and old ones transformed or lost, it is also the terrain on which meaning is legitimated, challenged, or subverted, and the arena in which both meanings and values are placed in conflict.

My purpose in speaking of culture in this general way is to point up the fact that the role of art in such processes is of particular significance. A work of art is a very particular focus, not only for publicly articulating ideas and values, but also for authorizing, subverting, or even eroding meaning and value. A work of art produced through court or civic commission, for example, gives particular authority to its subject whereas more popular art, through humor or transgression, often challenges or subverts ideas of authority. And much

contemporary advertising – possibly the most dominant form of public art – willfully exploits or even perverts meaning. Thus in these and many other ways a work of art does not merely represent or reflect natural, cultural, or social realities; it can itself be constitutive of what is taken to be real. Later in this chapter I build on this broadly Wittgensteinian idea of culture in order to show how the value of two rather different works of art can be seen in terms of their active capacity for focusing, in this extended sense, points of cultural observance.

If the meaning and significance of works of art are to be understood against the background of the practices and institutions of particular cultural times and places, however, this does not mean that they are in principle unintelligible to those who do not inhabit that time or place. Certainly in some cases, where the cultures are both widely divergent and where there has been limited communication, there may be very limited understanding. Prehistoric cave paintings are an obvious case in which we lack any sociocultural context within which to place the conventions of the work. Thus we can only speculate about what they mean. But in most other cases there is some continuity of history or some parity in activities and practices between people that is sufficient to ground a degree of understanding. In some cases there is also direct cross-cultural influence, such as within the popular music of the last century disseminated through travel, radio, and other developments in electronic communication. Nevertheless, understanding across time and culture is vulnerable to loss and susceptible to change, and the original significance of an artifact or work of art[5] can be lost, distorted, or overlaid by more local or contemporary associations. In such cases the *evaluation* of the work may not be based on any well-founded understanding but arise merely from assimilation into local fashions or tastes. In this sense the evaluation is then merely relative to the culture of reception or even to personal associations or preferences. For example, I am myself almost totally ignorant about the meanings of Australian Aboriginal paintings; thus, were I to try to evaluate or compare them, my judgment would be based merely on personal preference for one design or color scheme. No doubt in some cases their economic value in the international art market trades on such superficial judgment.[6] But for a less superficial evaluation of a work of art from another time, place, or social context, we have to understand something of the culture within which it was formed. Thus when Wittgenstein says that

[5] The two terms, *artifacts* and *work of art*, are of course distinct, and not all cultures have works of art in the same sense.

[6] For further discussion of these issues, see Chapters 2 and 12.

in order to understand what is meant by any particular aesthetic judgment, we need to describe a culture, he means the culture in which that work was produced or received. Thus, because any understanding of the work may be more or less informed by an adequate understanding of the culture in which it was produced, not all evaluations are of equal standing. But this is not to deny, of course, that one can enjoy art without understanding it.

Significantly, however – and this connects with Wittgenstein's notion of the spirit of a culture – at least one thing we mean by an outstanding or significant work of art is something that is made in acute response to its own times and purposes. In some cases it is this *temporal acuity* that has the potential to transcend its immediate circumstances of production. To illustrate these points I choose two examples from widely different cultural periods of Western art: Masaccio's fresco *Expulsion from the Garden of Eden*, from the very beginnings of the tradition of fine art (Figure 13.1), and a work by the brothers Jake and Dinos Chapman, *Zygotic acceleration, Bio-genetic de-sublimated libidinal model*, from the end of the twentieth century (Figure 13.2).

In discussing these works I am going to describe some conditions required for understanding them, as a basis for making a judgment about their aesthetic or intrinsic value. At some levels of understanding a work of art – such as recognizing what is depicted in the work or understanding what it is about (that is, is its subject matter) – is a matter of being right or wrong, a matter of more or less well informed cultural or historical understanding. But given an adequate understanding, seeing how a particular work of art presents its content or organizes the subject matter is not in the same way a matter of correct or incorrect understanding. I am proposing that in *aesthetic judgment* what is being evaluated is the way in which the content or subject matter is articulated or presented. Thus although a judgment of taste can, to use Kant's phrase, call upon the agreement of others, unlike a factual claim about the content of the work, it cannot demand that agreement. Rather, agreement and dispute about a work of art are about ways of seeing the work and about agreeing, or failing to agree, about such matters as the significance that any element has within the whole, or about what attitude the work invites to what it presents.

13.2 Variety of Values and Levels of Meaning: Masaccio's *Expulsion from the Garden of Eden*

Masaccio's *Expulsion from the Garden of Eden* is one small but discrete part of a fresco cycle that was initially planned and partially executed by the artist

Masolino on the walls of the Brancacci Chapel in Santa Maria del Carmine in Florence. Masaccio's fresco, completed around 1427, is positioned high on the left entrance arch to the chapel and complements Masolino's earlier fresco on the other side of the arch, also depicting Adam and Eve. It is undoubtedly a work of great value. Clearly it has *artistic* value in the sense that it is an extremely skillful piece of work. Most obviously also it has, and retains, a *religious* value that arises directly from its subject matter, location, and sacramental or didactic function. Because of its innovative place in the history of art it has also accumulated a highly prestigious *cultural*, specifically art historical, value. This, in turn, contributes to its prominent tourist, and hence *economic*, value within the city of Florence.[7]

What is it about this work that intrinsically gives it distinctive religious value and that authorizes its contemporary value as an icon of early Renaissance art? In its own times talk of the artistic value of a work such as this would turn on the skill and craftsmanship of the work considered within the requirements of its commission. The frescos embellishing the Brancacci Chapel played a complex role in the financial and political transactions between the Carmelite order and its patrons, the powerful Brancacci family. It was of value to the silk merchant Felice Brancacci, in powerful ascendancy in Florence until the return of the Medici in 1434, because of the way it would signify and advance his political position and serve to commemorate his family. But when the local and material interests of the Brancacci are merely a matter of the gains and losses of history, do any intrinsic qualities of the work remain? This is of course a general question that can be asked of any work made to further the interests of those who commission it. In many cases the values of such works are directly connected with our interests in the patrons and their purposes. But in some particular cases, such as this fresco by Masaccio, the work has qualities that transcend or go beyond these instrumental or extrinsic values.

Claims about the aesthetic or intrinsic value of a work of art, I have said, depend on the way the work is understood, and understanding a work of art depends to some extent or other on the ability to recognize what is there objectively to be seen in the work. In the case of this work by Masaccio, I am going to list three elements that provide such conditions for debating the meaning and value of his work. Without recognition of the *figured content*, the *subject matter*, and the *expressive qualities* of this

[7] In fact the economic value of this fresco cycle is so considerable that the chapel is now cordoned off from the rest of the church. Visitors are permitted access through a side door for a period of 20 minutes at a price comparable to the entry fee for major museums.

particular fresco, there can be no meaningful agreement or dispute about its distinctively aesthetic meaning and value. If these initial conditions of understanding are satisfied, then attention to the work as a work of art is a process of seeing how the content and subject matter function together and distinctively articulate the meaning of the work. Aesthetic evaluation of this work in the sense I am describing here will be formed as a judgment about the way in which the elements and organization of this work of art give particular and distinctive meaning or import to its content and subject matter.

Looking first at *content*, we can see that the fresco depicts two naked figures, male and female, walking across from the left. There is also a third, clothed figure, apparently floating above them. Such a relatively basic description merely lists and positions the figurative content of the work. But even this is not straightforward. Visual representation is based on many conventions, and although we easily see several figures depicted on this wall, how we do so, how we see them as spatially related, and whether every human with unimpaired sight would see the same is one particular issue. Contrast, for example, the conventions of depicting animals or people in cave painting, or in the many different sorts of cartoon imagery. Although it must be the case that we all draw to some extent on universal perceptual abilities in recognizing the figured content of any work, pictorial representation even at most basic levels also draws on many different kinds of graphic conventions. Seeing figures in this work, for example, demanded of its contemporary viewers a new form of perceptual and imaginative engagement with representational imagery, one based on newer perspectival and tonal conventions.

Yet such culturally developed perceptual skills or abilities are of a different order from the ability to know *who* the people are. Thus, second, we may distinguish the content of this work, its figures and their movements, from its *subject matter* – who the people are and what they are doing. Anyone with the relevant cultural background, that is, those with some degree of agreement in education and culture, will recognize who these figures are and what is happening – the angel Michael is expelling Adam and Eve from the Garden of Eden. Thus recognizing the subject matter in this case obviously depends on the viewer's knowledge of stories to be found in the Old Testament. And one point in distinguishing the content of a work from its subject matter is this. Significantly, for someone who does not have the relevant knowledge to see *who* these figures are, content and subject matter are *distinguishable*. But for anyone who does have the cultural understanding to know who is being represented, seeing that there are figures represented in the work and

identifying them are not two separate processes.[8] Such obvious but necessary cultural conditions of understanding are clearly relevant to the facts of the case, and thus to what counts as a correct or mistaken understanding of what there is to be seen in this work.

The conventions of pictorial depiction through which we recognize the content and subject matter of this work, however, are themselves one source of received opinion about its distinctive value. We are familiar with the art historical story, developed first by Vasari, that Masaccio's work makes major advances in realistic depiction – the two major figures are full and solid; they walk firmly on a clear level. Thus it is that the higher floating figure might seem spatially puzzling to someone who does not know the subject matter of the work. But putting the point about realism in terms of advancement, as Vasari and others did, can invoke a particularly contentious criterion of artistic value, for it invites the idea that historical changes in the tradition of Western art are the result of a progressive development toward some generalized ideal of verisimilitude or realistic representation. Yet there is no one standard of realistic depiction – different styles of art can be realistic in different ways, and mere illusion is neither a necessary nor a sufficient criterion of good painting.[9]

In contrast to this historically progressive view of realism in painting, the art historian Michael Baxandall in his illuminating book on fifteenth-century painting situates the particular sort of realism that is being developed by such painters as Masaccio, in which the bodies of people are depicted with a full substance and volume, within the development of the mercantile culture of the times (Baxandall 1972: section 9, pp. 86–87). The need for the buying and selling of wine in a wider commercial field, for example, gave rise to the use of barrels to store and transport the wine; in turn this required devising instructional diagrams for making barrels and mathematical techniques

[8] Compare the case of Piero della Francesca's small panel painting in the Ducal Castle in Urbino, commonly called *The Flagellation*, about which there is no agreement as to its subject. We can see that there is a man being subjected to flagellation in the background to the left, and that there are three still figures in contemporary dress to the foreground on the right, who may or may not be in the same continuity of space and time with the background group. But we do not know who the contemporary figures are, and there has even been dispute about the central figure on the left, which to most people clearly represents Christ. Thus its subject matter evades us. Nevertheless the subtle complexity of its perspectival composition, the ordering of light and shadow, and the poised moment of each grouping of figures indicate that some deeply significant relationship – and thus meaning – was there to be found, even though it is now lost to us. Knowledge of the subject matter is not *necessary* to recognizing the greatness of representational work of art, but lacking such knowledge limits our full understanding of its intrinsic value.

[9] I have discussed this further in Wilde (2004).

for measuring and gauging volume. So, in addition to more intellectual and philosophical reasons for applying mathematical skill to the construction of pictures at that time, which themselves connect with new interests in cosmology and the structures of the natural world, there were more immediate and quotidian practices that informed an interest and growing expertise in the artistic or pictorial skills of making things look solid. Making Adam and Eve solid and heavy in the way Masaccio did both presents the human body to our imagination as the strong but vulnerable substance that it is and presents these figures as agents walking into a material world not unconnected with our own.

In this way Masaccio's innovations in realistic style play an important role in the particular value of his work. Compared to those in the work of most earlier and contemporary masters, the figures in this work are more tangible, their expressions less schematic, and thus their presence is more continuous with our own. Because the details of substance and expression are so vividly rendered, the state of mind of these figures is quite vivid. Their gestures and facial contortions evidently give expression to some deep anguish. The figures both walk forward firmly, without pause or hesitation and side by side. But Adam covers his eyes – what is now ahead he cannot openly look at – while Eve now covers those parts of her body that she is ashamed that others may see. These are two different expressions of shame, and these *expressive qualities* are a source of the work's particular value in our own times.

So here is a third way in which understanding what is seen in this work depends on some shared cultural understanding in the lives of the people who look at it. Understanding the gait and expression of these figures as showing shame, for example, depends on some very general facts about our expressive and responsive relationships to each other in life beyond the work of art. To some extent at least this is cultural – unlearned human expressions and responses are developed and elaborated in different ways in different cultures and communities. But recognizing what is expressed in an artifact goes beyond the recognition of feeling in life, even while depending upon it, for there are also more abstract issues involved in responding to a work of art, such as recognizing the expressive resonance in different configurations of colors, shapes, tones, and textures. Thus there has to be some shared cultural agreement in responses not only to expressive behavior in life but also to these more abstract qualities both within nature and within art, if we are to interpret a work of art as expressive.

Given some degree of shared cultural understanding of the content, subject matter, and expressive qualities of this fresco we, as people of another

time, can respond to it as an image in continuity with our own sense of physical space, mirroring our own vulnerable carnal embodiment. Although made nearly five hundred years ago, this work speaks to a contemporary sensibility familiar with the depiction of movement and expressive action in photography and film, in ways that other styles of representation do not. The distinctively expressive features of the work invite identification with the abjection and fortitude of these supposedly ancestral figures, in a way that directs reflection on our own condition. This, then, is a very particular source of the work's contemporary value.

And so it is at this point – when the expressive force of this particular and unique presentation of a culturally familiar subject is realized – that the values of the work may be said to transcend its historical context and even its immediate sacramental function. Through its very particularity, that is, through the unique way in which the content, the subject matter, and both the literal and more abstractly expressive elements of the work relate and cohere, the work actively engages attention and has the potential to move and to mobilize the thoughts and feelings of any observer who understands its subject. Such aesthetic attention is not for the purpose of eliciting biblical or historical information, about which there can be clear agreement or discussion of evidence, nor even necessarily directed toward reinforcing personal faith, although it may well still have the power to do that, for even to someone without shared belief in the ancestral story of Adam and Eve, the aesthetic qualities of this work may give some insight into the force and significance of the story, even beyond its role within any particular religion.

This brief analysis of the different levels and sorts of cultural understanding presupposed by this work gives us a model of the conditions required to reach any point of agreement about the intrinsic value of something we consider to be a work of art. Although such common understanding does not determine agreement in aesthetic judgment, it shows how such judgment can be more or less well informed, and thus not merely a matter of subjective taste. Nevertheless, seeing how a work of art articulates its content or subject matter is, in one particular sense, personal. For even though another person can often help one see something one had not noticed about a work, one has still to experience it for oneself. Judgment in art is not just a matter of concurring with experts. Ultimately the way individuals evaluate what they see in a particular work of art depends on the experience, interests, and sensibilities they bring to it. But although in this sense aesthetic judgment is a matter of personal response, given the conditions of understanding of the sort I have described through the example

of Masaccio's work, aesthetic judgment is not merely a matter of subjective taste.

Furthermore, to emphasize the *particularity* of the work is to point to the fact that any substitution by another work with the same subject would be a change in meaning or significance, and thus in value. A work of art is in this sense unique, in contrast with the way in which some other sorts of visual signs such as maps or diagrams can be replaced by others with the same meaning. Thus it is that we value authenticity in art. Although originality and authenticity can be fetishized, works of art that copy another artist's style lack those often subtle elements of the original work that enable that work to focus attention in the unique way it does. Of course, some artists can copy another artist's style so well that it may deceive even those with considerable expertise. But a forgery is a work done with the intent to deceive the viewer into believing that it was conceived and executed through another's unique point of view. Thus it constitutes a betrayal of what we value in looking at a work of art.

13.3 Comparison and Continuity: The Chapmans' *Zygotic acceleration, Biogenetic de-sublimated libidinal model* (*enlarged* × *1000*)

The work of the contemporary British artists the brothers Jake and Dinos Chapman certainly has high commodity value. It gained prominence toward the end of the twentieth century as part of the work produced by a small group of British art-school graduates whose keen sense of the transgressive edge of contemporary art and whose professional acumen about the new art gallery circuit called their work to the attention of collectors such as Charles Saatchi. In contrast with Masaccio's work, which was made by a master craftsman working at a trade, the Chapmans' work is made knowingly and purposefully by two people educated in the tradition of fine art. However, the Chapmans, with their usual wits about them, would probably reject the word *fine*, for one of the things that the Chapmans' work does is willfully challenge or subvert the very idea of beauty that directed this tradition. In a television interview Jake Chapman said, "Conceptual Art challenges the idea that it is the job of a work of art to create objects of transcendent beauty."[10] Indeed a strong motivation of their work seems to be their contempt for popular or commercial works of fine art offering sentimental images of beautiful landscapes or vaguely erotic nudes.

[10] *How Sick Is Your Art?* Produced and directed by Bernadette O'Brian, Channel 4, 2003.

On first sight it may be thought that there is nothing in common at all between their work and that of Masaccio. Yet Masaccio's work stands at the beginning of the very tradition within which these two contemporary artists have their identity and against which they self-consciously construct their work. However, one significant difference between these works arises from the fact that during this tradition there has been a gradual separation of the production of art from its original commissioning sources such as the church or the court. Whereas earlier artists responded to commissions presented through legal contract, the Chapmans offer their work on an open market mediated and directed by dealers. Apart from work on the periphery such as portraiture, there is now little outside fine art that prescribes its subject matter or specifies its materials. Thus in the absence of any determining context, works that challenge traditional or unreflective expectation have more chance of attracting the attention of entrepreneurial dealers and curators eager to be seen to be of their own times. Since much contemporary art is now also confined within a narrow cultural or institutional grouping, and has lost the wider formational contexts that informed the general public's understanding of art, it is often difficult to discern what the art is about. Thus it is with the Chapmans' construction *Zygotic acceleration, Biogenetic de-sublimated libidinal model (enlarged × 1000)*.

The *content* of this work may be obvious – it is a group of synthetic models of almost naked pubescent children grafted together in disturbing ways. But what does it mean; does it have any *subject matter*? Contemporary art, in the tradition of Duchamp at least, does not have subject matter in the sense in which more traditional work does. But even Duchamp's work has to be seen in the context of its own polemic and is not open to any process of free association by the viewer. Jake Chapman's remark quoted earlier places their work broadly within the movement of conceptual art and as such explicitly requires some engagement with ideas or concepts informing this work. But unlike those of the Masaccio work, these ideas are not obviously in the general cultural domain. However, the brothers do help us by listing a set of concepts as the title of the work. Applying these concepts, particularly in the unstable syntactical formation given in the title, does indeed contextualize and direct what we see in a variety of playful ways. But to what purpose – is it merely willful provocation?

Given the conceptual context of the work we may need to place it within some wider discursive framework. Thus another thing that Jake Chapman has said that we might see as informing this work is that models are the most neurotic medium possible. The sorts of models he is speaking of, and which the brothers characteristically use as the materials of their work,

are shop window mannequins or children's dolls or model soldiers. In the Chapmans' work it is often the transgressive assemblage of such things that provides focus for attention and play of thought. But such objects already carry their own meanings. Although a shop window model of a prepubescent girl may have been designed to signify wide-eyed innocent appeal and the smooth featureless body avoids overt signs of adolescent sexuality, the figure is nevertheless charged with the very thing that is being avoided. They are one vivid example of the way in which contemporary marketing works through the exploitation of libidinous interest. It is this disturbing ambiguity, where what is repressed is apparent, that has real social significance outside the context of art, which the Chapmans are describing as "neurotic" and are willfully exploiting when they use such commercial models as the materials of their art.

If Masaccio's work can be seen as responsive to the emerging commercial culture of fifteenth-century Florence in the ways indicated by Baxandall, the Chapmans' work can equally be understood in recognition of the later stages of that culture. The Chapmans are members of a generation who take the all-pervasive culture of advertising for granted, and as creative artists they are conspicuously alert to these culturally distinguishing features of their own time. As with Masaccio, it is this cultural acuity that gives their work distinction within their own time. In neither case is this merely a matter of reflecting the culture, for the work of these artists is in some sort of interactive dialogue with its own culture – the two works I am comparing here both provide in different ways a point of observance within the culture, to use Wittgenstein's term. In our contemporary culture, the artistic skill of the advertising image is to play with images, representations, and meanings, devising ever new connotations. Within advertising this creative talent is directed by the instrumental purpose of marketing the product, and the connection between the image and the product is largely one of fantasy; thus the meaning of the image is very often related to the actual use-value of the product in willfully distorted and perverse ways. The Chapmans use their easy familiarity with this manipulation of meaning to expose the fabrication of sentiment underpinning marketed fantasies. Charles Saatchi's interest in and patronage of the Chapmans cannot be unconnected from this aspect of their work.

My reason for speaking of the Chapmans alongside Masaccio, however, is not merely to compare and contrast some issues of cultural provenance that might inform an understanding of the content and stylistic formation of work, for I think that there is a continuity of theme between the works I have selected. Both Masaccio's *Expulsion* and the Chapmans' work, I propose, are

about human abjection. More specifically, both are about the consequences of eating of the Tree of Knowledge. In the Masaccio the vicissitudes and limitations of human life are presented as poised between abjection and fortitude. The ways in which the solidity and expressivity of the figures are interrelated in this work, I have suggested, demand both a compassionate recognition of their despair, loss, and vulnerability and a recognition of their determination to go forward. Such fortitude in this world is itself a strength that may be used either to live together or to destroy each other. In the Chapmans' case, the cultural provenance of subject matter is less explicit, and thus any meanings embodied in their work are more elusive. However, the content of the work, interrelating with its title, invites play with thoughts and images of cloning and genetic mutation, that is, with possibilities leading our imagination along that branch of the Tree of Knowledge that we now describe as biological science. But although we see the vulnerability and innocence of the figures in this work, their lack of any inwardness is alienating. Unlike the rendering of the figures in Masaccio's *Expulsion*, this work is not expressive; it is not fabricated through pigment and gesture; it is assembled from gruesomely distorted plastic models. Thus any innocence manifested in the figures is transparently exploitable – as is our own innocence in biotechnological development, and as is the viewer's in looking at this work. It is unclear to what extent the Chapmans' work willfully invites prurient interest; the work conflates ignorant fascination about the path along which developments in biotechnology may take us with our awareness of the uneasy and vulnerable place that infantile sexuality manifestly has in our own sexually charged public culture. Thus in a very different way from Masaccio, but through a similar responsiveness to its times, this work by the Chapman brothers reconstitutes its contemporary realities in a way that ably focuses – to use Wittgenstein's word once more – our "observance" on that culture. Works of art such as this are a site of reflections on our own society and culture.

13.4 Conclusion

My purpose in this chapter has been to discuss two works of art from two widely different periods in the tradition of Western art in order to identify their aesthetic interest and thereby their intrinsic value. Given the radical difference in circumstances of production and reception between a fifteenth-century commissioned fresco, which remains in its original ecclesiastical setting, and a late twentieth-century work made with a keen sense of the contemporary entrepreneurial art market, the two works have different

kinds of *economic* value. The earlier work, because of its original religious function and its historical, and specifically art historical interest, has also retained and accumulated various sorts of *cultural* values, which can be contrasted with the cultural prestige following on the evident notoriety of the later work. As works of art, however, both works have in common a very particular sort of value, namely, their acuity to their own times. These works do not merely reflect the wider social, intellectual, and commercial interests of their own times, but each gives a focus to such interests that, to use Wittgenstein's phrase, constitute very particular points of "cultural observance." This is a crucial component of their distinctive value as works of art. Some understanding of the cultural context of each work is required, I have also claimed, in order to make an *aesthetic* judgment, for an aesthetic judgment, in a sense that can be contrasted with responses of pleasure or displeasure, which may or may not be based on such understanding, requires attention to the particular way in which the subject or content of the work has been embodied or made manifest. However, although the understanding that informs such judgment may be more or less accurate or partial, the aesthetic judgment itself is not similarly amenable to correction. If you disagree with my judgment of these works, that is, with the way I see significant and particular meaning to be articulated in each one, and thus with the way I evaluate them, all we can do is look at the work together and possibly you could show me how you see it. There is no other way of establishing the intrinsic or aesthetic value. Yet crucially, in various ways and to different degrees, people do share aesthetic judgment, and the fact that works of art mobilize and communicate our mental life publicly in the way they do is one very general reason why we attribute such special value to them.

References

Baxandall, Michael. 1974. *Painting and Experience in Fifteenth Century Italy: A Primer in the Social History of Pictorial Style.* Oxford: Oxford University Press.

Hume, David. 1970. Of the Standard of Taste; Dissertation IV. In *Four Dissertations* (1757). New York: Garland.

Kant, Immanuel. 1987. *The Critique of Judgment* (1790), trans. Werner S. Pluhar. Indianapolis: Hackett.

Wilde, Carolyn. 2004. Danto and the End of Art. In Kerstin Mey, ed., *Art in the Making: Aesthetics, Historicity and Practice*, 97–121. Oxford: Peter Lang.

Wittgenstein, Ludwig. 1970. *Lectures and Conversations on Aesthetics and Religious Belief*, ed. Cyril Barrett. Oxford: Basil Blackwell.

Wittgenstein, Ludwig. 1980. *Culture and Value*, ed. G. H. von Wright, trans. Peter Winch. Oxford: Basil Blackwell.

FOURTEEN

Time and Preferences in Cultural Consumption

Marina Bianchi

14.1 Introduction

Only recently has economic theory started to address the problem of cultural value and valuation when *consumers'* choices are involved. One reason for this lack of analysis is the ambiguity that surrounds, in economics, the relationship between the use-value and exchange-value, or price, of goods. This may sound a bit paradoxical, since in economics use-value, in the form of utility and preferences, has occupied a central role in explaining the determination of prices, inverting the previous paradigm of cost-based determination. Yet, since use-values imply an inextricable interaction of objective and subjective attributes of goods, analyzing them proved to be problematic and was left outside economics, in the realm of psychology, sociology, or medicine. For economists, choices freely made reveal the individual's reservation price and subjective utility with no need for further investigation, since basic preferences are deemed to be coherent and stable over time.

Utility, then, remains the main goal individual choices are intended to maximize, but, emptied of any real meaning, it bears no explanatory power in solving the complex interplay that runs between individual desires and constraints. Yet how use-values are created and modified in consumption, and how they interact with exchange-values, cannot be lost sight of if actual choices are to be understood. This is especially true when cultural values are at stake.

Recent analyses both within and outside economics have started to fill this gap, recovering an earlier forgotten tradition, in which use-value and

I wish to thank Russell Belk, Andreas Chai, Philip Cook, and Michael Hutter for their helpful and detailed comments and suggestions.

individual motivations were central to choice; this is the eighteenth-century philosophical tradition of David Hume and Adam Smith. Some of these new insights I shall investigate later in this chapter. One, however, is important to recall here. This is the proposition, coming from the field of experimental psychology, that individual motivations can be separated into two broad categories: those involving activities that are intrinsically motivated and self-rewarding and those for which activities are extrinsically motivated, being simple intermediaries for achieving externally set goals.[1] The economist Tibor Scitovsky (1992) reasoned along similar lines when he distinguished between "defensive" and "creative" consumption, between consumption whose aim is simply to relieve pain and discomfort – as in the satisfaction of basic needs – and a more self-rewarding consumption, whose aim is to produce positive pleasure such as one experiences in reading, playing, listening to music, walking for pleasure, or conversing.[2]

This distinction is important for two reasons that I shall explore more fully later. The first is that cultural goods fall into the modality of self-motivated and pleasure-enhancing consumption. Obviously one can engage in the consumption of art and culture for any number of extrinsic reasons: spiritual or moral elevation, knowledge, status, work, monetary rewards, and so on. But artistic creations are there mainly to be enjoyed and, through the senses, to stimulate the mind. The second reason is that conflicts and imbalances may arise between these two modalities of consumption, for example, when (or if) the more pleasure-yielding, creative activities lose ground in comparison with the more defensive ones as a result of changes in their relative cost structure. It should be noticed, however, that the costs and constraints consumers face when choosing are those represented not only by money and prices, but also by other more hidden constraints such

[1] In the field of experimental psychology, for example, Deci (see Deci and Flaste 1996; Deci and Ryan 2002) distinguishes between intrinsically motivated and extrinsically motivated actions, Apter (1992, 2001) between paratelic and telic states. The cultural anthropologist Csikszentmihalyi (1975) focuses on what he calls flow experiences to indicate the features of activities that are self-fulfilling (provide self-generated rewards). I am indebted to Bruno Frey for this reference to the work of Deci. An application to the problem of selecting goods of Deci's distinction between intrinsic and extrinsic motivations is in Frey and Stutzer (2004). For behavioral approaches to a theory of motivation see Kahneman et al. (1999).

[2] In introducing the distinction between comfort and pleasure, Scitovsky drew on contemporary psychological studies linked especially to the name of Berlyne (see Berlyne 1971; Berlyne and Madsen 1973). The distinction between defensive and creative products is due to the civil servant/economist Ralph Hawtrey (Hawtrey 1926: 189–190); see the discussion in Bianchi (2003).

as the availability of time and the knowledge and skills necessary to select and produce use-values.

In this chapter I shall concentrate precisely on these different, less visible, forms of constraints. My underlying assumption is that the incentive structure that governs the choice of cultural goods is more complex and open ended than is the case with defensive or goal-related goods. It relies more heavily on accumulated experience and skills and on available time, and it does not necessarily involve satiation. In other words, qualitative features matter more than quantitative ones, and the traditional monetary constraints of price and income also have less impact than the constraints represented by patterns of previous consumption and by the time that is required to consume the goods involved.

The argument is organized as follows. In the first part I analyze the time constraints that the specific technology of consumption imposes on choices involving cultural goods. I analyze next the technological changes that might have helped to relieve some of these constraints by rendering consumption time more flexible. In the second part of the chapter I survey some of the explanations from the field of experimental psychology that help explain those features of cultural goods that make them enjoyable. Then on the basis of these analyses I discuss how the differing and changing structure of constraints and rewards may affect the final use-value and configuration of cultural consumption. This analysis is complemented by an extended example: that of reading for pleasure. My aim is to show how, when the different modalities of motivations and constraints are spelled out, the interplay between use-value and exchange-value gives rise not only to contrasts and conflicts but also to innovative solutions. As discussed by Michael Hutter in Chapter 4 and Terry Smith in Chapter 2, these solutions present opportunities for enlarging both the scope and the enjoyment of cultural value.

14.2 Time Constraints

The fact that time constraints may pose a threat to the creation of cultural value is well known and analyzed in economics. The now vast literature related to the problem of the so-called cost-disease phenomenon in the live arts has shown that some cultural sectors, in particular live performances, may suffer systematic productivity lags, and increasing relative costs, simply because they require fixed amounts of time to be produced. Whereas the time required to fly from Rome to London has been reduced, thanks to technological progress, to just two hours, the time required to play a symphony will always be the same. Salaries, however, will not lag behind in the

performing arts sectors but will increase more or less in line with the salaries in higher-productivity sectors. As a result cultural goods and activities that are more dependent on time rigidities will lose out in competition with those cultural and noncultural activities that are not (Baumol and Bowen 1966; Towse 1997; Caves 2000; Throsby 2001).

Yet if production takes time, so too does consumption, although this problem has received much less attention, even though it shows the same form of the "disease" that affects production. The productivity of consumption may increase unevenly among goods as a result of the different time constraints that their specific technology of consumption requires. If one thinks, for example, of a basically defensive activity such as food consumption, technological advances have enormously reduced both the time involved in the home preparation of food (consider, for example, the progression from wood stoves to microwaves) and the time and flexibility of its consumption. Refrigeration has allowed a great variety of food to be kept longer and to be transported; fast food is quickly obtainable and easily eaten on the run. This is not the case with many cultural goods whose consumption time cannot be divided, or compressed and speeded up. If a symphony takes an hour and a quarter to be played, it also takes an hour and a quarter to be listened to. A ballet performance cannot be danced at a faster pace, or be broken into discrete sequences that can be followed at a time of one's own choosing. The result is that the time necessary for consuming these goods has increased relative to that for other goods. Correspondingly, and rather perversely, the opportunity costs of time have also increased since, as a result of price-lowering productivity gains, real average incomes have increased over the years.[3] The effect of these processes is that goods less demanding of costly time will be substituted for those more demanding of it.

Tibor Scitovsky was among the first economists to draw attention to these processes and to analyze their impact on consumption. In a 1959 article he stressed that the consumption of leisure activities, in particular those devoted to intellectual pursuits, is highly time consuming, especially if one includes the prior investment in skills that such activities demand (Scitovsky and Scitovsky 1959). Yet economic progress has not "freed" time; nor has it cheapened its cost. Despite the unprecedented productivity gains in housework, and the progressive shortening of the working week, for Scitovsky the total amount of work time has not decreased, but taken different forms, as in the increased time spent in commuting and in personal care and related

[3] With the result that the forgone earnings from time spent in consumption have increased too; see Becker (1976).

services.[4] The inevitable result of these more binding time constraints is that leisure consumption has been reduced or has shifted toward activities that economize on time.

This process, however, is not without consequences for the quality of leisure time and for consumers' overall utility. According to Scitovsky, leisure activities (and cultural activities in particular) that are quicker to consume must also require less knowledge and intellectual effort. They should not be complex but demand little in terms of concentration, memory, and attention. They should also be "conservative" rather than innovative. The process thus becomes self-perpetuating since, as a result of these features, the consumer becomes ever less skilled and less discriminating (Scitovsky and Scitovsky 1959: 100–101; Scitovsky 1986).[5]

Gary Becker's analysis of the efficient allocation of consumption time stressed the substitution effects generated by different relative opportunity costs of time (Becker 1965, 1976). Yet no trace can be found of Scitovsky's concerns with the quality dimension of time and in particular the possible quality losses, which the higher price of consumption time can cause. This was left to Staffan Linder, who studied the impact that the increasing scarcity of time has on its rational use. As did Scitovsky, Linder argued that since productivity increases have made goods cheaper relative to time, consumption time will be reallocated toward activities that are more "goods intensive" (Linder 1970: 78, 80). This could be done through continuous and/or simultaneous consumption (e.g., eating and at the same time playing on the computer, drinking, listening to music, and talking on the phone). The activities that might lose out would be those devoted to culture and to the development of the mind and spirit that for Linder are much less dependent on goods (ibid.: 95, 100) and more on a free use of time that relies on pauses and associations, on anticipations and memories.

In recent years there has been a lively debate in the United States on the topic of the reduced availability of free time. Work time on the whole has undeniably risen in the United States (Schor 1992, 2000), and it is on the rise

[4] As recent studies have shown, time-saving devices in the household have led to an improvement of the quality of outcomes rather than to a reduction in the amount of work; see Gershuny (1988).

[5] In the same article Scitovsky also discusses the productivity lags that afflict the arts (see also Scitovsky 1972 and 1983), thus anticipating Baumol and Bowen's (1966) formulation of the cost disease phenomenon in the live arts. Overviews of the problem of the cost disease are in Towse (1997) and Throsby (2001). These points are also addressed in Bianchi (2003). See Besharov (2005) for a pointed priority claim on behalf of Scitovsky.

in Europe, too, after a period of decrease. Additionally, analysts have stressed that even independently of the objective trend of time availability people *perceive* a decreasing control over their own time and an increasing *sense* that time is scarce (Robinson and Godbey 1997: 48, 305).[6] The argument here is that the increasing speeding up and goods intensity of both work and leisure time put ever-higher demands on the users of time that no increased availability of hours per se seems able to match. More and more activities are performed with the same attitudes one devotes to work (time efficiency, the elimination of slack, etc.).

Do we have to conclude that, as with the cost-disease phenomenon affecting the performing arts, the more contemplative, time-consuming, and technologically rigid cultural goods will in the course of time disappear? The conflict here is even more distressing than in the case of cultural production: If public support of the arts might artificially lower their production costs, in the case of cultural *consumption* not even negative prices might provide the time necessary for their consumption. Yet, as in the case of cultural production, both technological changes activated by economic progress and consumers' own active responses have interacted with the rigidities of consumption time and caused new solutions to appear.

14.3 Time Flexibility

Many of the strategies that firms have introduced and adopted in order to overcome or diminish the impact of the cost disease in the *production* of arts have also favored the containment of the cost disease in their *consumption*. As has often been stressed, major advances in the technology of reproduction – from print to photography, from telegraph, radio, and video transmission to the Internet – have helped reduce unit production costs and provided strong antidotes to the cost-disease phenomenon. In addition to these factors, many of the organizational solutions envisaged by firms have contributed effectively to lowering the monetary and information costs of access to cultural goods.[7]

[6] For this increased sense of time pressure Schor (2000) blames society and consumerism, while Robinson and Godbey (1997) blame consumers who have not been able to adjust their behavior so as to manage free time properly. It should not be forgotten, however, that our increased life expectancy has been a source of expanded free time.

[7] The processes of vertical integration in the book, record, and film industries have reduced unit costs, while the creation and exploitation of genres and specialized products, and of author reputation, plus the existence of knowledgeable and dedicated consumers, have contributed to reduce information costs for the latter (see Caves 2000: 147).

These changes have also extended to the technology of consumption. The time, skills, and modes of cultural consumption have changed radically as a result. Already many of the technological changes that had transformed the consumption of comfort, or "defensive," goods had affected the consumption of "creative" goods, thanks to the existing complementarities between the two. The technology of lighting, for example, remained unchanged until the use of coal gas in the early nineteenth century. Just to keep a house illuminated required the labor of one person to trim wicks (Crowley 2001: 111–115). Gas and electrical illumination, however, not only produced comfort but loosened time constraints on all manner of activities, including cultural ones. To be specific, the changes activated by the technology of reproduction in the creative sector have introduced four new features into consumption technology that contribute to making time more flexible and productive. These are durability, reproducibility, modularity, and decomposability.

First, durability is obtained through the improved technology of duplication, preservation, and storage.[8] It has the effect of both extending the time horizon for exercising choices and enlarging the menu of available cultural experiences. It increases flexibility in consumption (since choices can now be made reversible), and as a consequence it also increases the potential for a more efficient use of time (even if this freedom is not actually exploited). These processes have two effects: They alleviate time constraints (effectively, one's time endowment is made greater), and they decrease the opportunity cost of time by reducing the risk, costly errors, and regret that are associated with time-constrained choices.

Second, reproducibility does the same but also allows for increased accessibility and diffusion of cultural consumption opportunities.[9] Accessibility and diffusion in turn facilitate information and exposure, permit the acquisition of informational details, and ease the selection of desired characteristics. The total effect is a gain in recognizability and familiarity.[10] Accessibility also multiplies the use and functions of time, allowing for simultaneous consumption (listening to the radio while driving, reading when traveling) and

[8] Old jazz classics, for example, have recently been "surgically" cleaned of the noise of old recording, restored, and presented in a stereo version in the 50-CD "Jazz Reference" collection.

[9] As Steven Knopoff (Chapter 8) and Lourdes Arizpe (Chapter 9) show through the simple medium of videotaping of tribal dances and other cultural practices.

[10] The technology of reproduction, as Walter Benjamin emphasized in his famous essay (1968 [1936]), has robbed a work of art of its uniqueness but has also deprived it of its specific cult and ritual value (aura). Images now – Benjamin focused especially on films – are made separable and movable so as to be viewable by larger audiences (1968: 231).

a reduction of slack time. Here the opportunity costs of time are lowered through its more efficient use.[11]

Third, modularity in art – but also in furniture, in clothing, in the interactive use of new-media cultural products, and so on – is obtained by exploiting the transferability of characteristics from one cultural good to another. Certain key properties become the matching links that allow for new combinatory solutions to appear. The evolution of styles, genres, series, or fashions is an example of modularity at work.[12] Besides favoring familiarization and understanding, modularity opens up possibilities for consumers to recombine elements of cultural products and actually produce a desired consumption good. From creating one's own private collection of art, books, and music to newly combining the elements of one's own dress, these are all activities allowed by the modularity of production and reproduction.[13]

Finally, decomposability reflects and is made possible by the complexity of cultural goods' characteristics. By making cultural experiences decomposable into discrete units, step by step learning is facilitated, as is the matching of skills to the difficulty of the task. Stopping a recorded live performance to study, repeat, savor a particular segment; splicing bits of music to create a new musical composition; managing the timing of reading by segmenting the experience at one's chosen pace, all exploit new opportunities offered by this dimension of technical reproduction. Decomposability is complementary to modularity and together they allow – as in an open-ended puzzle – for an active and flexible recombinability of cultural goods' characteristics and an innovative use of time.

What is the impact of these new features on the quality of consumption time? The four characteristics I have discussed in fact weigh differently on the satisfaction drawn from consumption time. Scitovsky and Linder focused principally on the feature of reproducibility (infinite replicas of the same music and infinite variations of slightly different versions, as well as

[11] The wide range of changes – new formal and informal rules of interactions – that have accompanied the reduction in the costs of using and producing information through the development of the Internet are discussed in Hutter (2001).

[12] Half-jokingly, Alfred Barr Jr., founding director of the New York Museum of Modern Art, once wrote that Saks Fifth Avenue, by playfully importing art features into its more mundane products, did more to popularize modern art than "any two proselytizing critics"; see Kimmelman (2003: 14).

[13] Interactive online video games, such as recent South Korean products, allow players to accumulate weapons, armor, and personal features in a combination that is likely to be unique (more than one hundred thousand combinations are possible). Players therefore can create their own acting personas who can meet, speak, and build alliances with those fashioned by other players.

standardization of products). In fact, reproducibility may tend to overcrowd consumption time and accelerate familiarity with an artwork, thus causing a quick erosion of its information content as well as cheapening it by mere excess of exposure. Durability, too, can cause overfamiliarity, for example, when a museum that is no longer collecting attracts no new visitors, or when an attractive old building that has always been there is no longer "seen." The case is different, however, with modularity and decomposability; as we have seen, they allow for an innovative use of time and one's own skills by allowing for a creative use of characteristics.

Technological changes then operate on goods' availability and consumption constraints in multiple ways of which some are indeed productive of new opportunities for value-creation. But what makes an aesthetic experience valuable, and what makes some cultural values more enjoyable than others? The answer, we learn mostly from psychological research, lies chiefly in their ability to stimulate us through change, novelty, and self-renewal.

14.4 Aesthetic Preferences

Both Gestalt theory and experimental aesthetics have been very influential in the studies of the motivational mechanisms underlying aesthetic preferences (Crozier and Chapman 1984). Gestalt focused mainly on the *organizational* elements of a work of art that elicit aesthetic responses (Arnheim 1969), while experimental aesthetics, pioneered by Wilhelm Wundt, Ernst Weber, and Gustav Fechner in the second half of the nineteenth century, sought to investigate the specific *features* of an artwork that are positively correlated with feelings of pleasure.[14]

In this last field of analysis the new experimental aesthetic of Daniel Berlyne has been most important (Berlyne 1971; Berlyne and Madsen 1973). He relied mainly on a body of neuropsychological research that studied the relation between the stimulus potential of a given situation (arousal) and the feelings of pleasure or displeasure that seemed to be associated with it. In the course of a coherent set of experiments he discovered that the specific variables of an aesthetic experience that are responsible for positive hedonic value are conflict or contrast related. He called them collative to indicate their relational and connective nature. Specifically, they are novelty, surprise, variety, complexity, and uncertainty. Positive hedonic responses, however, do not increase monotonically with increases in the stimulus potential. Both low and high levels of arousal are aversive. Pleasure is maximal for

[14] On the role of Fechner's studies on aesthetics, see Arnheim (1986: 40).

intermediate levels of arousal, when novelty, variety, uncertainty, and so on, are felt to be neither too high nor too low.

In this scheme, the pleasure of an aesthetic experience can be increased in two ways: by *increasing* its stimulus potential, that is, its novelty, variety, or complexity, when this is felt to be too low (e.g., boring), and by *decreasing* it when this is felt to be too high (e.g., threatening). Solving a puzzle, reading a novel, or visiting a museum may act on both these dimensions of aesthetic experience. As the experience unfolds, familiarity, mastery, and control increase and reduce the initial uneasiness that is linked to the new experience, while opening up a new ability to detect its novelty and complexity. Within this interpretative framework, however, it is clear that reaching a position of maximal pleasure is not the same as reaching a position of rest, the equilibrium position of economic models. Replicating the experience inevitably erodes its novelty potential: maximal pleasure, when repeated, becomes diminishing pleasure. Contrary to older models of optimal arousal there is an exploratory, dynamic dimension to Berlyne's theory of motivation.

The Berlyne model led psychological research on experimental aesthetics till the beginning of the early 1980s. However, more recently it has been criticized both because it advances a theory too independent of cultural determinants and because the experimental material used in the laboratory could be seen to match poorly the multidimensionality of an experience of art.[15] Yet much of the research that has followed seems not so much to refute Berlyne's approach as to reach complementary conclusions. Apter's reversal theory, for example, though partially critical of Berlyne's model, can be seen as enlarging and developing several of Berlyne's results (Apter 1992, 2001).[16] Apter's theory introduces an important qualification into arousal models, one that is missing in all of them, Berlyne's included, namely, the specific identification of the motivational context within which arousal-seeking or arousal-avoiding behaviors occur. In particular Apter distinguishes two modes of behavior or two states of mind that, structuring as they do experience and associated feelings, can be seen as their metamotivational frame. The first is what Apter calls the telic state; this privileges goals over means, it is future oriented, and in it seriousness and achievement prevail. In the

[15] Recent experiments on complexity have also been interpreted as failing to replicate the bimodality of Berlyne's hedonic curve. See further in Kubovy (1999).

[16] Reversal theory's core structure and concepts are presented in opposition to models of optimal arousal; Apter (2001) associates Berlyne with those models, but this, as we have seen, is a misclassification.

second mode, the paratelic, the quality of the activity takes priority over goals, and playfulness and spontaneity prevail.[17]

Being in one mode or the other influences the way in which stimulus and preferences interact. While in the telic mode arousal avoidance is preferred, in the second, preference goes to arousal seeking. This means that an event or activity that is low in arousal may be experienced as pleasurable and relaxing in the first mode but boring in the second. Conversely, an activity that is high in arousal may be perceived as a source of either anxiety or pleasant excitement, depending on whether the first or the second mode is dominant at the moment of the experiencing.[18] This motivational system thus shows bistability; that means that the preferred level of a variable might jump to an opposite value when there is a switch or reversal of one metamotivational mode into the other.[19]

Applied to the arts this model is able to suggest useful insights into the various mechanisms that might induce pleasurable stimuli. The variables eliciting enjoyment are not different from Berlyne's collative variables of change, though Apter calls them cognitive synergies. The ambiguities, metaphors, and interplay between reality and imagination that commonly reside in artistic creations are stimulating thanks to their continual metamorphoses and the switches of interpretations they produce (Coulson 2001: 230).[20] More basic, however, is the fact that artistic activities are organized so as to induce a paratelic, ludic, and self-rewarding state that facilitates arousal-seeking behavior. This is obtained through the use of frames that both protect, and mark a distance from, the domain of serious actions. Concert halls, art galleries and theaters, as well as – invoking creative activities in their wider

[17] Apter lists three additional metamotivational pairs: the conformist-negativistic mode, which refers to the way rules and constraints are experienced; the mastery-sympathy mode, which deals with the transactive aspects of situations; and the autic-alloic mode, which involves the social dimension of experiences. See further in Apter (2001).

[18] Other instances of preference reversal are well known in economics and behavioral psychology. In expected utility theory the ordering of preferences may depend on the method of eliciting them – the so-called framing problem; see Thaler (1991: 143–144). Additionally, different time discounting at different moments of choice can cause such reversals. See further in Strotz (1955–1956).

[19] For Apter (2001), the reasons for this reversal can be exogenous, as when a sudden negative event induces a telic mode and arousal aversion, or endogenous, as when satiation occurs. In the latter case, interestingly, switches occur spontaneously simply because of the passage of time, which introduces repetition.

[20] Cognitive synergies are types of puzzles or paradoxes that occur when a given entity is seen or experienced as having opposite or mutually exclusive characteristics. Occurrences may be successive, as when the meaning of an entity switches to another of opposite import, as with the Necker cube or Gestalt forms, or simultaneous, as when multiple layers of interpretations overlap. See further in Coulson (2001: 230).

sense – sports and playing fields, parks, sea resorts, and so on, work as protective devices that transform variables otherwise experienced as threatening and upsetting into sources of excitement and pleasure.

The applicability of reversal theory to aesthetic experiences and to psychological practice has been criticized because of its complexity and the indeterminacy that continual reversals can cause. Yet it also places an important caveat on naïve expectations of sustaining a stable and high hedonic level over time.

Last is another set of analyses of aesthetic preferences that arises from research in evolutionary psychology (Barkow et al. 1992). Of particular interest in this context are those studies that have focused on the formation of landscape preferences, that is, of aesthetic responses to the physical environment.[21] In the model proposed by Kaplan (1992), four variables are selected as capturing the salient environmental features that both work as predictors of preferences and are linked with the process of acquiring and processing knowledge. They are coherence, complexity, legibility, and mystery. At one extreme there are landscapes characterized by uniform and repetitive features that show high coherence and therefore facilitate a more or less immediate understanding. At the opposite extreme are landscapes characterized by the presence of partially screened views, by winding and bending paths that suggest mystery and favor inferential exploration. In between are landscapes whose variety of cues increases legibility and understanding, or whose complexity elicits more exploratory behavior. The results of laboratory experiments in which subjects are presented with photo or slide questionnaires show that mystery is the most consistent predictor of aesthetic preferences. Conversely, landscapes that are difficult to understand because of lack of coherence or that are boring because of lack of complexity are the least preferred. Pleasurable landscapes, then, are those that have partially open-space configurations, that are easily readable yet not boring, and most of all that prefigure new opportunities and discoveries if only one were to venture more deeply into the scene.[22] One detects an interesting

[21] The idea is that aesthetic preferences provide a sort of cognitive guide that enables individuals to explore, learn, and exploit better those features that have higher survival success (see Orians and Heerwagen 1992). Aesthetic preferences, interestingly, are described as the affective responses to learning (or the affective bias toward patterns of information; see Kaplan 1992). I owe the reference to this literature to Roger Koppl.

[22] Of particular importance for Kaplan is the learning that occurs when drives are satisfied: it is at this moment that an organism is in the best position to explore and gain information over its environment that may be used at a later time (Kaplan 1992: 584). Speculative knowledge is unrelated to any specific outcome useful at the moment.

convergence here with Apter's protective framework and Berlyne's view of optimal arousal as a mixture of familiarity and novelty.[23]

Other analyses of environmental preference patterns have been applied to the features of urban spaces, housing locations, architecture, and landscape photos and paintings (Orians and Heerwagen 1992). Again, the features of the environment that balance opportunities of refuge and openness, evoking "the feeling that there is always more to be learned" (ibid.: 572 and 573), seem to be the ones that heighten more positive responses. Frank Lloyd Wright's houses provide almost the perfect example of this open-ended balance (Orians and Heerwagen 1992). In his architectural solutions, straight-line patterns and simplified ornamentation, so easily produced by the machine, are combined with a conservative respect for the features of the surrounding environment and the materials used. His unadorned walls, his stained-glass windows, his repetitions and alternations of colors and materials – brick, glass, wood, stone, terra-cotta – coupled harmony and contrast and lent to the lived environment a sense of rhythm and variation that Wright called the music of the eye.[24]

14.5 Differing Rates of Habituation

Let me briefly summarize the features that seem to characterize pleasurable stimuli and aesthetic responses. There are some features that belong to what may be termed the cognitive types of responses: novelty, variety, complexity, uncertainty, synergies, and mystery. All of these capture the stimulus that is derived from a clash or contrast between actual and accumulated knowledge. They activate curiosity and provide the incentives for explorative activity. Then there are those that are linked to the temporal dimension of responses. All the variables just mentioned, plus surprise, depend on the time "distance"

[23] These studies also address the impact that other ecological variables such as the presence of trees or flowers have on our perception of the environment. People whose apartment windows overlook trees were declared to be more satisfied with their environment than those whose view was of a building or grass. The appeal of trees, flowers, and clouds is explained in this evolutionary approach as a marker of seasonal change that promises richness and abundance of life.

[24] See Larkin and Brooks Pfeiffer (2000: 57). When building his own house in Scottsdale, Arizona (called Taliesin West, a project that lasted from 1937 until his death in 1959), Wright wrote this of the desert landscape: "Out here the obvious symmetry soon wearies the eye, stultifies the imagination, closes the episode before it begins. So there should not be any obvious symmetry in building in the desert. . . . Arizona needs its own architecture. The straight line and broad plane should come here – of all places – to become the dotted line, the textures, broken plane, for all in the vast desert there is not one hard un-dotted line!" (Quoted in Larkin and Brooks Pfeiffer 2000: 298).

from the last exposure to a certain event. This dimension is less analyzed in the studies I have referred to, because most experiments are not repeated over time to allow for habituation. Yet this dimension is highly important.[25] Both the passage of time and the acquisition and diffusion of knowledge shift the reference point of an experience. Repetition and acquaintance can cause adaptation and satiety, transforming what was once exciting into something boring. But the reverse can also occur, when what was originally exciting, or mildly so, becomes more exciting because time and knowledge have added the potential of new discoverable dimensions to the experience. Finally there are features that circumscribe the context within which responses actually form. These include the environmental conditions (social and cultural) and the individual metamotivational frame. By shaping the ways in which an experience is organized and perceived, as we have seen, these too shape the sign of the aesthetic response, causing the same event to be positively or negatively felt.

It is not difficult to show that many cultural activities, because of their complexity, internal variety, and combinatory relation with other forms of activities, can activate one or all of these dimensions of change, thus activating economies of learning and innovative uses of one's own time that are also pleasure enhancing.[26] This might explain why for many art goods repetition and exposure do not erode pleasure. As in the example of Wright's houses, they are in fact able endogenously to produce change and therefore become a source of sustained pleasure.[27] Many changes in the technology of consumption have also favored these economies of change and variety, as we have seen, by increasing flexibility and freedom of use through modularity, and by reducing information costs through easier accessibility. For these

[25] The economist Herrmann Heinrich Gossen (1983 [1854]) was the first to recognize the relevance that the duration and, more importantly, the frequency of an experience have on the rewards associated with it. In particular he thought that every experience of a given duration, when repeated, would generate decreasing returns because of increasing boredom. For an analysis of these points, and the disruptive effects that the recognition of time can have on traditional choice theory, see Georgescu-Roegen (1983), Steedman (2001), and Nisticò (2005).

[26] These can be called economies of variety; they exploit the cumulative dimension of arts consumption (Throsby 2001: 117), for which the accumulated consumption capital has many complementary uses and can be transferred advantageously from one employment to another (e.g., the lover of visual art's appreciating ballet, and vice versa); on these points see Bianchi (1998b, 2002).

[27] An analysis of the various ways in which novelty can be used strategically in consumption choices is in Bianchi (1998a, 1999). For an analysis of the pleasure derived from music, see Rozin (1999: 127). An analysis of the application of Berlyne's and Csikszentmihalyi's approaches to architecture is in Benedikt (1996).

reasons art and cultural goods seem to promise higher use-values in time than alternative sources of satisfaction. They should enjoy a strong competitive advantage and systematically prevail in the allocation of consumption time. Yet there are counteracting factors, some of which have been discussed. I will now add some other qualifications.

The first is that the technology of reproduction has allowed for many more goods to compete with each other for consumers' time, money, and human resources. Many of the devices that have been time *saving* have also been time *consuming*. Television, radio, compact disks, videos, and the Internet do save time in the various ways we have previously discussed, yet they also consume time, providing a constant source of new substitutes and alternative time uses. Substitutes may differ significantly in terms of the investment time they require: Those that are more readily available and cheaper in terms of time can then easily replace cultural goods that tend to be more complex or novel and varied. Second, if it is true that leisure time has shrunk in quantity and because of the more hasty way it is used, the motivational counterpart of this process is a dominance of telic states, those that are averse to stimulus-enhancing activities.[28] Finally, both this fiercer competition among goods and the perceived pressure on time might reduce exposure and favor the formation of habits. Habits, rules, and routines are rational economizing responses to informational and time-binding constraints, yet they are also the sources of behavioral rigidities. Once established, these patterns become difficult to break, even if they prove to be pleasure reducing rather than enhancing. As several studies now seem to have confirmed, comfort-related goods are indeed the first we grow used to (Frederick and Loewenstein 1999), showing higher rates of habituation than competing alternatives.[29]

What we have arrived at, then, is that in valuing the way different cultural goods interact with each other and with noncultural goods, many different factors must be taken into account. The first are the costs of access, which include time to use, investment time, and skills. Then there are the rewards associated with each, both present and prospective. Finally there are the

[28] And there must also be a cultural-social propensity, since, as Scitovsky often said, in our societies the acquisition of production skills is more highly regarded than the acquisition of consumption skills (Scitovsky 1985 and 1992: 269).

[29] One of the most interesting debates in recent economic and behavioral psychology concerns the processes that might lead people to form negative habits and addictions. Different explanations have been provided. Some stress the rationality even of negative addictions (Becker and Murphy 1988; Becker 1996); for an alternative approach, see Elster and Skog (1999) and Skog (1999). Others show that choices may present intertemporal anomalies and lock-ins (Thaler 1991; Loewenstein and Elster 1992; Herrnstein and Prelec 1992; Loewenstein et al. 2003).

costs of exit from habitual patterns of behavior that may restrict the set of available choices, transforming what was once a situation of competing options into a single monopolizing choice. All these elements are difficult to discriminate, manage, and maintain and suggest that there is no simple recipe that will cause the more rewarding to prevail in consumption choices. It follows (though it would be tempting to suggest otherwise) that there is no normatively *correct* use of time. Yet there is a general argument to be made in favor of cultural goods: They, because of their complexity and open-endedness, are the least prone to habituation and to the loss of use-value over time.

14.6 Reading for Pleasure

In Latin the word *fingere, fictio*, means "to invent, to imagine," but also "to state falsely, to tell lies." This double-sidedness in literary creations was already revealed in the different interpretations and values that Plato and Aristotle put on art. Art as lie or art as a conveyor of truth, art as corrupting and art as educating, were for them two contrasting values embodied in fictional representations of reality (Segre 1984: 214). Yet it is especially in this contrast that the ability of literary creations to attract is located.

In the eighteenth century with the increasing diffusion and diversification of books made available by the combination of print with the growth of literacy, a new and expanding public of readers started to take shape in Europe and North America. Books could be very expensive, but along with an array of other goods they were also made readily accessible and very cheap by peddlers. Bookshops allowed extensive borrowing, as did the numerous circulating libraries.[30] With the new public, a new revolutionary form of literature attracted readers: the novel. In private and public libraries it soon accompanied and then supplanted the old books of piety, and the more serious history or biographical books.[31] This public preference, of course, was both feared and opposed. Self-appointed guardians of morality and propriety insisted that tastes had to be shaped in acceptable ways. The female reader in particular was a constant object of satire and criticism. Although there were also voices raised in favor of the novel, including that

[30] In mid-eighteenth-century England there were over 100 libraries in London, and nearly 1,000 in the provinces (Brewer 1997: 178). Subscription libraries, also an important source of book borrowing, provided only selected and more serious genres (Cunningham and Kennedy 1999).

[31] By Victorian times fiction had become the leading literary genre and today it represents 70% of the paperback market in the United States (Nell 1988: 19).

of Joseph Addison in *The Spectator*, who welcomed the relaxing pleasures of the imagination that accompanied the reading of them (Woodmansee 1994), the predominant view was skeptical. Novels, though often carrying moralizing messages, were basically unproductive and sought solely for the pleasure they provided. Yet they did not lose their power to attract. Why? What is it that caused and still causes us to enjoy these "verbal imitations of reality" (Segre 1984: 215)?[32]

First of all, reading for pleasure shares its power to entrance and to capture attention with many other forms of narrative activities: storytelling and listening, fantasizing and daydreaming, news, television series, songs, folk tales, memories, legends, myths, jokes, movies, celebrity tales, and video games. Indeed a large amount of our daily time is spent in forms of narrative activity (Nell 1988: 47). Yet the power of the novel does not arise from its fictional nature alone, as in daydreaming, or from its realism, as in news. It arises from the interplay it is able to establish between the fictional and the real, between the world of lies and that of truth. Certain rules must be observed. Lies are "authorized" and disbelief suspended only if credible and logically sound justifications are offered. If consistency is bent to serve the interests of the fictional plot, the novel fails to entice. But it fails also when its fictional devices do not screen and recreate reality inventively, establishing a protective frame that allows the reader to keep a distance from the facts of the plot. Only with such distancing do feelings of sorrow and pain become enjoyable.[33] These rules of unresolved contrasts and unstable balances also bind the other characteristics of a novel, such as those between the possible and the impossible, between suspense and repetition, between empathy and alienation.

In the interplay between fiction and reality, between the known and the unknown, and between certainties and uncertainties, it is not difficult to identify those cognitive shifts from one interpretation to another that stimulate curiosity and attention. Also stimulating are temporal contrasts activated by suspense, repetition, and delays that knit together the events of a novel. Additional displacing effects are obtained by the otherness of the contexts, such as when the plot is placed in exotic, faraway, or futuristic

[32] For Segre (1984: 215–216), the reason why the debate on the autonomy or heteronomy of art is still unsettled today is the difficulty people have in accepting an activity that is not finalized; see also Bianchi (1999: 135).

[33] The role that protective devices play in screening from reality contributes to solving a puzzle that literary critics were baffled by: How comes it that people enjoy tragedies? A discussion of the different answers that have been given to this problem is in Budd (1996: 116).

worlds. These are the processes that explain the never-ending stimulus that reading provides.

But reading for pleasure also yields other gains. Most of the features that the technology of reproduction has brought into being have greatly advantaged not only the production of literature but also its consumption. The infinite reproducibility that print allows does not cause the same effects of saturation that might be at work with other art forms such as music or visual art – for example, when these invade public spaces or cross use contexts as in advertising. Being mass produced and reproduced does not erode the pleasure of reading a classic; in fact, between past and present literature there is more complementarity than substitutability. Diffusion, as with music or movies, helps the consumption of books by promoting communities of readers and the sharing of reactions. The technology of decomposability – much exploited in the past in the many novels that were published serially in newspapers and magazines[34] – also allows the consumer to enjoy multiple selected readings personally chosen. Modularity, finally, allows knowledge to be exported into styles, series, and genres; it also generates combinatory discoveries that make reading a never-ending delight.

As far as time constraints are concerned, contrary to the other forms of fiction narrative, such as movies and stage performances, novels allow for a much greater flexibility of consumption. The time of consumption can be slowed or accelerated, or made to incorporate pauses and delays. In fact many of the pleasures of reading lie precisely in the possibility of mastering one's own reading time. And, although other forms of narratives found, for example, in gossip and celebrity magazines can be even less demanding in terms of time, the enjoyment they generate also remains more fugitive.

14.7 Conclusions

Cultural goods share with other creative goods, such as conversing with friends or playing sports, the ability to renew themselves endogenously. They are therefore less prone to the decreasing pleasure associated with habituation. This should provide a strong competitive advantage for these goods relative to comfort-related ones. Yet there are additional factors that militate against this outcome. The first are represented by the time costs of access. Though the technology of reproduction has lessened these costs,

[34] *The New York Times* has recently restarted offering serialized books chapter by chapter. In Italy over the last two years newspapers have offered, with great success, whole classic books at a very affordable price.

others have appeared, such as overcrowding and overexposure. Additionally, an ever-increasing number of cultural and noncultural products compete for consumers' time and skills. Cultural products that easily and readily please the consumer also very easily tend to become winning substitutes, even if they are less rewarding in the long run. Once such choices are transformed into habits, they are also difficult to abandon, even if one consciously regrets clinging to them.

I have analyzed the possible problems and conflicts between exchange-values, in the form of opportunity costs and time constraints, and rewards, in the form of prospective use-values. As we have seen, the links here are much more complex than traditional economic assumptions would allow, and they do not necessarily resolve themselves in favor of the more rewarding, self-enlarging cultural activities and values. Yet there is much to be gained by addressing the question of motivations and value-creation in cultural activities and the way they interact with economic values. To the various interdisciplinary approaches explored in this volume I have added the contribution of recent experimental research in psychology. This has clarified our understanding of the role played by motivations in different experiential settings and helped us uncover hidden costs of choices that are normally not included in market price.

References

Apter, M. J. 1992. *The Dangerous Edge: The Psychology of Excitement*. New York: The Free Press.

Apter, M. J., ed. 2001. *Motivational Styles in Everyday Life: A Guide to Reversal Theory*. Washington, DC: American Psychological Association.

Arnheim, R. 1969. *Visual Thinking*. Berkeley: University of California Press.

Arnheim, R. 1986. *New Essays on the Psychology of Art*. Berkeley: University of California Press.

Barkow, J. H., L. Cosmides, and J. Tooby, eds. 1992. *The Adapted Mind: Evolutionary Psychology and the Generation of Culture*. Oxford: Oxford University Press.

Baumol, W. J., and W. G. Bowen. 1966. *Performing Arts: The Economic Dilemma*. New York: Twentieth Century Fund.

Becker, G. S. 1965. A Theory of the Allocation of Time. *Economic Journal* 75(299): 493–517.

Becker, G. S. 1976. *The Economic Approach to Human Behaviour*. Chicago: University of Chicago Press.

Becker, G. S. 1996. *Accounting for Tastes*. Cambridge, MA: Harvard University Press.

Becker, G. S., and K. Murphy. 1988. A Theory of Rational Addiction. *Journal of Political Economy* 96:675–700.

Benedikt, M. 1996. Complexity, Value, and the Psychological Postulates of Economics. *Critical Review* 10(4): 551–594.

Benjamin, W. 1968. The Work of Art in the Age of Mechanical Reproduction. In W. Benjamin, *Illuminations* (1936), 217–251. New York: Harcourt, Brace and World.

Berlyne, D. E. 1971. *Aesthetics and Psychobiology*. New York: Appleton Century Crofts.

Berlyne, D. E., and K. B. Madsen, eds. 1973. *Pleasure, Reward, Preference*. New York: Academic Press.

Besharov, G. 2005. The Outbreak of the Cost Disease: Baumol and Bowen's Founding of Cultural Economics. *History of Political Economy* 37(3): 413–430.

Bianchi, M. 1998a. Consuming Novelty: Strategies for Producing Novelty in Consumption. *Journal of Medieval and Early Modern Studies* 28(1): 3–18.

Bianchi, M. 1998b. Taste for Novelty and Novel Tastes: The Role of Human Agency in Consumption. In M. Bianchi, ed., *The Active Consumer: Novelty and Surprise in Consumer Choice*, 64–86. London and New York: Routledge.

Bianchi, M. 1999. Design and Efficiency: New Capabilities Embedded in New Products. In P. Earl and S. Dow, eds., *Knowledge and Economic Organization: Essays in Honour of Brian Loasby*, Vol. 1, 119–138. Cheltenham: Edward Elgar.

Bianchi, M. 2002. Novelty, Preferences, and Fashion: When Goods Are Unsettling. *Journal of Economic Behavior and Organization* 4:1–18.

Bianchi, M. 2003. A Questioning Economist: Tibor Scitovsky's Attempt to Bring Joy into Economics. *Journal of Economic Psychology* 24:391–407.

Brewer, J. 1997. *The Pleasures of the Imagination: English Culture in the Eighteenth Century*. Hammersmith: HarperCollins.

Budd, M. 1996. *Values of Art: Pictures, Poetry and Music*. London: Penguin Books.

Caves, R. E. 2000. *Creative Industries. Contracts between Art and Commerce*. Cambridge, MA: Harvard University Press.

Coulson, A. S. 2001. Cognitive Synergy. In M. J. Apter, ed. 2001, 229–250.

Csikszentmihalyi, M. 1975. *Beyond Boredom and Anxiety: Experiencing Flow in Work and Play*. San Francisco: Jossey-Bass.

Crowley, J. E. 2001. *The Invention of Comfort: Sensibilities and Design in Early Modern Britain and Early America*. Baltimore: Johns Hopkins University Press.

Crozier, W. R., and A. J. Chapman, eds. 1984. *Cognitive Processes in the Perception of Art*. Amsterdam: North Holland.

Cunningham, B., and M. Kennedy. 1999. *The Experience of Reading: Irish Historical Perspectives*. Dublin: Library Association of Ireland.

Deci, E., and R. Flaste. 1996. *Why We Do What We Do: Understanding Self-Motivation*. New York: Penguin Books.

Deci, E. L., and R. M. Ryan, eds. 2002. *Handbook of Self-Determination Research*. Rochester, NY: University of Rochester Press.

Elster, J., and O. Skog. 1999. *Getting Hooked: Rationality and Addiction*. Cambridge: Cambridge University Press.

Frederick, S., and G. Loewenstein. 1999. Hedonic Adaptation. In D. Kahneman et al. 1999, 302–329.

Frey, B. S., and A. Stutzer. 2004. Economic Consequences of Mispredicting Utility (mimeo). Zurich: University of Zurich.

Georgescu-Roegen, N. 1983. Herrmann Heinrich Gossen: His Life and Work in Historical Perspective. In H. H. Gossen (1854)1983, xi–cxlix.

Gershuny, J. 1988. Time, Technology, and the Informal Economy. In R. E. Pahl, ed., *On Work: Historical, Comparative and Theoretical Approaches*. Oxford: Oxford University Press.

Gossen, H. H. 1983. *The Laws of Human Relations and the Rules of Human Action Derived Therefrom* (1854). Cambridge, MA: MIT Press.

Hawtrey, R. G. 1926. *The Economic Problem*. London: Longmans, Green.

Hutter, M. 2001. Efficiency, Viability and the New Rules of the Internet. *European Journal of Law and Economics* 11(1): 5–22.

Herrnstein, R., and D. Prelec. 1992. Melioration. In G. Loewenstein and J. Elster 1992, 235–264.

Kahneman, D., E. Diener, and N. Schwarz, eds. 1999. *Well-Being: The Foundations of Hedonic Psychology*. New York: Russell Sage Foundation.

Kaplan, S. 1992. Environmental Prefences in a Knowledge-Seeking, Knowledge-Using Organism. In J. H. Barkow et al. 1992, 581–598.

Kimmelman, M. 2003. The Saint. *The New York Review of Books* 20(11): 12–15.

Kubovy, M. 1999. On the Pleasures of the Mind. In D. Kahneman et al. 1999, 134–154.

Larkin D., and B. Brooks Pfeiffer, eds. 2000. *Frank Lloyd Wright: The Masterworks*. Milan: Rizzoli.

Linder, S. B. 1970. *The Harried Leisure Class*. New York: Columbia University Press.

Loewenstein, G., and J. Elster, eds. 1992. *Choice over Time*. New York: Russell Sage Foundation.

Loewenstein G., D. Read, and R. Baumeister, eds. 2003. *Time and Decision: Economic and Psychological Perspectives on Intertemporal Choice*. New York: Russell Sage.

Nell, V. 1988. *Lost in a Book: The Psychology of Reading for Pleasure*. New Haven, CT: Yale University Press.

Nisticò, S. 2005. Consumption and Time in Economics: Prices and Quantities in a Temporary Equilibrium Perspective. *Cambridge Journal of Economics* 29:943–957.

Orians, G. H., and J. H. Heerwagen. 1992. Evolved Responses to Landscapes. In Barkow et al. 1992, 555–579.

Robinson, J. P., and G. Godbey. 1997. *Time for Life: The Surprising Ways Americans Use Their Time*. University Park: Pennsylvania State University Press.

Rozin, P. 1999. Preadaptation and the Puzzles and Properties of Pleasure. In D. Kahneman et al. 1999, 109–133.

Schor, J. 1992. *The Overworked American: The Unexpected Decline of Leisure*. New York: Basic Books.

Schor, J. 2000. Working Hours and Time Pressure: The Controversy about Trends in Time Use. In D. Figart and L. Golden, eds., *Working Time: International Trends, Theory and Policy*, 73–86. London: Routledge.

Scitovsky, T. 1972. What's Wrong with the Arts Is What's Wrong with Society. In T. Scitovsky 1986, 37–46.

Scitovsky, T. 1983. Subsidies for the Arts: The Economic Argument. In T. Scitovsky 1986, 149–159.

Scitovsky, T. 1985. How to Bring Joy into Economics. In T. Scitovsky 1986, 183–203.

Scitovsky, T. 1986. *Human Desires and Economic Satisfaction. Essays on the Frontiers of Economics*. New York: New York University Press.

Scitovsky, T. 1992. *The Joyless Economy: The Psychology of Human Satisfaction* (1976), revised ed. Oxford: Oxford University Press.

Scitovsky, T., and A. Scitovsky. 1959. What Price Economic Progress? *The Yale Review* 49:95–110.

Segre, C. 1984. *Teatro e Romanzo*. Turin: Einaudi.

Skog, O. 1999. Rationality, Irrationality, and Addiction: Notes on Becker and Murphy's Theory of Addiction. In J. Elster and O. Skog, eds. 1999, 173–207.

Steedman, I. 2001. *Consumption Takes Time: Implications for Economic Theory*. London: Routledge.

Strotz, R. 1955–1956. Myopia and Inconsistency in Dynamic Utility Maximization. *Review of Economic Studies* 23:165–180.

Thaler, R. H. 1991. *Quasi Rational Economics*. New York: Russell Sage Foundation.

Throsby, D. 2001. *Economics and Culture*. Cambridge: Cambridge University Press.

Towse, R., ed. 1997. *Baumol's Cost Disease: The Arts and Other Victims*. Aldershot: Edward Elgar.

Woodmansee, M. 1994. *The Author, Art, and the Market: Rereading the History of Aesthetics*. New York: Columbia University Press.

PART FIVE

CULTURAL POLICIES

FIFTEEN

What Values Should Count in the Arts?

The Tension between Economic Effects and Cultural Value

Bruno S. Frey

15.1 Introduction

The basic distinction made in this volume compares "economic value," expressed in monetary terms, to "cultural value," reflecting cultural, aesthetic, and artistic significance. This chapter makes a different distinction that is rarely made explicit but that is of central importance to the decision process in cultural policy. On the one hand, "value" is attached to the economic effects of cultural activities: When cultural values are created, economic activity is bolstered. The increase of commercial activities induced is measured by the so-called impact effect. On the other hand, the value of culture is reflected in the increased utility to consumers and nonconsumers of a particular cultural activity. This type of value is measured by "willingness-to-pay studies." I argue that these two values dominate cultural policy, but they capture totally different aspects and are proffered by different kinds of communities.

People involved in the arts as administrators or entrepreneurs – they are referred to as *arts people* in this chapter – are fond of *impact studies*. These studies measure the economic effects of a particular artistic activity such as that of a museum or festival. In contrast, people trained in economics and applying it to the arts – they are referred to as *arts economists* in this chapter – are fond of *willingness-to-pay studies* measuring the external effects, that is, those welfare-increasing effects of artistic activities not captured by the market. These preferences are rather surprising. Arts people focus more on the economic effects of the arts than economists do. Or conversely: Arts economists concentrate more on the artistic aspects than arts people do; they even argue that impact studies may be counterproductive for the arts, thus rendering a disservice to the arts.

261

The two views stand in an isolated way beside each other. On the one hand, arts people often pay considerable sums of money to commission impact studies. They do not commission willingness-to-pay or contingent valuation studies.[1] They disregard them and, insofar as they know them at all, they consider them at best to be purely academic exercises. On the other hand, arts economists have undertaken dozens if not hundreds of contingent valuation studies of the arts and have published them in scholarly journals.[2] They have not been commissioned by the respective art institutions but have rather done so for academic purposes. They consider impact studies to be inappropriate and methodologically weak.

In this chapter, I want to put the two opposing views in perspective.[3] I attempt to be more general than the "economic" approach favored by arts people and the "artistic" approach favored by arts economists. The appropriate level is the political one, where decisions on art are taken. This level helps us to do justice to both approaches and to see in what respects the two aspects are lacking. This avenue also differs basically from the standard economic approach to the arts. Our analysis reveals that the conflicting approaches focus on quite different aspects and therefore rely on a different analysis and methodology:

- Arts people take the artistic value as given. They see no need to establish that it contributes to human welfare. They take it as a matter of course that the support of the arts belongs to the essential tasks of governments. The need to *activate* decision makers actually to undertake artistic projects is seen as the real problem. They feel that the decision makers can best be convinced to become active when it is demonstrated to them that the artistic project yields large economic benefits. Impact studies serve to prove this claim "scientifically."

[1] The editor of the special issue "Contingent Valuation in Cultural Economics" in the *Journal of Cultural Economics* (Schuster 2003: 157) states in his introduction: "To date many of the CVM (Contingent Valuation Method) studies in the cultural field have been hypothetical, conducted by economists who are perhaps more interested in their analytical techniques than in informing actual policy debates. Few seem to have been commissioned by actual clients who have decisions to make." He does not or is not able to state what few studies were indeed commissioned.

[2] Noonan (2003) identifies more than one hundred studies of various cultural goods; see also Mourato and Mazzanti (2002).

[3] No methodological discussion of either impact or willingness-to-pay studies is intended. There is an extensive literature available. For impact and willingness-to-pay studies, see, for example, Throsby and Withers (1979), Throsby (1994, 2001), Frey and Pommerehne (1989),Towse (1997), Frey (2000), De la Torre (2002), Epstein (2003). For contingent valuation see the special issue of the *Journal of Cultural Economics* (2003), and for recent important examples Bille Hansen (1997), Santagata and Signorello (2000), Thompson et al. (2002), Willis (2002).

- Arts economists find it essential to establish the *need* for government support of any art project. According to classical welfare economics, a necessary condition is that the project in question produces external effects not captured by the market. Only then is there an argument for government support. If there are no external effects, the artistic project can be produced by the market, provided it yields a profit reflecting higher social benefits than costs. Willingness-to-pay studies are the best method to identify these external effects. In contrast, standard economists applying their methods to the arts do not consider political activation; they find it sufficient to offer their conclusions about whether there are external effects legitimizing government intervention.

At the level of political decision making, both views play an important role. It is indeed crucial for willingness-to-pay studies to establish the need for government intervention – if not, it can be concluded that the market will perform the activities more cheaply and efficiently. But it is also crucial that the projects are actually undertaken. This process requires political activation. However, both approaches need to be undertaken with care. Unfounded claims for government support threaten to backfire, because in that case many nonartistic projects would also easily qualify for government support, overtaxing public revenues. The same occurs if it can easily be shown that the market can well supply the artistic project in question. Political activation induced by impact studies is equally crucial, as it overcomes one of the major weaknesses of willingness-to-pay studies: the separation between evaluation and decision (Frey 1997). Willingness-to-pay studies must urgently go beyond being a purely intellectual exercise.

This chapter proceeds as follows: Section 15.2 sets the stage by characterizing the views of arts people and arts economists, reflected in impact studies and willingness-to-pay studies, respectively. The following section presents a critical examination of the two views, showing that both are lacking. Section 15.4 discusses the consequences for decision making in the arts.

15.2 Setting the Stage: Characterizing the Two Views

15.2.1 Impact Studies

The economic benefits of artistic projects as measured by impact studies typically consist of the direct expenditures associated with a project, as well as the indirect expenditures induced by suppliers and visitors to the arts project. Consider the case of a classical opera festival that is proposed to be

established. The direct expenditures benefit the artistic and administrative personnel engaged in the project and the suppliers of material goods and services. The recipients of direct expenditures create indirect benefits in turn by spending a large part of their revenues on the supply of these goods and services. For example, the provider of costumes for the singers must spend money to produce them, and the recipients of those expenditures again spend a large part of it. The visitors to the opera festival also spend money in addition to the entrance fee, for instance, on transport costs, hotels and meals, hairdressers or clothes. Thus, a multiplier process is set in motion by the establishment of the opera festival, going well beyond the direct expenditures.

Arts people assume that the persons directly and indirectly benefiting from the festival will provide political support for its establishment. This support is based on the economic advantages gained and is quite independent of the artistic benefits created by the artistic project.

15.2.2 Willingness-to-Pay Studies

Arts economists favor willingness-to-pay studies because they seek to measure whether the total benefits created by the artistic project outweigh the total costs. If it turns out that the net benefits are negative, the art project should not be undertaken, as society is worse off with it than without it. The market captures some of the benefits and costs, most importantly by visitors paying an entrance fee to attend an artistic activity, in our example the festival. As the visits are voluntary, it makes sense to assume that people only attend the festival and pay the entrance fee if the benefits to them outweigh their costs. But the market does not capture part of the benefits and costs. In particular, there are positive external effects accruing over and above the direct benefits; the most important ones are existence, option, bequest, education, and prestige values. They are characterized by the fact that they increase people's welfare but cannot be captured in monetary terms by the suppliers of the artistic project. This often means that the arts project is not commercially viable, though society's welfare would be increased by its existence.

There are several methods to capture such external effects. The most prominent technique to measure the willingness to pay is known as contingent valuation. It uses carefully crafted representative surveys to reveal how much utility the arts project would generate. The willingness-to-pay approach is based on classical welfare analysis. The underlying idea is that with a perfect market a (Pareto-) optimal or (potentially) welfare maximizing use of the economic resources available to society is generated (Peacock

1969; Throsby 2003). When the market is not perfect, there is a case for public intervention. The government should rectify the shortcomings of the market. In the example of the opera festival, the suppliers of the festival should receive a subsidy from the government amounting to the size of the positive external benefits created. This intervention is designed to overcome the otherwise nonexistent, or negligible, supply of the arts project.

15.3 Critical Evaluation

Both arts people and arts economists consider only limited goals and seek to attain their respective goals in an inadequate way.

15.3.1 Shortcomings of Impact Studies

Arts people wishing to activate decision makers to support arts projects take into account only a part of the underlying motivation. By focusing on the expenditure impact, arts people implicitly assume that decision makers are solely responding to the economic benefits of such projects. The motivational structure of people is, however, much broader:

- People are prepared to support artistic activities for many different reasons, of which selfish economic benefits are only one, and perhaps not even the most important one. An important reason for supporting the arts is an intrinsic interest in art. People enjoy arts activities for themselves (direct consumption benefits) as well as for their heirs and other people (indirect benefits). These are exactly the benefits captured by the willingness-to-pay techniques. They should therefore be of interest to arts people, especially as people with such an intrinsic love of the arts are often prepared to make a great effort to influence the political process in favor of the arts. At least in the case of classical art forms, such intrinsic interest is on average highly correlated with education and therefore income. It is well known that such persons tend to participate more intensively in political activities. They therefore are more influential in the political process than persons less intrinsically interested in the arts.
- People or organizations commercially benefiting in a direct way from an artistic project do not necessarily support it. They may expect other projects to give them even higher profits. From a commercial point of view, a sport event such as a football championship may be preferable to a classical music festival. To rely solely on the economic benefits of an artistic endeavor, as is done when calculating impact values, is

therefore dangerous. To rely on the commercial benefits when arguing for an arts project means that the argument is lost if another, nonarts project is shown to yield even higher benefits. In that case, the use of an impact study would be counterproductive.

15.3.2 Shortcomings of Willingness-to-Pay Studies

To rely on the values generated by willingness-to-pay studies is also inadequate, again because the motivational aspects are ill conceived. The basic idea that the existence of positive external effects of arts projects constitutes a case for government intervention does not take into account the specific incentives of governmental decision makers. It is necessary to consider that these decision makers may pursue their own goals that are certainly not identical to, or even compatible with, "general social welfare."[4] Rather, politicians pursue their own utility. A love of the arts is only one, probably not very important, argument in their utility function; others are income, prestige, and power. Most importantly, government politicians must be reelected in a democracy and must cling to power in an authoritarian or dictatorial system. This means that in election times the politicians in power have only limited, if any, interest, at least in "high" art, which is known to be appreciated only by a small percentage of the electorate.

Public officials may exhibit a more continuous interest in the arts because they do not depend on reelection. But they derive utility from being able to become active in the way they best see fit, which is not necessarily best for the arts. Bureaucratic interventions in the form of public subsidies have strings attached, which are inimical to artistic freedom. It follows that the basic idea of classical welfare economics that government interventions serve to overcome the misallocation due to external effects is politically naive. Indeed, it may even happen that government intervention worsens the state of the arts. It is therefore not sufficient simply to demonstrate the existence of positive external effects of an arts project; rather, it is necessary to analyze how these values enter into the political process, and to what extent they are taken into account.

15.4 Conclusions: Consequences for Arts Policy

The preceding discussion reveals that the approaches of both arts people and arts economists are valuable and are needed, but that both are lacking

[4] This is the message of the New Political Economy or Public Choice; see, for example, Mueller (2003).

in important respects. Both of them need to be extended in order better to reach their different goals, overcoming market failure in the willingness-to-pay studies and activating the political process in impact studies.

A broader approach to studying arts policy can only be outlined here. When the willingness-to-pay approach of arts economists identifies a "market failure," the relevant question is what social decision-making system is best able to provide society with the art desired by the population. Government support by subsidies is not the only alternative to the perfect market. There are many more possibilities available. Examples are the designed use of pricing, such as handing out art vouchers to the population; indirect government support, for instance, via tax breaks; or providing institutional conditions favoring voluntary supply via volunteer work and donations to the arts. Such a broad approach is more useful and more practical than an abstract analysis confined to the study of willingness to pay. But the discussion has also shown that the willingness-to-pay approach is able to convey valuable information on the intrinsic utilities provided by arts projects.

Activating political decision makers is of crucial importance for arts policy. For that reason, the politicoeconomic interdependence as a whole needs to be studied. This goes far beyond the narrow self-interest of persons benefiting commercially that is addressed in impact studies. To analyze how arts supply comes about links up closely with the broader analysis emanating from market failure. An important focus must lie with the various groups of actors determining arts policy. They comprise the population or voters; collective actors in the form of firms, nongovernmental organizations, and interest groups for the arts; and governmental actors, namely, politicians in power and in the opposition party, as well as public officials in their various occupations. For these actors, it is necessary to be aware of the restrictions they face, be it time, effort, resources, or reelection and bureaucratic constraints. Extrinsic incentives such as the commercial interests captured by impact studies as well as intrinsic interests in the arts need to be considered. This also includes aspects recently analyzed in economic psychology. An important example is the systematic misprediction that potentially occurs between the time of decision and consumption (Frey and Stutzer 2003). The arts may be an area in which individuals find it difficult to predict correctly how much utility they will experience from a particular arts project when they consume it in the future. Often they tend to be rather skeptical, especially when they have to decide about a new and therefore unfamiliar form of art. They therefore believe that they will not enjoy it in the future. In fact, however, they inadvertently become used to the new art form and

enjoy it when they actually consume it. Such misprediction may lead to systematically distorted decisions with respect to the arts.

Both impact studies and willingness-to-pay studies should play an important role in cultural policy. But it is argued that presently both of them are inadequately conceived. Impact studies capture only a small part of the potential political support for (and opposition to) a cultural project. In particular, the support of art derived from intrinsic values must be taken into account. Willingness-to-pay studies are necessary to establish clearly the nonmarket benefits (and costs) of cultural projects, such as existence, option, bequest, education, and prestige values. But isolating these values is certainly not sufficient for a cultural project to find the political support necessary for it actually to be undertaken.

The two approaches thus *complement* each other. The willingness-to-pay studies undertaken by economists are indispensable for two reasons: By identifying nonmarket benefits, they provide the rationale for political intervention, and they identify the political support for the cultural project based on intrinsic values. Impact studies are indispensable in order to activate the support for cultural projects of commercial agents. Cultural policy so far has not taken advantage of the complementarity between the two approaches. It has either relied on welfare economics and has therefore disregarded all political aspects or solely relied on the support of commercial agents, which is far too narrow a view. Cultural policy would certainly benefit from a broader approach building on and combining the strengths of each type of study. But this requires learning on both sides: "Arts people" need to learn to appreciate that cultural activities do not necessarily have to be provided and financed by the state but that if they are, sound reasons (based on willingness-to-pay studies) must be provided; "arts economists" must learn that it does not suffice to undertake welfare theoretic exercises, but that the political process must also be taken into account.

References

Bille Hansen, Trine. 1997. The Willingness-to-Pay for the Royal Theatre in Copenhagen as a Public Good. *Journal of Cultural Economics* 21:1–28.

Contingent Valuation in Cultural Economics. 2003. *Journal of Cultural Economics* Special Issue: 155–285.

De la Torre, Marta, ed. 2002. *Assessing the Values of Cultural Heritage.* Los Angeles: Getty Conservation Institute.

Epstein, Richard A. 2003. The Regrettable Necessity of Contingent Valuation. *Journal of Cultural Economics* 27:259–274.

Frey, Bruno S. 1997. Evaluating Cultural Property: The Economic Approach. *Journal of Cultural Economics* 6:231–246.

Frey, Bruno S. 2000. *Arts and Economics: Analysis and Cultural Policy.* New York: Springer.

Frey, Bruno S., and Werner W. Pommerehne. 1989. *Muses and Markets: Explorations in the Economics of the Arts.* Oxford: Basil Blackwell.

Frey, Bruno S., and Alois Stutzer. 2003. Mispredicting Utility (working paper). Institute for Empirical Research in Economics, University of Zurich.

Mourato, S., and M. Mazzanti. 2002. Economic Valuation of Cultural Heritage: Evidence and Prospects. In Marta De la Torre, ed., *Assessing the Values of Cultural Heritage*, 51 76. Los Angeles: Getty Conservation Institute.

Mueller, Dennis C. 2003. *Public Choice III.* Cambridge: Cambridge University Press.

Noonan, Doug. 2003. Contingent Valuation of Cultural Resources: A Meta-Analytic Review of the Literature. *Journal of Cultural Economics* 27:159–176.

Peacock, Alan. 1969. Welfare Economics and Public Subsidies to the Arts. *The Manchester School of Economic and Social Studies* 37:323–335. Reprinted in Towse 1997, 501–513.

Santagata, Walter, and Giovanni Signorello. 2000. Contingent Valuation of a Cultural Public Good and Policy Design: The Case of Napoli Musei Aperti. *Journal of Cultural Economics* 24:181–204.

Schuster, J. Mark. 2003. Contingent Valuation in Cultural Economics: Introduction. *Journal of Cultural Economics* 27:155–158.

Thompson, E., M. Berger, G. Blumquist, and S. Allen. 2002. Valuing the Arts: A Contingent Valuation Approach. *Journal of Cultural Economics* 26:87–113.

Throsby, David. 1994. The Production and Consumption of the Arts: A View of Cultural Economics. *Journal of Economic Literature* 32:1–29.

Throsby, David. 2001. *Economics and Culture.* Cambridge: Cambridge University Press.

Throsby, David. 2003. Determining the Value of Cultural Goods: How Much (or How Little) Does Contingent Valuation Tell Us? *Journal of Cultural Economics* 27:275–285.

Throsby, David, and Glenn Withers. 1979. *The Economics of the Performing Arts.* London: Edward Arnold.

Towse, Ruth, ed. 1997. *Cultural Economics: The Arts, the Heritage and the Media Industries.* Cheltenham: Edward Elgar.

Willis, K. G. 2002. Iterative Design in Contingent Valuation and the Estimation of the Revenue Maximizing Price for a Cultural Good. *Journal of Cultural Economics* 26:307–324.

The Public Value of Controversial Art

The Case of the *Sensation* Exhibit

Arthur C. Brooks

All the others translate: the painter sketches
A visible world to love or reject;
Rummaging into his living, the poet fetches
The images out that hurt and connect.
W. H. Auden, "The Composer"

16.1 Introduction

There is probably no point at which the cultural value of art is brought more clearly into public view than when art creates a scandal. This is nothing new. In 1815, for example, Goya's *Nude Maja* (*La Maja Desnuda*) created a public stir that landed the artist in front of the Spanish Inquisition, where he was forced to answer charges of obscenity. The work, today considered an icon of cultural value, was deemed culturally destructive by some authorities at the time.

Similar controversies about cultural value erupt periodically to this day. Over the past 20 years, scandals have erupted on numerous occasions in the United States, in which government funds have gone to subsidize the production or exhibition of art considered by some to be obscene, blasphemous, or offensively unpatriotic. The resulting value clashes between opponents and supporters of the offending art have constituted battles in America's so-called culture wars between one group that is traditional, conservative, and religious, and the other that is permissive, liberal, and secular (Himmelfarb 1999).

There are few better examples of a battle over the cultural value of art than the infamous *Sensation* exhibit at New York City's Brooklyn Museum of Art. In September 1999, the museum opened a show featuring works by British artists under age 40 that were owned by the art collector Charles Saatchi

(Rothfield 2001). The show had several pieces that generated immediate controversy. The most notorious was *Holy Virgin Mary*, a large painting by the Nigerian-born artist Chris Ofili, in which the Madonna was adorned with elephant dung and pictures of women's genitalia cut out from pornographic magazines. Another piece some people found objectionable was Damien Hirst's *This Little Piggy Went to Market, This Little Piggy Stayed Home*, which featured a pig split in half and preserved in formaldehyde.

Protests erupted from traditional religious groups, conservative political activists, and New York's Republican mayor, Rudolph Giuliani. In a September 1999 press conference, Giuliani asked, rhetorically, "How can you ignore something as disgusting, horrible, and awful as this?" and proceeded to take action against the government-funded museum.[1] He cut off city funding, attempted to fire the museum's board of trustees, and announced plans to evict the museum from its building (which is owned by the city).

Sensation's supporters reacted with equal bombast, accusing the mayor of threatening censorship by withholding public resources and of having no sense of the exhibit's exquisite quality. Arnold Lehman, the museum's director, declared that the exhibition was "a defining exhibition of a decade of the most creative energy that's come out of Great Britain in a very long time."[2] Lehman, with the backing of the American Civil Liberties Union, sought and won a legal restraining order against the mayor's actions.

Public furor disappeared when the exhibit moved on to its next location; the controversy became irrelevant, and the city dropped its action against the museum after six months. While it has faded from public view, however, the case still nicely illustrates the peculiarities of the cultural value of controversial art: It is a paradox in which, in the very same works of art, some people see a positive contribution, while others see nothing but degradation.

This chapter explores the differing perceptions of cultural value created by *Sensation*. Using public opinion data on the exhibit, I find that certain demographically identifiable groups tend to perceive public cost (negative cultural value) of controversial art, while others perceive benefits. This fact has clear implications for the design of cultural policies. Specifically, I predict that inducing museum attendance in general (not necessarily for controversial shows) among young people will raise their tolerance for contentious exhibits such as *Sensation*.

Beyond illuminating the public opinion in the *Sensation* case, the broader point of this chapter is to show that cultural value is the true driver of public

[1] http://www.pbs.org/newshour/bb/entertainment/july-dec99/art_10-8.html.
[2] Ibid.

opinion about the arts and must be better understood and measured by policymakers if they are to design arts policies that create maximal public good. Measurement of cultural value – compared with economic value – has traditionally been considered an exercise in futility by policymakers, who tend to throw up their hands and hope for the best. But as this chapter demonstrates, cultural value is measurable, and the results of such measurement may yield valuable information to neutralize perceptions of negative net cultural value.

16.2 The External Benefits and Costs of Art

Most goods and services meaningfully affect only their direct producers, sellers, and consumers. For example, when I make a deposit of funds into my bank account, the only parties likely to perceive it (or care about it) are me and my bank. This, however, is not the case for the class of goods and services that produce what economists call *externalities*: spillover effects onto those that have no direct market relationship to the good or service. Externalities can be either positive or negative. For example, a noisy street fair may negatively affect neighbors who are not participating in it, or a company's private research and development might improve existing technology for everybody.

Economists argue that externalities tend to distort markets and advocate policies that correct them. In the case of external costs, the party imposing the externality must "feel the pain" in order to make production or consumption decisions that are efficient – in which the benefits from the service or good, net of total costs, are highest. The remedies favored by economists for addressing external costs are usually a variant of taxation: Producers or consumers of the activity in question should face fines, fees, or some other penalties, with the objective that they lower the activity to acceptable levels. External benefits receive the opposite treatment: The activity is subsidized or otherwise rewarded; as such, producers or consumers have an incentive to increase it.

The standard economic case for government support of the arts can be understood as one of correcting a beneficial externality. The traditional reasoning is that the arts, while directly enriching artists, arts firms, and arts consumers, also produce cultural benefits that spill over onto the rest of us. The possible sources of external benefits can be classified as follows (Frey 1997; McCarthy et al. 2001):

- *Education.* People may be culturally enriched by living in a community with a vital arts sector, even if they do not specifically attend arts events.

- *Prestige.* The arts may confer external prestige on their community.
- *Option for future use.* People may value the option to consume the arts in the future and hence derive benefit from their current preservation.
- *Bequests to future generations.* Future generations may enjoy arts that are preserved today.
- *Economic improvement.* The arts can improve a community's economic conditions by attracting "high-value" citizens who seek an artistic environment
- *Expressive freedom.* Society may benefit from an environment in which tolerance (expressed in subsidies) flourishes for all kinds of art.
- *Diversity.* Society might benefit from greater cultural tolerance when majority groups are exposed to other cultures and taste through the arts.

The external benefits of the arts are not the end of the story, however. Indeed, the case against controversial art such as that in *Sensation* can be understood in terms of external cultural costs. These costs can be categorized as follows (Bhabha 2001).

- *Offense.* People may be offended by indirect exposure to (or even the mere existence of) art that has religious, sexual, or political content. This offense may occur because the art denigrates something or someone of value (e.g., the Madonna) or because it glorifies something or someone disliked (e.g., homosexuality).
- *Inscrutability.* There may be cost involved with art that is intellectually or aesthetically impenetrable for the majority of people.
- *Exacerbation of conflict.* Bhabha (2001) identifies the case in which unusual tastes are thrown up before the majority as "minority public interest." In contrast to the diversity benefit identified earlier, this may create conflict between groups.

In the case of most goods and services that create externalities, disagreements arise over the magnitude of the effect but not its sign. For instance, arguments about pollution abatement policies usually focus on whether, how, and how much to penalize pollution production; they do not feature one group that believes pollution is *bad*, and another that believes it is *good*.

But disagreement over the sign of the external effect is precisely the case with controversial art. If the Brooklyn Museum's director calls *Sensation* "the defining exhibition of a decade," and the mayor calls it "disgusting, horrible, and awful," we can be confident that there are at least two groups in the population, one that sees *Sensation* as inflicting a public cultural cost

and the other that sees it as creating a public cultural benefit. This provides insight into the apparent intractability of battles in the "culture wars": The sides are *culturally* too far apart. This point is especially clear in recent research, which shows that, on an extremely wide range of cultural issues, supporters of the arts bear little resemblance to the rest of the population. For example, Lewis and Brooks (2005) find that arts donors are 32 percentage points more likely than the general American population to say they have no religion, 18 points less likely to see homosexual sex as wrong, 10 points more likely to describe themselves as politically left-wing, and 12 points more likely to support abortion on demand.

These differences make arts policy difficult, as long as any of the subsidized content is controversial. Indeed it is difficult to conceive of a satisfying policy for *any* activity if one part of the population perceives efficient treatment of it to involve subsidies, while for the other it involves censorship (or at very least, that it not be government funded).

If the two sides to this debate are randomly distributed throughout the population, the design of noninflammatory cultural policy may be an exercise in futility. However, if the proponents of the opposing viewpoints are demographically distinguishable, there may be more hope for building policies that seek, on the one hand, to support art that is occasionally controversial, but, on the other hand, to prevent provocation of "culture wars" skirmishes. For example, if a certain portrait can be drawn of those perceiving public costs from something like the *Sensation* exhibit, then museum marketing efforts can be most effectively targeted to them.

16.3 Data and Models

What characteristics should influence the sign on the public value one perceives from controversial art? The literature on arts participation and public opinion gives clues in this regard. Studies of arts attendance (e.g., McCarthy et al. 2004) generally find that performing and visual arts attendees are older, wealthier, more highly educated, and more likely to be women than those who do not attend. They are also more likely to have received some arts education in the past. Studies of political support for government arts subsidies (e.g., Brooks 2004) indicate that those most sympathetic to arts subsidies have relatively high education levels, are not religious, and are politically left-wing. These past studies allow us to hypothesize that those who would perceive a public benefit from controversial art should be older, have higher income and education levels, be less religious, and belong to the political Left.

Table 16.1. *Public opinion about the* Sensation *exhibit*

	The Brooklyn Museum of Art has a right to show *Sensation* (%)	The government should be able to ban this exhibit (%)	The government should be able to withdraw funding because of this exhibit (%)
Strongly agree	35	25	28
Mildly agree	22	10	9
Mildly disagree	8	17	19
Strongly disagree	31	43	41

Source: Center for Survey Research and Analysis, University of Connecticut.

A unique dataset exists to investigate the question of whether supporters and opponents of controversial art are demographically distinct. In September and October 1999, the Center for Survey Research and Analysis at the University of Connecticut conducted a random telephone survey of 1,006 American adults regarding their views on controversial art in general, and the *Sensation* exhibit in particular. The survey consisted of about 40 questions that probed respondents' views on the propriety of objectionable art, censorship, and public funding. It also collected a limited amount of demographic information from each person. The survey is useful but not perfect. Indeed upon reading the questions, it seems that one intention of the survey designers might have been to elicit public support for the *Sensation* exhibit. For example, before asking about whether *Sensation* should be banned or public funding withdrawn, they describe the exhibit for respondents unfamiliar with it by saying, "the exhibit . . . includes material some people have said is offensive. The material includes a picture of the Virgin Mary with elephant dung on one breast." Clearly, this is a major understatement of the controversial content of Ofili's work. Not surprisingly, the survey results portray a public not especially scandalized by the work. As Table 16.1 shows, 57 percent of those surveyed thought that the museum had a right to show *Sensation,* 60 percent felt the city should not be able to ban the exhibit, and 60 percent did not feel the city should be able to withdraw its support. On the basis of these results, the Research Center's director concluded that "the assumption by many that the Brooklyn Museum event is being met with strong public opposition is just not true. Americans prefer that museums be free to display art that they think is appropriate."[3]

[3] See http://www.freedomforum.org/templates/document.asp?documentID=6454.

Table 16.2. *Demographics of survey respondents*

Characteristic	Mean (Standard deviation)
Respondent is a man	0.48
Respondent's age	54.9 (16.18)
Respondent did not complete high school	0.07
Respondent completed high school	0.56
Respondent completed university	0.24
Respondent holds postgraduate degree	0.13
Respondent classifies self as politically "Left"	0.24
Respondent classifies self as politically "centrist"	0.41
Respondent classifies self as politically "Right"	0.34
Respondent's household income	$53,865 ($33,595)
Respondent identifies self as a Christian	0.77
Respondent visited a museum in the past year	0.38

Source: Center for Survey Research and Analysis, University of Connecticut.

The real extent of public tolerance for controversial art such as that in *Sensation* is probably overstated in these responses – perhaps dramatically so. However, the data still allow us to discern the variance in views on the questions in Table 16.1 (and indirectly, variance in perceived public value) that is explained by sociodemographic variation in the population.

The demographics in the Connecticut data are summarized in Table 16.2. They show that the sample is slightly more than half women, is approximately a decade older than the average American, and has a household annual income of about US$54,000. Politically the sample is more or less balanced and is three-quarters Christian (although we only have information on religious affiliation, not on the more important variable of the intensity of religious practice). The sample is more educated than what is found in most random surveys, with 37 percent having completed college or higher. It also appears more arts-loving than we would expect: While other surveys, such as the Survey of Public Participation in the Arts, usually place the annual likelihood of attending a museum at around 27 percent (McCarthy et al. 2004), these data found 38 percent of respondents attended a museum in the past year. Altogether, one suspects that there is a sample nonresponse bias built into these data, in which those uninterested in the arts were least likely to participate in the survey.

Using these data, I use a two-pronged strategy to estimate perceived public value in *Sensation* on the basis of personal characteristics. First, I estimate the degree to which the demographics in Table 16.2 predict the degree of support for the positions in Table 16.1, using a statistical technique called

ordered probit regression, which measures how a one-unit change in each of the Table 16.2 variables affects the propensity to move up the scales in Table 16.1.[4]

Clearly, the variables in Table 16.1 are only indirect proxies for perceived cultural value. Together, they describe attitudinal *results* of the value people perceive. For example, the belief that *Sensation* creates positive public value should lead people to be more likely to believe that the museum should be able to show the exhibit, less likely to believe the government should be able to ban it, and less likely to believe the government should be able to withdraw funding. The decision to attend museums should also indirectly reflect perceptions of value, to some extent.

A useful technique to find the latent measure of perceived cultural value lurking behind these variables is principal component analysis, which constructs a new variable (or distinct variables, if there appear statistically to be more than one) on the basis of the three in Table 16.1, plus museum attendance. The latent variable, which I call CULTVALUE, is centered around 0 (and has a standard deviation of 1). The minimum value is −1.71; the maximum value is 1.24. Note that CULTVALUE is distributed arbitrarily around 0, so negative estimates do not necessarily have the practical implication of negative external value. (Similarly, positive estimates do not necessarily denote positive external value.) Rather, this is simply a comparative index.

In building CULTVALUE, the measure of support for allowing the city to ban the exhibit contributed approximately 57 percent of the value, lack of support for the right of the museum to show the exhibit contributed 25 percent, lack of support for the government's right to withdraw funding contributed 11 percent, and past museum attendance contributed 8 percent.[5] Figure 16.1 depicts the distribution of CULTVALUE and shows that positive values fall in a narrower range than negative ones. This finding suggests that those who perceived a lower external value from *Sensation* felt their position more deeply than those who perceived a higher one.

We can explore the role of demographics on perceived value by looking at the way the Table 16.2 variables (except museum attendance, which is now embedded in the CULTVALUE) affect CULTVALUE. I do so using the ordinary least squares procedure, which measures the change in CULTVALUE attributable to a one-unit change in each of the variables in Table 16.2.

[4] For technical details on this and the other statistical models, see the Appendix to this chapter.

[5] All of these measures are statistically significant, and they do not reveal any other latent factors.

Figure 16.1. The perceived cultural value of *Sensation*, constructed from principal components.

16.4 Results and Discussion

The ordered probit models show that the variables that push up support for the museum's right to show *Sensation* also push down support for the government's right to ban the exhibit or withdraw its funding. These variables are museum attendance, age, being a man, and identifying oneself as a political liberal. In contrast, the variables are pushed in the opposite direction by being a political conservative. Exposure and sympathy to art are the strongest predictors of support for *Sensation*: Visiting a museum over the past year is associated with an increase in more than half a support category for the museum's right to show the exhibit. Thus, for example, if two people are demographically identical, except that one has attended a museum and the other has not, and the nonattendee mildly disagrees that the museum has the right to show the exhibit, we can predict that the attendee will mildly *agree* that it should be able to do so. It would probably be an error to assert that museum attendance is entirely what *causes* this difference in attitude, because an unmeasured predisposition to consume art most likely stimulates both museum attendance and attitudes toward *Sensation*. Thus, the variable that measures perceived value, taking attitudes and attendance into account simultaneously, should be useful.

Table 16.3. *Predicted estimates of CULTVALUE*

	Political Left male	Political Left female	Political Right male	Political Right female
25 years old	−0.03	−0.19	−0.76	−0.92
43 years old (25th percentile)	0.19	0.02	−0.54	−0.71
57 years old (median)	0.35	0.19	−0.37	−0.54
69 years old (75th percentile)	0.49	0.32	−0.24	−0.41

The ordinary least squares model tells us that the main predictors of positive perceived value from *Sensation* are age, being a man, and being on the political Left. Self-identifying as a political conservative pushes perceived value down. While the effect of political beliefs is not especially surprising, the age and gender effects might well be. Indeed, we might predict that women (who attend museums more than men) and young people would be more likely than men and older people to tolerate – and find positive public value in – controversial art such as the *Sensation* exhibit. However, we consistently see precisely the opposite pattern in these data. One explanation, besides the straightforward assertion that women and young people are intolerant of controversial art, is that these groups are especially likely to react negatively to question *wording* or some other aspect of the survey context. The absence of an education effect in the regressions here is also quite surprising, given the fact that past research has shown higher education associates with more attendance and support for government arts subsidies.

The predicted values of CULTVALUE (constructed with the coefficients in Table A2) are summarized in Table 16.3. In this table, I predict CULTVALUE on the basis of sex and political orientation, as well as several age levels. These ages are the median (57), the 25th and 75th percentiles (43 and 69), as well as 25 (to look at the young adult population in the sample). All the predicted values lie within the range of the data. The lowest predicted negative value, −0.92, belongs to a 25-year-old woman who labels herself a conservative. The highest predicted positive value, 0.49, belongs to a 69-year-old man who is politically liberal. Recall that CULTVALUE is distributed arbitrarily around 0. Thus, what the predictions tell us is that groups with lower perceived values are more likely than others to see either negative externalities or lower positive externalities.

These results contain two main cultural policy and management design implications. First, those perceiving the highest and lowest levels of public

value in *Sensation* – as constructed on the basis of opinions on whether the museum should show the exhibit, and whether the government should take action as a result – are identifiable demographic groups. Therefore, we can rule out the possibility that positive and negative perceived value is spread throughout the population either randomly or solely on the basis of variables not identified here.

Second, the "target" demographic groups for managers and policymakers depend on the policies we seek to undertake. For example, if the objective of the Brooklyn Museum were to enhance tolerance for exhibits such as *Sensation*, broadening audience attendance would probably be a productive strategy. Further, a group the museum might focus on in particular would be young people, who currently appear to be most intolerant of *Sensation* (and sympathetic to government attempts to ban it or cut off its funding). Note that this strategy does not imply that the museum needs to undertake outreach to young adults for controversial art in particular – the key appears simply to be to attract them to the museum in the first place.

The broader implication of this result is that if a cultural policy objective is for more people to see controversial art in terms of its external cultural benefits (such that exhibits such as *Sensation* do not provoke public scandal), demand-side policies such as arts education should be particularly beneficial. Supply-side cultural policies – subsidies to artists and arts organizations, for the most part – will not likely have this beneficial side effect.[6]

16.5 Conclusion

The Brooklyn Museum of Art's notorious *Sensation* exhibit represents an excellent example of how the ambiguous sign on the net cultural value of public art can lead to bitter battles over relatively small public expenditures (which is one aspect of economic value).[7] Indeed, the American "culture wars" in general are probably at least partly explained by this kind of value

[6] Not everyone would assert that increasing tolerance for an exhibit like *Sensation* is a desirable thing to do, of course. Some might argue that this represents a cultural coarsening (e.g., Bennett 2000).

[7] Ironically, it was precisely the controversy in the *Sensation* case that linked the cultural value of the exhibit to its economic value. The public outcry resulted in far higher attendance than expected for the exhibit, and a dramatic increase in the market value of the collection on display. Some believe that this was one of the objectives of the exhibit's owners and sponsors all along. See David M. Herszenhorn, "Brooklyn Museum Accused of Trying to Lift Art Value," *The New York Times*, September 30, 1999.

disagreement. However, as this chapter demonstrates, these disagreements are not necessarily inevitable, because cultural value could be better understood and measured than it usually has been in the past, leading to better (and less controversial) arts policies.

APPENDIX

The empirical specification for the ordered probit model is $y_i^* = \alpha + \beta' X_i + \varepsilon_i$ for survey respondent i, where α is a constant term, and ε is a random disturbance. A series of parameters μ_j ($j = 0, 1, 2$) defines the categories in Table A1, where $y_i = 0$ ("strongly disagree") if $y \leq \mu_0$; $y_i = 1$ ("mildly disagree") if $\mu_0 < y \leq \mu_1$; $y_i = 2$ ("mildly agree") if $\mu_1 < y \leq \mu_2$; and $y_i = 3$ ("strongly agree") if $y > \mu_2$. The results are summarized in Table A1.

The Ordinary Least Squares model is $VALUE_i = \alpha + \beta' Z_i + \varepsilon_i$, where Z is simply X from the model without the variable for museum attendance. The results are summarized in Table A2.

Table A1. *Ordered probit regression results*

	The museum has a right to show this exhibit	The government should be able to ban this exhibit	The government should be able to withdraw funding because of this exhibit
Constant	−0.38 (0.26)	0.31 (0.27)	0.77*** (0.27)
Visited museum	0.59*** (0.1)	−0.24** (0.1)	−0.20** (0.1)
Age	0.014*** (0.003)	−0.007** (0.003)	−0.013*** (0.003)
Male	0.21** (0.09)	−0.19** (0.09)	−0.09 (0.09)
High School	−0.10 (0.2)	0.22 (0.2)	0.11 (0.2)
University	−0.10 (0.22)	0.30 (0.23)	0.26 (0.22)
Postgraduate	0.04 (0.24)	0.36 (0.25)	0.30 (0.25)
Political Left	0.30** (0.13)	−0.21* (0.13)	−0.30*** (0.12)
Political Right	−0.28*** (0.11)	0.50*** (0.11)	0.47*** (0.11)
Household income	0 (0.0016)	−0.0003 (0.0015)	0.0009 (0.0015)
Christian	−0.12 (0.11)	0.10 (0.11)	0.09 (0.11)
N	494	490	495

Note: Standard deviations shown in parentheses; *** denotes significance at the .01 level; ** denotes significance at the .05 level; * denotes significance at the .10 level. Household income is measured in thousands of 1999 U.S. dollars.

Table A2. *Ordinary least squares regression results*

Variable	OLS coefficient (standard error)
Constant	−0.68*** (0.23)
Age	0.012*** (0.003)
Male	0.17** (0.08)
High school	−0.06 (0.17)
University	0.03 (0.18)
Postgraduate	0.10 (0.20)
Political Left	0.23** (0.10)
Political Right	−0.50*** (0.09)
Household income	0.0011 (0.0010)
Christian	−0.08 (0.09)
N	540
Adjusted R^2	0.13

Note: OLS, ordinary least square. Standard deviations shown in parentheses; *** denotes significance at the 0.01 level; ** denotes significance at the .05 level; * denotes significance at the 0.10 level. Household income is measured in thousands of 1999 U.S. dollars.

References

Bennett, William. 2000. The Humanities, the Universities, and Public Policy. In Gigi Bradford, Michael Gray, and Glenn Wallach, eds., *The Politics of Culture: Policy Perspectives for Individuals, Institutions, and Communities*, 226–235. New York: The New Press.

Bhabha, Homi. 2001. The Subjunctive Mood of Art. In L. Rothfield, ed., *Unsettling "Sensation": Arts Policy Lessons from the Brooklyn Museum of Art Controversy*, 93–95. New Brunswick, NJ: Rutgers University Press.

Brooks, Arthur C. 2004. In Search of True Public Arts Support. *Public Budgeting & Finance* 24(2): 88–100.

Frey, Bruno S. 1997. Evaluating Cultural Property: The Economic Approach. *International Journal of Cultural Property* 6(2): 231–246.

Himmelfarb, Gertrude. 1999. *One Nation, Two Cultures*. New York: Knopf.

Lewis, Gregory B., and Arthur C. Brooks. 2005. A Question of Morality: Artists' Values and Public Funding for the Arts. *Public Administration Review* 65(1): 8–17.

McCarthy, Kevin F., Arthur Brooks, Julia F. Lowell, and Laura Zakaras. 2001. *The Performing Arts in a New Era*. Santa Monica, CA: RAND Corporation.

McCarthy, Kevin F., Elizabeth H. Ondaatje, Laura Zakaras, and Arthur Brooks. 2004. *Gifts of the Muse: Reframing the Debate about the Benefits of the Arts*. Santa Monica, CA: RAND Corporation.

Rothfield, Lawrence. 2001. Introduction: The Interests in "Sensation." In Lawrence Rothfield, ed., *Unsettling "Sensation": Arts Policy Lessons from the Brooklyn Museum of Art Controversy*, 1–14. New Brunswick, NJ: Rutgers University Press.

SEVENTEEN

Going to Extremes

Commercial and Nonprofit Valuation
in the U.S. Arts System

Bill Ivey

The complex U.S. arts system is viewed with curiosity and at times even
with admiration. But absent a ministry of culture or similar central cul-
tural authority, the United States has unwittingly advanced concepts of
value that poorly engage the larger public purpose. From the perspective
of an arts-management insider, valuation today resides in either the *pop-
ular* or the *precious*. However, one view overstates the significance of art
as asset and commodity, and the other overstates the importance of the
supply-side desires of refined arts elites. "Art-as-commodity" in the arts
industries, and the "art-is-what-you-need-even-if-you-don't-want-it" view
in the nonprofit arts, have generated unhelpful practices while raising thorny
public policy questions. To illuminate specific problems and outline possi-
ble solutions, we must engage in a kind of reverse engineering, looking to
the development of U.S. for-profit and nonprofit arts industries for factors
that shape divergent definitions of value. To the extent that trade in U.S.
arts products has spread the model of copyright-protected revenue streams
around the world, and to the degree that countries with strong traditions of
government support for culture seek to emulate U.S. cultural philanthropy,
the unique challenges posed by commercial and nonprofit valuation in the
U.S. arts system are object lessons of global significance.

17.1 Value in the For-Profit Arts

The 2004 merger between Sony Music and BMG has, among other things,
put the two most consequential archives of recorded American music and
spoken word assembled during the twentieth century under the ownership of
a single, non-U.S. corporation. The exact size of the two collections of master

disks and tapes has never been made public (and is most likely unknown), but it is fair to assume that the combined archive of disks, tapes, and digital masters will include at least 5 million recorded performances. Of course, mergers and acquisitions in the media industries have been commonplace for decades; what seems striking about the latest one is the total lack of public concern it generated regarding the potential threats to significant cultural heritage that arise when heritage changes hands just like any corporate asset. Nevertheless no one should be surprised; the decoupling of culture and public policy in the U.S. arts system is a logical outgrowth of a century-old approach to valuation that reduces art to the status of commodity.

The notion that original recordings of the blues of Robert Johnson, vintage performances by Enrico Caruso, jazz solos of Louis Armstrong, outtakes of Bob Dylan recording sessions – millions and millions of disks, tapes, and hard-drive data points – could be bought, sold, bundled up, shipped beyond U.S. borders, and potentially discarded by new owners constitutes a stark commentary on the cultural consequences of one approach to valuing art in the U.S. corporate system. And these risks to heritage are not mere hypotheses; after all, in the early 1960s, RCA Records dynamited one of its own warehouses, blowing the building along with thousands of master disks shelved inside into the Delaware River.

This sense of art as commodity or corporate asset pervades one part of the U.S. art-making system. Beginning in the early twentieth century, advances in technology and the subsequent emergence of collaborative art forms accelerated the commodification of the for-profit arts in the United States. While it can be demonstrated that notions of art as property and related concepts of copyright and work for hire can be traced over centuries, the capacity to transform fleeting musical and theatrical events into products that could be bought and sold was something totally new. These arts products triggered a qualitative redefinition of the relationship between art and corporate values.

We must remember that for the painter, novelist, or photographer, business practices and public policy linking art making and commerce have evolved in a straight line over the centuries. Ownership of a manuscript or painting resided with the individual who created the play or mural, and the art product could either be sold, as in the case of a painting, or, for authors and their manuscripts, licensed to a company that would manufacture and distribute copies of the work. Before 1900, the opportunities to profit from the exploitation of artworks were distinctly limited, and the galleries and publishing houses that evolved to help connect artists and audiences for the most part exhibited a distinctly small-time, boutique character. Cultural

institutions such as theaters, musical ensembles, and museums existed in the nineteenth century, but they were either wards of the government, like libraries, or small businesses deriving income from admission fees or, from time to time, from the largess of wealthy patrons.

The business model for the arts, in particular the performing arts, was dramatically transformed during the first three decades of the twentieth century. Driven by new technologies, a new American arts system and new "arts industries" grew; by 1921, for example, record sales totaled $16 million and by 1920 there were 20,000 silent movie theaters operating across the country. Music of all kinds made its way to 78 rpm disks, and radio helped make national stars of troupers seasoned on the vaudeville stage. By 1925, there were 15 different studios producing films; in 1927, New York City's Roxy Theater opened, seating more than 6,000 moviegoers. And the performing arts began to move out of the live theater and concert hall into the homes of average Americans. Recorded music made the transition first; within a few years radio added comedy, drama, and instantaneous news to the mix of armchair information that could be consumed at home. By the time the nation celebrated the millennium New Year, digital video disks (DVDs), movies-on-demand, satellite radio, and the iPod had more or less completed the transition begun a century before; Americans could now engage the performing arts at home and on their own timetable, without regard to the needs of institutions that had traditionally nurtured the connection between artists and audiences.

As arts products permeated society, Americans pretty much ceased to engage the performing arts as practitioners, abandoning art making to a designated class of skilled specialists, replacing hands-on art making with the simpler act of passive consumption. The image of an American family gathered after supper to enjoy a poetry recitation, dramatic reading, or piano recital faded into a nostalgic haze. Cultural consumption was fueled by something entirely new – performances bundled into arts products. Movies, records, and radio shows *were* bundles: No single artist, no matter how talented, could create a movie, record, or radio program alone. In fact, the characteristic shared by nearly all the new vernacular art forms advanced by twentieth-century technology was their collaborative character and complexity; this complexity made it hard to determine just which of the many participating artists – actors, directors, screenwriters, radio dramatists, studio musicians, songwriters, record producers – should at the end of the day be credited with creating these new works. Such questions were unimportant in the nineteenth century. Before recording, film, and broadcasting, what passed for arts products were for the most part the work of

individuals. It was the novelist or poet, the composer at a desk or piano, the painter or photographer in her studio or darkroom who handed society the manuscripts and images that constituted the essence of cultural heritage. And by and large the paintings, photographs, and musical and literary manuscripts that contained and conveyed cultural heritage either were assembled in private collections or found their way to the public or quasi-public libraries and museums that had for many decades ensured access to America's cultural past.

In addition to being collaborative, the arts products of America's new twentieth-century cultural mainstream were expensive; they not only required the talents of many artists, but also engaged technicians, specialized studios, and complex systems for broadcasting and for wholesale and retail distribution. Whereas painters, photographers, authors, and composers only required a few dollars' worth of raw material and sufficient time to complete an artistic enterprise, movies, records, and radio shows required both substantial upfront investment and elaborate mechanisms both to recover costs and ideally to retain sufficient profit to fund the next collaborative artistic venture.

So who would own the copyright to the musical or dramatic content of these new arts products? The obvious answer was not a *who*, but a *what*. The copyright to the finished product – the film, radio show, or disk – became the property of the corporate entity that had assembled the creative team, financed the project, and distributed it to audiences around the country. Companies, like painters and composers in the past, began to own art, not as artists but as the entities that had commissioned work for hire. For emerging U.S. arts industries, it was fortuitous that the Supreme Court had determined in 1886 that in the eyes of the law corporations held many of the rights once reserved for individuals. By 1900 the legal groundwork was firmly in place to allow corporations in effect to create and own the rights to new works of art – recordings, movies, and radio shows.

This was something totally new. After all, an opera, symphony concert, or play performed in 1850 had no value to the producer – the impresario who assembled cast and crew – beyond admission fees charged at the door. A long run with many performances constituted success; a short run might produce financial disaster. But lacking any mechanism for recording a performance and thereby transforming it into a product that could be bought and sold and distributed to audiences unable to attend the original performance, there was no motivation for the producers of theatrical or musical events to secure copyright to the performance itself. Of course, composers would be compensated, and actors, singers, instrumentalists, and technicians would be paid, but once the marquee lights were extinguished and the sets and

costumes packed away, the performance itself – the specific union of art and artists – had no ongoing ability to generate revenue.

The earning power of these new collaborative art forms was not at all dependent on face-to-face contact between an artistic event and a paying audience. On the contrary, live audiences were either incidental (in the case of radio shows) or not even allowed (in the case of movies and sound recordings). Audiences paid for these new artworks either by purchasing interchangeable parts like disk records, or by purchasing a ticket in one of hundreds of theaters that would simultaneously exhibit a duplicate film print, or by rushing out to the store to buy Ivory Soap, Lucky Strike cigarettes, or hundreds of other products that sponsored programming delivered "free" over the radio. Consumers needed never to lay eyes on a live actor, singer, or instrumentalist. Just as an author controlled the copyright to her poem, arts companies, empowered by the Fourteenth Amendment, policed collaborative works. Thus was the relationship between the performing arts and society forever transformed in America's twentieth-century arts system. For the first time corporations owned works of art as though they had created them; for the first time, the earning power of the performing arts was severed from the arts event itself.

Corporate control of the copyrights of collaborative artworks that began early in the twentieth century set in motion forces that are still advancing today. First, in serving shareholders, the corporation seeks to derive maximal value from its arts assets. Innovative business leaders (such as the record/publishing executive Ralph Peer) determined that most copyrights could best be exploited if they were rented rather than bought and sold, and the development of a complex system of royalties and revenue streams within the collaborative arts was set in motion. Corporations worked to protect rights and revenue streams through legislation, contract, and government regulation. By limiting public access to recordings, films, and radio (and later television) programs, corporations could maintain competitive prices. In general, corporate ownership of collaborative arts as works for hire valued art to the extent that the art asset could generate income from revenue streams secured by contract, law, and regulation. This approach to value in the arts industries flourishes today: Film studios and record companies release on DVD or compact disk (CD) only those historical films or recordings that have present-day market value. In addition, more and more consumption resembles short-term rental, not consumption; an iTunes download can only be copied five times, and a musical ringtone license that costs $2.50 must be renewed every 90 days.

Market value replaces artistic value in a commodified cultural system. For example, in a study completed by the media executive Tim Brooks (2005)

and commissioned by the U.S. Library of Congress, an analysis of 400,000 important historic sound recordings revealed that only 14 percent of them were available in CD reissues authorized by rights-holding record companies. Even more strikingly, the largest single block of reissues – 33 percent – is drawn from the post-1955 rock 'n' roll era, a period that falls within the memory of many living music fans. Only about 10 percent of recordings from the first two decades of the last century have been reissued, and virtually nothing from the 1890s, the industry's infancy. The long digital "tail" of online music may make some antique tracks available, but the basic fact remains: The character of musical heritage in the United States is defined by the perceived value of music of different eras in the contemporary marketplace. In a similar fashion, perceived market value increasingly determines which contemporary artists are signed to contracts, which films and television shows are produced, and much of what is aired on commercial and public radio. The rise of market research, the perceived increased value of many copyright-protected revenue streams, and the consolidation of production and retail companies have further marginalized artistry.[1]

To value art as *popular* – art as a commodity – is to elevate the notion of *demand* (or perceived demand) as the only factor determining which art and artists make it through the gates of production and distribution. As American films, CDs, and television shows spread around the globe, popularity and demand might be construed as the alpha and omega of the U.S. cultural system. However, even as iTunes, Wal-Mart, podcasts, and ringtones symbolize rampant artistic commodification, a very different notion of value in art is simultaneously straining to define hierarchies within the U.S. cultural landscape.

17.2 Value in the Nonprofit Arts

Here is a quick hint: Every year, more than 8,000 musicians graduate from American conservatories and schools of music. Each new graduate possesses

[1] Interestingly, artists working in the collaborative arts system have benefited from innovative revenue streams developed in response to new technologies. ASCAP, BMI, and SESAC collect royalties from the live and broadcast performances of compositions and distribute these royalties to songwriters. The Screen Actors', Directors', and Writers' guilds collect and pay residuals for new uses of existing work. However, painters and photographers – artists not caught up in new technologies and the collaborative, corporate-managed arts – continue to function in a centuries-old system of compensation. Unlike those at work in European Union countries, U.S. visual artists still do not share in appreciated resale prices for original works, and there exists no equivalent to songwriters' performing rights organizations for designers, photographers, or painters.

the bachelor of music or bachelor of arts in music degree that should be the ticket to a credentialed performance career. But there are only about 400 symphony orchestras in the United States, and, of these, only 65 are "of consequence." Simple math dictates that the 8,000-plus musicians who enter the market each year constitute a body larger than the total of all players employed in all of America's significant orchestras. Clearly, in the education of performing artists, employment opportunity does not play a significant role.

In fact it is obvious that this entire segment of the U.S. art spectrum – the nonprofit arts – has evolved a notion of value just as dysfunctional as the unrestrained commodification that haunts America's for-profit arts industries. I would state it this way: Nonprofit arts organizations – especially the museums, orchestras, theaters, opera companies, and dance ensembles that enshrine the refined arts of Western Europe – act without any regard for audience demand. Nonprofit arts advocates are actually nonplussed when demand "rears its ugly head." Several years ago Americans for the Arts, the leading arts funding advocacy group in the United States, was surprised by the result of a national poll on arts education. The poll indicated that an overwhelming majority of American parents supported arts training in schools, but an equally large majority felt that current levels of arts education were adequate. Despite this survey evidence, the association remained undeterred, and the new advocacy campaign was accommodatingly entitled "Just Ask for More."

"Just Ask for More" could just as well serve as the battle cry for *all* nonprofit arts, because abstract assumptions about the intrinsic value of the nonprofit fine arts have generated a model that justifies the continual expansion of the supply of symphonic music, exhibitions, operas, and so on. In fact, what passes for policy research in the nonprofit arts world has recently been labeled "advocacy research," a confessional term, which accurately suggests a sense of value that allows nonprofit organizations continually to mount supply-side arguments in favor of increased funding, institutional growth, and outreach to new audiences.

Whereas the seeds of "art as commodity" can be traced to emerging technology and its impact on the collaborative arts in the early twentieth century, the underlying nonprofit concept of "unlimited value" assigned to the refined arts in the U.S. system is more recent, defined by embedded assumptions about the value of European arts and institutionalized by foundation and government policy dating from the middle of the last century. John Carey (2005) traces the notion that high art is inherently valuable to the eighteenth-century philosopher Immanuel Kant. It was Kant, Carey

argues, who convinced us "that art is somehow sacred, that it is 'deeper' or 'higher' . . . that it refines our sensibilities and makes us better people, that it is produced by geniuses who must not be expected to obey the same moral codes as the rest of us." In the United States supporters of classical music, museums, and ballet argue that because art is necessarily difficult, it arouses refined rather than base emotions, encourages active intellectual engagement, is especially original and authentic, and has a sacred or spiritual character (as opposed to the shallow and worldly *popular* arts, which are only useful as entertainment).

Many of the institutions dedicated to the refined arts are organized as nonprofit corporations. Nonprofit organizations had existed in the nineteenth century but they were distinctive primarily because of stated educational or charitable purposes; on paper they looked pretty much like their for-profit counterparts. It was the U.S. federal income tax, implemented in 1913 and modified in 1917, that defined nonprofit corporations as a separate category, expressly prohibited from distributing net revenues to owners or investors. In addition, the tax code enshrined two important principles essential to the nonprofit cultural sector: First, educational and charitable organizations were exempt from paying corporate income tax in the 1913 law; second, in 1917, tax deductions were provided to donors who supported these "not-for-profit" organizations.

As the sociologist Paul DiMaggio (1991) has established, American social elites in the nineteenth century sought to amass what Pierre Bourdieu (1984) has called "cultural capital," characterized by DiMaggio as "knowledge and familiarity with styles and genres that are socially valued and that confer prestige upon those who have mastered them" (p. 377). Nonprofit organizations in the early twentieth century became parking places for these class-driven enthusiasms of urban elites – wealthy citizens determined "to build organizational forms that, first, isolated high culture and, second, differentiated it from popular culture" (p. 374).

Through the 1920s private giving to museums, orchestras, and dance and opera companies was generally sufficient to sustain nonprofit arts institutions (many museums did not charge admission fees back then). When the Great Depression diminished the supply of donated funds, New Deal government leadership intervened by providing direct support to cultural institutions and to individual artists. Although much art of lasting merit was created through various works projects of the 1930s, Depression-era federal arts funding was primarily designed to provide employment. Many such projects that were developed outside the purview of urban arts elites and lacking the cachet of refined Europe-oriented big-city arts institutions

were criticized as populist and unprofessional. But despite its jobs-creation purposes, New Deal arts funding did provide a precedent for government support of cultural activity.

Early in the twentieth century the Carnegie Foundation began to provide some support for the arts, and from the 1930s forward the Ford and Rockefeller Foundations had made modest grants to major cultural organizations. By 1954 Rockefeller had in place a program of institutional support for the arts directed primarily at orchestras and theater companies, and by the mid-1960s the Ford Foundation had invested $30 million in support of the arts. But through the first half of the century overall foundation support for the arts was modest. It was in 1957, when W. McNeil Lowry took over the Ford Foundation's fine arts programs, that spending on arts projects began to grow significantly. Focusing on the performing arts, Ford provided funds to help stabilize the operations of established symphony orchestras. In less-developed fields like dance and nonprofit theater, the foundation actually helped create new institutions. Ford devoted tens of millions each year to advancing the performing arts and in 1966 gave $80 million to 61 symphony orchestras, an investment that still resonates today.

At the Rockefeller Foundation, arts programs were directed by Norman Lloyd, the former music dean at Oberlin College, who joined the foundation staff in 1963. Rockefeller concentrated its grant making on museums and visual arts, and, although its total funding did not approach Ford levels, Rockefeller did support a number of innovative projects. In addition, Rockefeller led the foundation community by generating a number of reports intended to justify increased investment in America's cultural life. Although the 1965 Rockefeller study, *The Performing Arts: Problems and Prospects*, primarily made the case for arts funding by private industry, other reports by the Twentieth Century Fund and the Federal Council on the Arts called for direct government support for cultural organizations. Aware that foundations lacked the resources necessary to support cultural institutions in perpetuity, cultural leaders pushed for a "handoff" of cultural funding that would transfer responsibility from private foundations to the federal government, a process that would duplicate similar transitions in education, welfare, and health.

The tone of reports advancing the importance of the arts was uniformly democratic. The Rockefeller study intoned, "The arts are not for the privileged few, but for the many." However, as the National Endowment for the Arts (NEA) deputy chairman Michael Straight observed in his biography of the NEA chairman Nancy Hanks, "The Rockefeller Panel held that the arts were 'for the many,' but could not be entrusted to the many" (p. 81).

Knowledgeable elites would determine which art should be nurtured and made more available. In addition, discussions of the range or character of American art worthy of support in an expanded funding system, whether or not that system would ultimately be implemented by the government or private industry, were notably absent from studies urging expanded investment in culture. So from the outset "The Arts" were assumed to refer to the European refined arts as they had found a home in America; just as obviously, no one thought an expanded concern for the size and character of the cultural scene required any interaction with the film, recording, and broadcasting industries. Clearly, the high art bias and the antimarket ethos shared by wealthy elites who filled the boards of nonprofit organizations had successfully infiltrated funding priorities of foundations as they expanded support for culture. Of course, there existed a persistent interest in nurturing *American* plays and *American* compositions, but there was little thought given to the notion that an arts funding system might engage the vernacular, popular, folk, commercial sectors so uniquely reflective of the nation's diverse democratic heritage.

When the National Endowment for the Arts was established in 1965 (the "handoff" envisioned by foundation leaders), the assumptions and policies developed in foundation work found their way into the governing principles and practices of the new federal agency. The NEA was to support only art that was "noncommercial, professionally led, and of high quality" and was not to exercise direction or control over the projects it funded. In addition, the *matching grant* system pioneered by Ford – a mechanism that required organizations to raise local funds in order to match grants dollar for dollar – became the standard NEA formula. As in Ford's program, the NEA grant-making process was advised not by scholars or critics, but by panels composed of artists and managers of arts organizations. Thus, the endowment's operating parameters were no wider than arts programs in big foundations, and, most significantly, the NEA was virtually prohibited from engaging the for-profit arts industries; it could fund only art of "high quality," where the terms *quality* and *excellence*, then as now, served as coded stand-ins for "the refined arts as presented by major institutions."

By the mid-1960s, the central mechanisms of valuation were in place within the foundation and government sectors: Investment would be in not-for-profit organizations, it would be aimed at a broad audience but directed by knowledgeable elites and self-interested arts professionals, and it assumed the higher value of refined arts of European lineage. From the beginning it was assumed that the national interest, the American quality of life, would be improved if the *supply* of high art were increased. Because sophisticated

leaders in the arts, business, and government lacked confidence in the ability of the general public to make discerning arts investments, *demand* never invaded discussions of funding priorities.

The past half-century has produced a significant cumulative investment in nonprofit organizations. In 1955, U.S. foundations made only about 500 grants to cultural organizations; there were more than 2,000 in 1980. During the same period, the total of foundation cultural grants distributed annually grew from $1.3 million to just under $150 million. Remember that by the late 1960s the National Endowment for the Arts had begun to add federal support to foundation giving; as early as 1980 the NEA distributed $155 million in more than 5,000 grants (in 2005 the agency granted $122 million in 2,100 grants). During the same period most U.S. states created cultural agencies of their own, as did many communities; their grant making only added to the federal and foundation largess directed at nonprofits.

Although political pressures inevitable in a diverse democracy gradually forced foundations and the NEA reluctantly to adopt a more expansive definition of art – embracing first jazz, then folk arts, design, and independent film – disdain for the commercial sector has remained a cornerstone of U.S. arts patronage, whether public or private. Just as foundations adopted the antimarket ethos of nineteenth-century cultural patrons, our federal arts agency has honored many of the same assumptions of artistic rank and value. In fact, because many (but by no means all) fine arts organizations were incorporated as nonprofit, nonprofit status by itself has gradually become accepted as an automatic marker denoting superior artistic output.

17.3 Effects

It is possible to identify some benefits that arise from the complexity of the U.S. arts system. A few decades ago, the absence of a minister of culture or other significant centralizing force in U.S. arts policy was seen by international specialists (somewhat unfairly) as both a symptom and a cause of America's limited capacity for meaningful cultural production and leadership. However, more recently, as a number of venerable ministry-of-culture systems have struggled to sustain long-established levels of central-government investment in art and arts organizations, the complex U.S. system has been viewed more sympathetically. And it is true that America's mixture of government funding, private philanthropy, corporate sponsorship, commercial investment, and earned income does constitute an effective mechanism for steering resources toward art and art making; after all, it is a system that does not, as the expression goes, "have all its eggs in one basket."

But, assessed as a way of aligning the cultural system with public purposes, the effects have been negative; the six-decade fixation by financial elites, foundations, and federal and state agencies on the demands of nonprofit organizations has produced a number of unfortunate outcomes. First, the scope of cultural policy debate in the United States been narrowed to take in little more than the supply-side needs of refined arts organizations. Public intellectuals, caught up in debates over congressional support for the NEA or the culture-war struggles over the appropriateness of one museum exhibition or another, have pretty much missed such culturally significant issues as copyright term extension, deregulation of broadcasting, or the sale of valued cultural assets through corporate acquisitions and mergers.

Deeply suspicious of both the motives and products of the demand-driven commercial arts sector, arts authorities have been unwilling to confront business practices within the for-profit industries, even when these policies have had a dramatic and direct connection with the refined arts in America. For example, forces that have shaped the field of classical recording play out within the commercial music industry. In the mid-1950s, classical music represented as much as 25 percent of all records sold; today, classical CDs are less than 2 percent of sales. Guild and union contracts, bottom-line demands of global entertainment companies, redundant repertory, and other factors contributed to the decline. Arts leaders are dismayed by the state of classical recording in the United States, but commercial-sector challenges cannot be readily engaged by the grant-making strategies employed by foundations and government arts agencies. As a result, despite regular press attention to the disappearance of the U.S. classical record industry over several decades, neither the NEA nor culturally engaged foundations ever attempted to craft an intervention capable of propping up the classical recording scene.[2]

In addition to directing the attention of arts leaders away from issues tainted by a commercial pedigree, five decades of support directed at nonprofit arts organizations has produced a sector that, in aggregate, is seriously overbuilt. There are in excess of 50,000 nonprofit cultural organizations in the United States today, but there has as yet evolved no outcry seriously advancing the notion that the nonprofit arts sector may have outgrown the capacity of its funding streams. But evidence suggests that the sector is too big; salaries of nonprofit arts managers have not kept pace with their

[2] Ironically, although *commercial* is a term of disdain in nonprofit arts circles, most U.S. art making is organized for profit. Art galleries, classical and jazz record labels, boutique independent film productions, and literary presses – each admired by arts aficionados – are almost always organized as for-profit enterprises.

commercial-sector counterparts, and many orchestras and museums have invaded endowments to balance annual budgets. A model of entrepreneurial sector growth pioneered in the 1960s has today been supplanted by fears about status quo maintenance and survival – funders today struggle to sustain organizations pumped up by decades of grant support. And need affects the quality of work: Caught up in the competitive scramble to attract and retain paying audiences, many cultural nonprofits have resorted to conservative programming – Mozart festivals, blockbuster Impressionist exhibitions, and ritualized holiday performances of the *Nutcracker* dot the U.S. arts scene. And how many symphony orchestras *do* we need; how many will communities support? Today, four decades after the Ford Foundation blessed 61 orchestras with grants that averaged more than $1 million each, no arts authority is willing to answer this question. In an atmosphere in which *more is always better*, demand is of no consequence.

There is another side to the coin: With the cultural policy conversation confined to the supply-side needs and desires of the nonprofit refined arts, America's for-profit film, recording, and broadcasting companies have been taken "off the hook": free to pursue shareholder value while defining art as commodity and heritage as asset. But letting demand shape the cultural landscape does not produce an arts system that serves the public interest. When American companies make only 14 percent of important heritage recordings available as CD reissues, and even that small number is "front-loaded," it becomes clear that demand is a poor arbiter of heritage value.

To the extent that the arts industries are engaged by policy at all, it is through traditional business concerns of regulation – global trade, revenue stream protection, and mergers and acquisitions – few legal constraints on business pay any special attention to culture. But legislation and government regulation in the United States have exhibited a light touch when it comes to American cultural industries, and, if anything, over the past 30 years that touch has become gentler. The Federal Communications Commission employs public-interest language as it regulates ownership and, to an extent, the content of radio, television, and telecommunications. But since the early 1980s officials have conflated the public interest with a vigorous marketplace, steadily lifting regulatory constraints perceived to be contrary to the business interests of media corporations.

The same marketplace tilt pervades other issues. Congress has gone along with the corporate view of copyright extension and protection of intellectual property in digital technologies. Copyrights to America's earliest films and sound recordings – works for hire controlled by record companies and studies – are now protected until the middle of this century; the Digital

Millennium Copyright Act makes it easy for corporations to generate "take-down letters" attacking Web sites perceived to infringe on trademarks or copyrights. Courts charged with interpreting U.S. statutes have also tended to side with corporate interests. Unfortunately, cultural leaders possessing the economic clout and political capital necessary to weigh in on arts issues have been absent from the telecom and intellectual property debates, instead limiting their involvement to matters of direct concern to nonprofits such as NEA budget levels, the tax benefits of donated appreciated property, and so on. From time to time a U.S. congressional hearing might challenge the content of comic books, movies, or recordings, but apart from the demagoguery of the culture wars serious investigation of the effect of American business practice on the vibrancy of the cultural scene is virtually nonexistent.

If it can serve as any consolation, the United States arrived at this place by an organic process: Technology, legislation, corporate practice, social pretension, and artistic prejudice conspired to produce an intractable division in the arts scene. The stark commodification of art and heritage – art that is *popular* – operates in a market-driven world of protected revenue streams. At the same time, the hierarchical assumptions and supply-side focus of the nonprofit community – art that is *precious* – function without reference to the laws, business practices, and consumer desires that define most of the arts scene for most citizens. A system that allows commercial interests unchecked exploitation of art products while insisting that citizens feast on an ever-expanding supply of fine arts is not aligned with the public interest. The profile of the U.S. cultural landscape will ultimately be improved only by the willingness of leaders to engage in softening the hard edges of America's poorly articulated, disparate, and ultimately extreme mechanisms for assigning value to art.

References

Bourdieu, Pierre. 1984. *Distinction: A Social Critique of the Judgement of Taste*, trans. Richard Nice. Cambridge, MA: Harvard University Press.
Brooks, Tim. 2005. *Survey of Reissues of U.S. Recordings*. CLIR Reports, Pub. 133. Washington, DC: Council on Library and Information Resources.
Carey, John. 2005. *What Good Are the Arts?* London: Faber & Faber.
DiMaggio, Paul J. 1991. Cultural Entrepreneurship in 19th-Century Boston: The Creation of an Organizational Base for High Culture in America. In Chandra Mukerji and Michael Schudson, eds., *Rethinking Popular Culture: Contemporary Perspectives in Cultural Studies*, 374–397. Berkeley: University of California Press.
Rockefeller Brothers Fund. 1965. *The Performing Arts: Problems and Prospects*, Rockefeller Panel Report No. 7. New York: McGraw-Hill.
Straight, Michael. 1988. *Nancy Hanks: An Intimate Portrait*. Durham, NC and London: Duke University Press.

Further Reading

The following publications provide further perspectives on issues raised in this chapter.

Bradford, Gigi, Michael Gary, and Glenn Wallach, eds. 2000. *The Politics of Culture: Policy Perspectives for Individuals, Institutions, and Communities.* New York: The New Press.

Brenson, Michael. 2001. *Visionaries and Outcasts: The NEA, Congress, and the Place of the Visual Artist in America.* New York: The New Press.

DiMaggio, Paul J., ed. 1986. *Nonprofit Enterprise in the Arts: Studies in Mission and Constraint.* New York: Oxford University Press.

Eliot, Marc. 1989. *Rockonomics: The Money behind the Music.* New York: Franklin Watts.

Levy, Alan Howard. 1997. *Government and the Arts: Debates over Federal Support of the Arts in America from George Washington to Jesse Helms.* Lanham, MD: University Press of America.

Munson, Lynne. 2000. *Exhibitionism: Art in an Era of Intolerance.* Chicago: Ivan R. Dee.

Passman, Donald S. 2000. *All You Need to Know about the Music Business,* revised ed. New York: Simon & Schuster.

Schiffrin, Andre. 2000. *The Business of Books: How International Conglomerates Took Over Publishing and Changed the Way We Read.* New York: Verso.

Zeigler, Joseph Wesley. 1994. *Arts in Crisis: The National Endowment for the Arts Versus America.* Chicago: A Capella Books.

Index